GET UP A PARTY!
Mid-Century Burlesque Advertising

**Compiled and with
an essay by
BRUCE SIMON**

GET UP A PARTY! Mid-Century Burlesque Advertising
First Printing September 2019
All text, editorial matter and digitally restored artwork
Copyright 2019 Bruce Simon
No reproduction without the written permission of the author
except for review purposes.
Contact Bruce Simon at kinevideo@aol.com

Dedicated to my beautiful daughter Mimi, who gets the fun of it all as she circles her pole with the greatest of ease and from Burlesque's past, the beaten down guys who just wanted a laugh and a good time and the hard-working comics and glamorous gals who gave it to them.

Here's an odd confession from someone publishing a book of Burlesque show advertisements; I've never actually been to a Burlesque show. You probably haven't either; they've been relatively extinct since the dawn of the sexual revolution some 50 years ago, having been supplanted by X-rated films, Playboy magazine and, horrors! People actually having non-procreative sex!

There is a new Burlesque, of course, and I appreciate the spirit and the talent of the participants, but to recreate the original Burlesque sensibility is an impossibility; Burlesque was a product of a society in transition; a transition between a time of an almost complete lack of public acknowledgement of sexuality to one of a sexuality so public that many thought it a threat to the nation. The joyous tease of a Burlesque dancer, coupled with comedy of an unleashed nature, so undomesticated that Lenny Bruce himself started as a Burlesque comic, was a revelation in entertainment; heretofore a family-centric enterprise with motion pictures being heavily censored and vaudeville being a notoriously scrubbed clean medium where any loose talk or actions on stage could and would imperil an entertainer's livelihood.

Our modern impressions of the world of Burlesque are colored by representations that by their very nature could only give us a whitewashed impersonation of the reality of the artform. Motion pictures, such as "Lady of Burlesque" starring Barbara Stanwyck and comedies starring the Burlesque headliners Abbott and Costello made during the era of the Production Code could only offer the vaguest impression of what live audiences saw.

I don't consider myself an expert on the form in any way, shape or manner. I also don't consider Burlesque as any deep pool of interest for study and examination, at least by me. I present this book, containing what I believe is the largest printed collection of Burlesque advertisements, gathered from around the country and spanning three decades as first, and most importantly to me, a graphic feast of one of my personally favorite artforms, the newspaper display ad; where hand lettering, semi-hysterical ad copy and heavily screened photos combine to stir a fevered desire to consume. These ads, for the most part, appeared in the

mainstream commercial medium of the daily newspaper amongst the movie ads on the entertainment page. Decorum was barely maintained as the advertiser strained to convey in the most inoffensive way the licentious delights to be had. Any stirring of the animal impulses in the reader by looking at these ads should be cause for alarm, you might need to get out more.

There are four galleries of advertisements following this introduction; three of which present ads from various regions of the U.S. and the fourth, a presentation of a sampling of snappy cartoon books hawked by candy butchers strolling the aisles of the theatres during performances.

I believe these advertisements conjure up their time for us better than any film could, letting us imagine an era where the unmoored men of the nation; young men, old men, military men, indigent and defeated men, working men, professional men, traveling men, reasonably happy married men, curious men, lonely men, confirmed bachelors and social misfits alike, gathered together, drifting in one by one to laugh and to gape and gawp, untethered from the social norms of the times. The title of this book is taken from an admonition from many of the ads within; "Get Up a Party!" For most, there was no party, just a night of raucous laughter and some very intense and solitary contemplation.

-Bruce Simon

GALLERY ONE

CONSISTING OF:

LOS ANGELES BURLESQUE- an essay from MINESHAFT #15

Advertisements from the LOS ANGELES EXAMINER 1936-1963

Advertisements from SAN FRANCISCO EXCLUSIVE magazine and the OAKLAND TRIBUNE 1953

Advertisements from THE PLAYGOER magazine from San Francisco 1947-1961

Authors note: The entertainment provided by the female impersonators appearing at Finocchio's doesn't strictly adhere to the definition of Burlesque to some, but to me the combination of humor and glamor is spot on.

The following are, for the most part, a collection of newspaper ads for Burlesque shows from the pages of the Hearst-owned Los Angeles Examiner circa 1947-55. Amusingly, they appeared on the Entertainment page of the paper alongside ads for the latest movies and stage shows, with the comic section on the reverse of the page. Ads for night clubs, strip clubs and the likes of Burlesque greats Ginger Jones, "The Wham-Wham Girl" and Lili St. Cyr shared the page with the latest Disney films and Hollywood musicals while Jiggs and Maggie, Blondie and Tim Tyler cavorted on the verso.

These ads are beautifully designed, many with stylish hand lettering and illustrative effects, setting off the heavily screened photos of the Burlesque queens. They promise fun and elaborate productions with legions of leggy beauties and the obligatory baggy-pants comics for the errant husbands, traveling salesmen and lonely and overcoated auto-eroticists populating the threadbare, sticky seats of the once-proud movie and vaudeville houses.

It's quite stunning to think in these days when entertainment is, in many cases, canned and most people stare sullenly at their smartphones or shuffle in and out of their multiplexes that, in the not too distant past, there was once was called "nightlife". Dozens of nightclubs, where you could entertained for the price of a drink, floor shows and name orchestras by the score, vaudeville bills with the biggest stars entertaining you live and, if you were in a certain mood, a visit with Tempest Storm, Chili Pepper or Jennie Lee, "The Bazoom Girl".

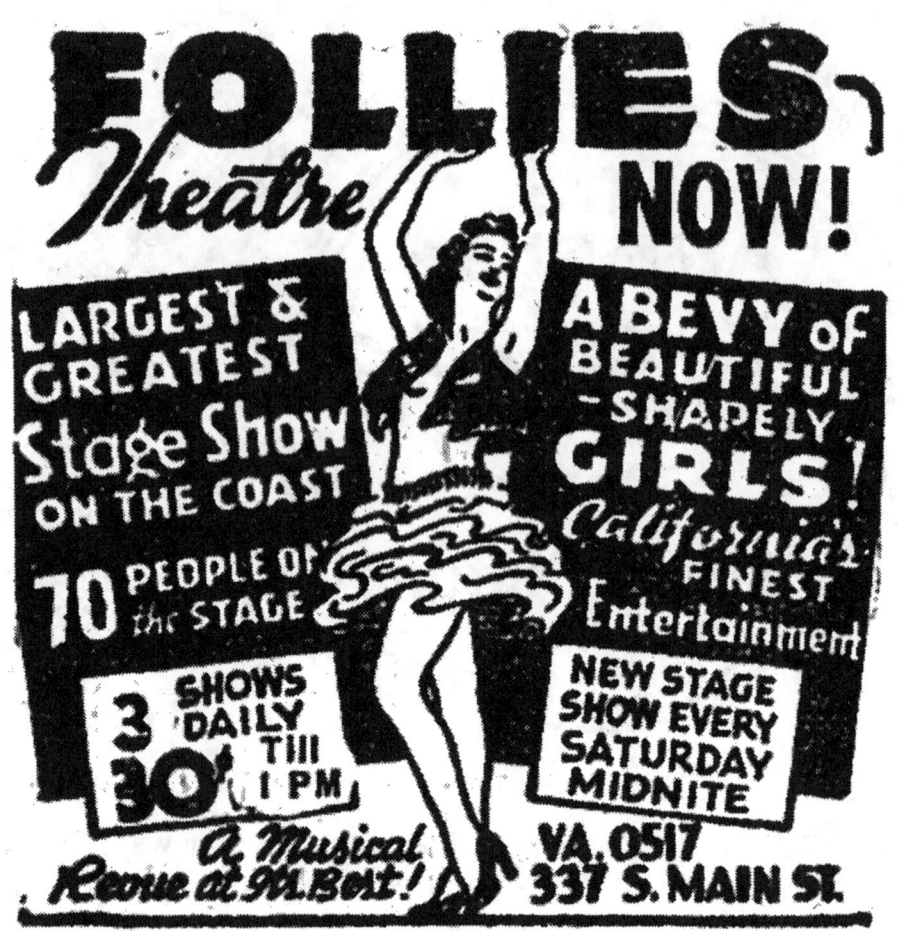
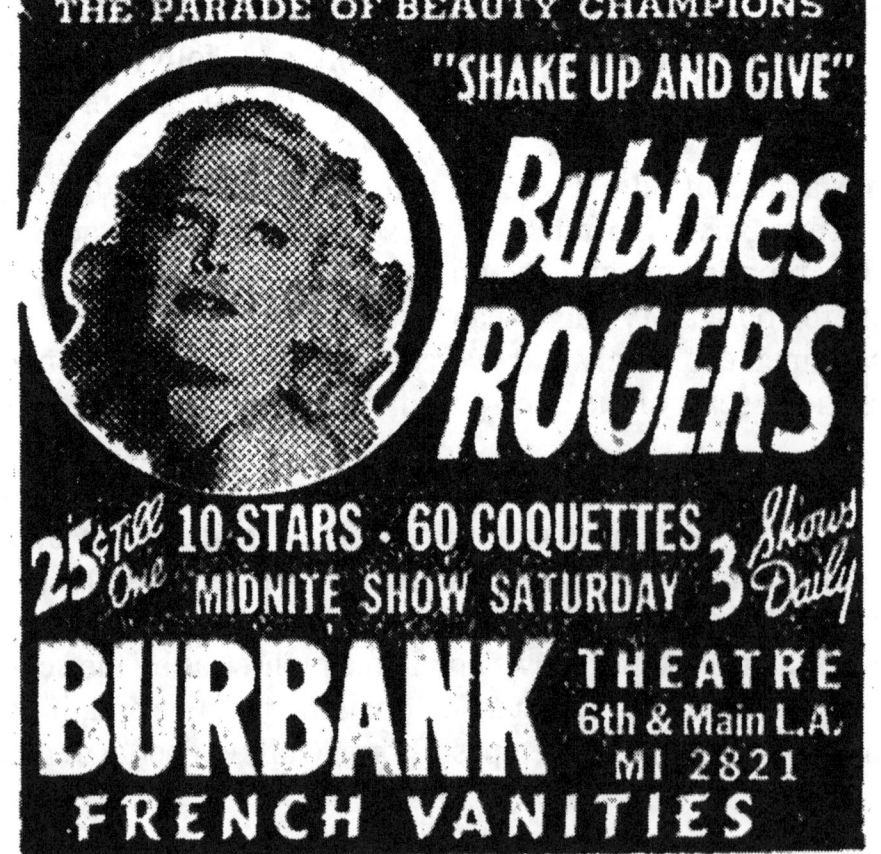

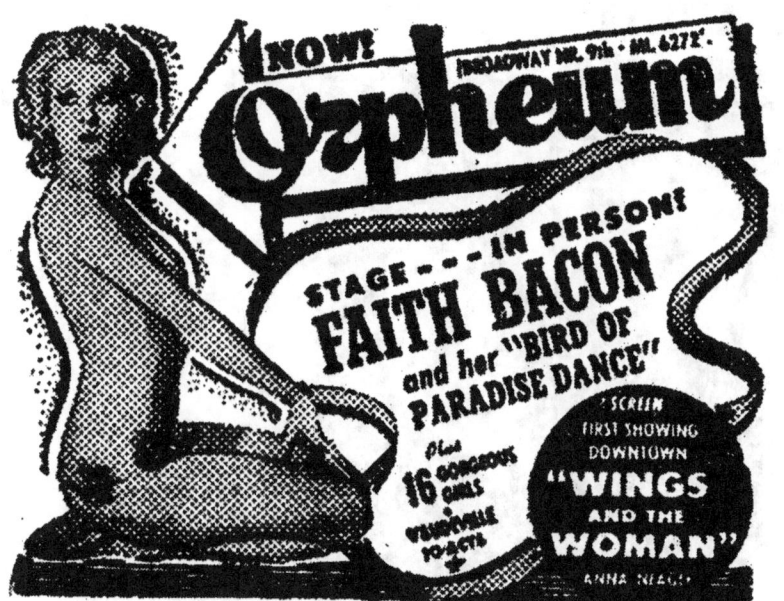
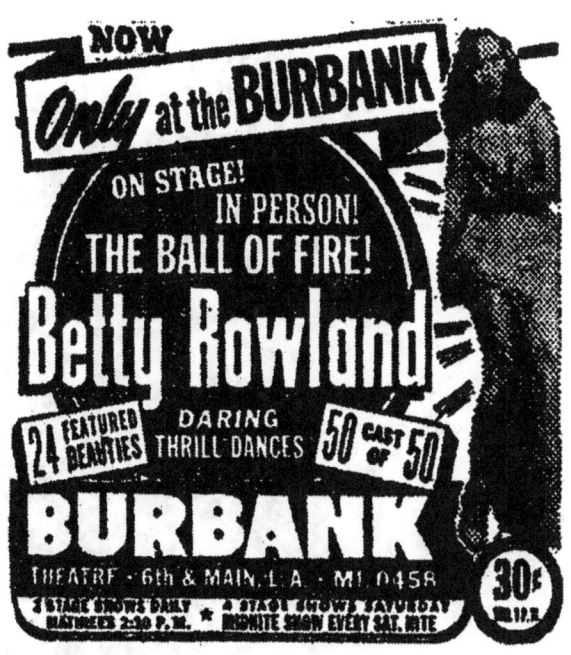
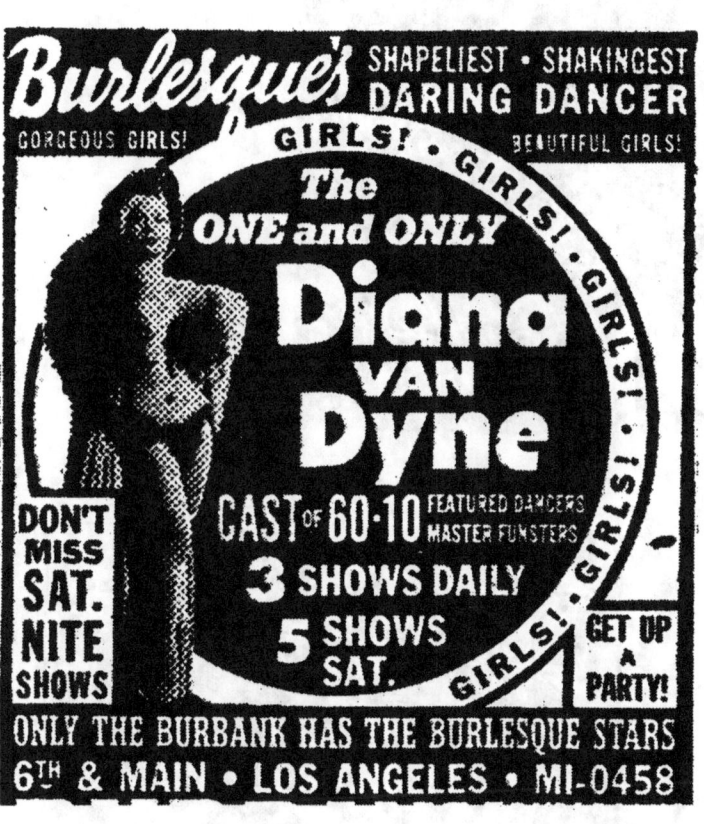
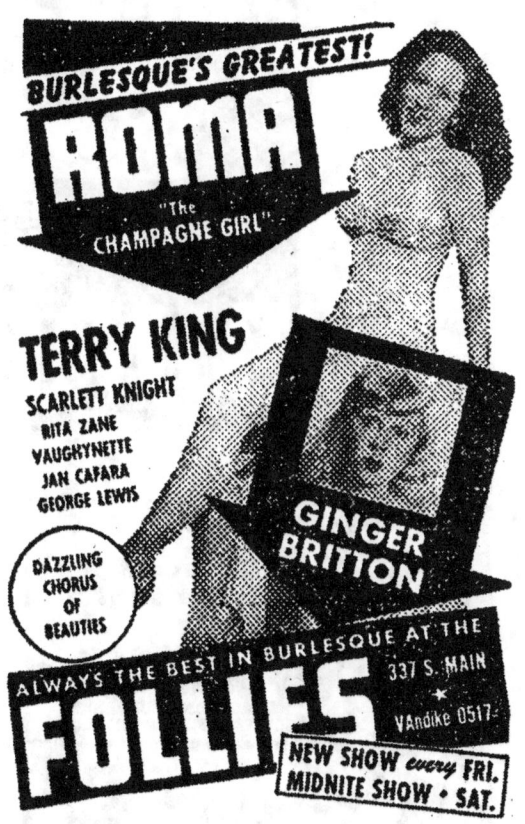

2 SHOWS TODAY 5:30 — 8:30
2 SHOWS SAT., 7:30 AND 10 P.M.
HOT AS A ROBOT BOMB!
"A HONEY IN THE HAY"
THE TOWN'S TORRID STAGE SHOW
MUSART ★ Figueroa at Pico ★ PR. 6644 ★ NIGHTLY AT 8:30

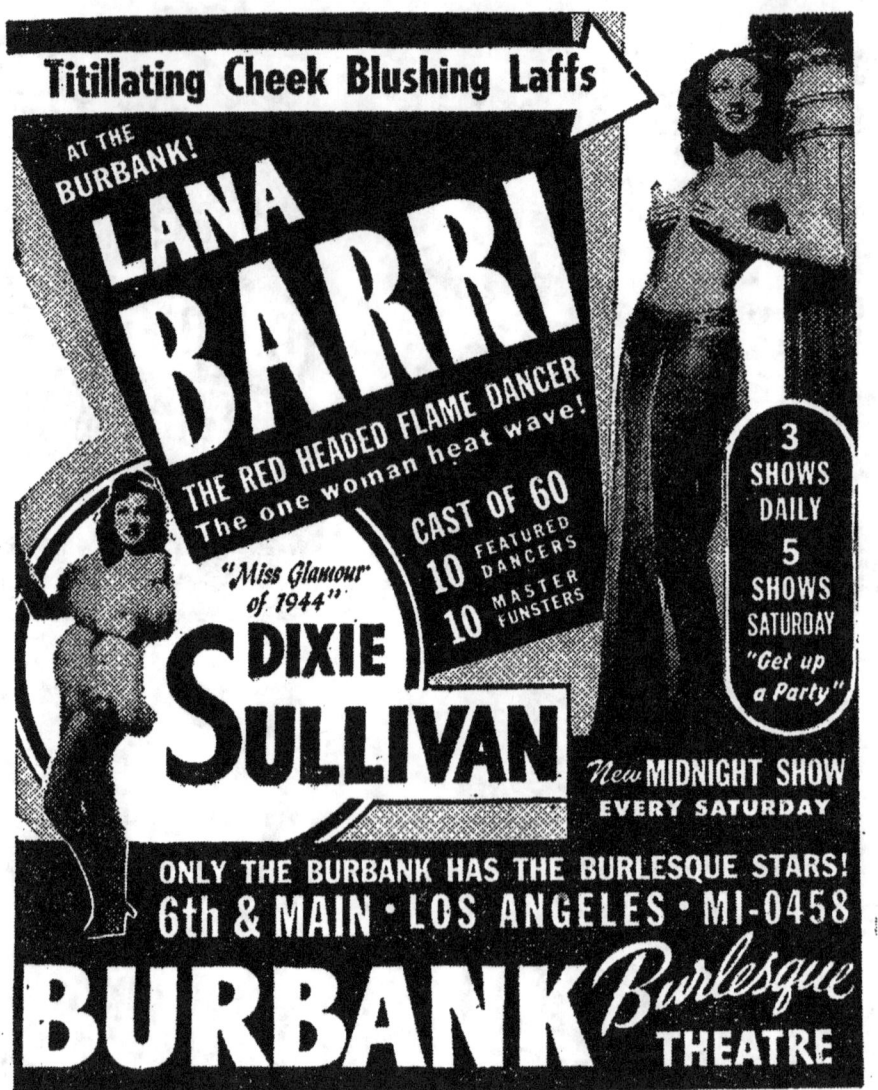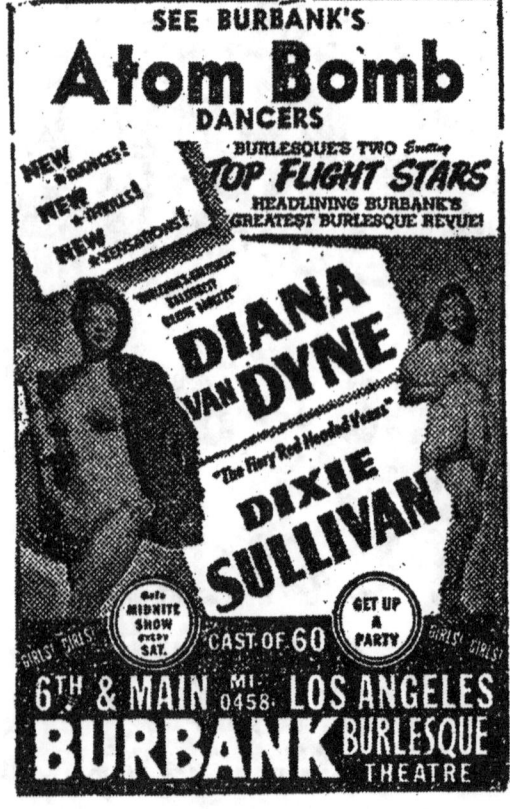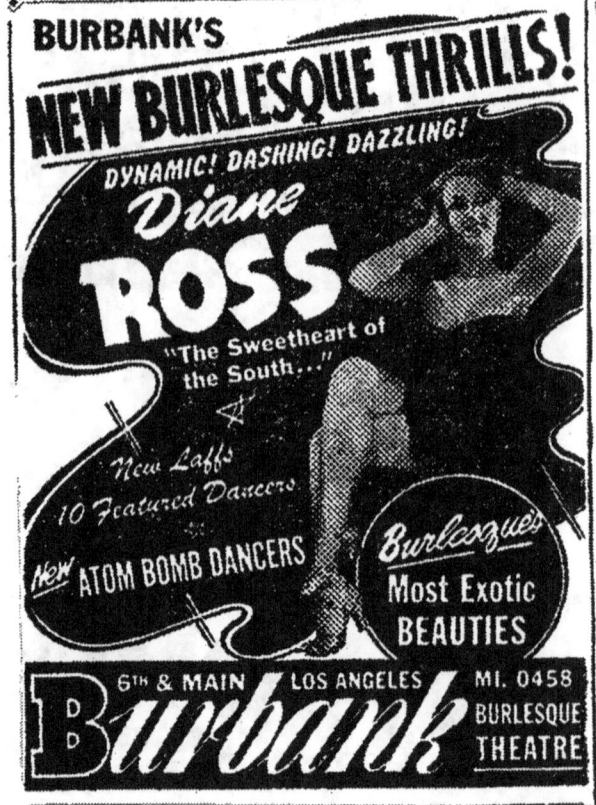

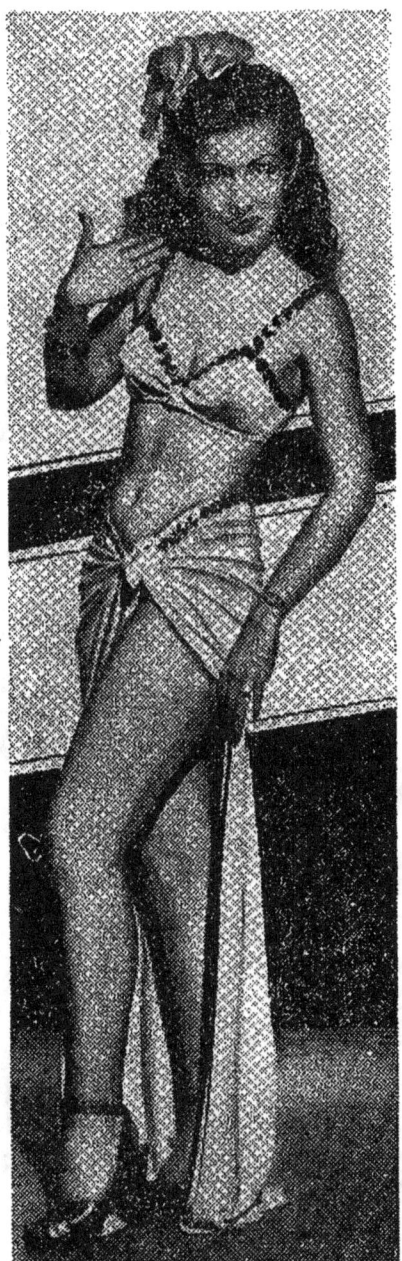

DANCER Dixie Sullivan is featured in Burbank revues.

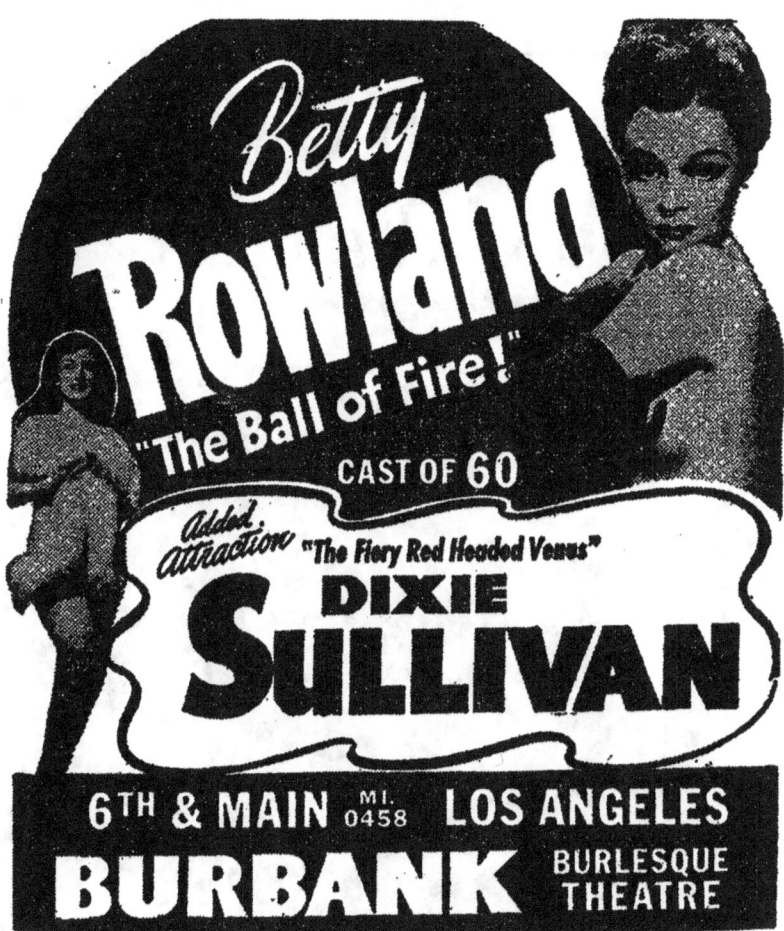

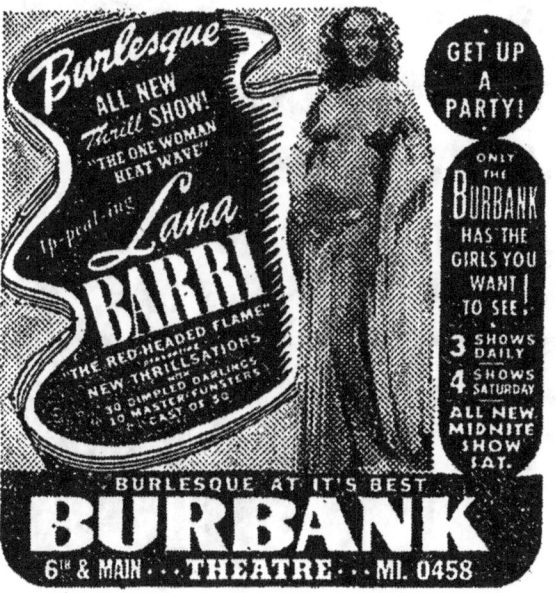

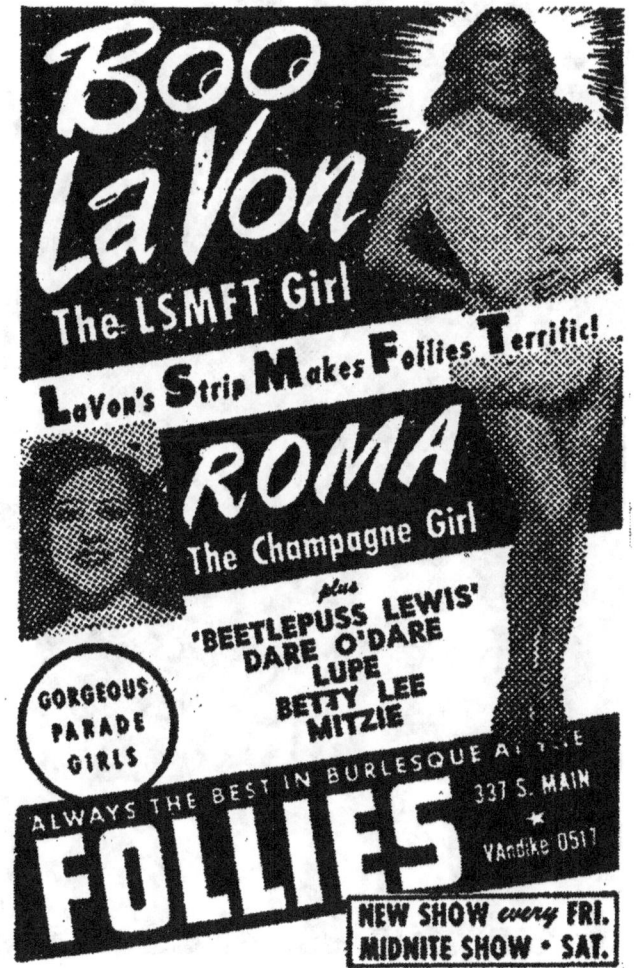

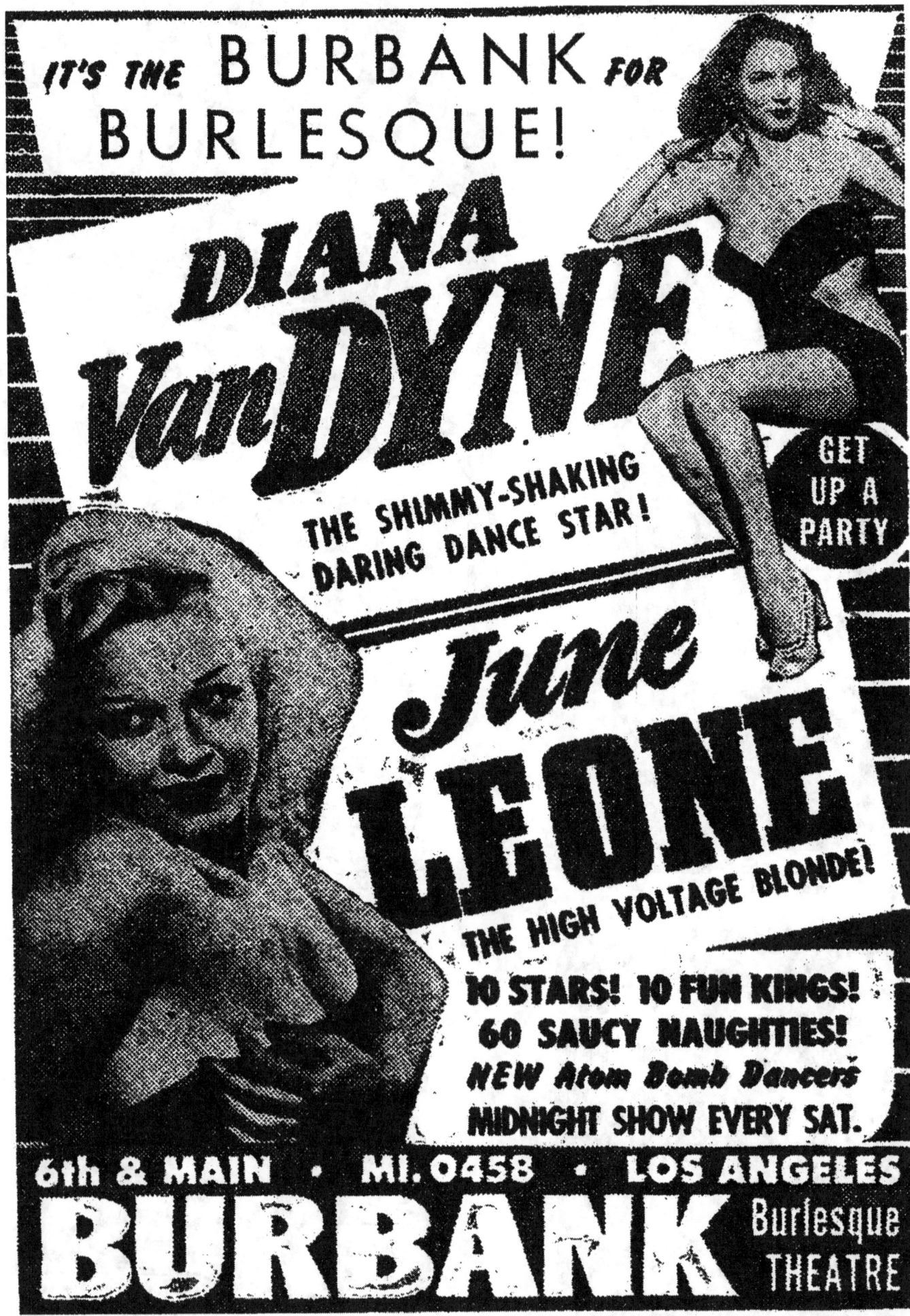

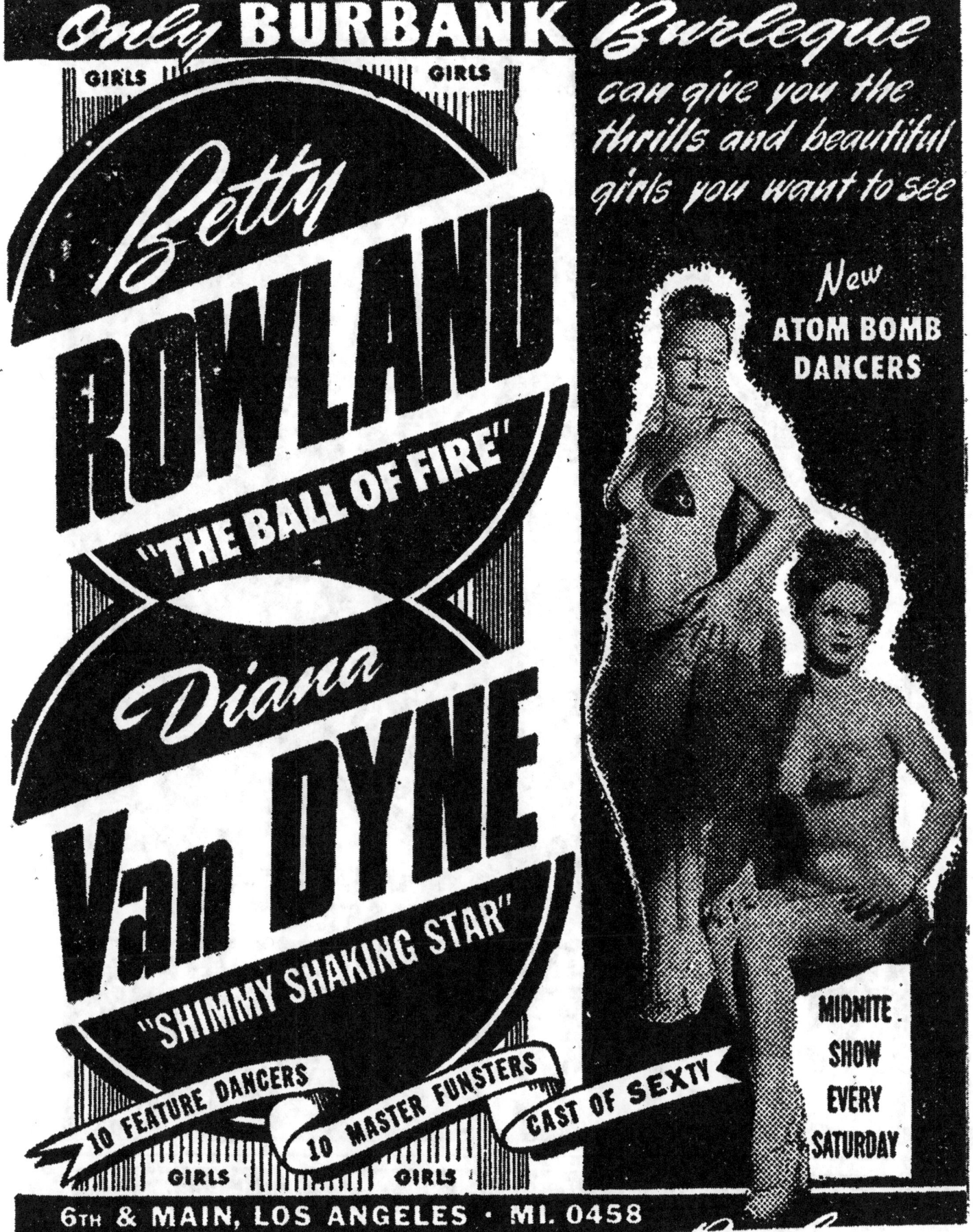

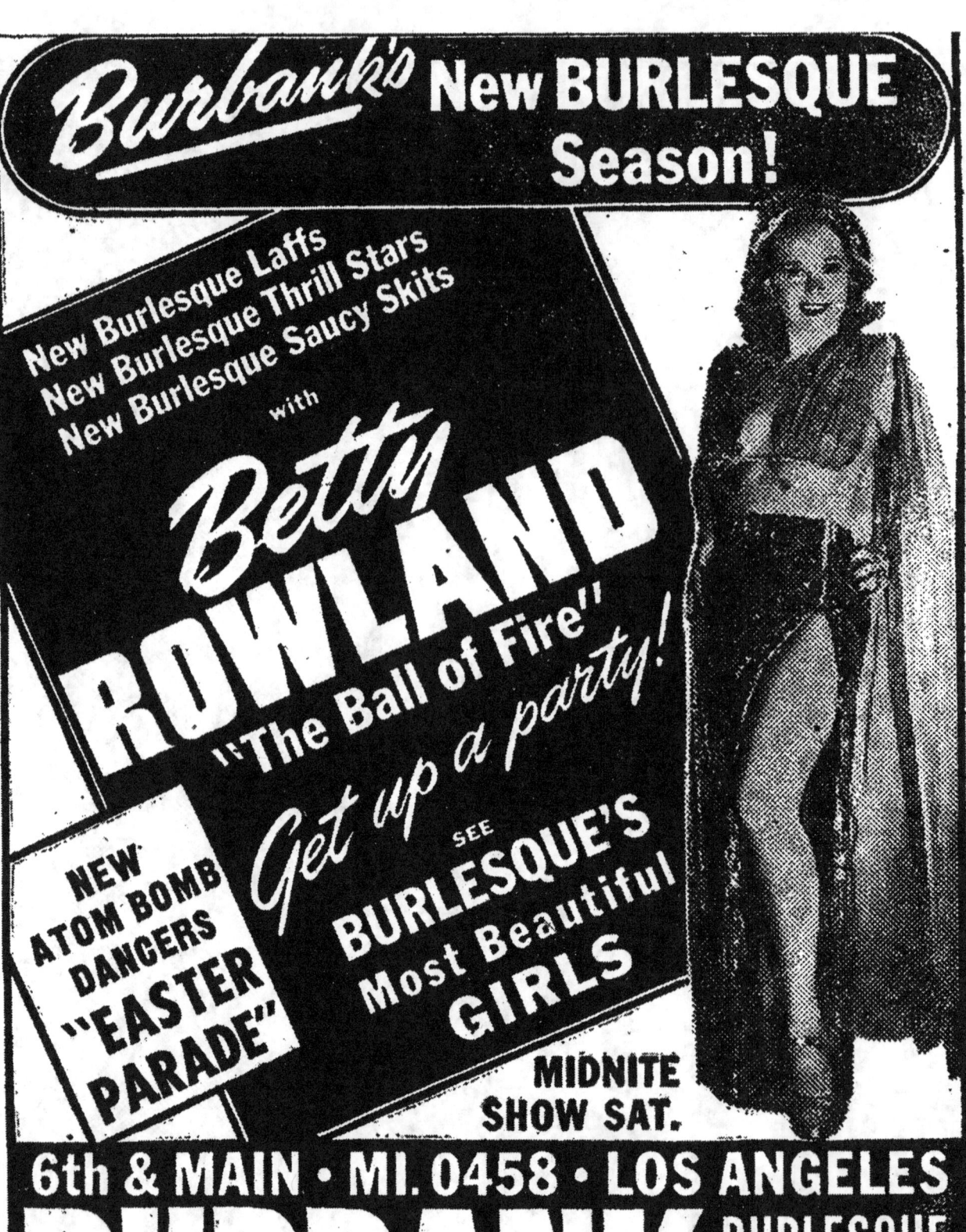

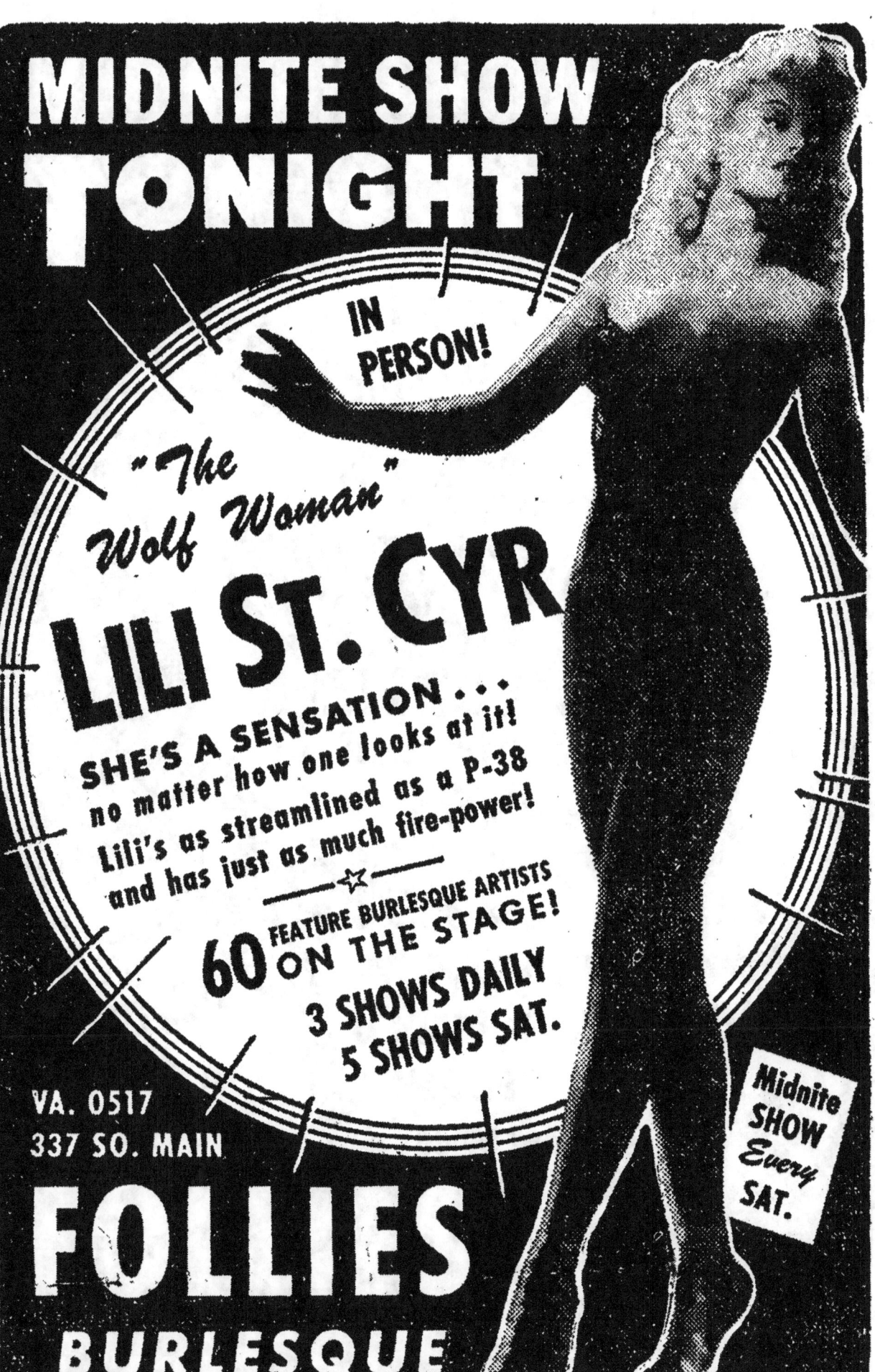

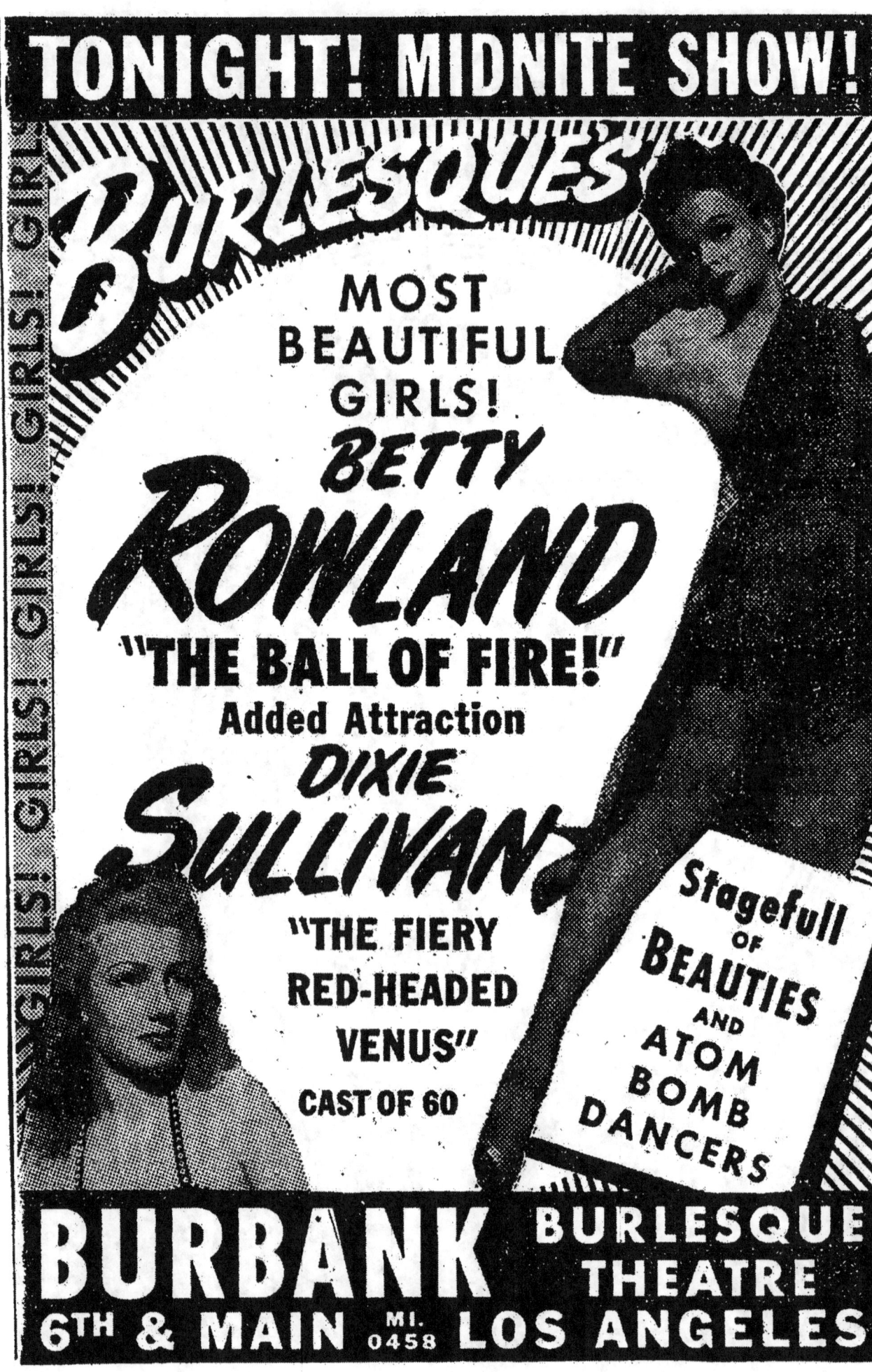

BURBANK'S NEWEST STRIPSATION

The New Ravishing Star

HELENE LOVETT

BURLESQUE'S BODY *Beautiful*

PREMIERE ENGAGEMENT
Direct from NEW YORK

10 STARS
CAST OF SEXTY
6th & MAIN
DOWNTOWN
LOS ANGELES

BURBANK
BURLESQUE THEATRE · MI 0458

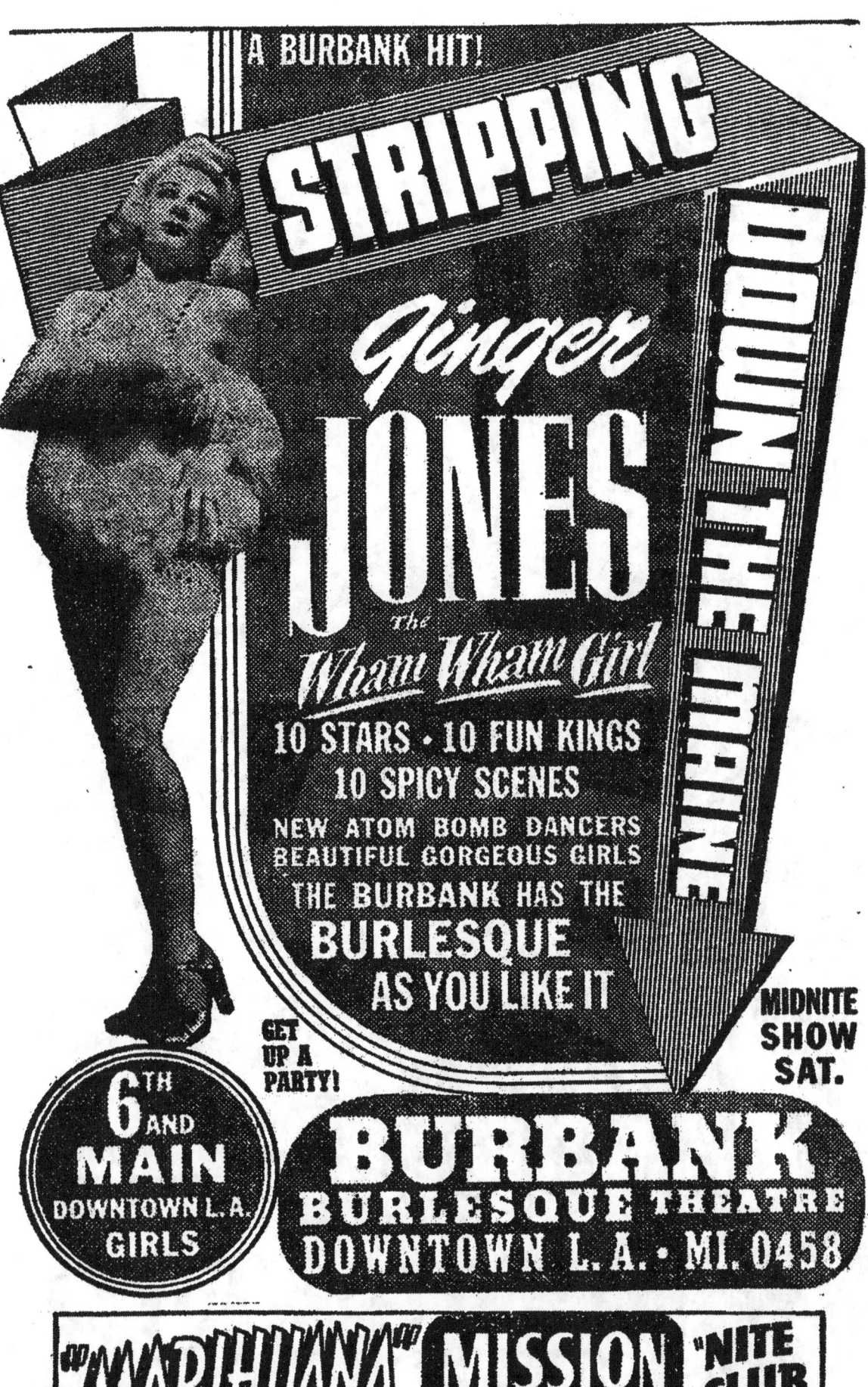

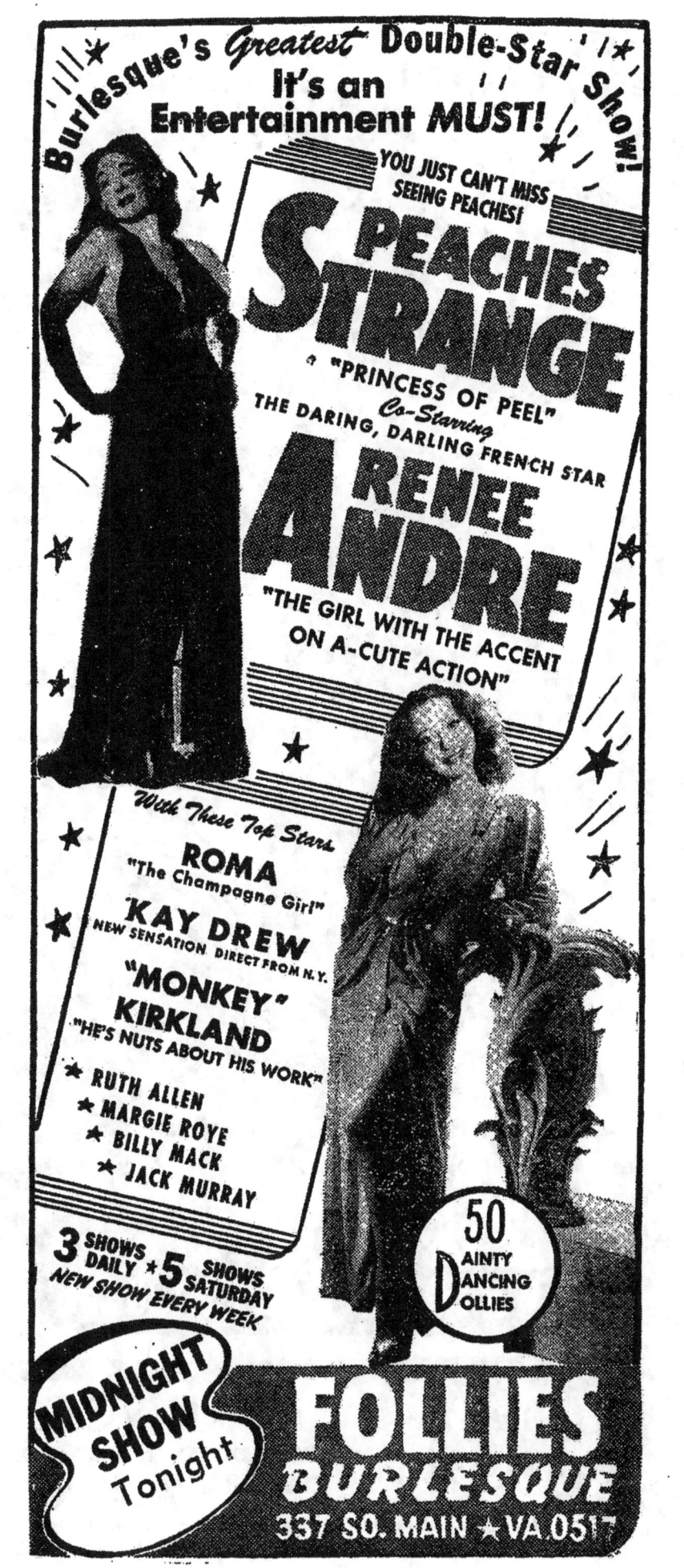

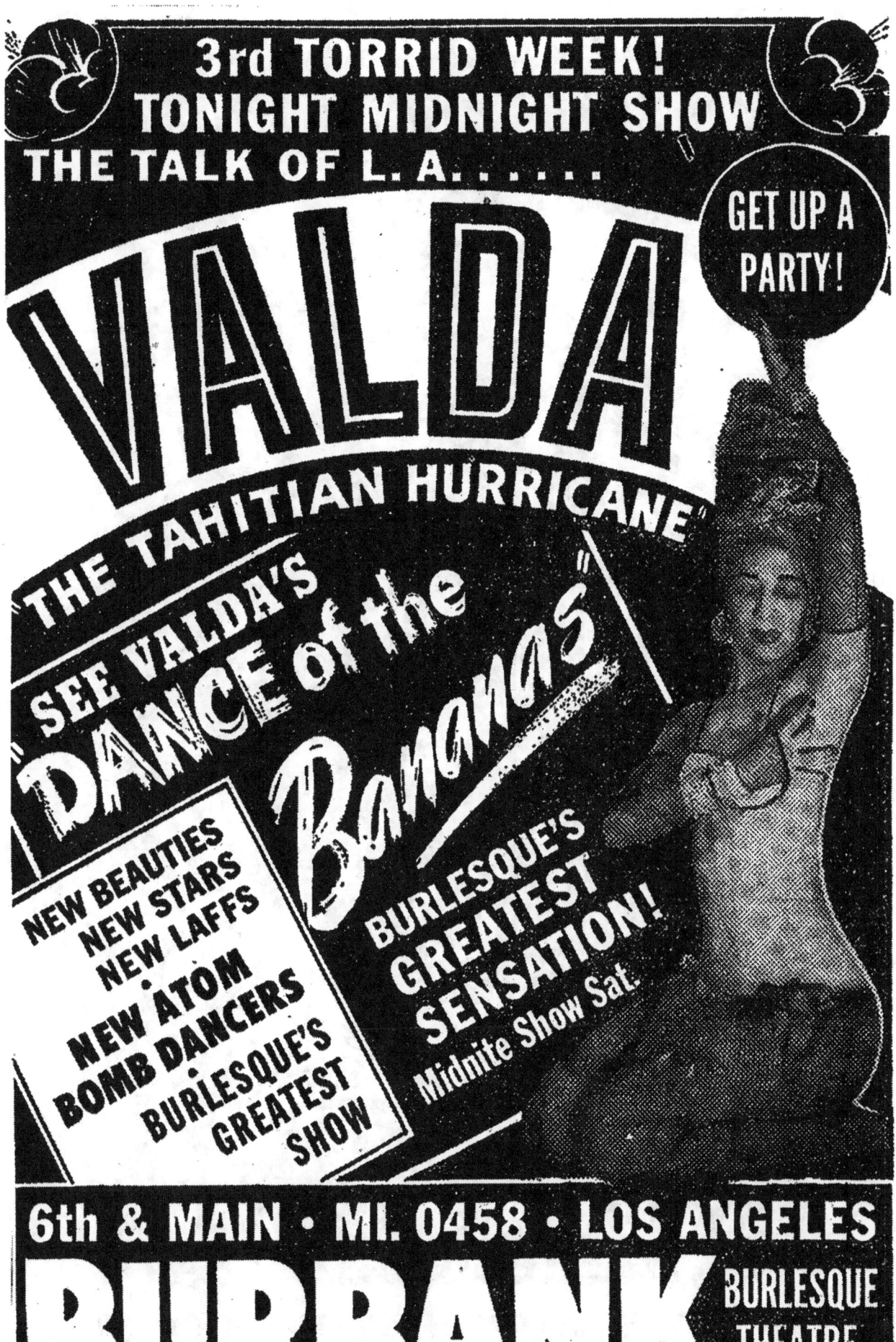

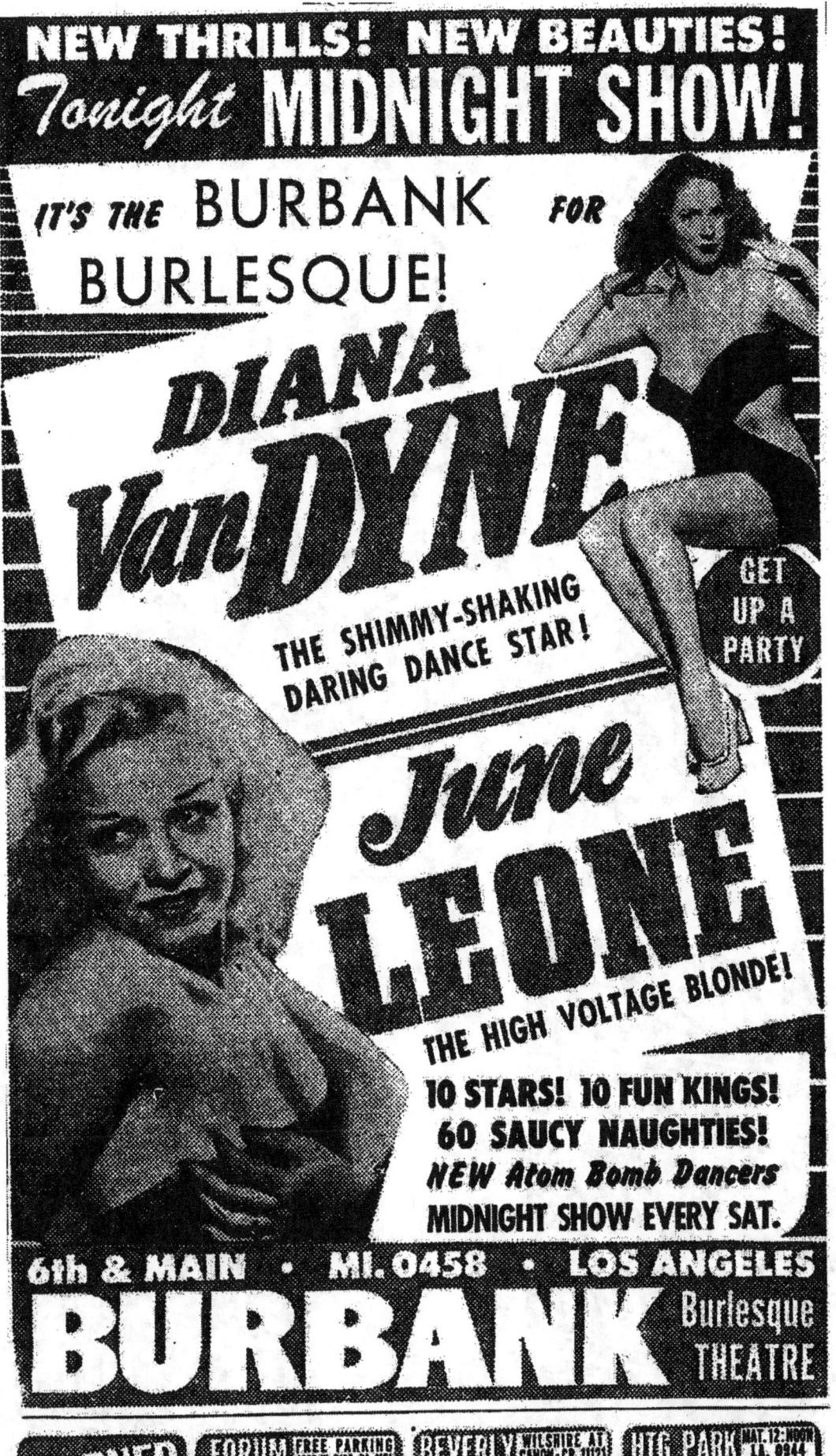

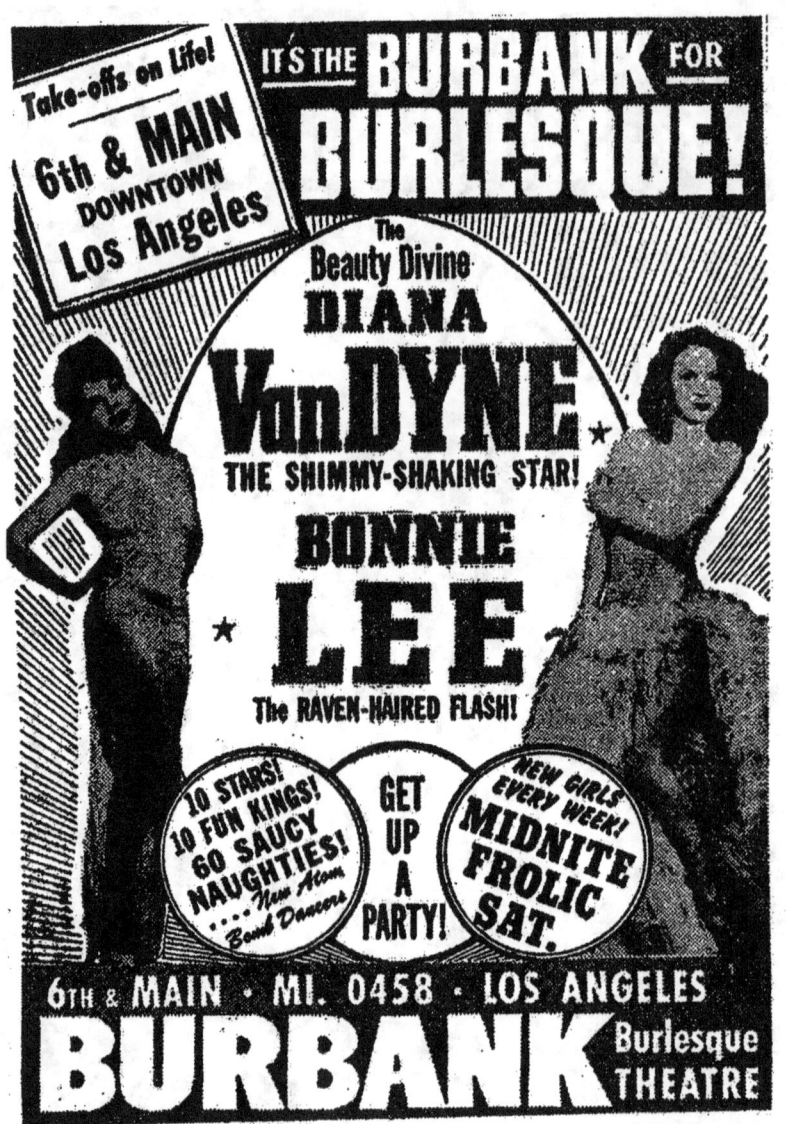
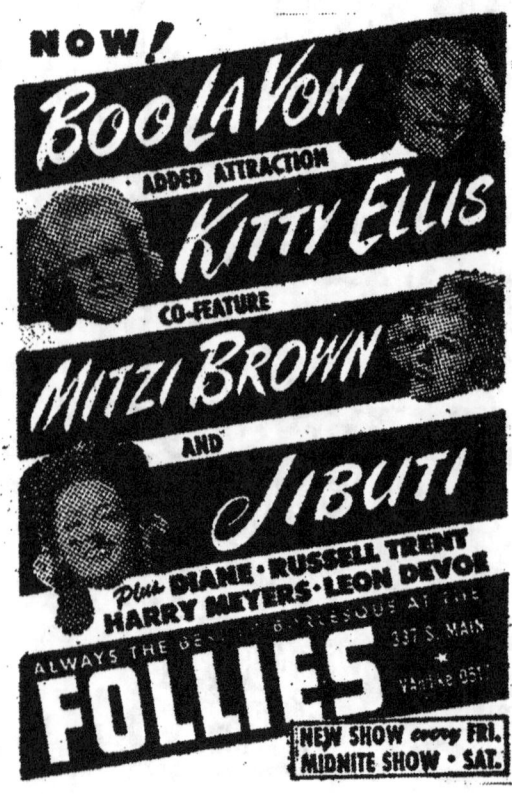
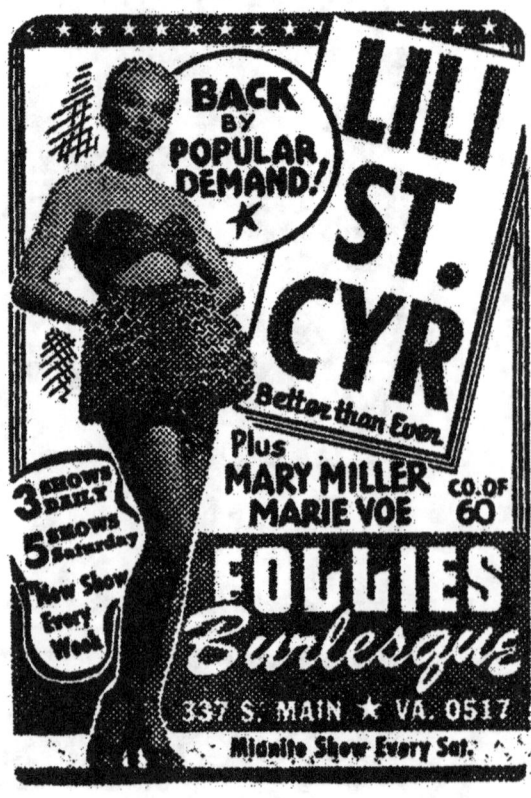

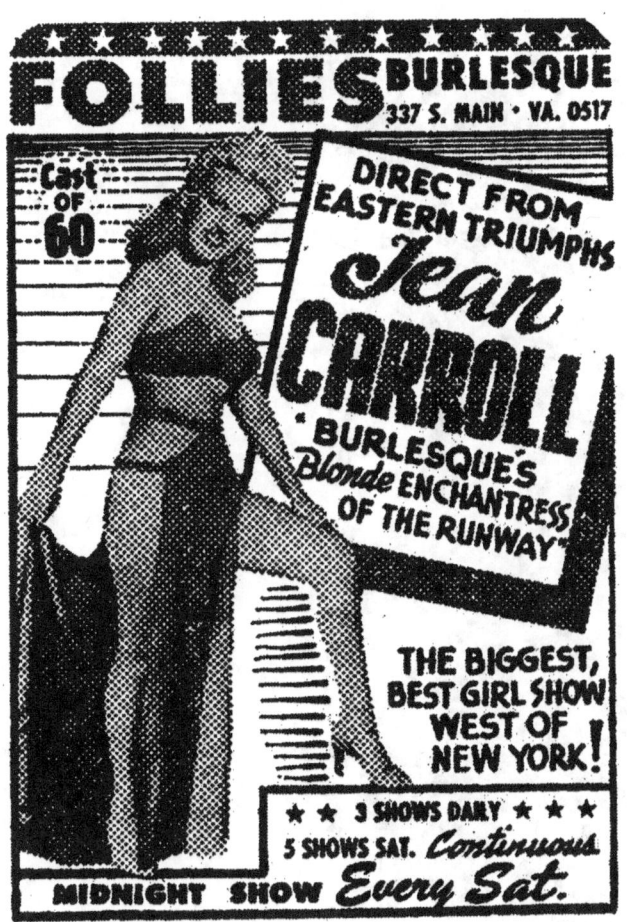
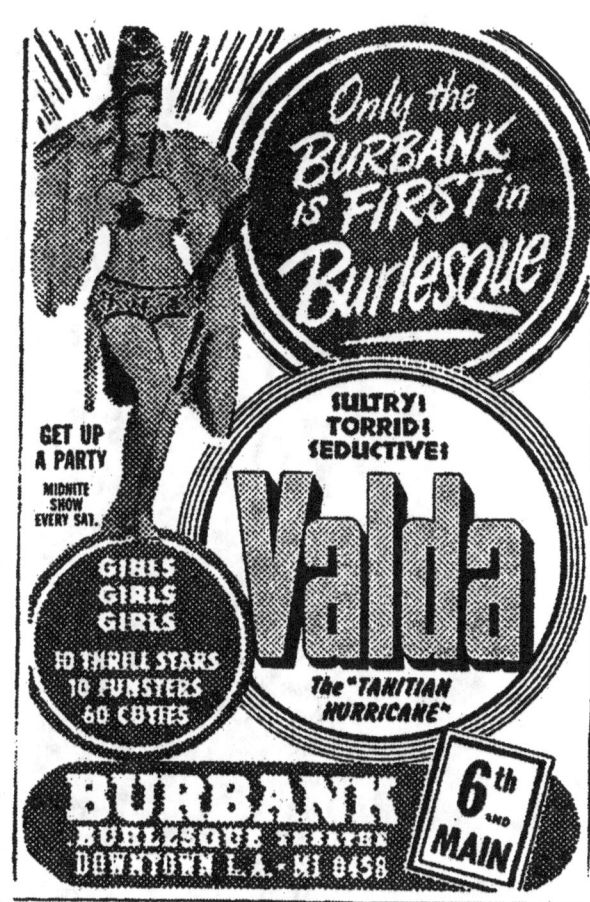
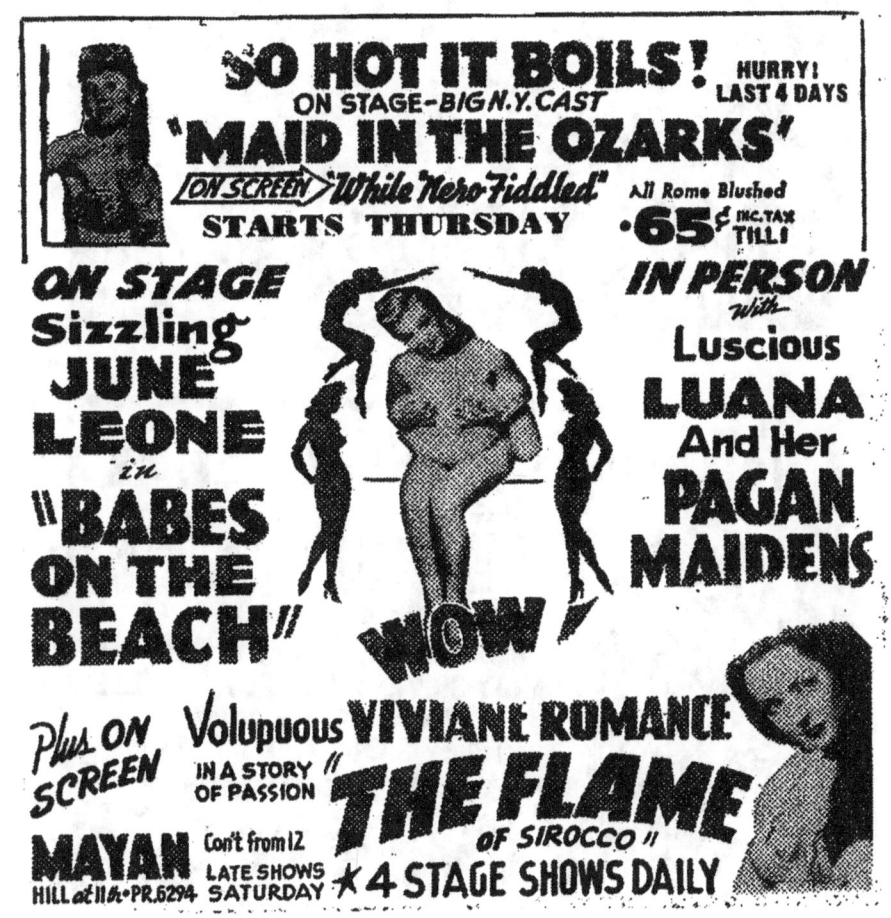

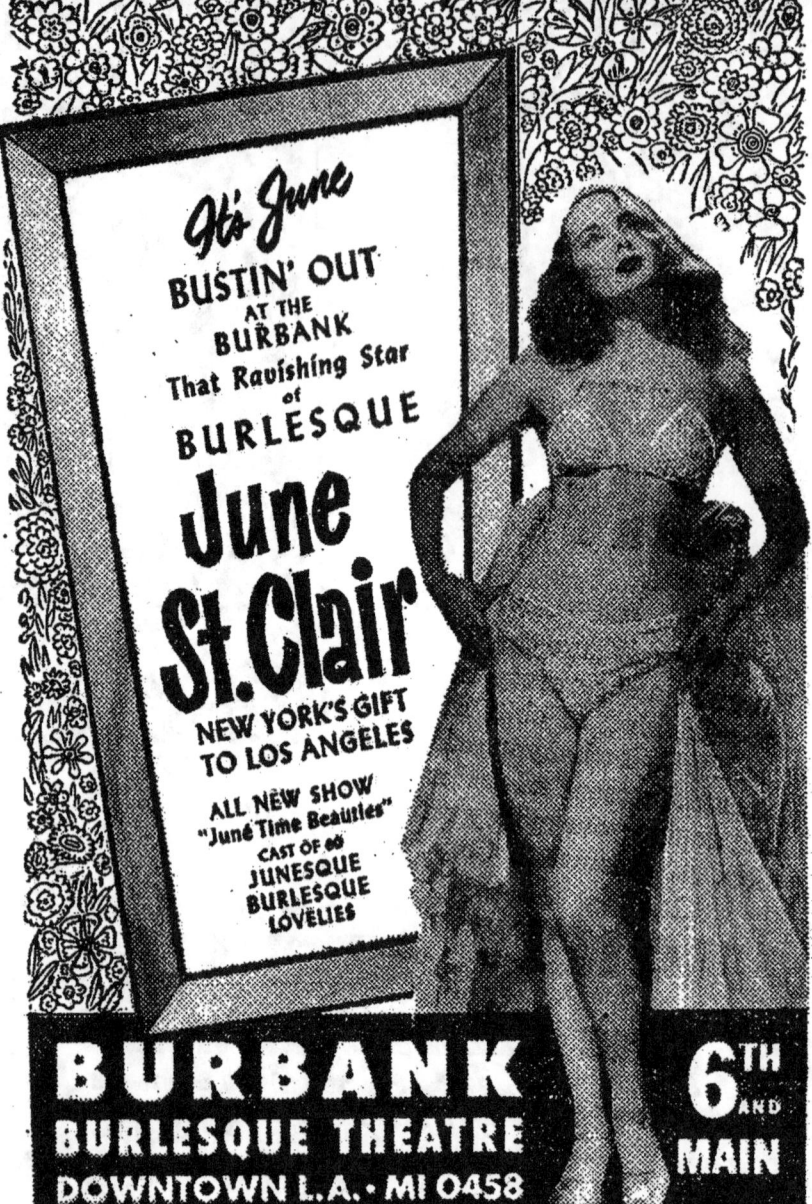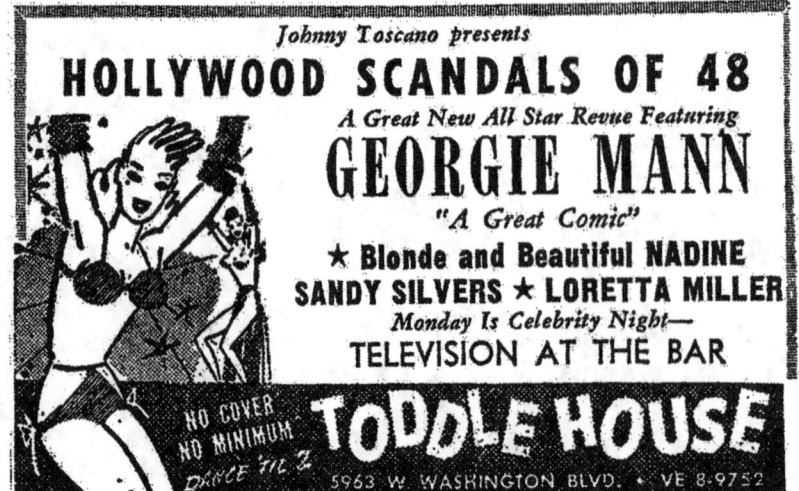

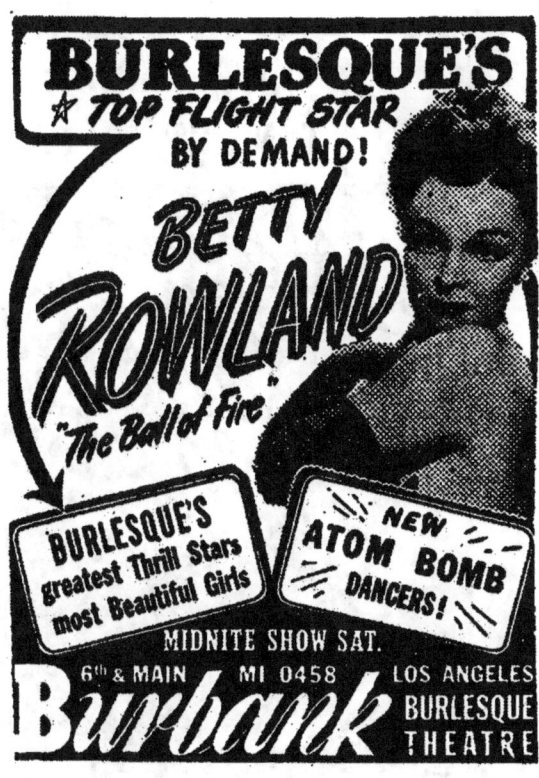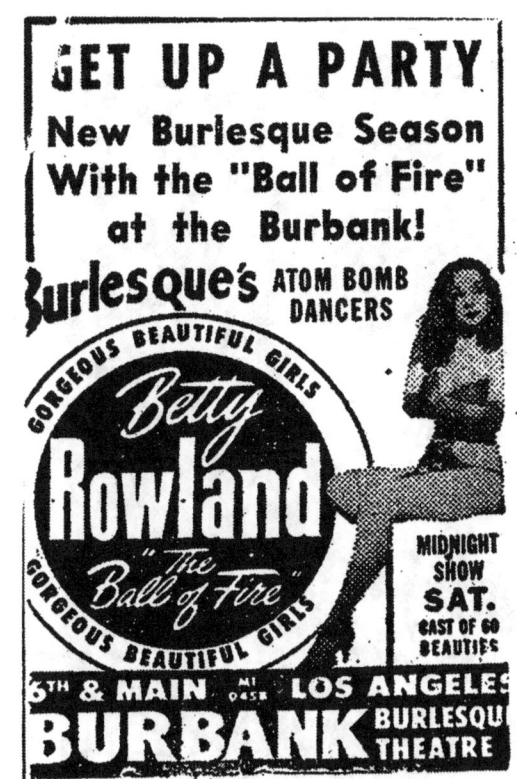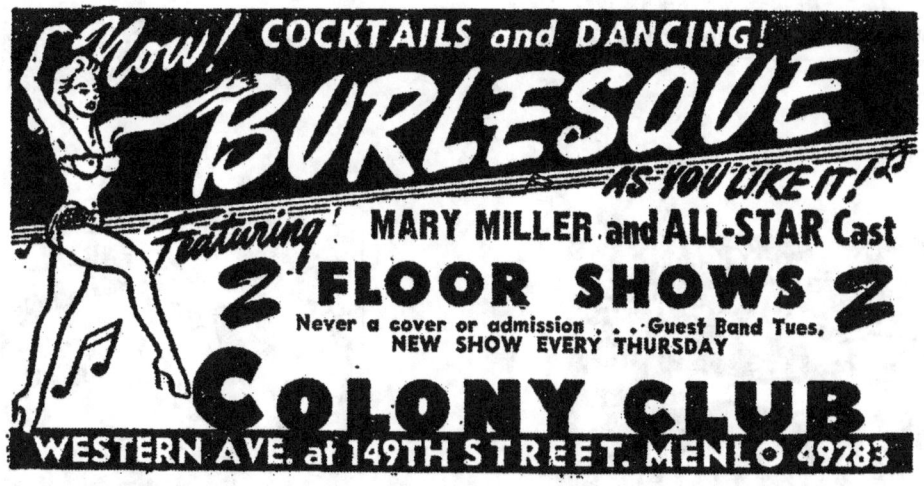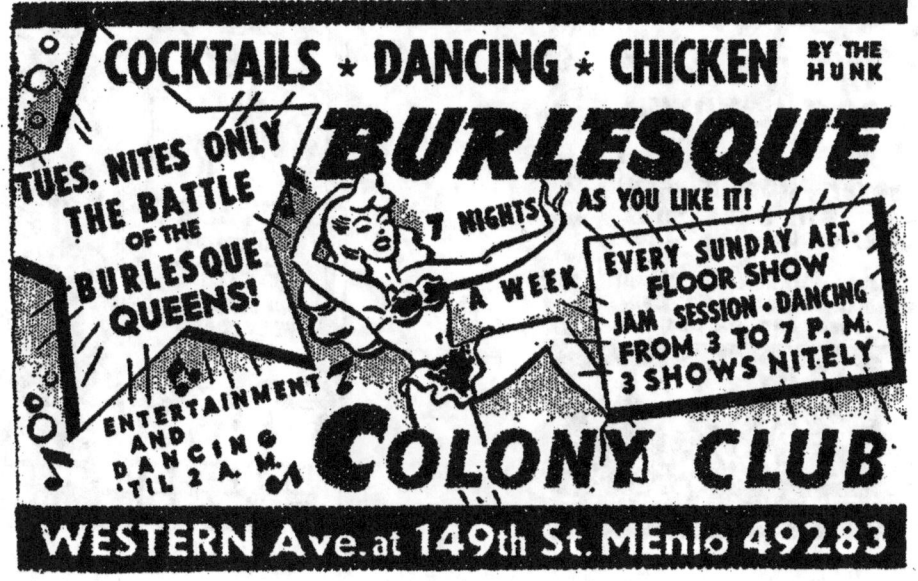

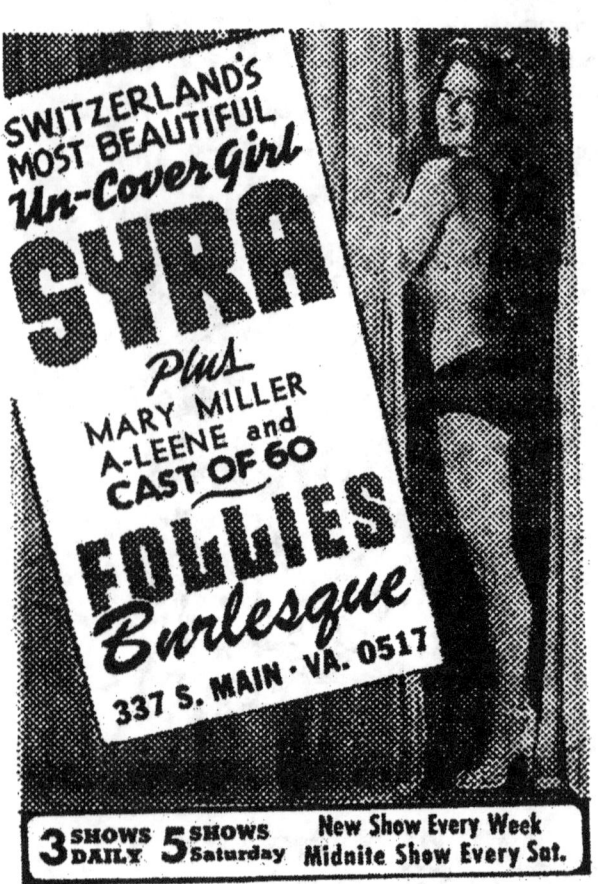
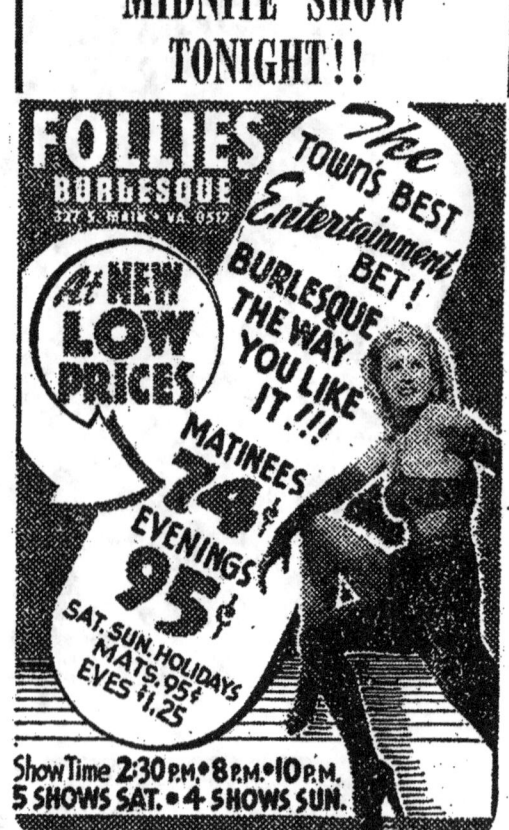
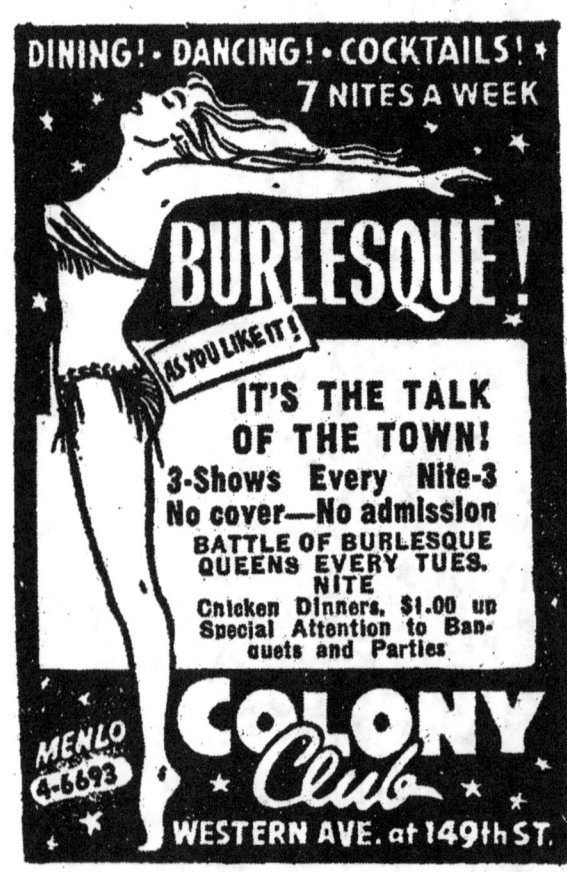
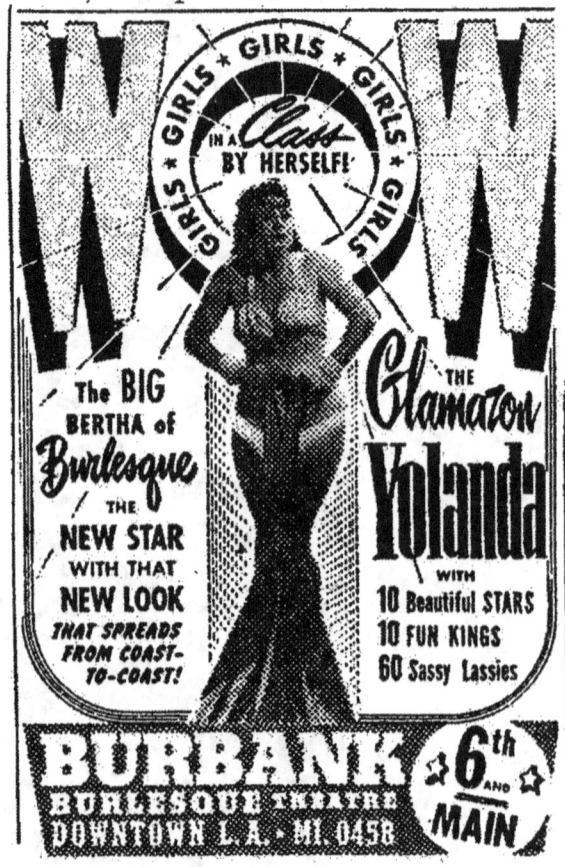

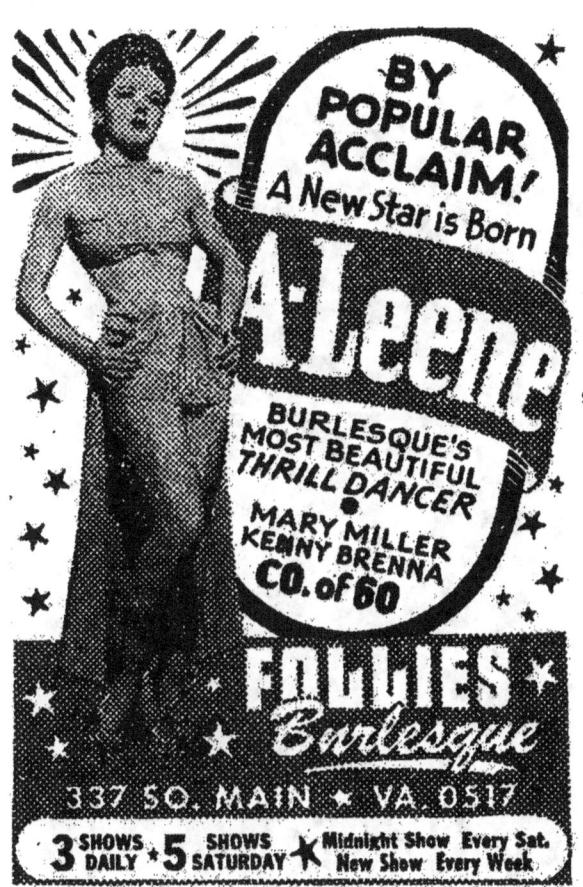
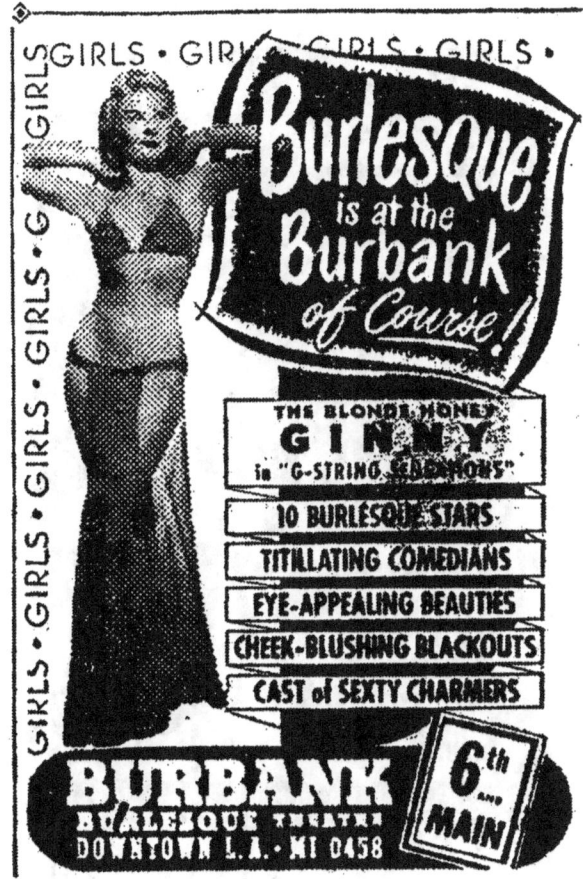
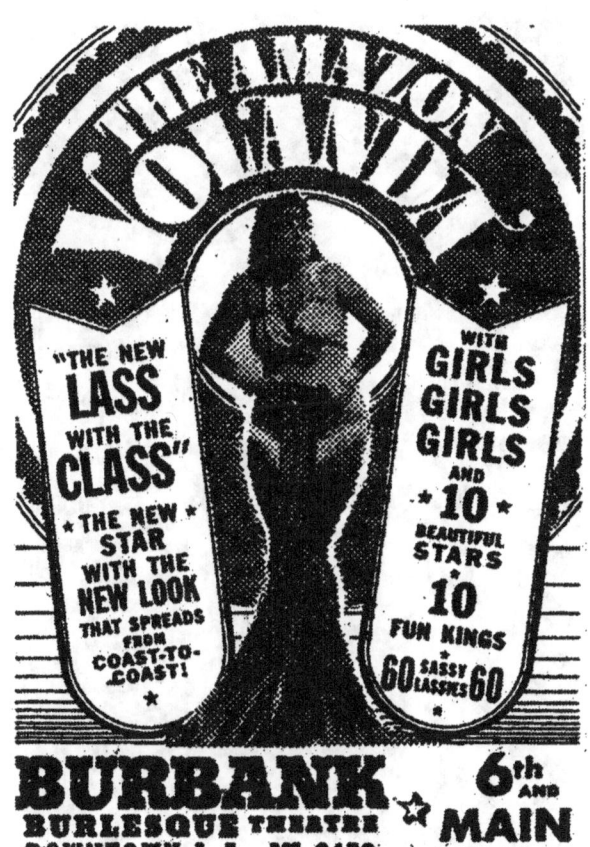
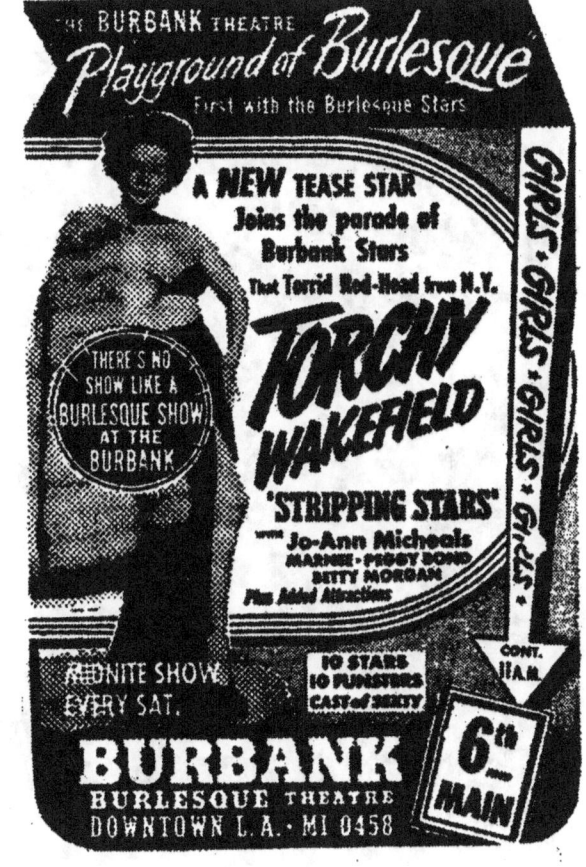

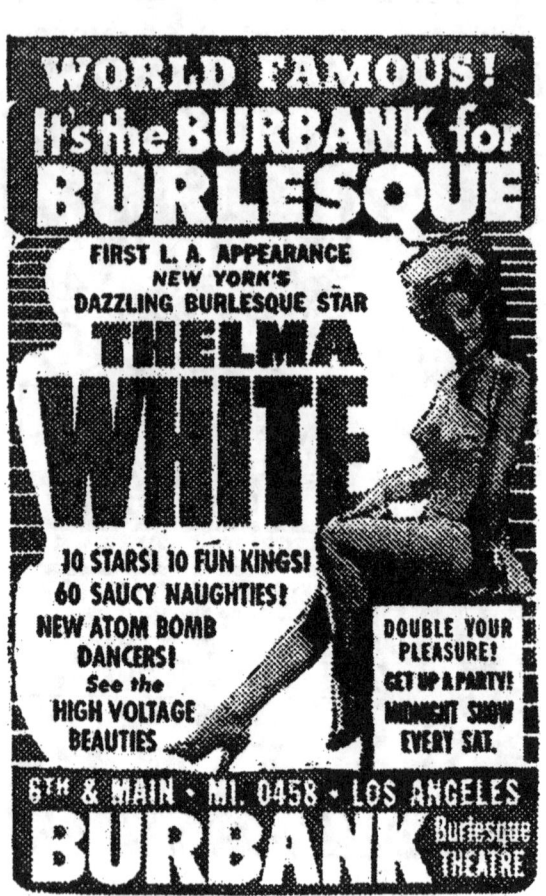
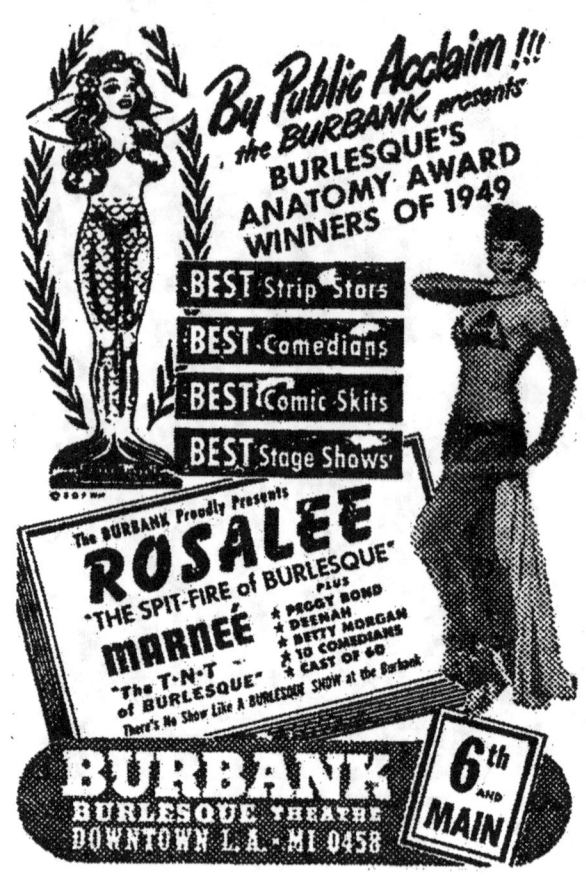
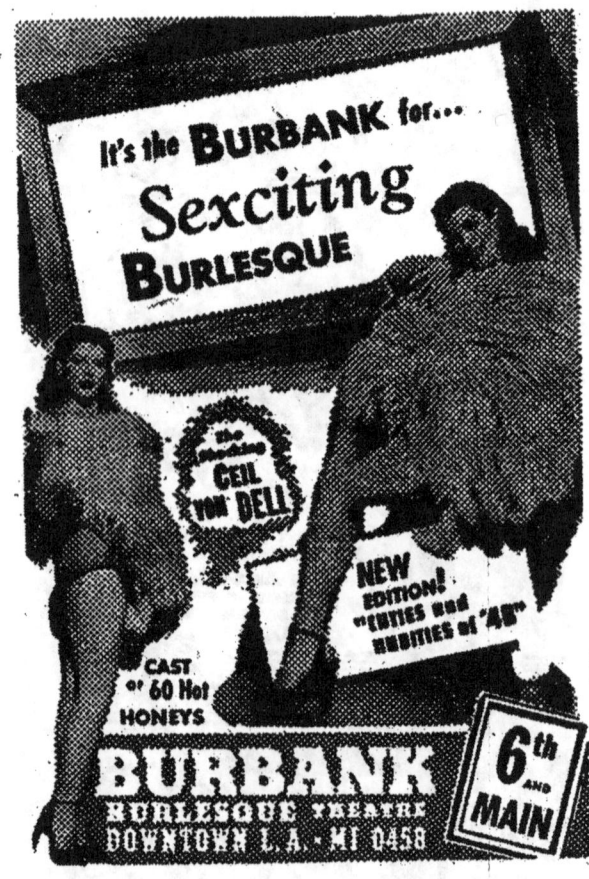
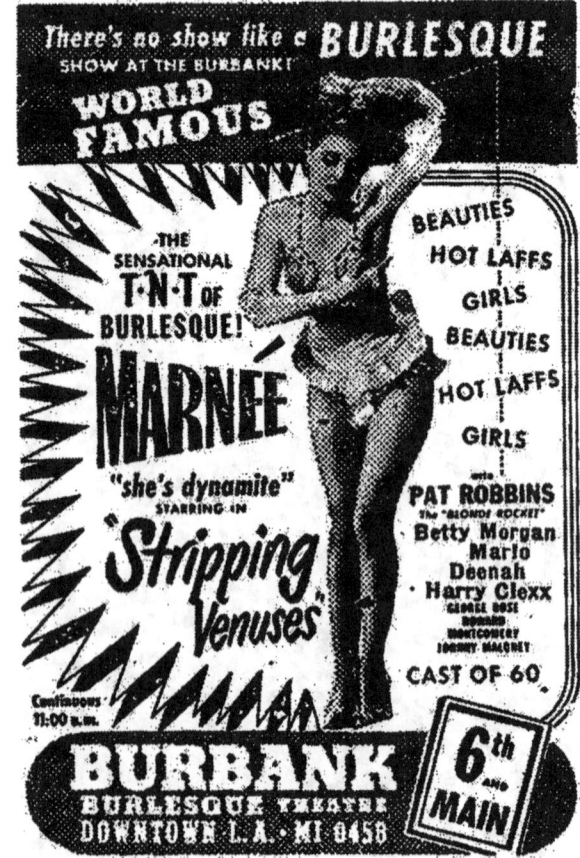

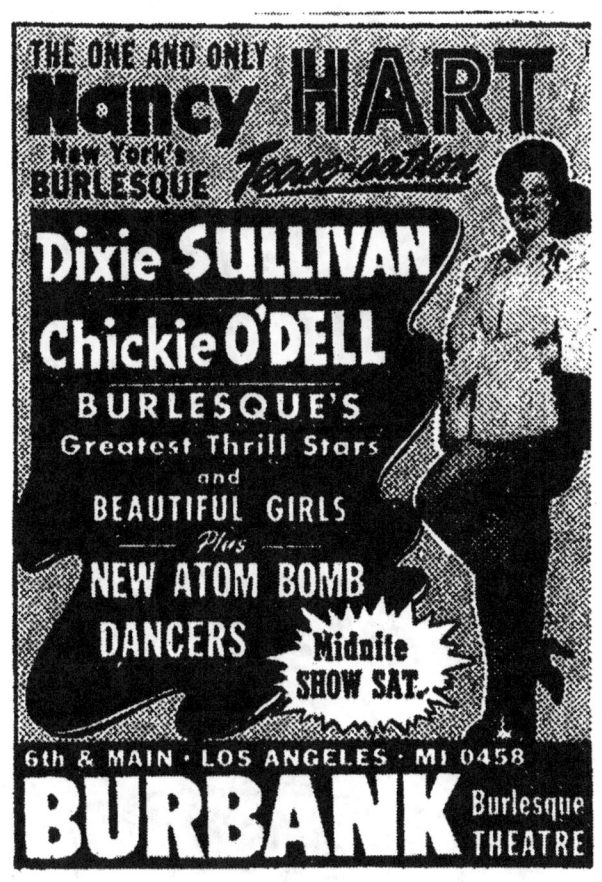
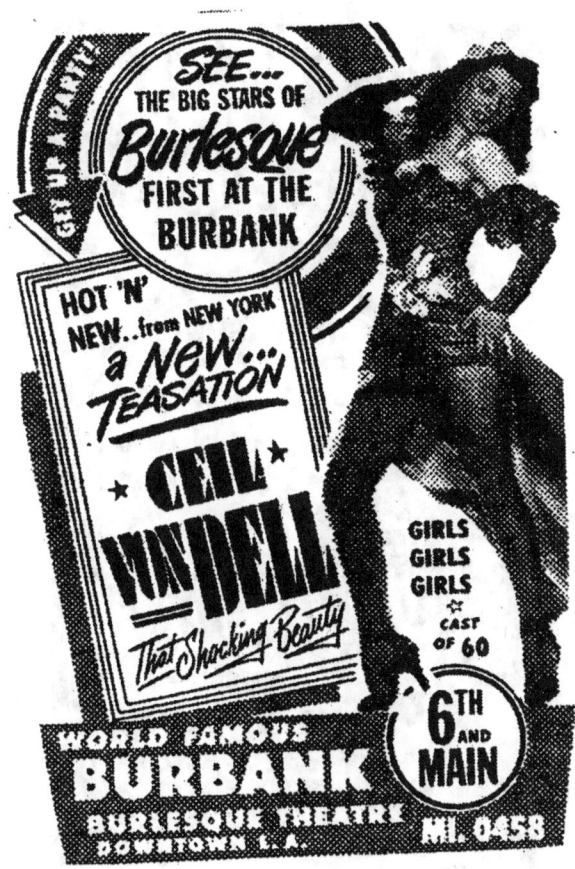
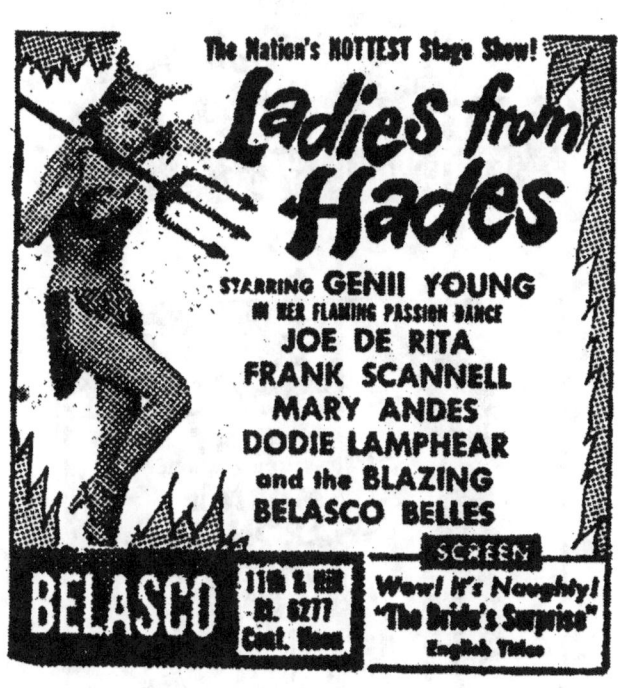
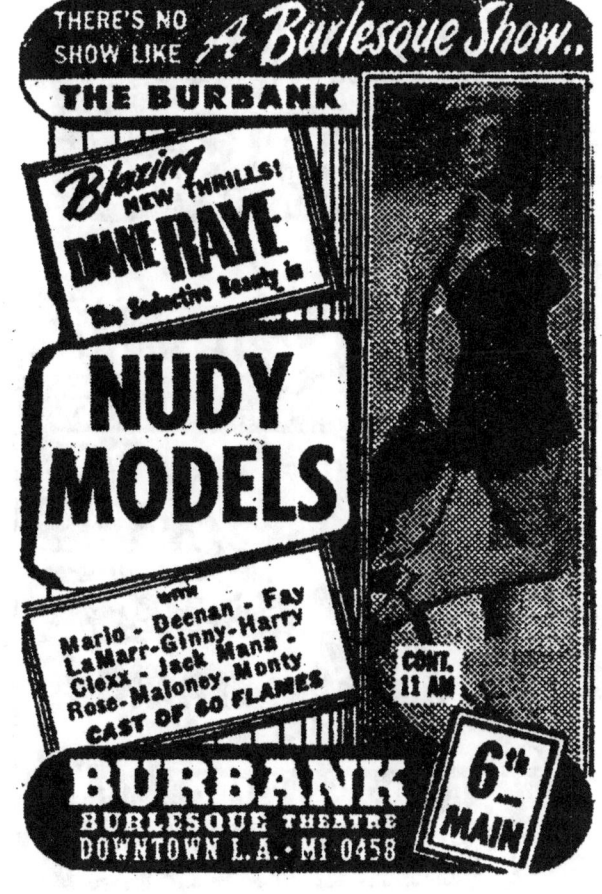

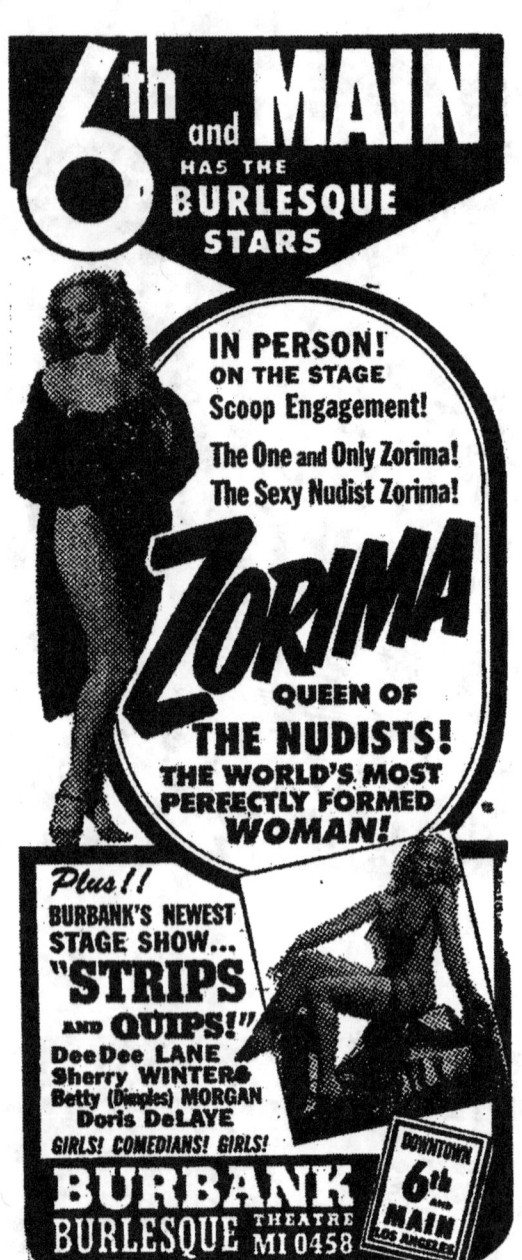
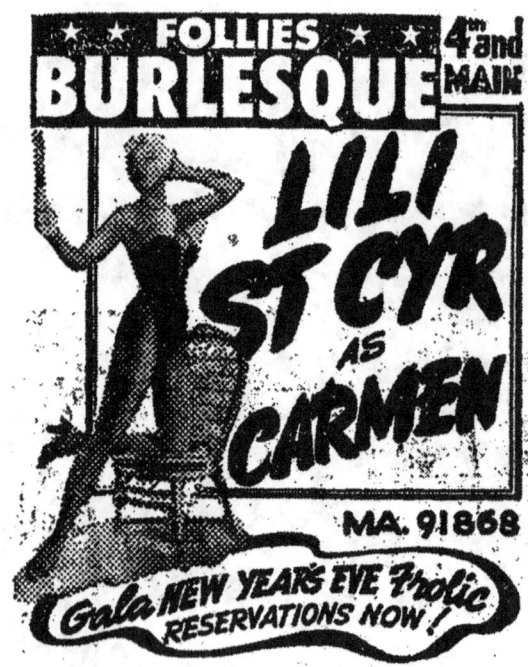
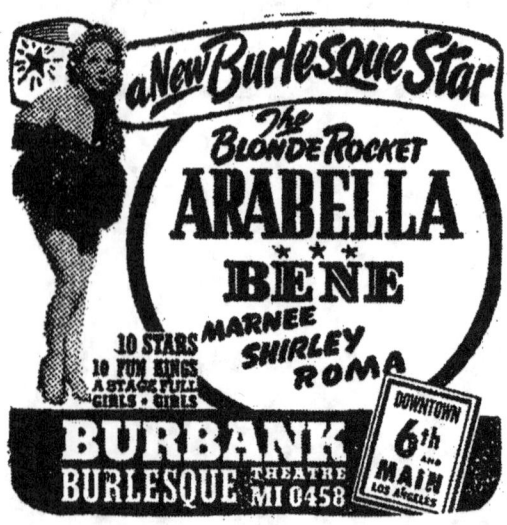
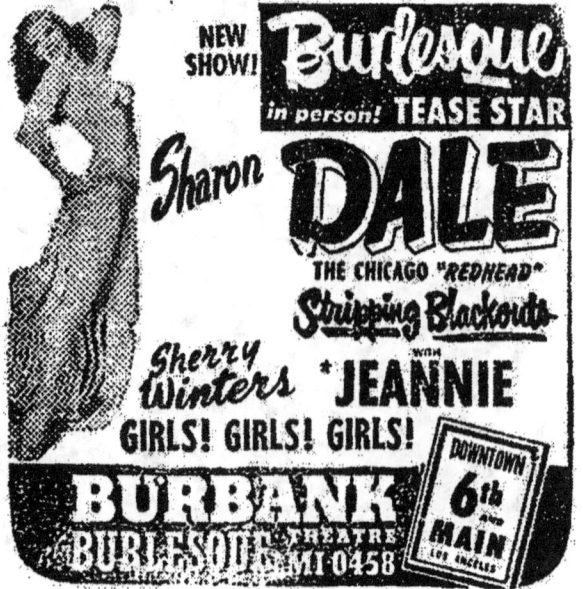
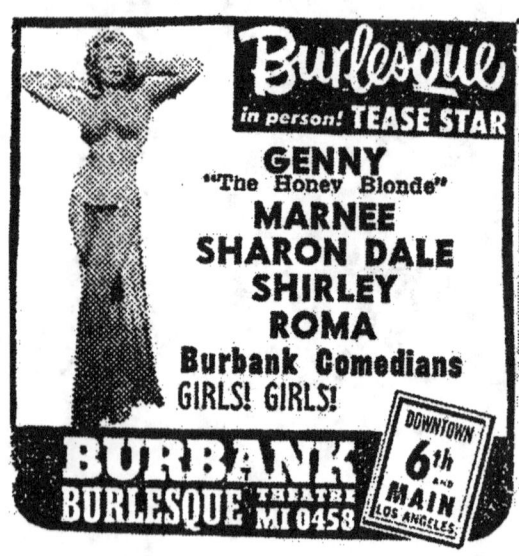

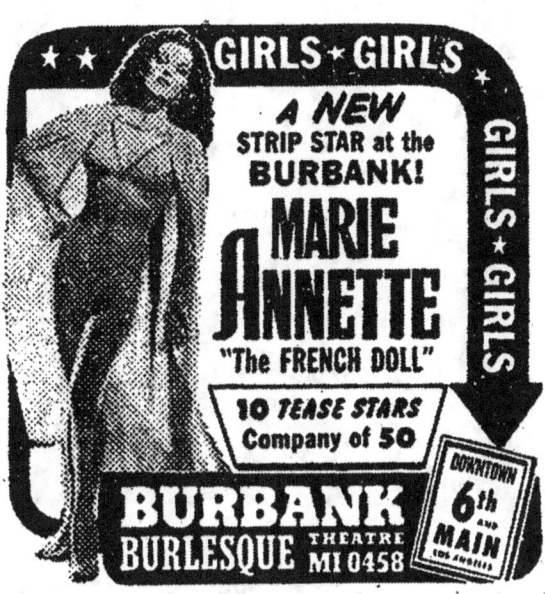
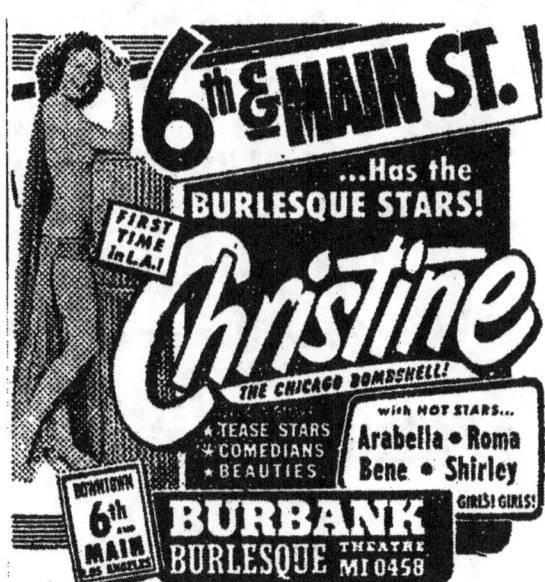
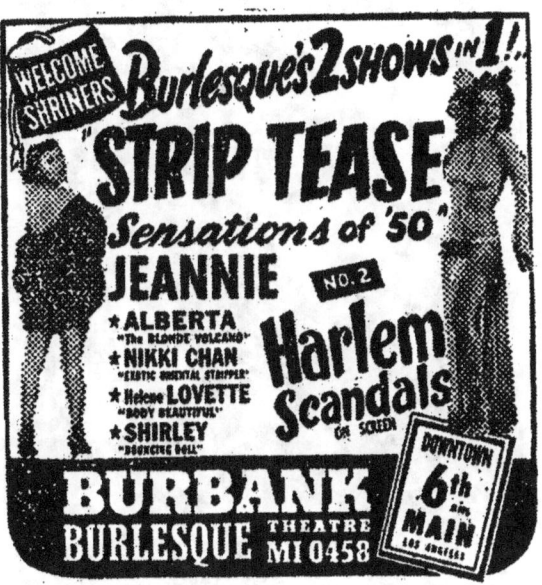
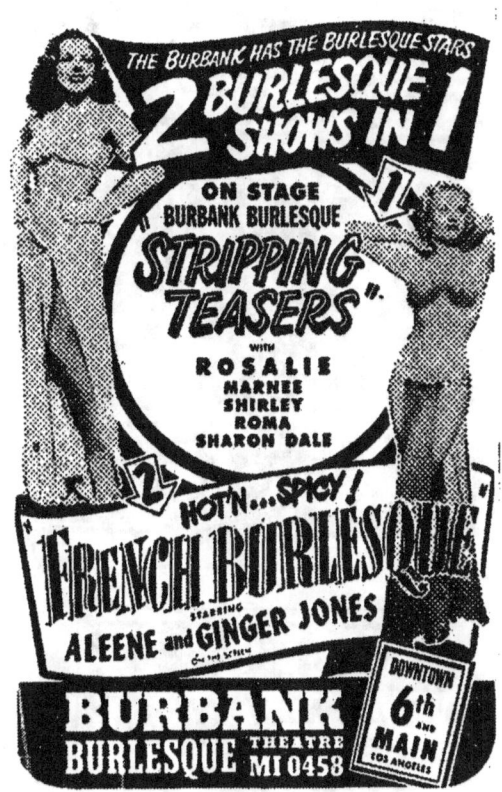
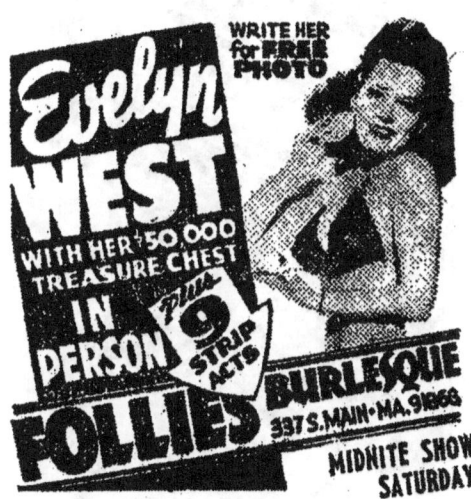
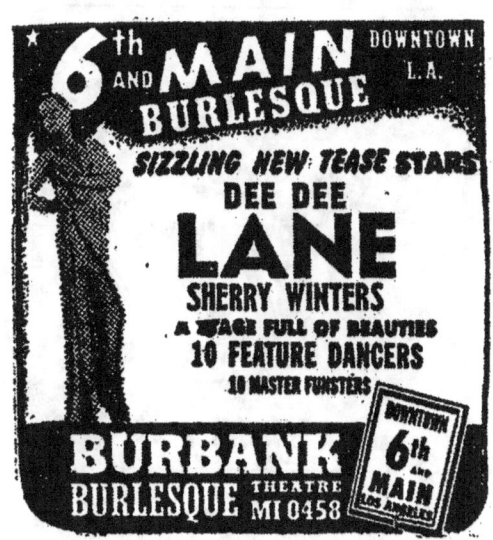

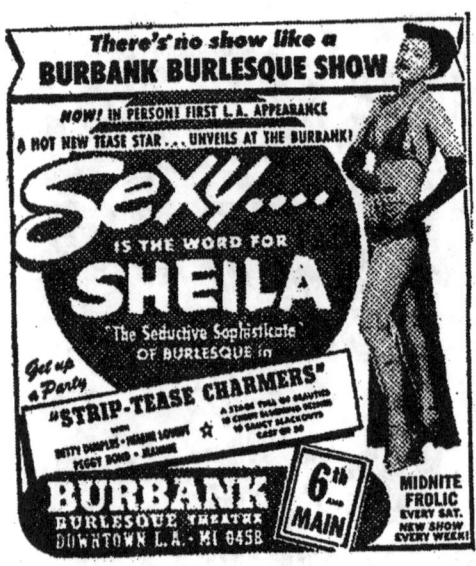
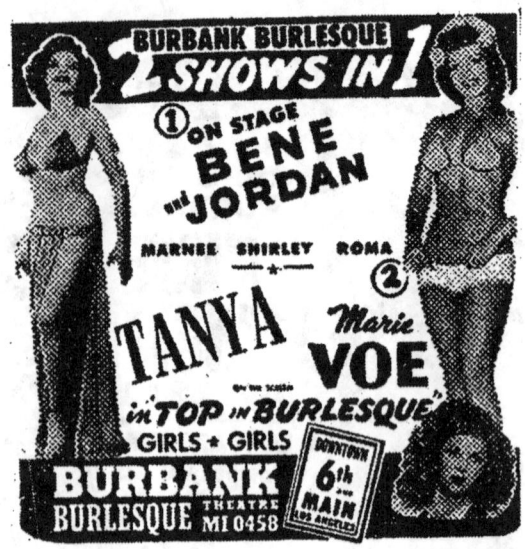
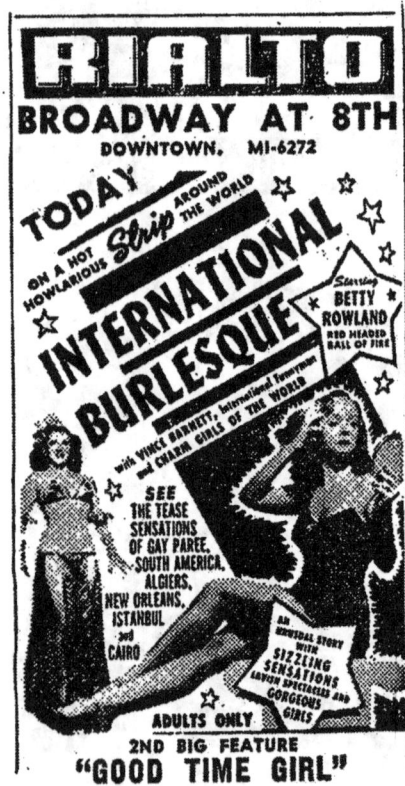
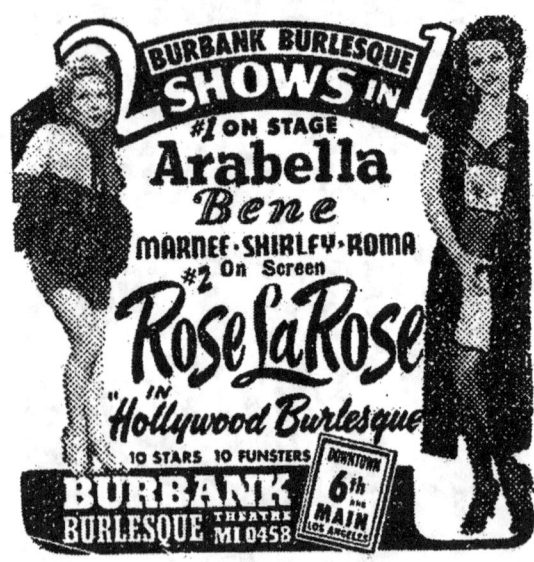
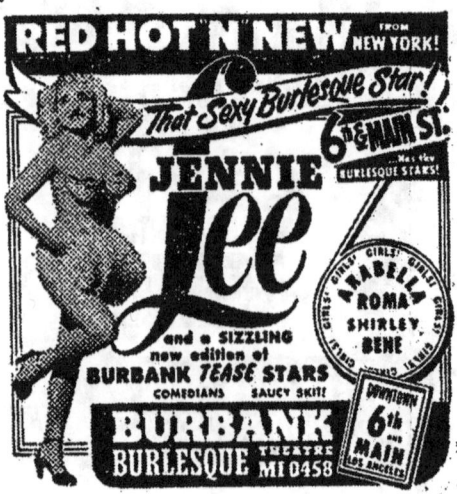
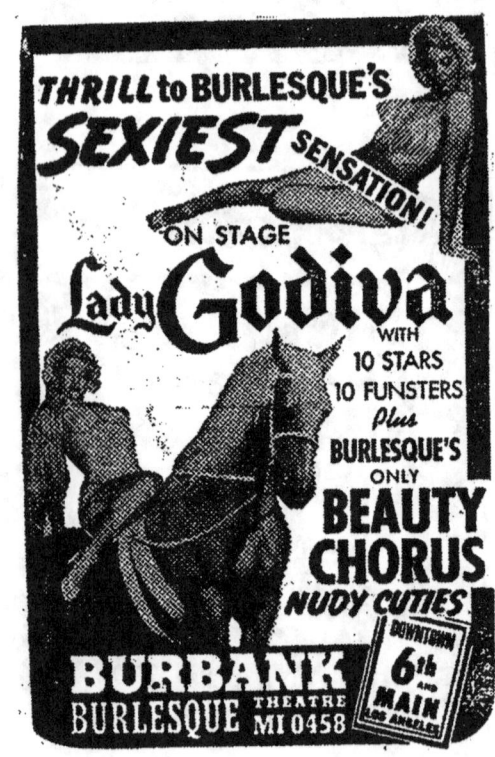

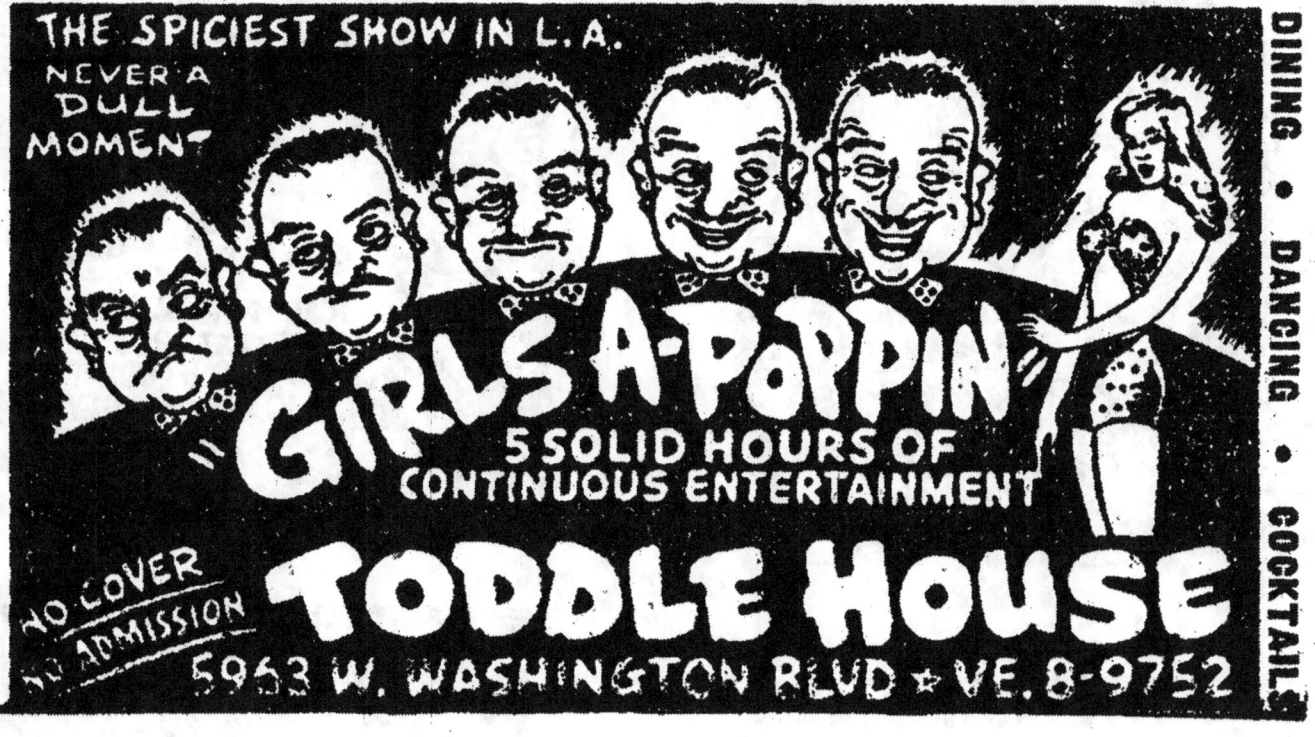
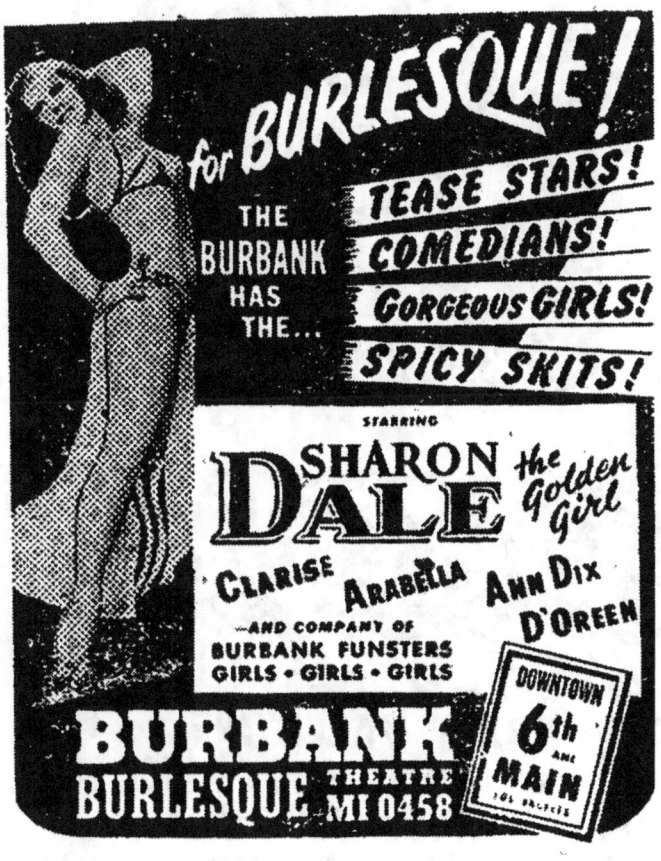

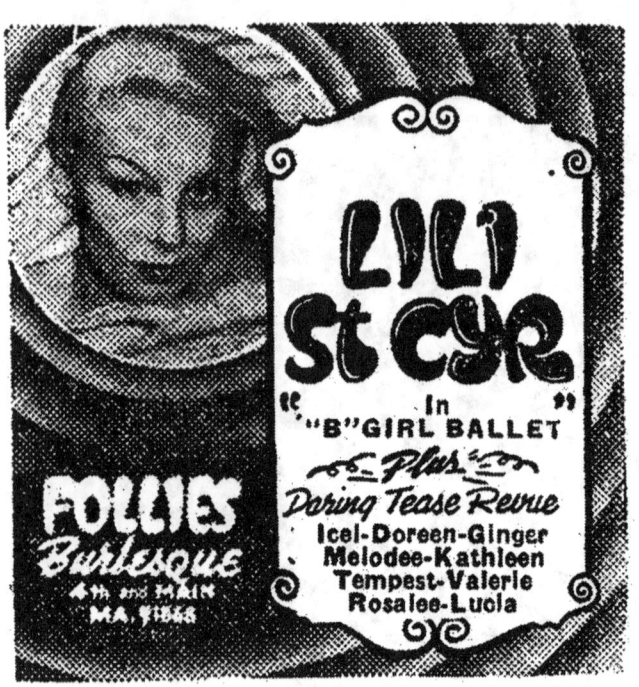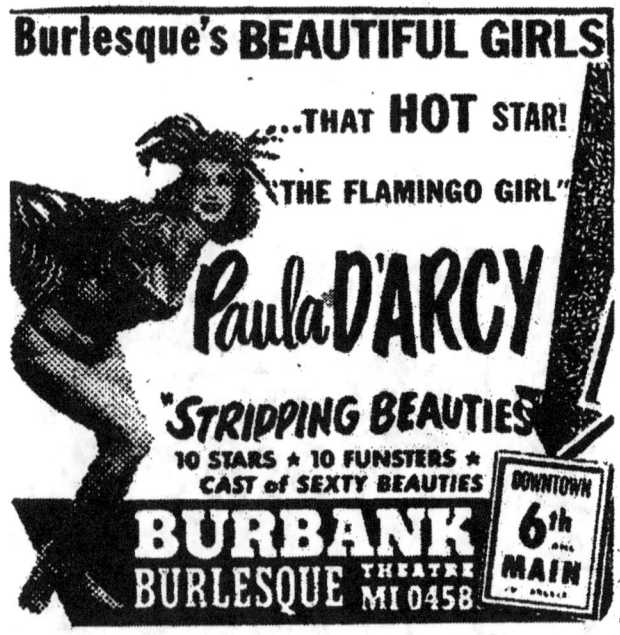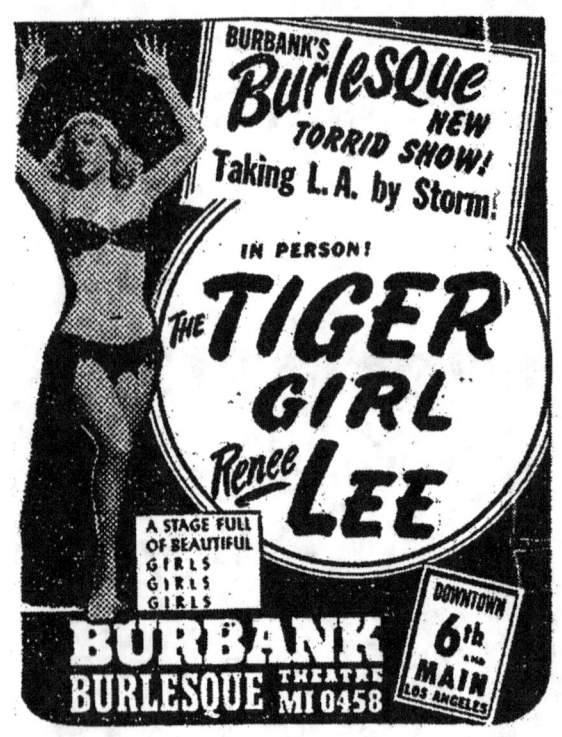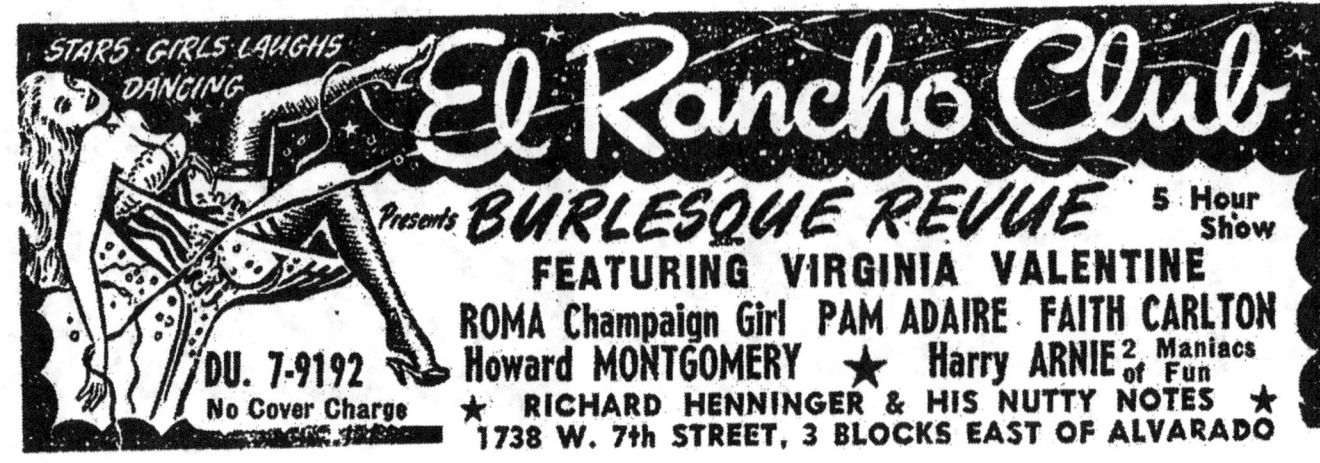

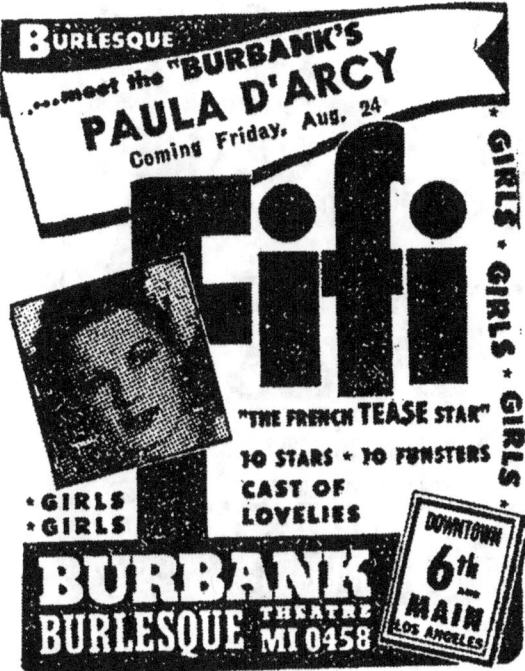
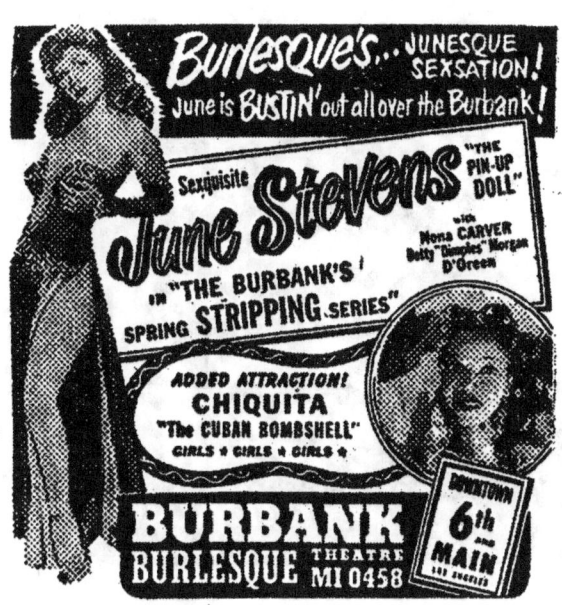
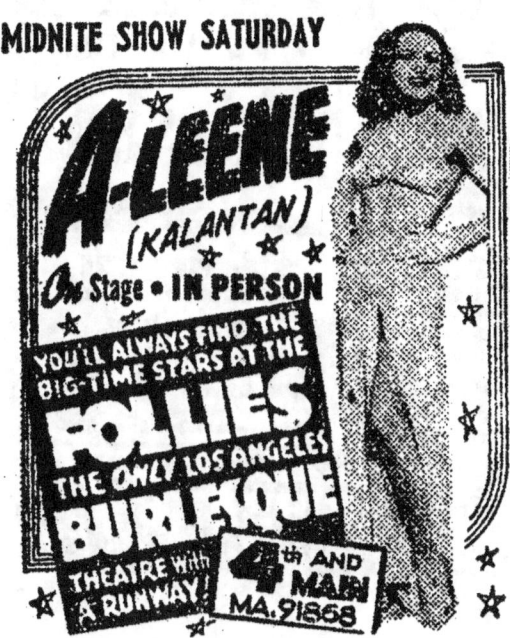
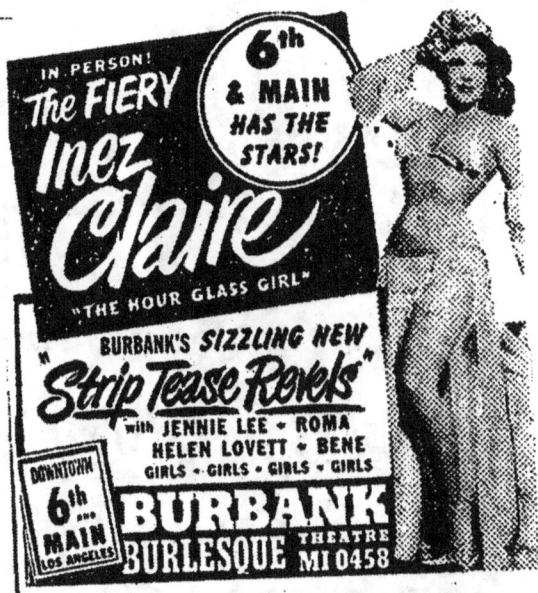
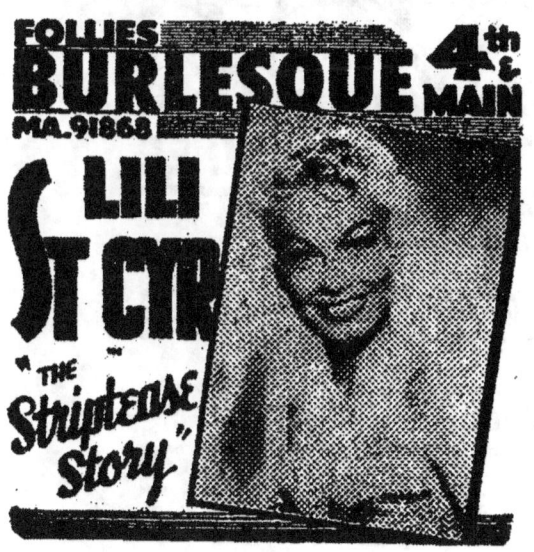
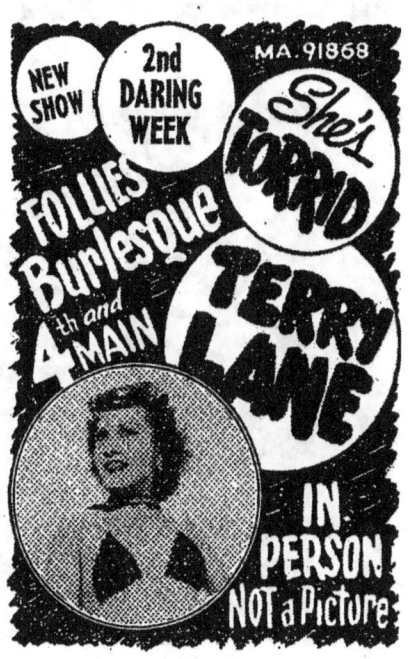

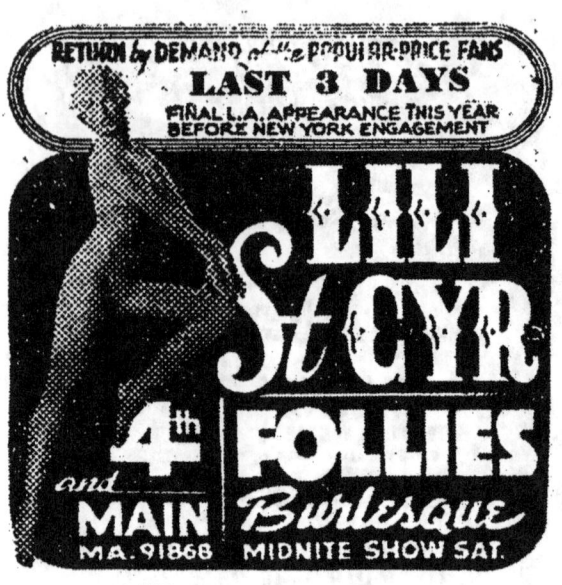
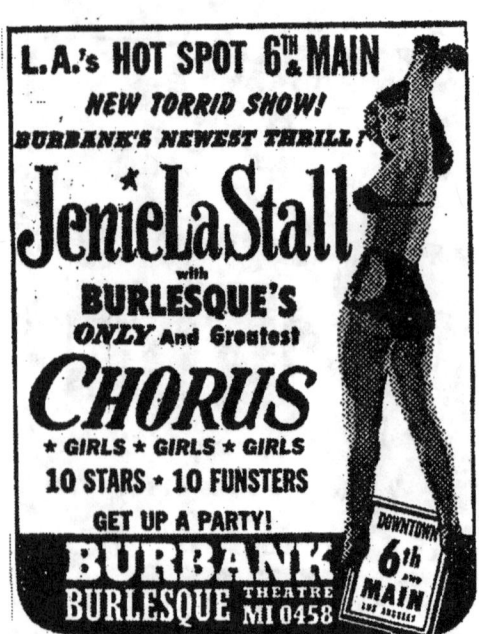
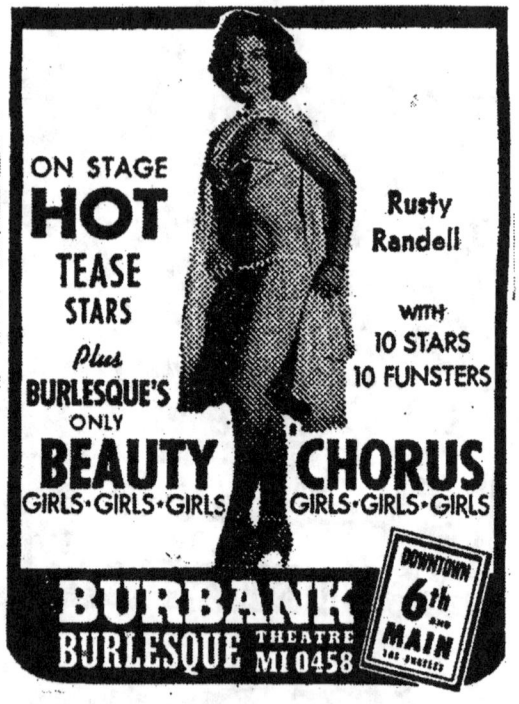
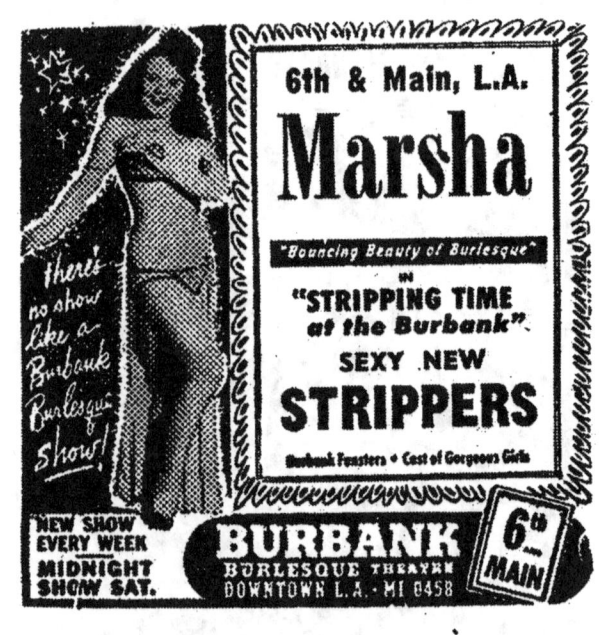
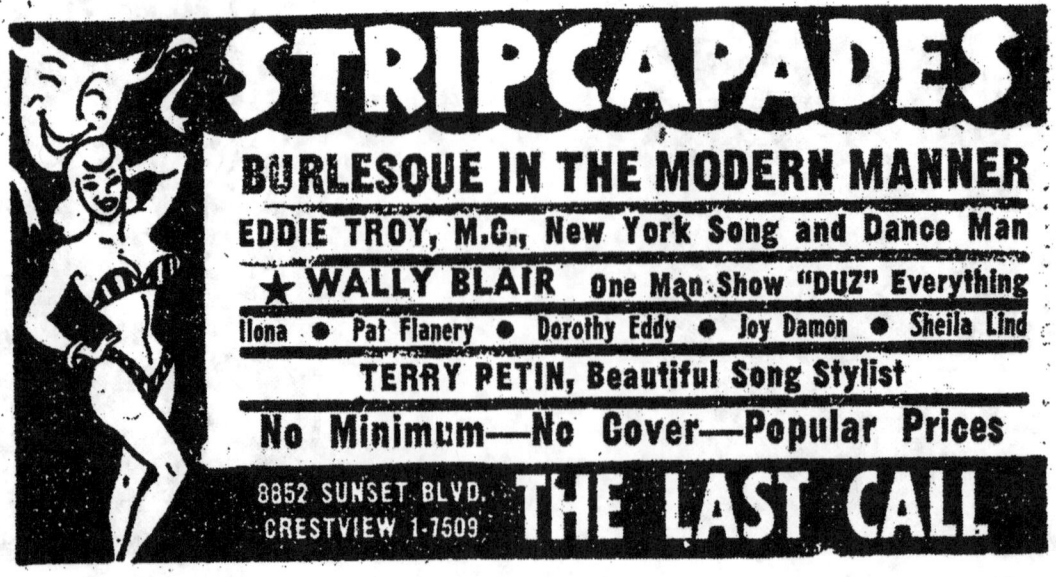

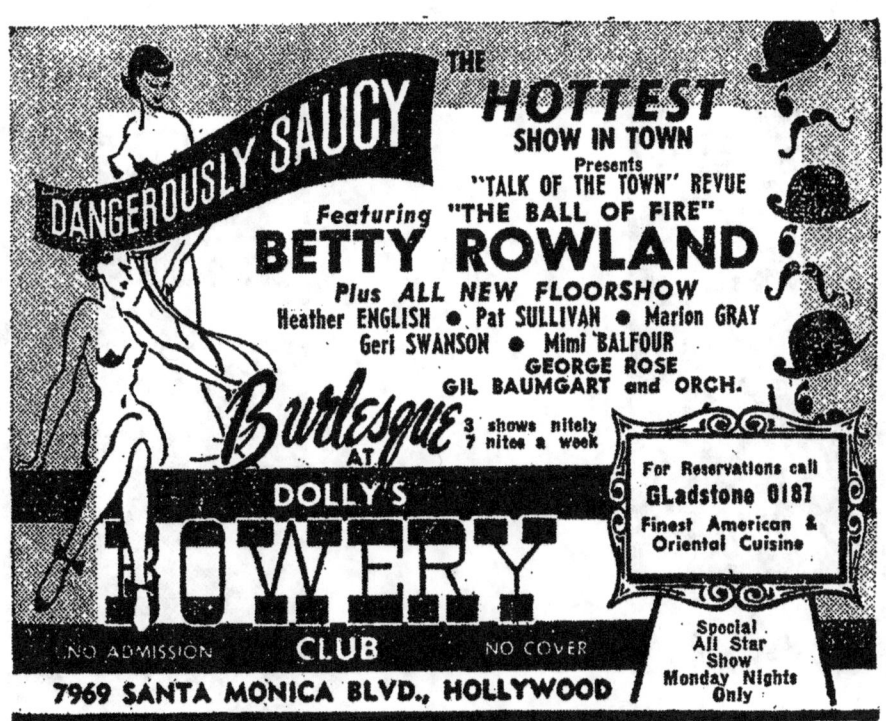

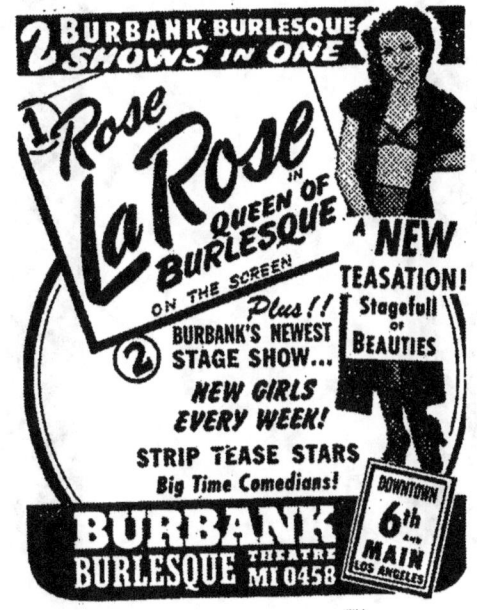

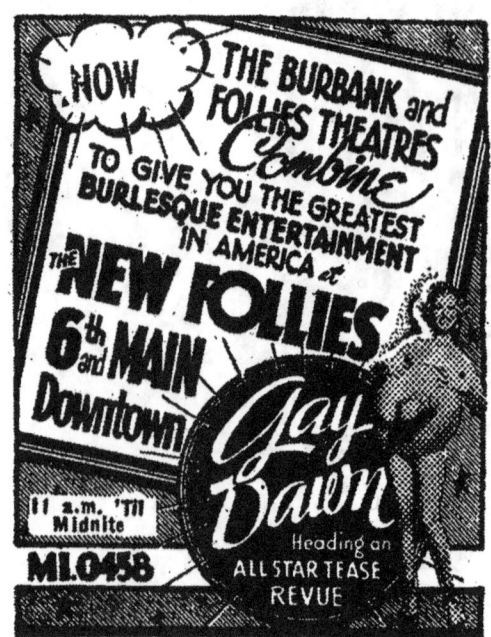
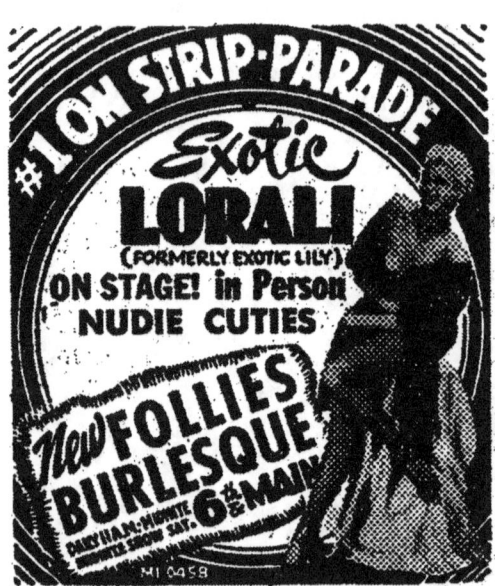
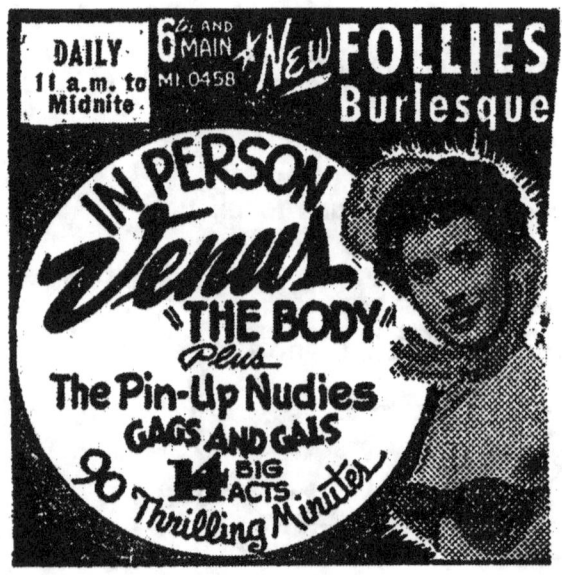
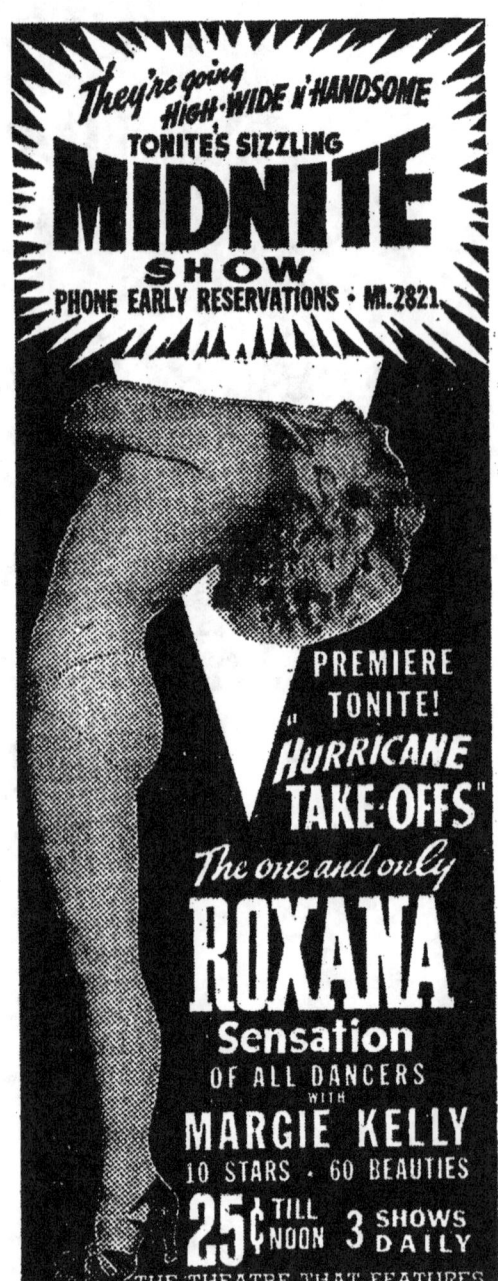
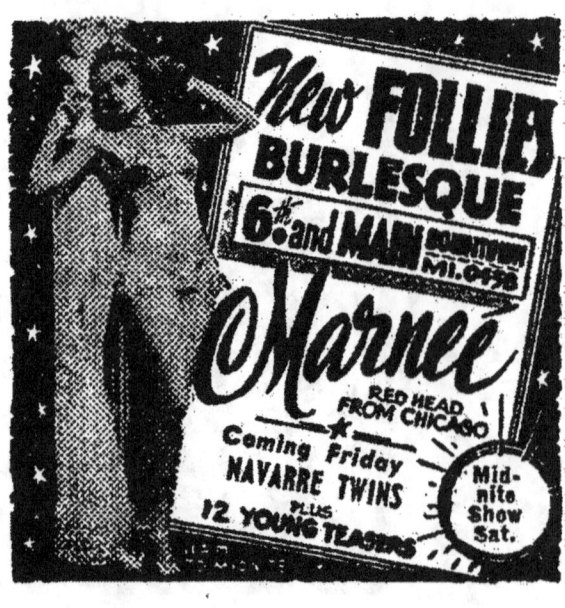

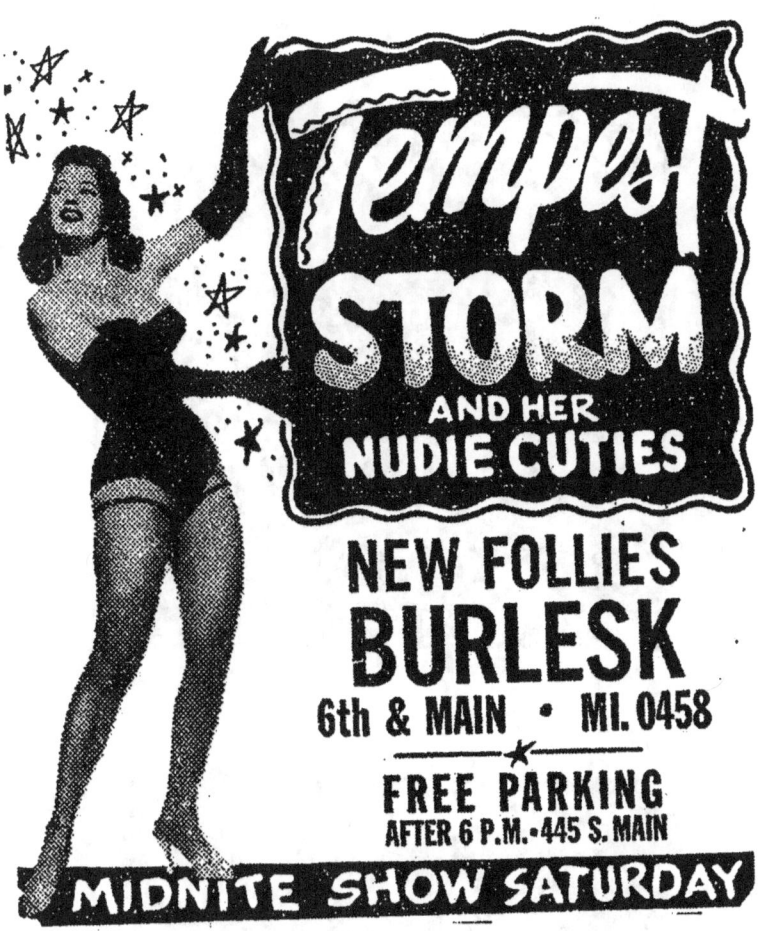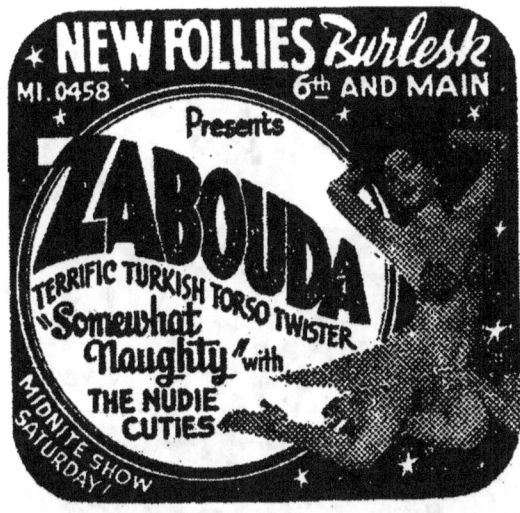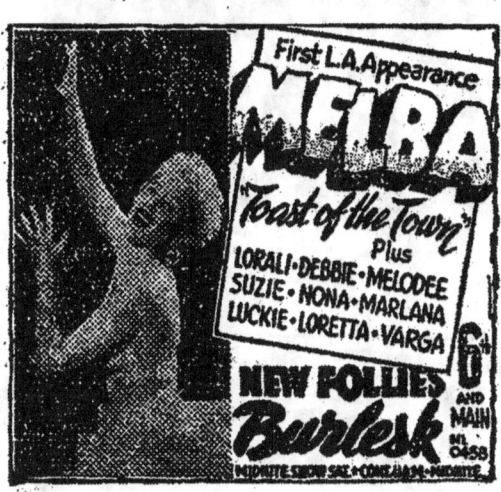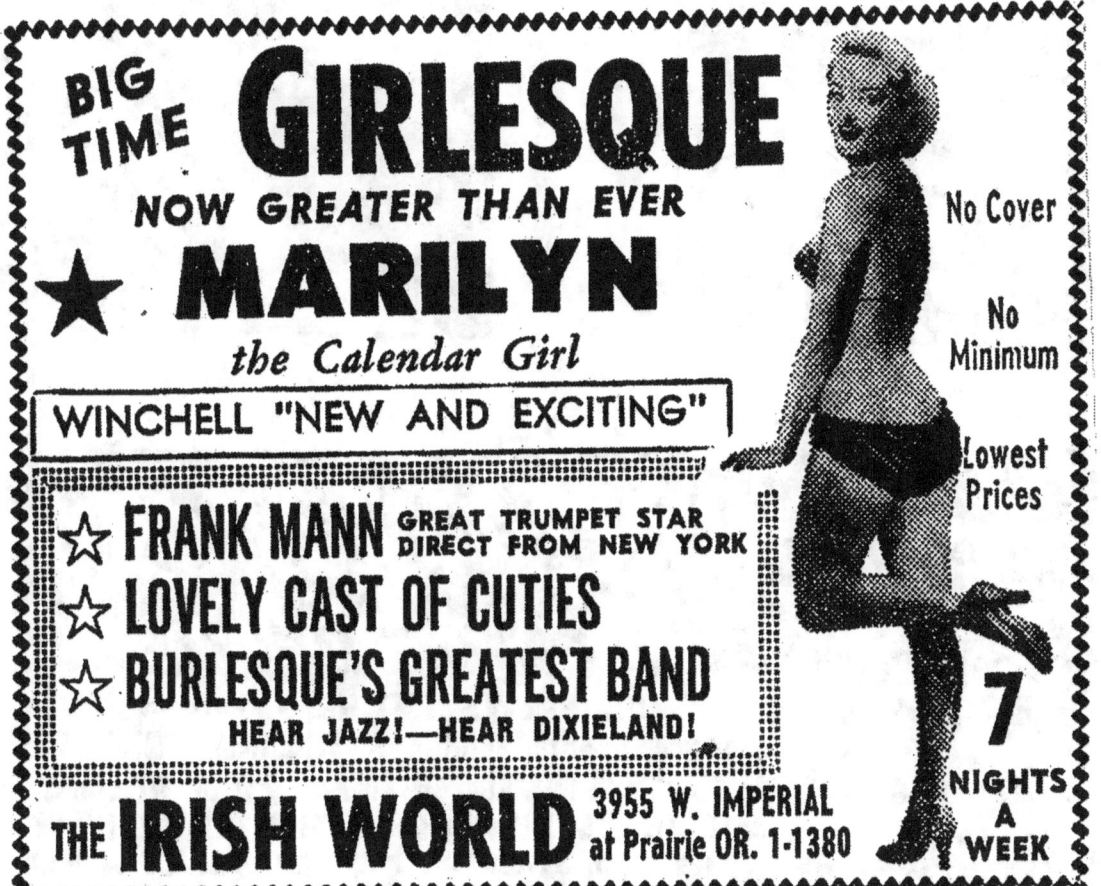

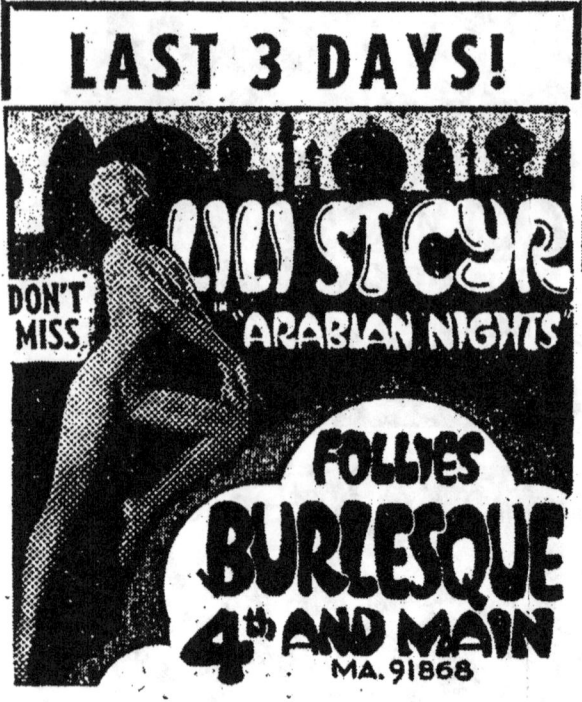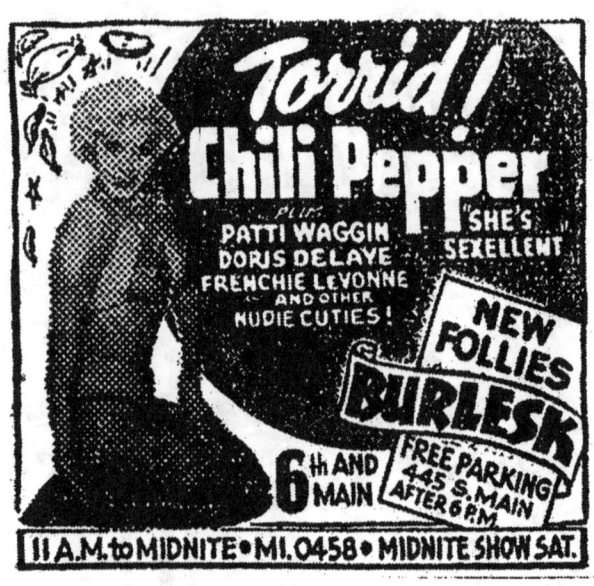

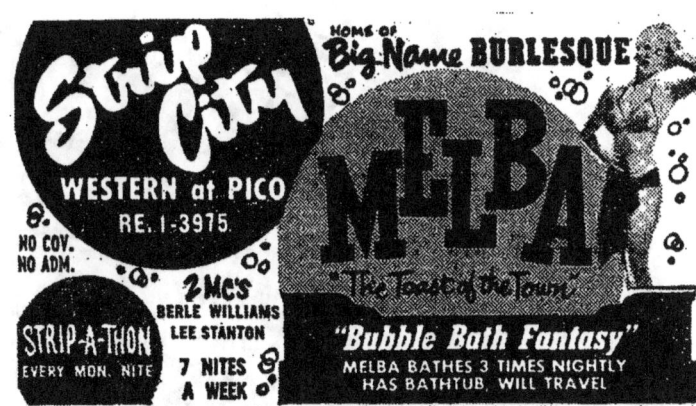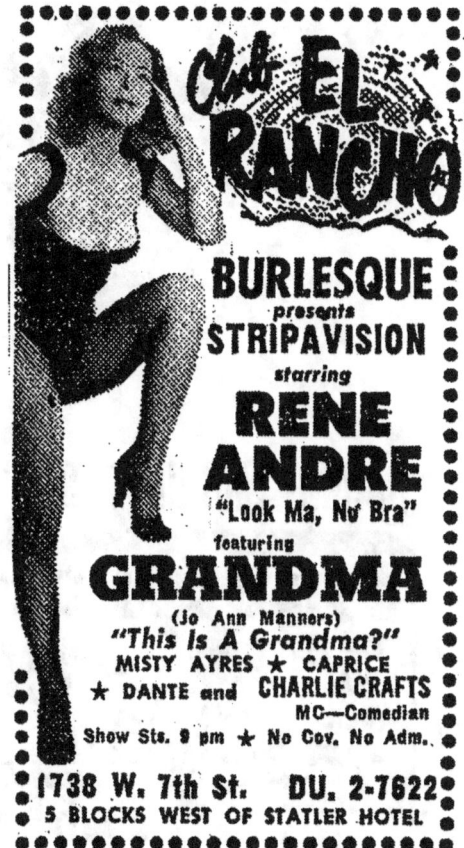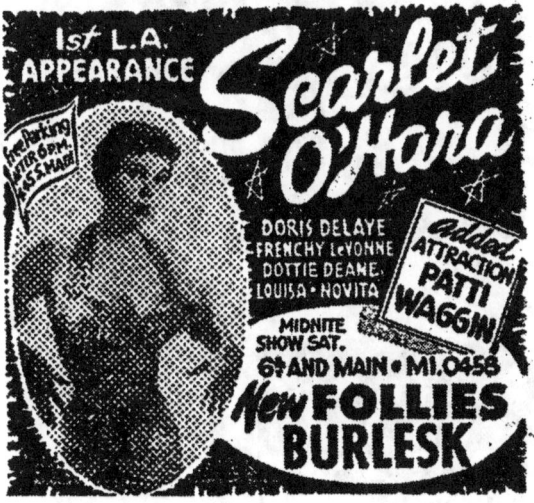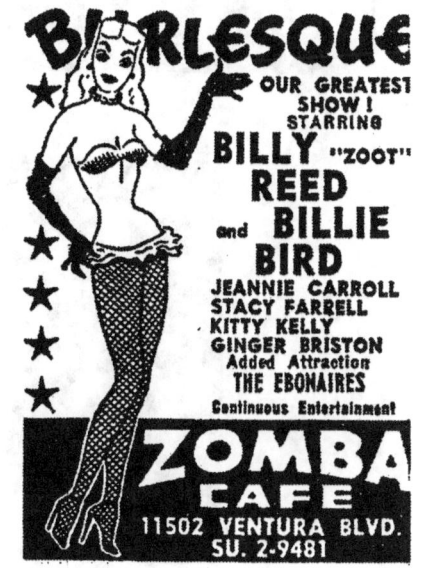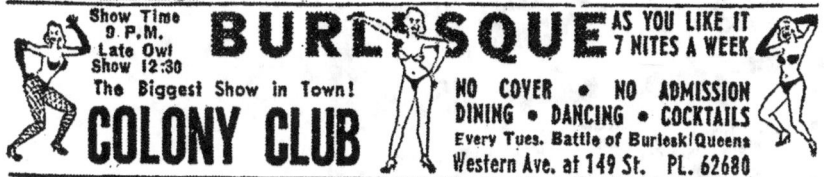

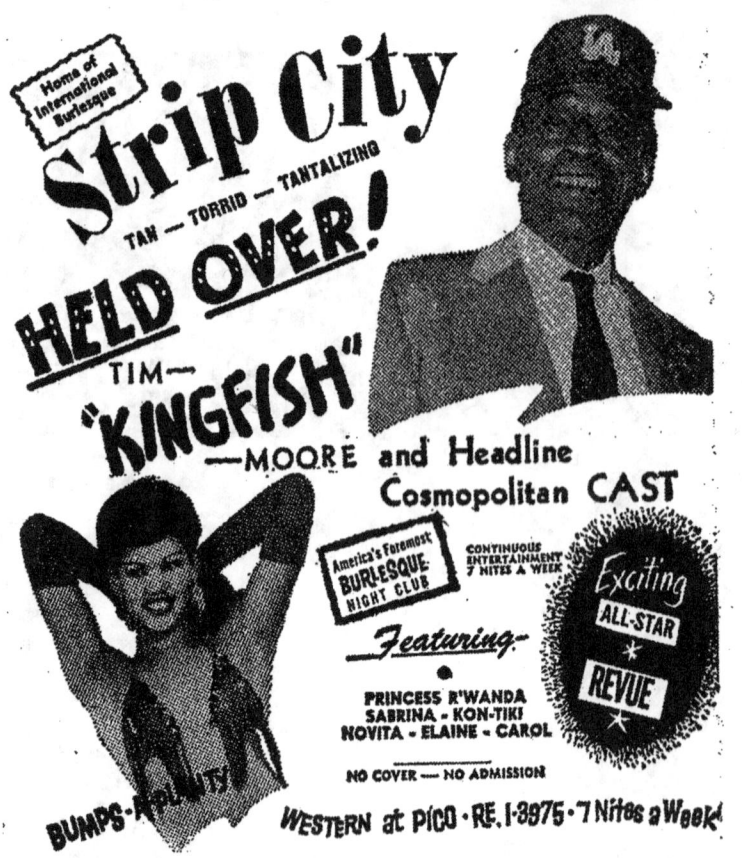
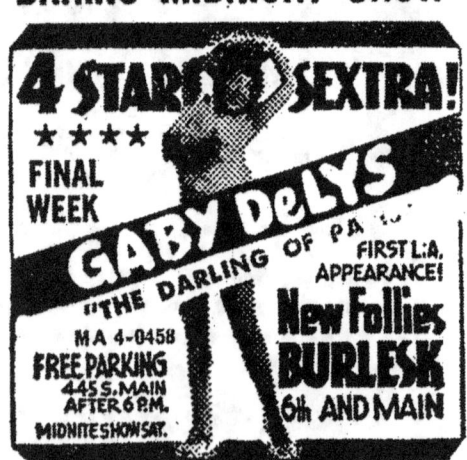
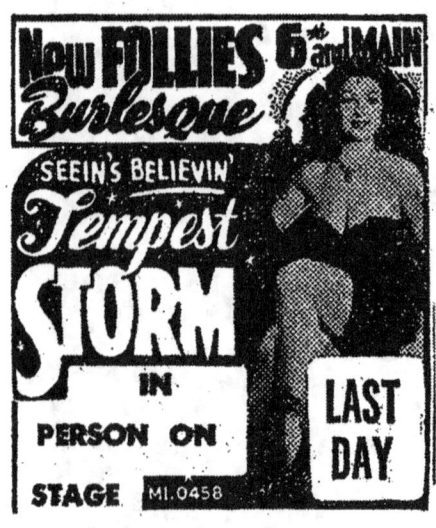
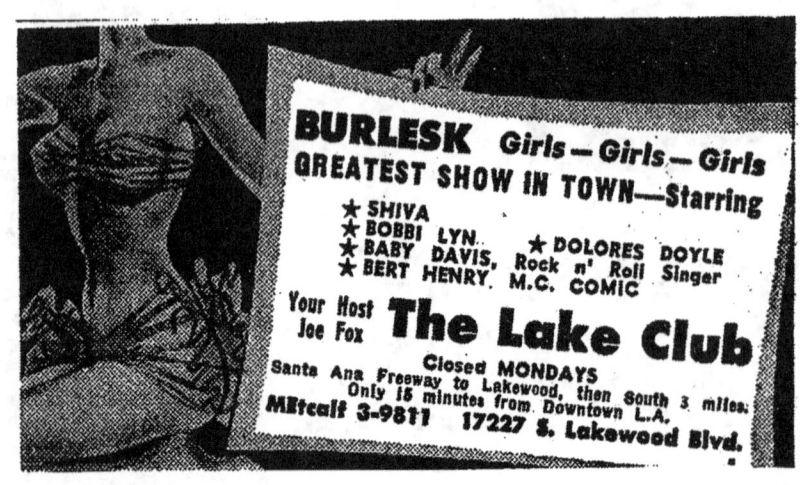

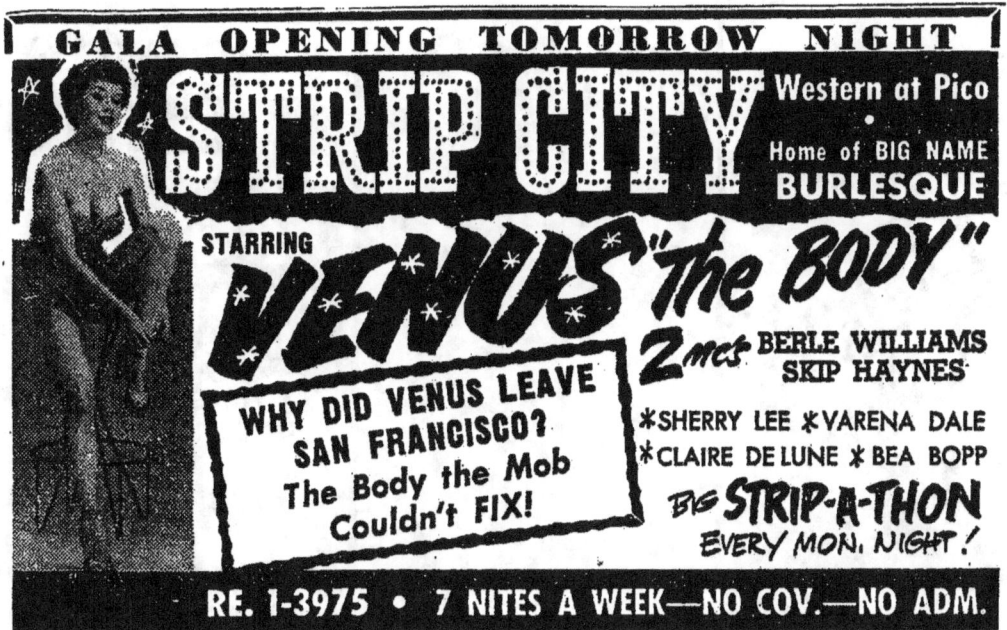
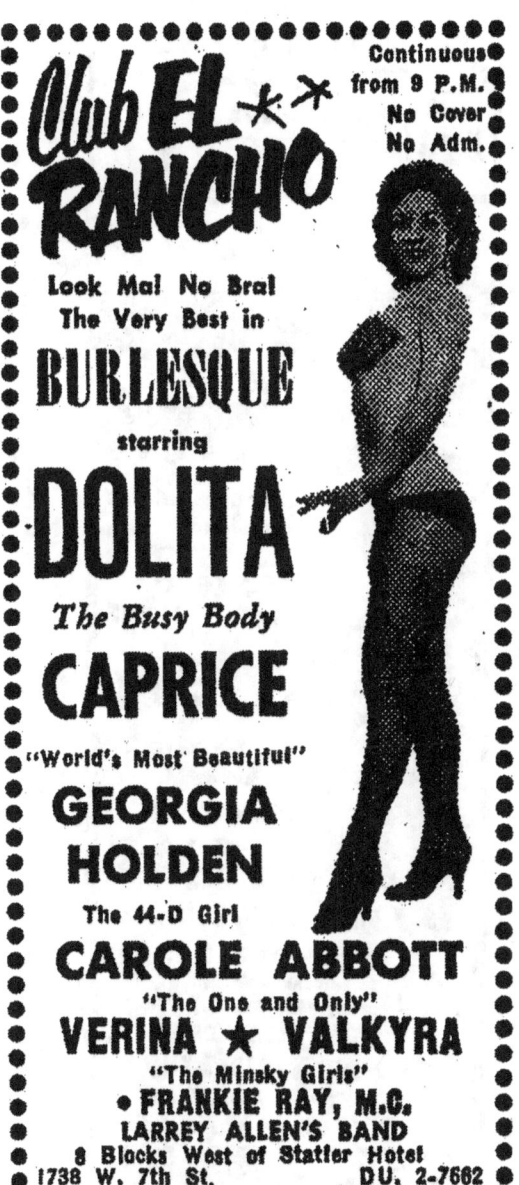
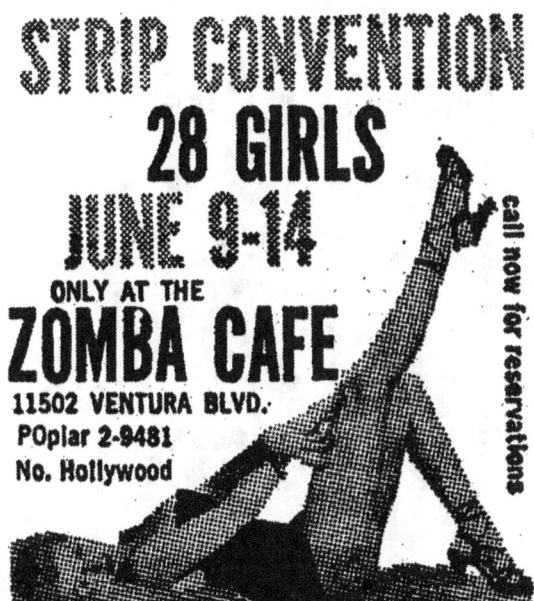
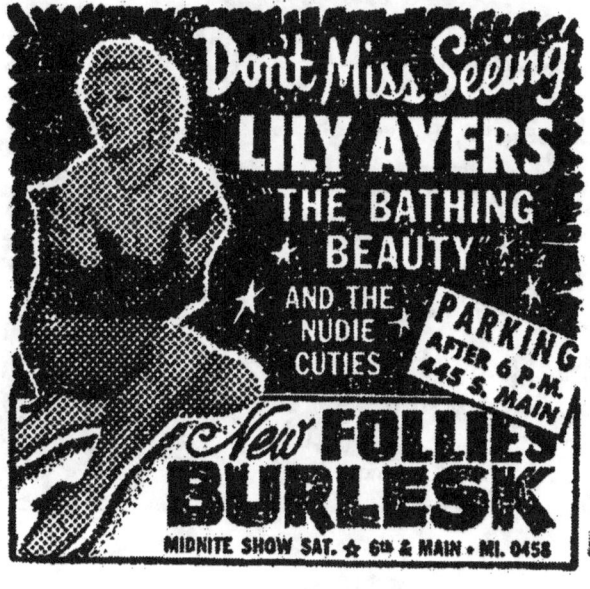

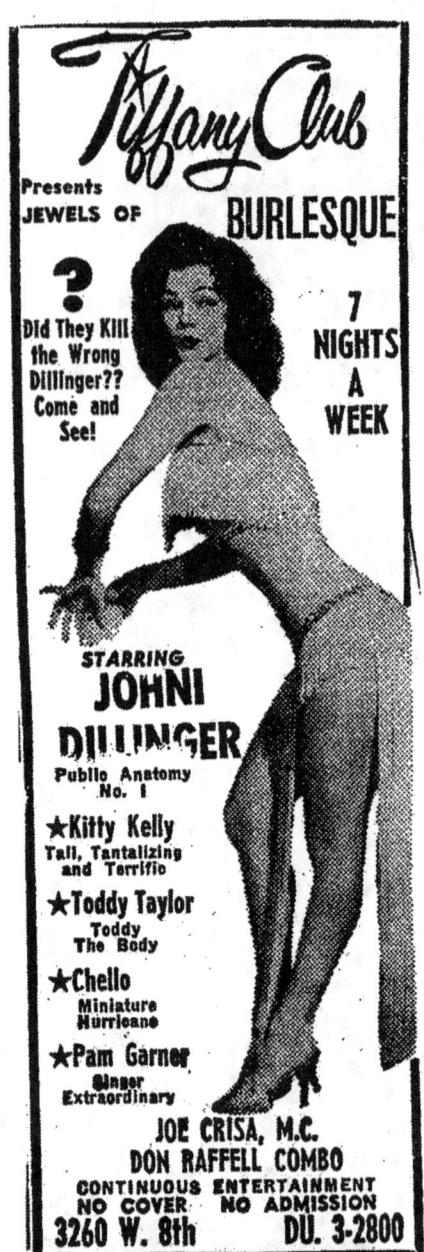
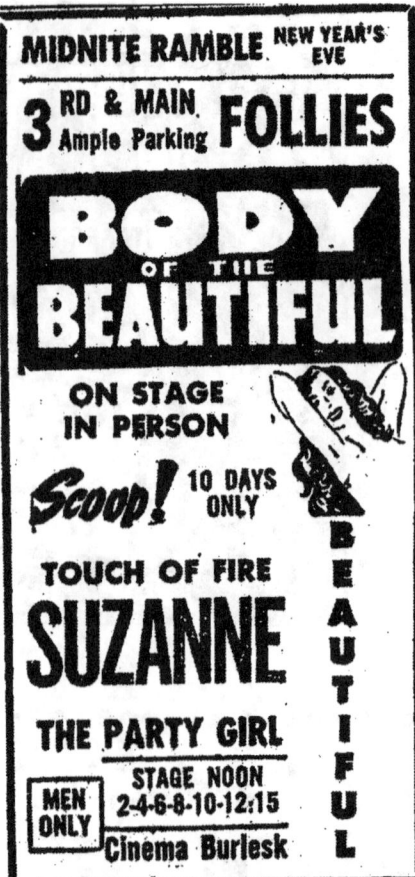
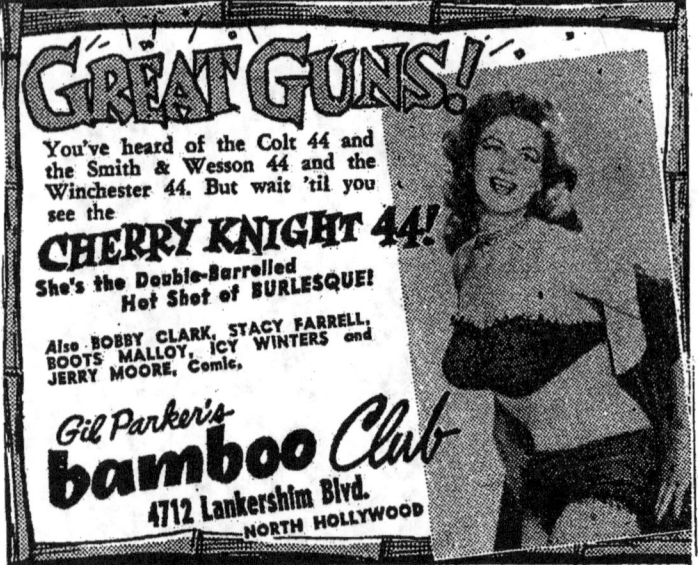
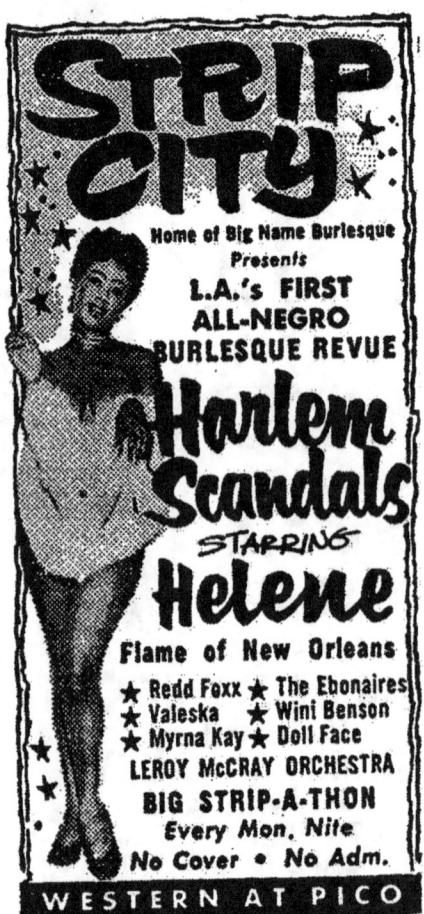

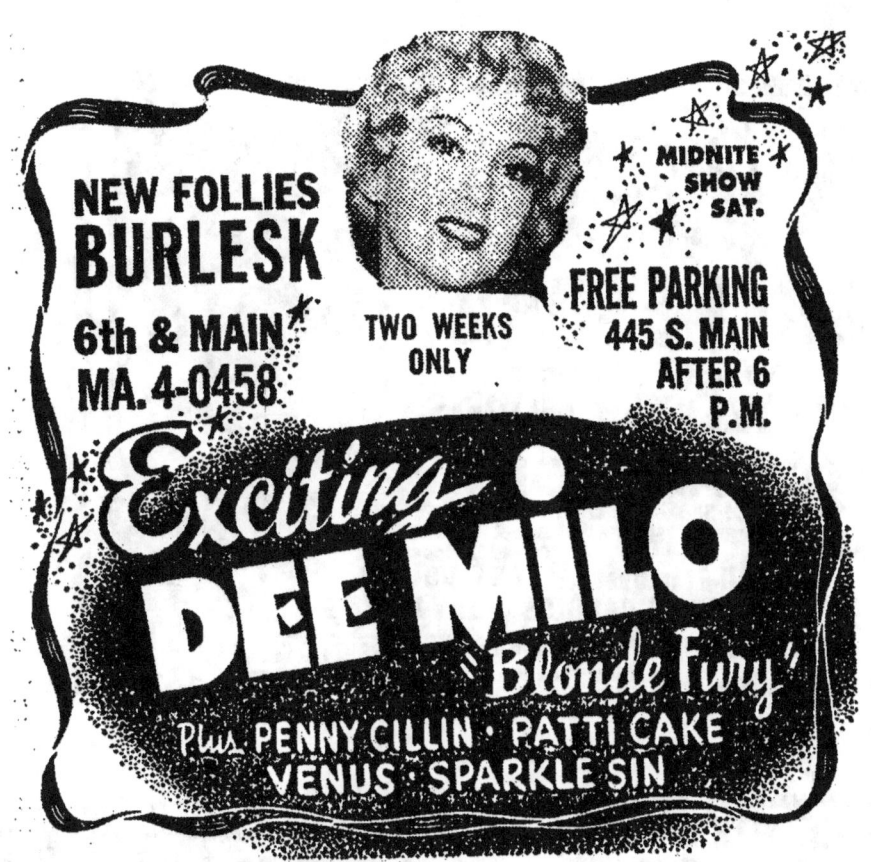
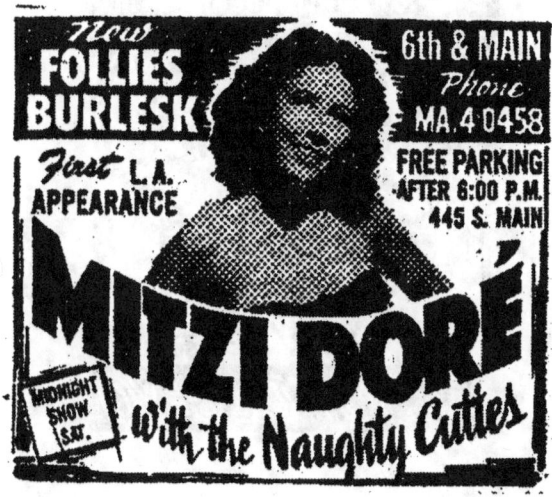
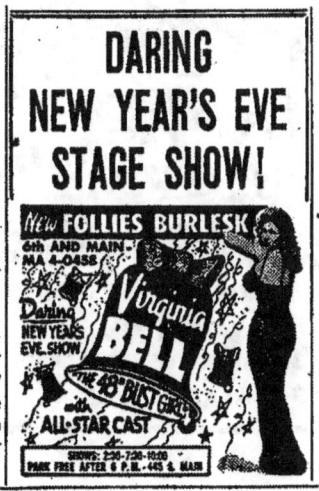
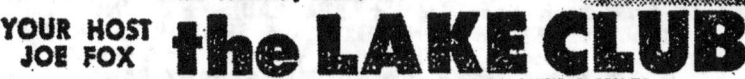

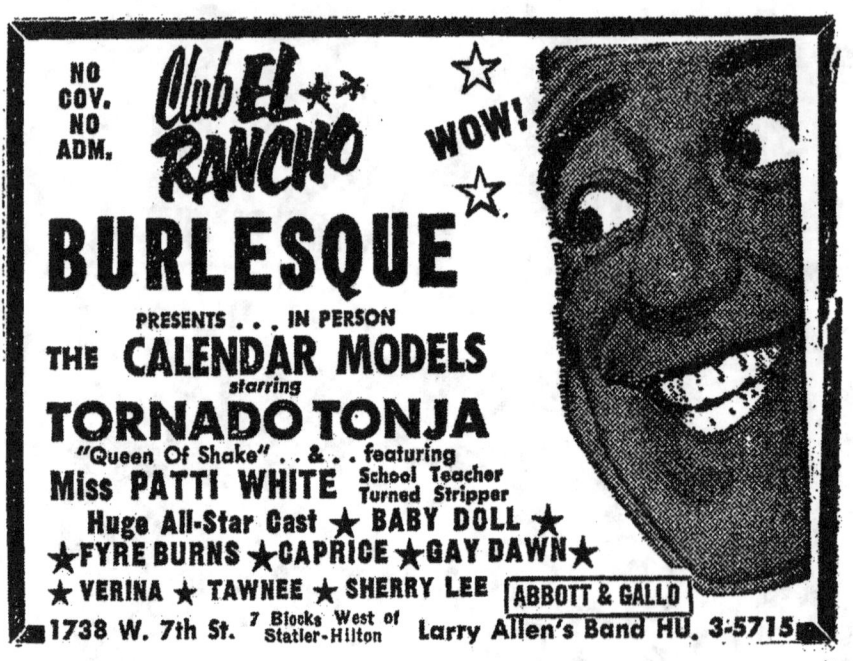
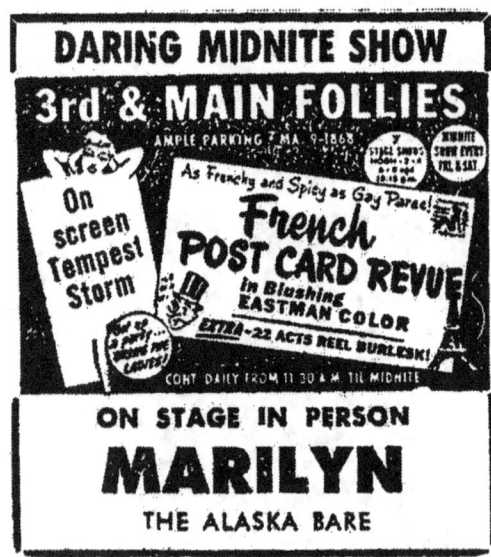
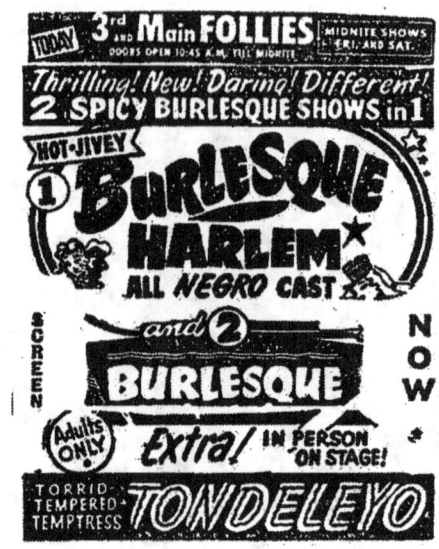
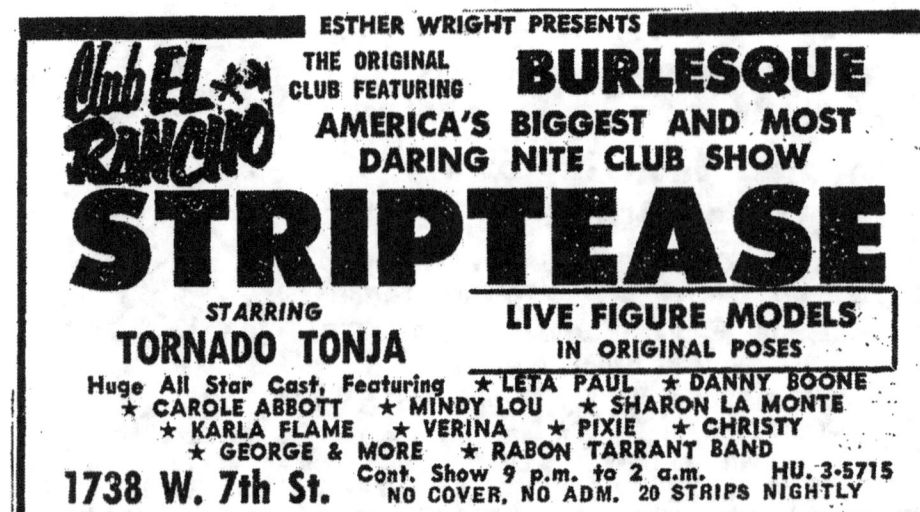

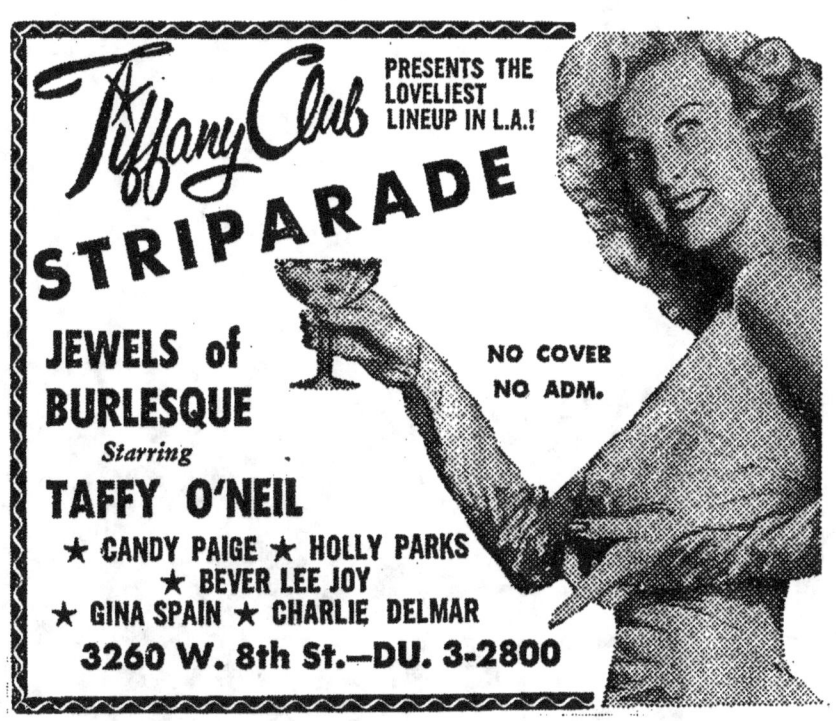
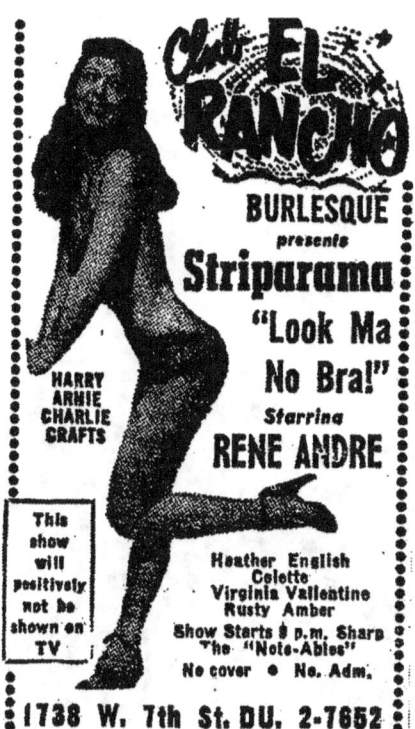
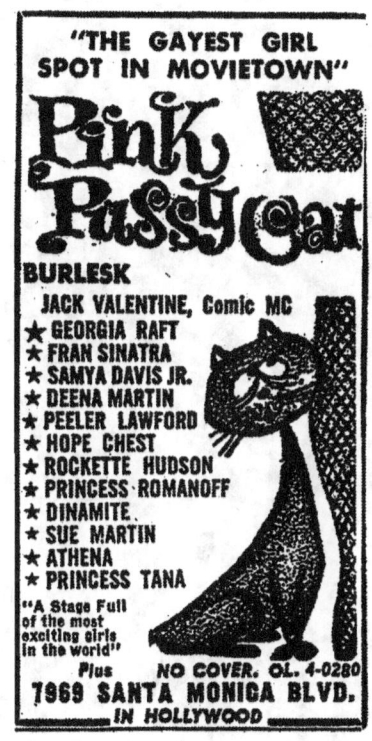
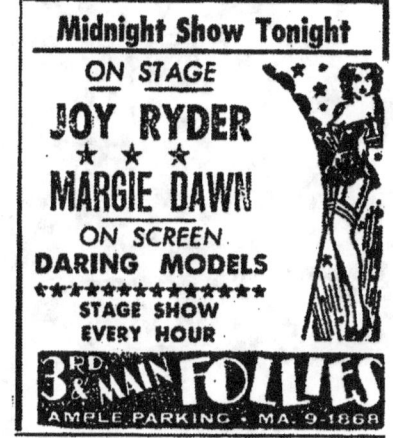
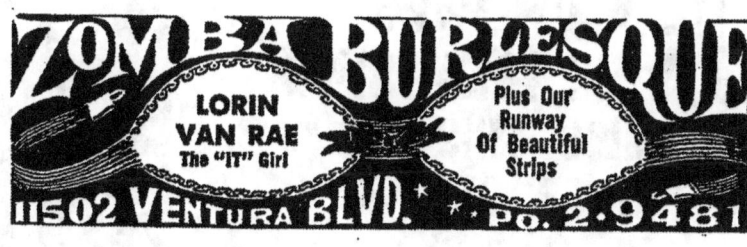
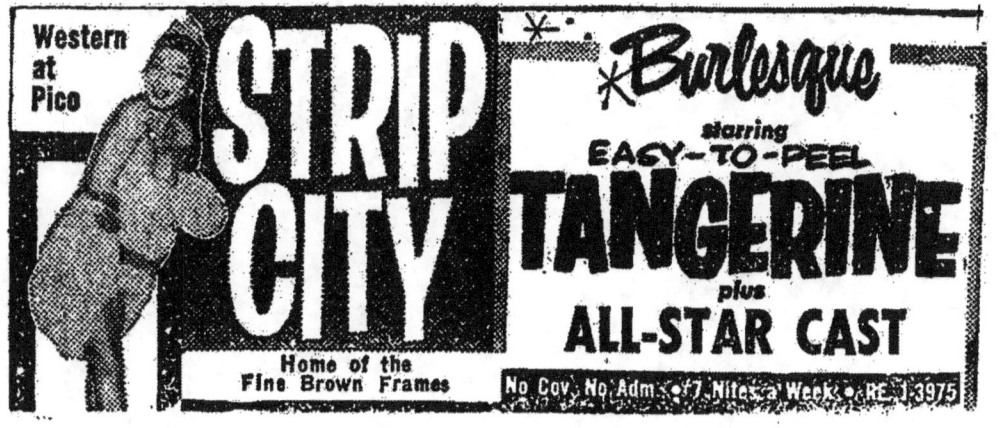

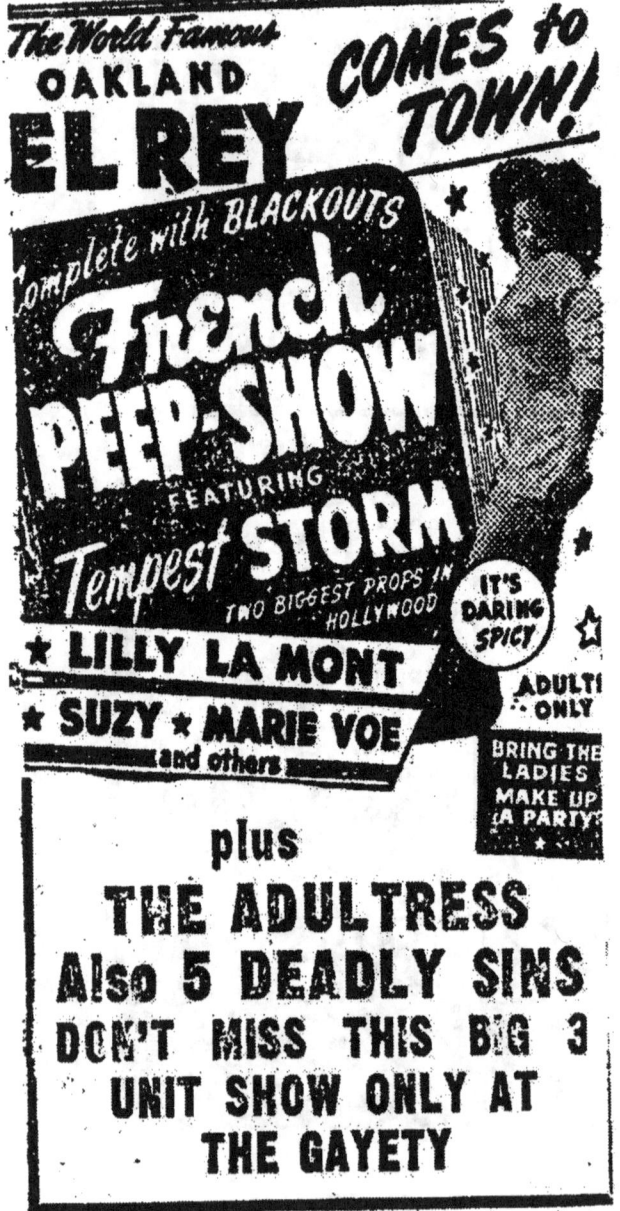
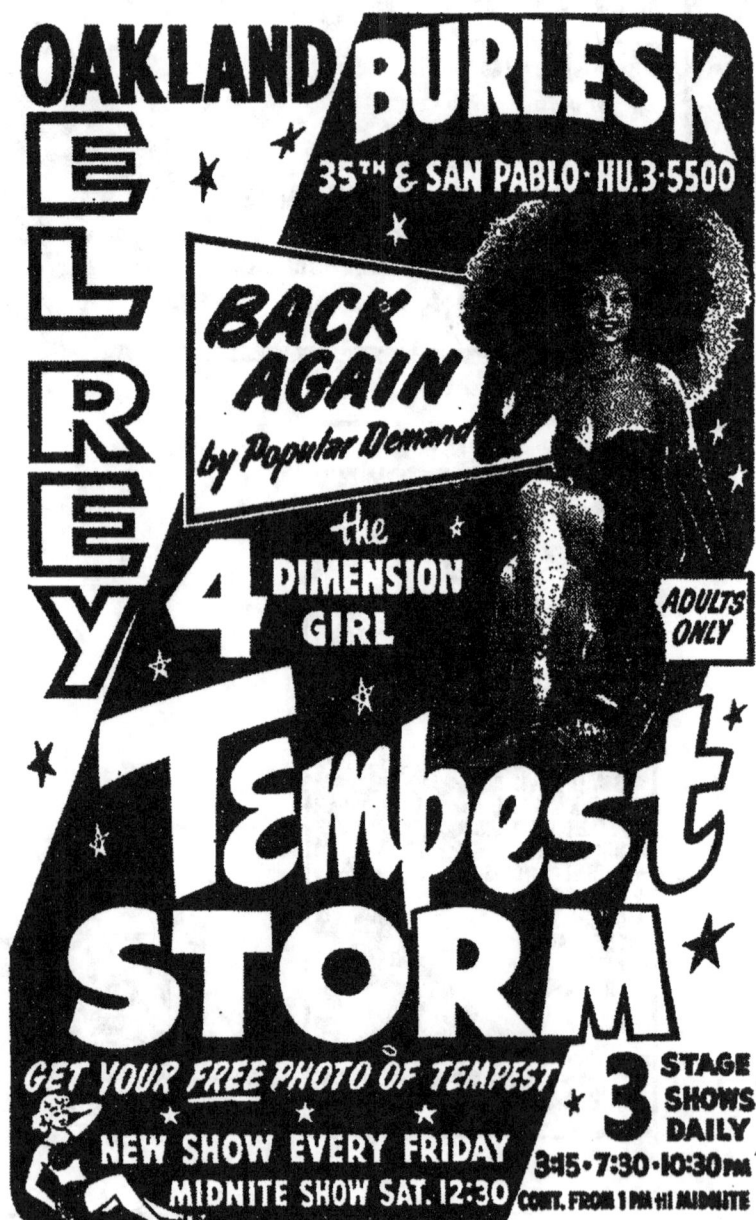

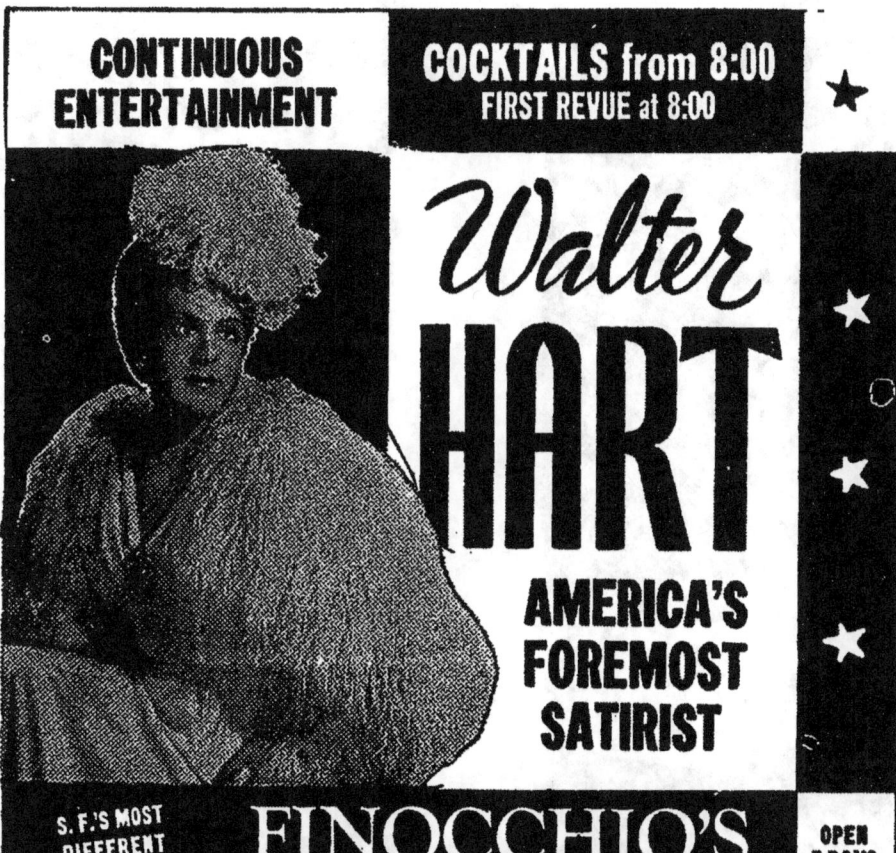

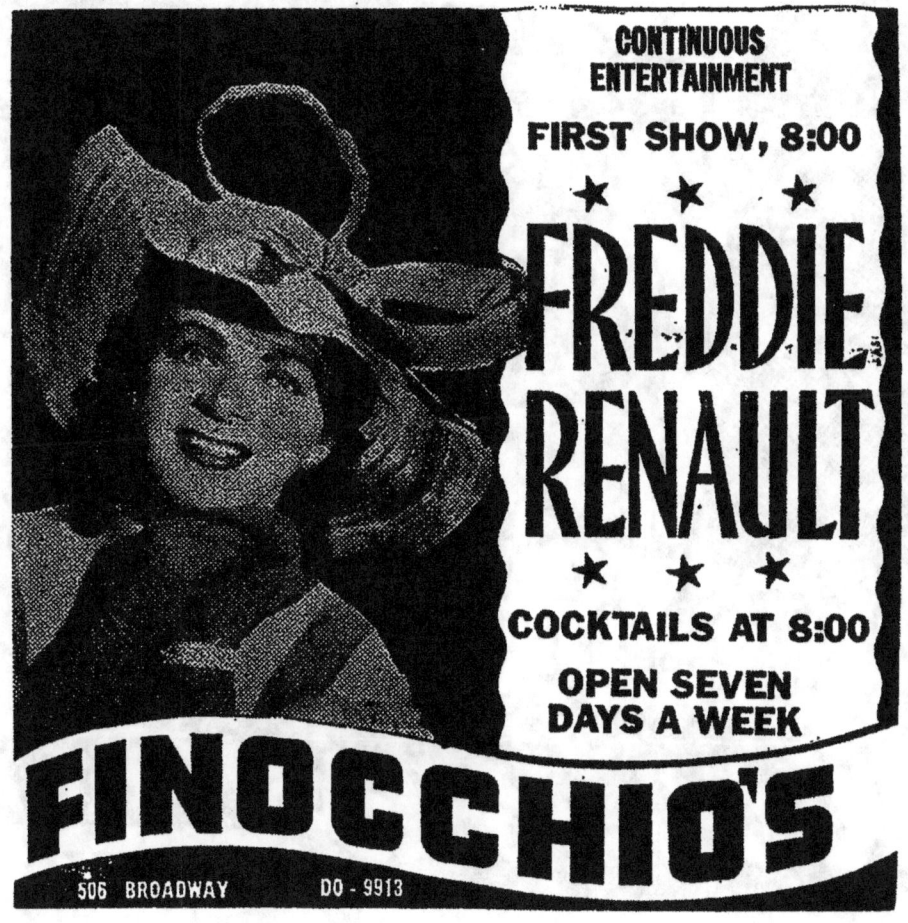

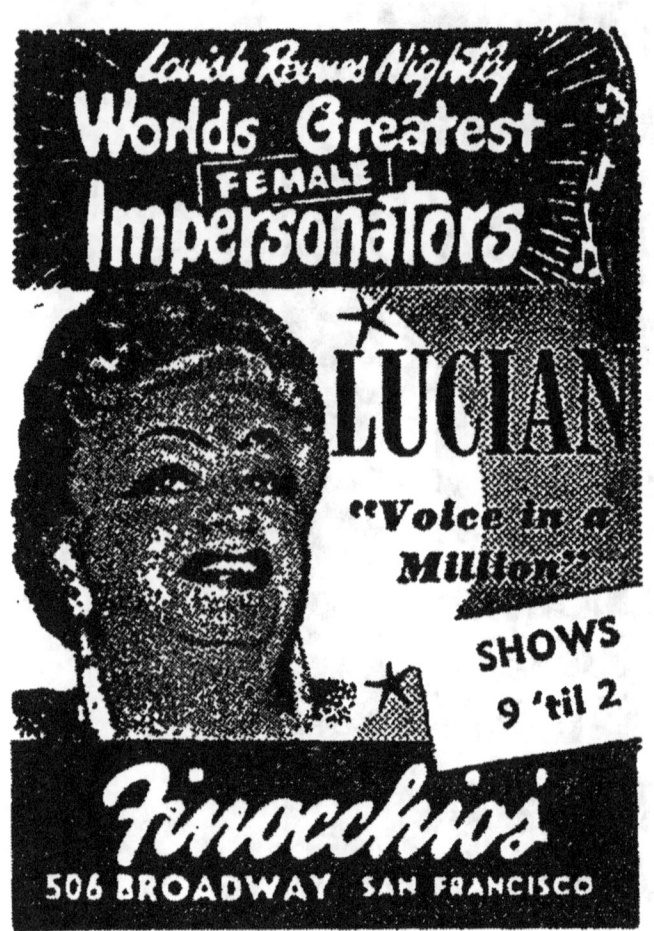
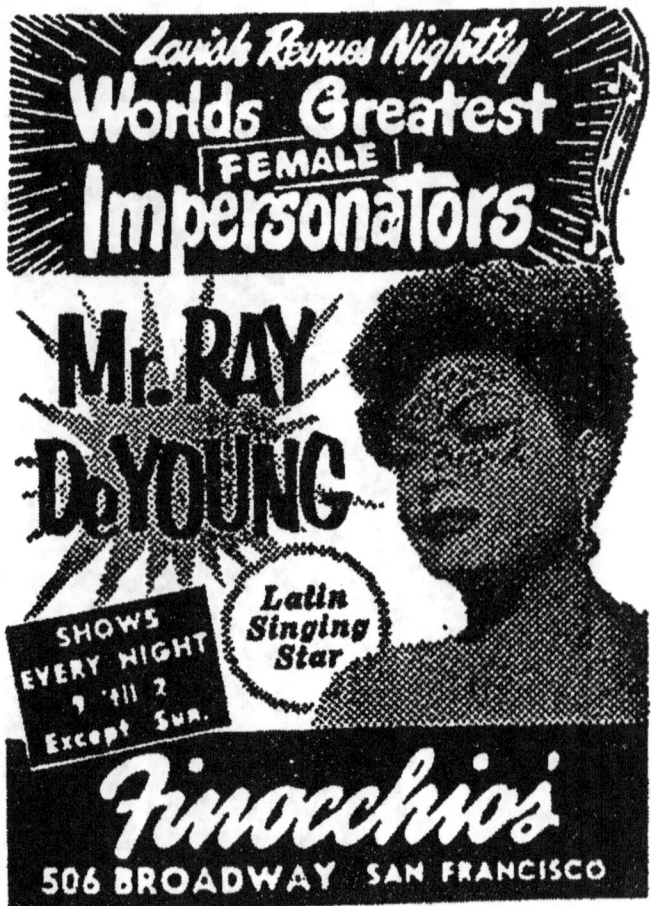

Lavish Revues Nightly
Worlds Greatest FEMALE Impersonators

LES LEE — INTERPRETIVE DANCER

CONTINUOUS ENTERTAINMENT NIGHTLY 9 'TIL 2

Finocchio's 506 BROADWAY

CLOSED MONDAY

Lavish Revues Nightly
Worlds Greatest FEMALE Impersonators

Mr. CARROLL WALLACE — FAMOUS SONG STYLIST

CONTINUOUS ENTERTAINMENT NIGHTLY 9 'TIL 2

Finocchio's 506 BROADWAY

CLOSED MONDAY

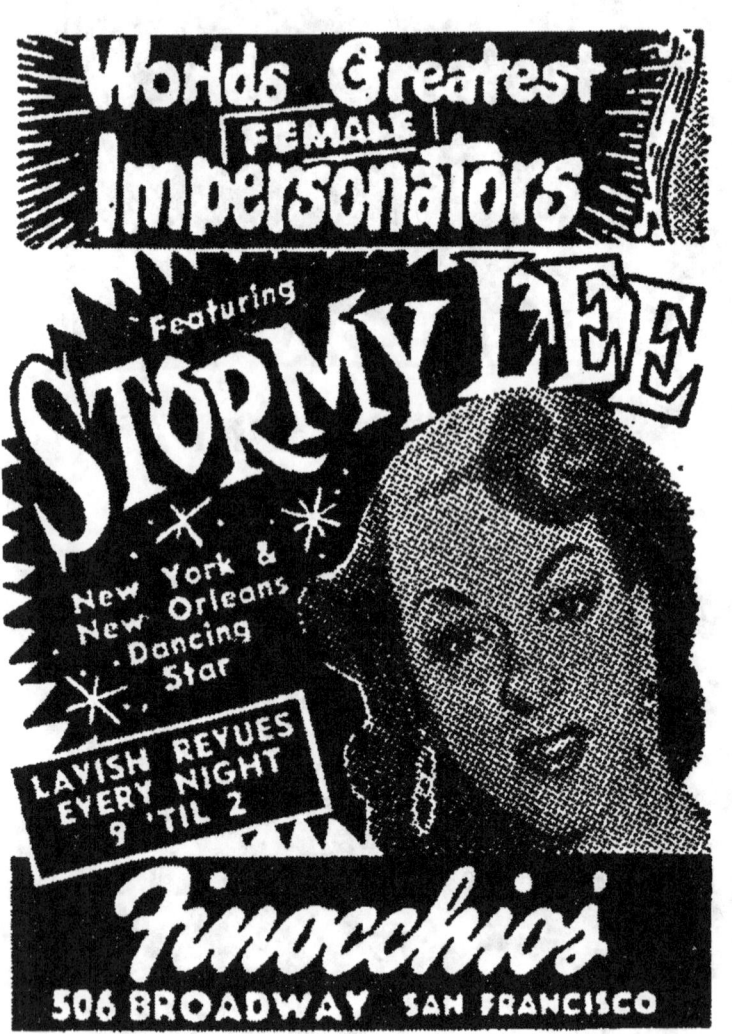
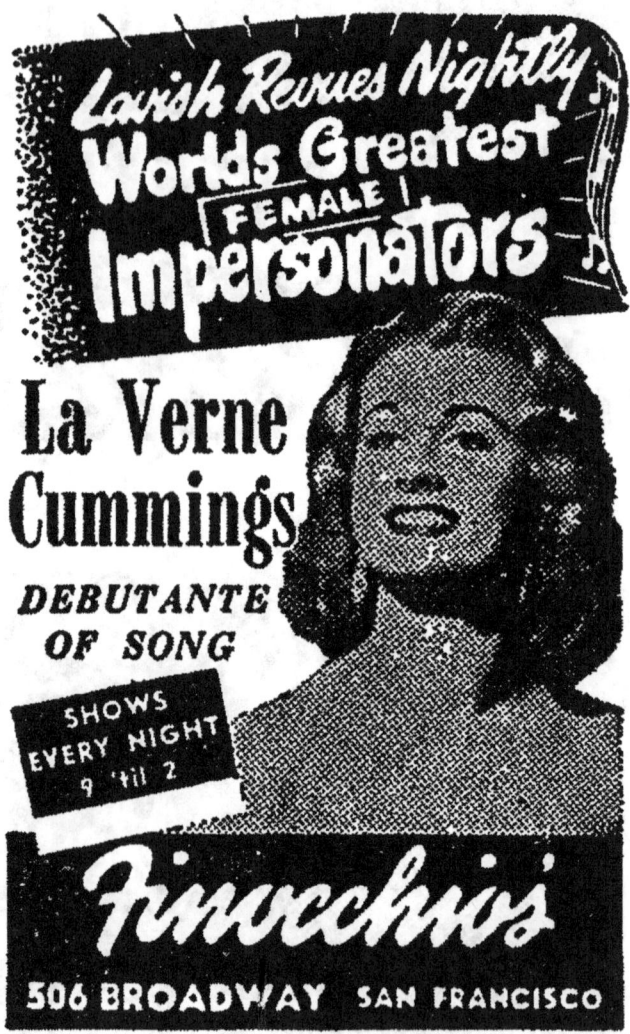

GALLERY TWO

CONSISTING OF:

Advertisements from THIS WEEK IN CHICAGO magazine 1949

Advertisements from the CINCINATTI POST and TIMES-STAR 1950-1959

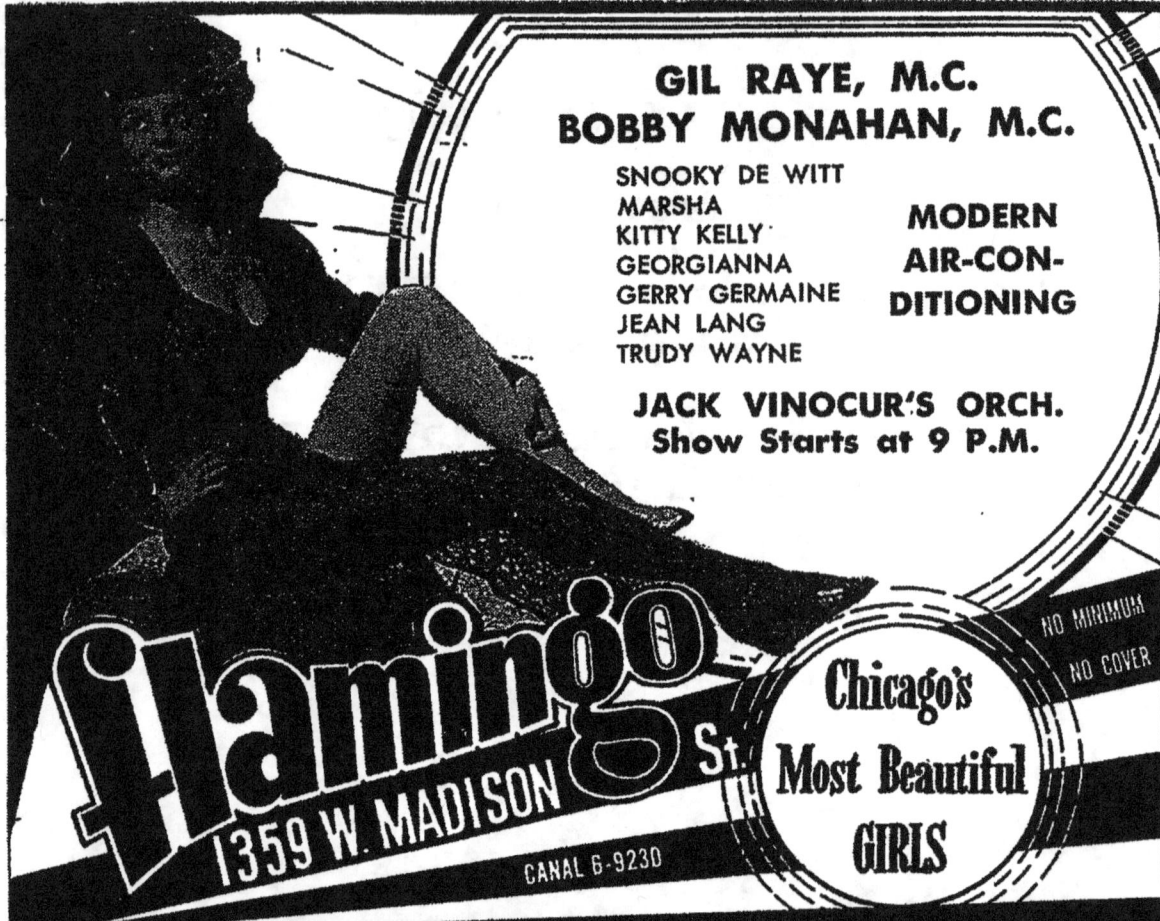
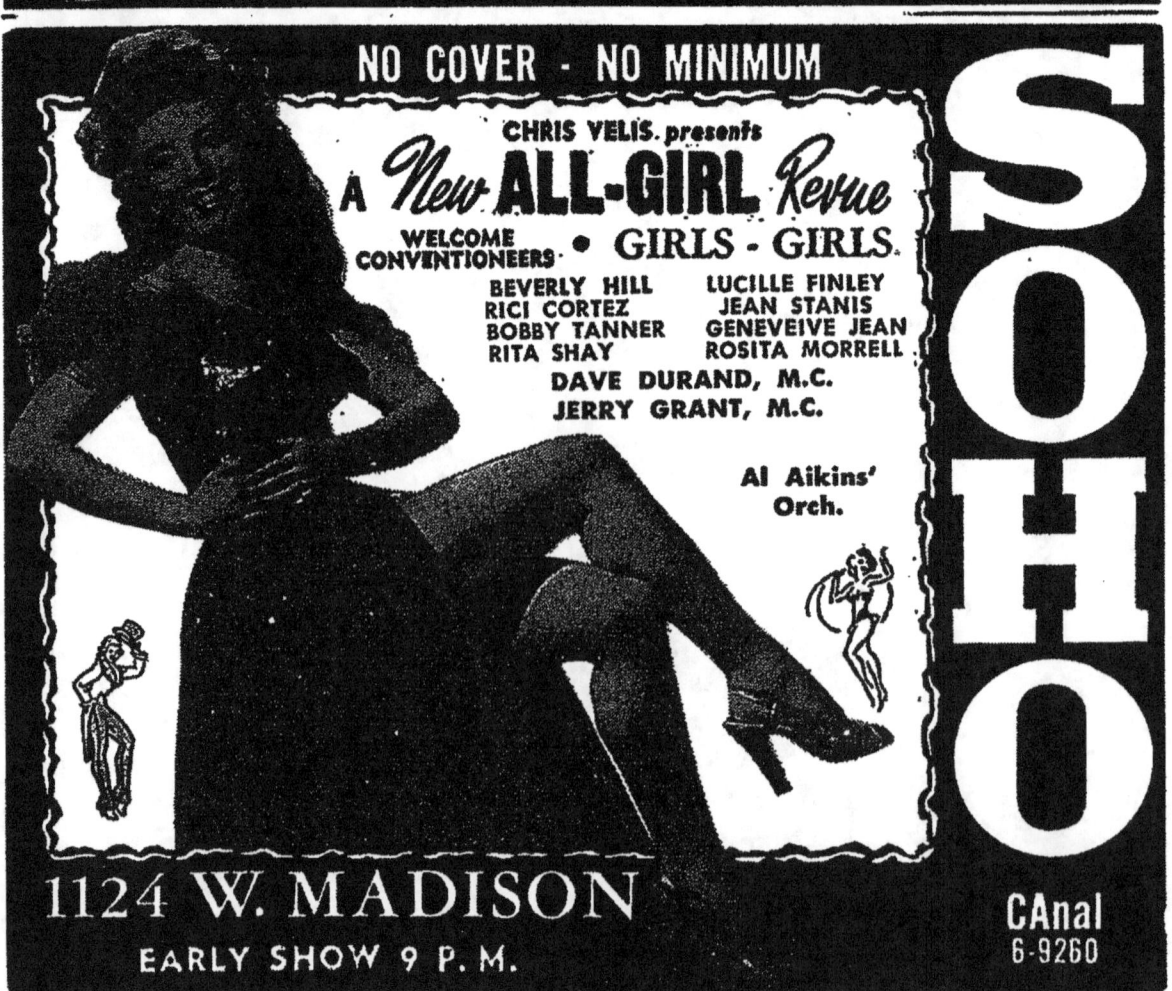

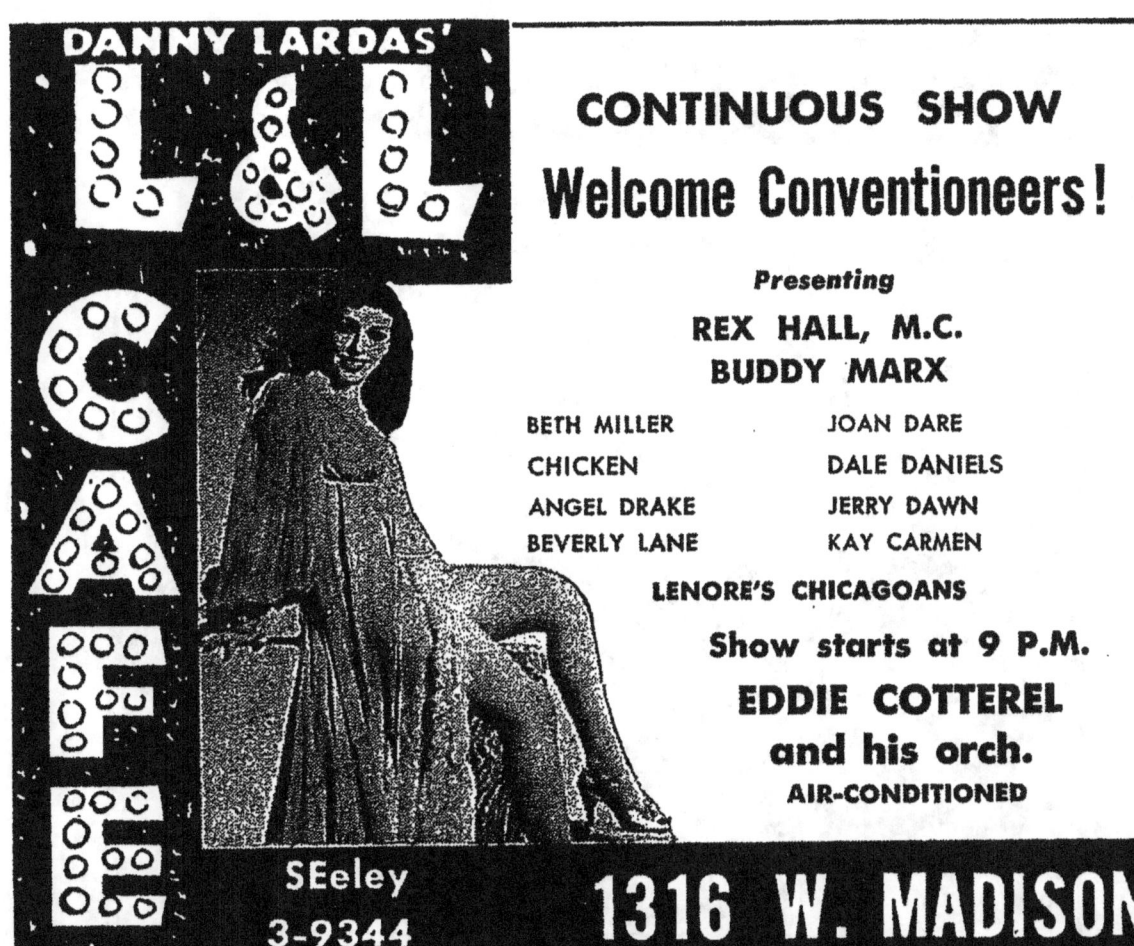

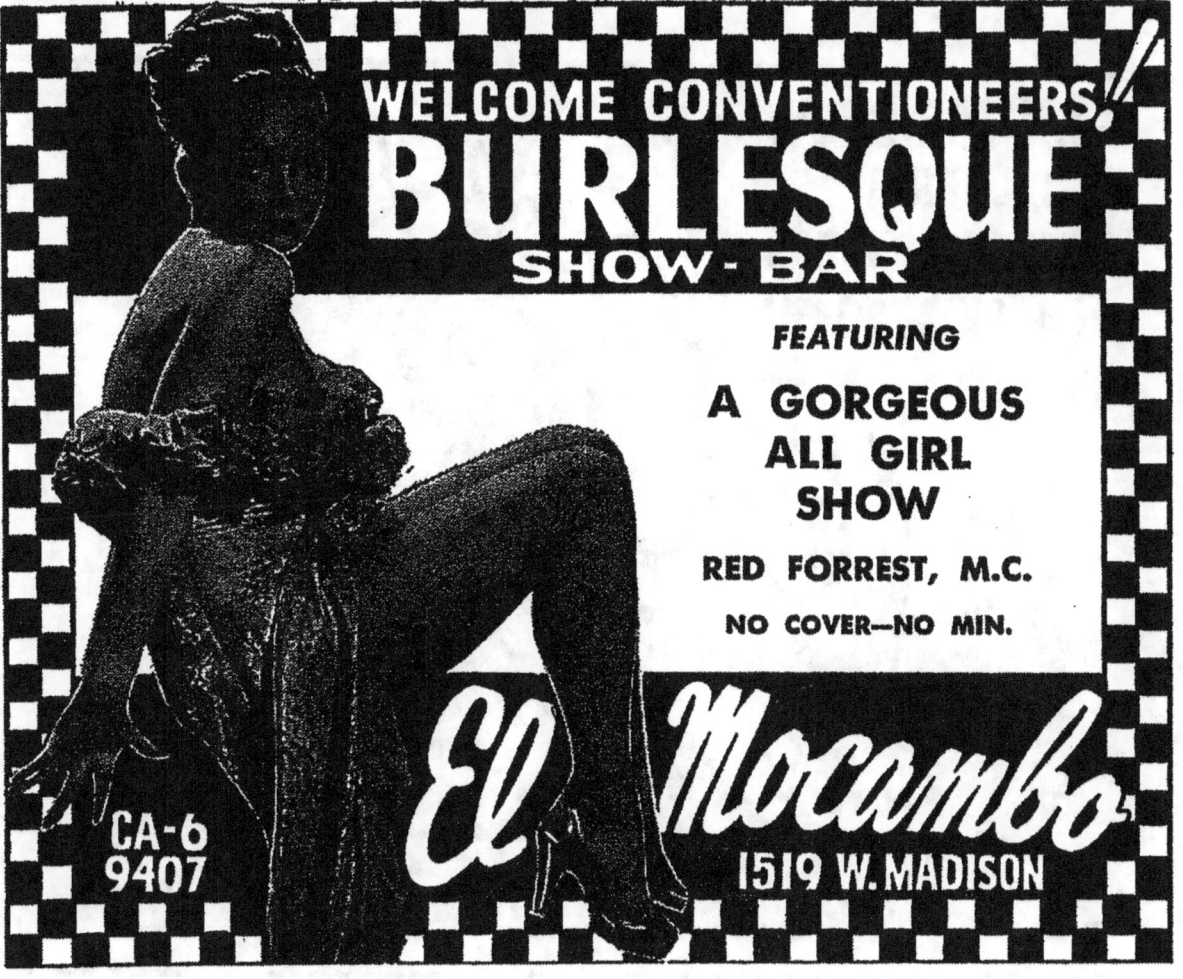

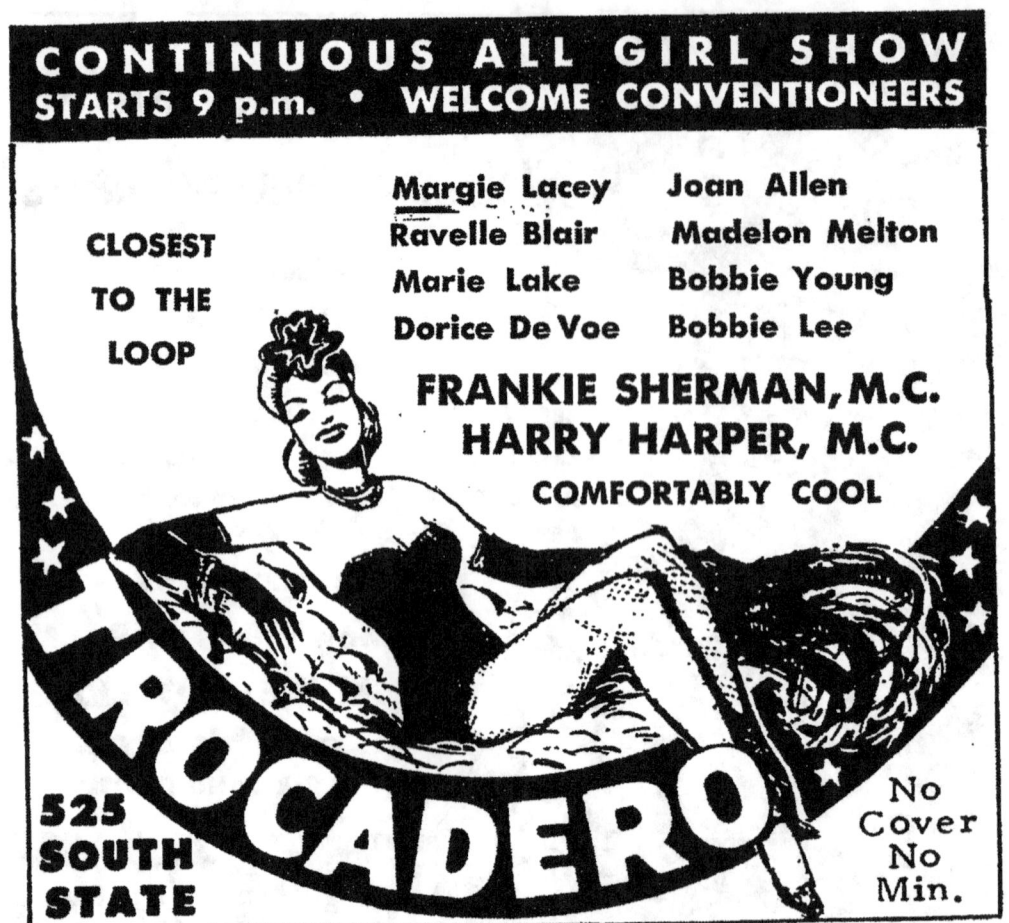

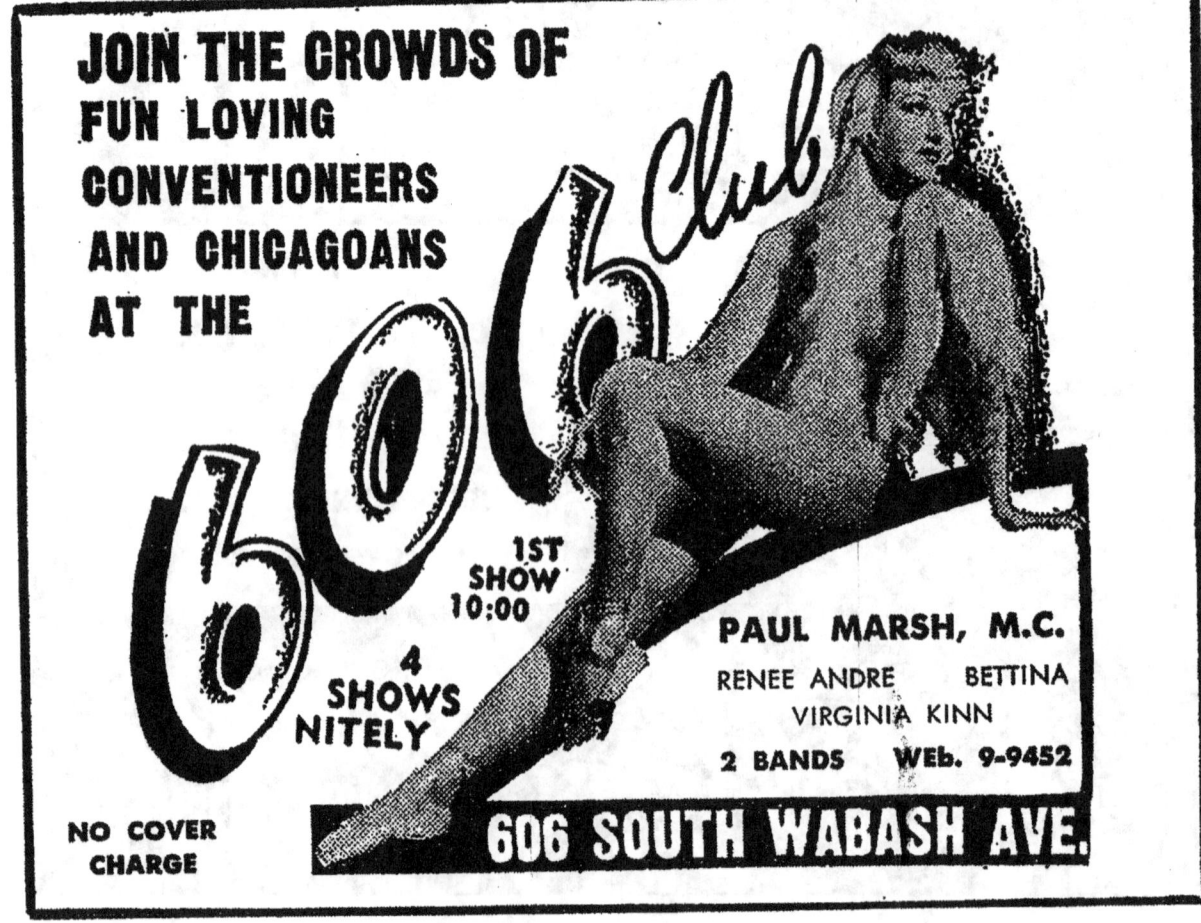

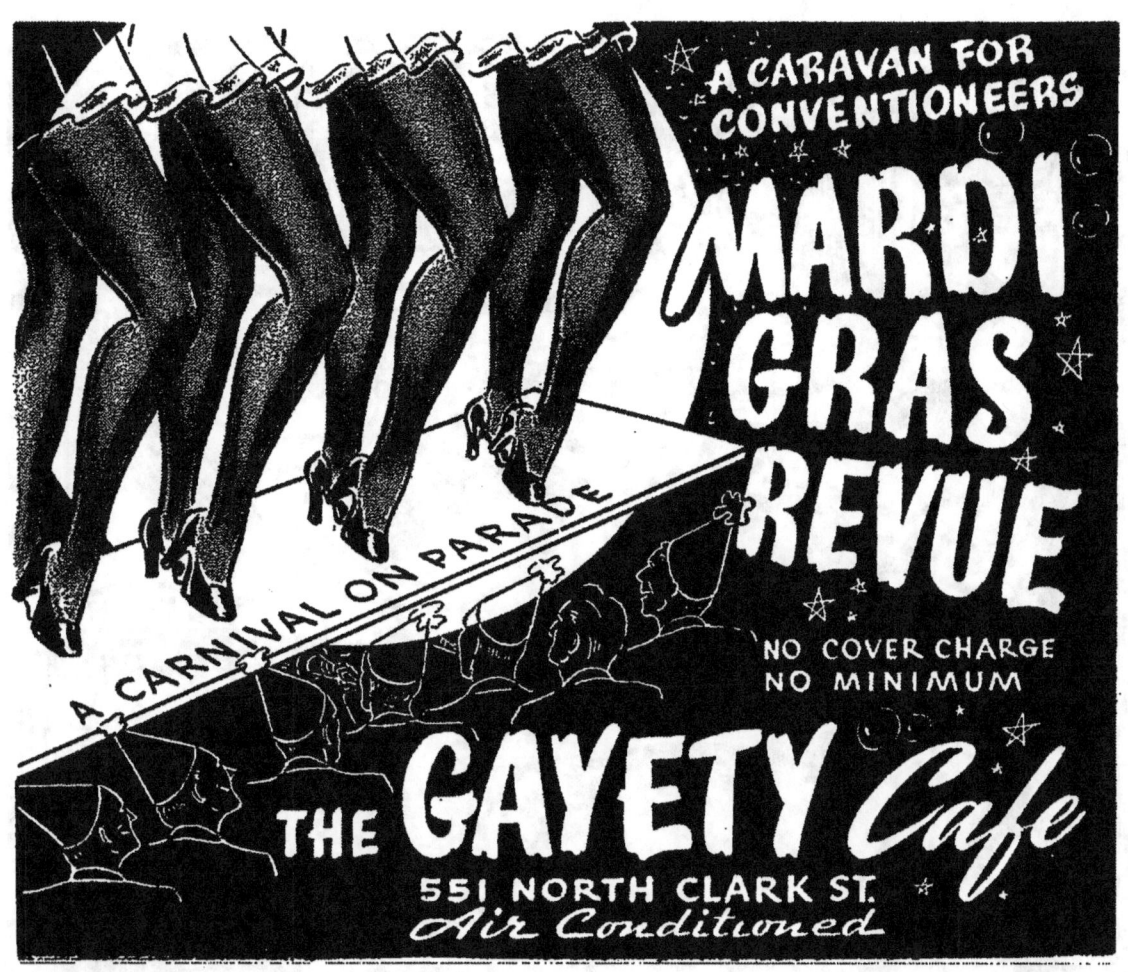

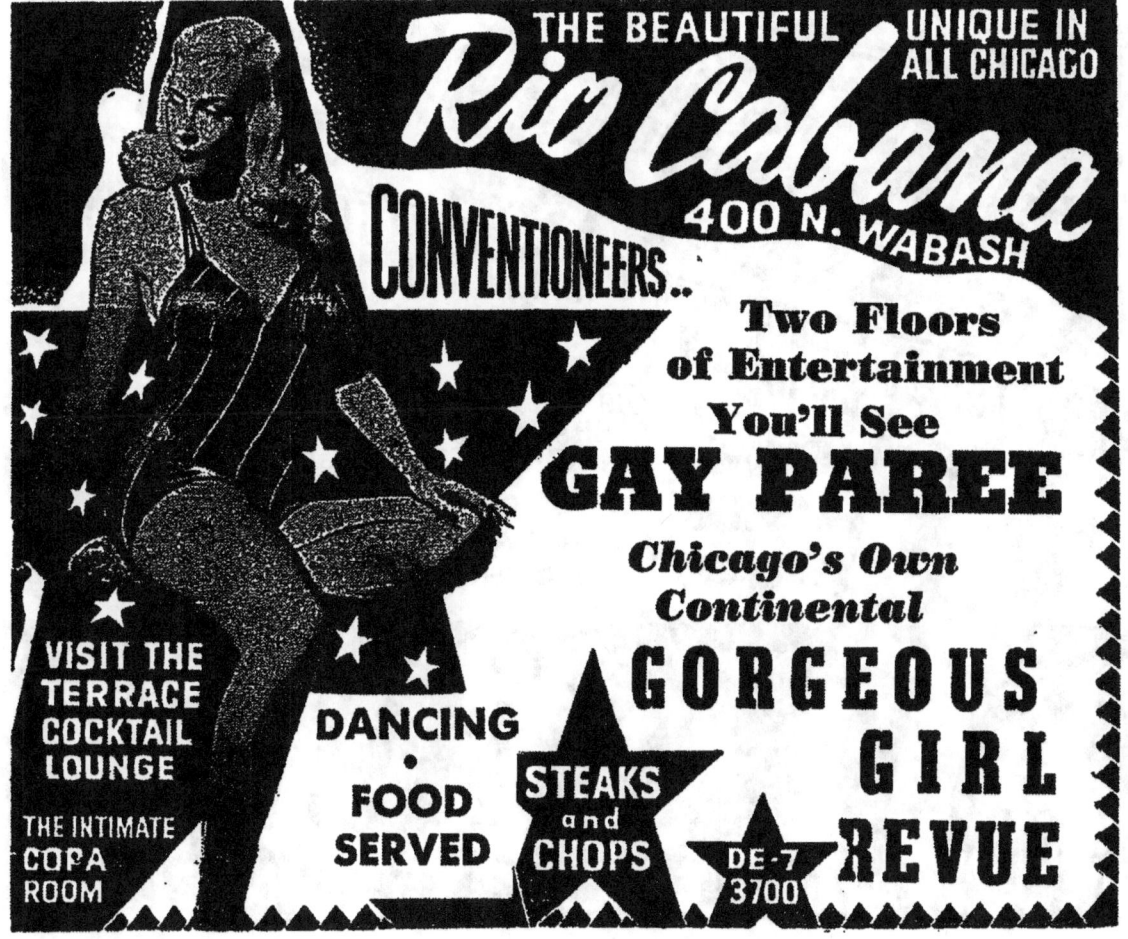

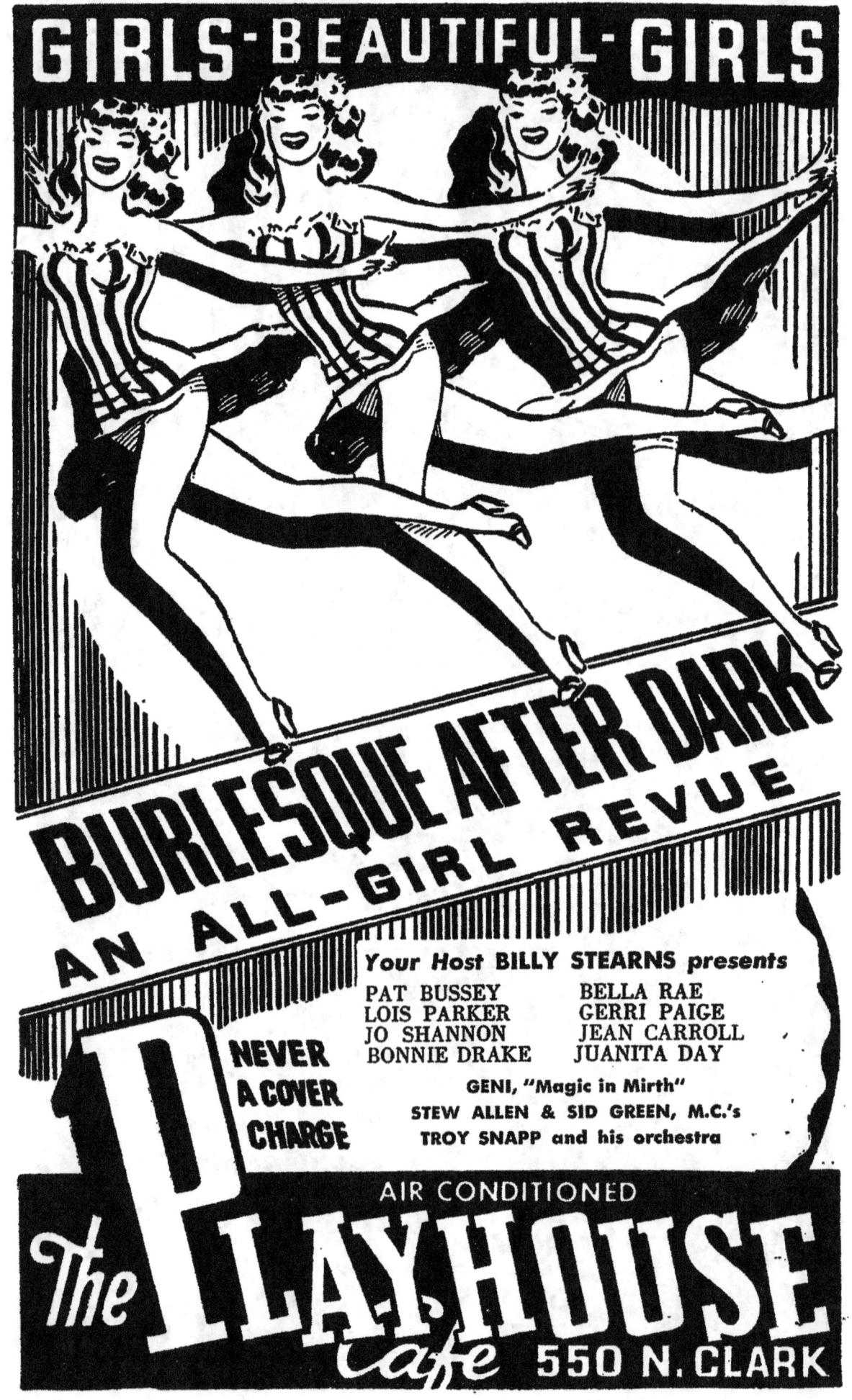

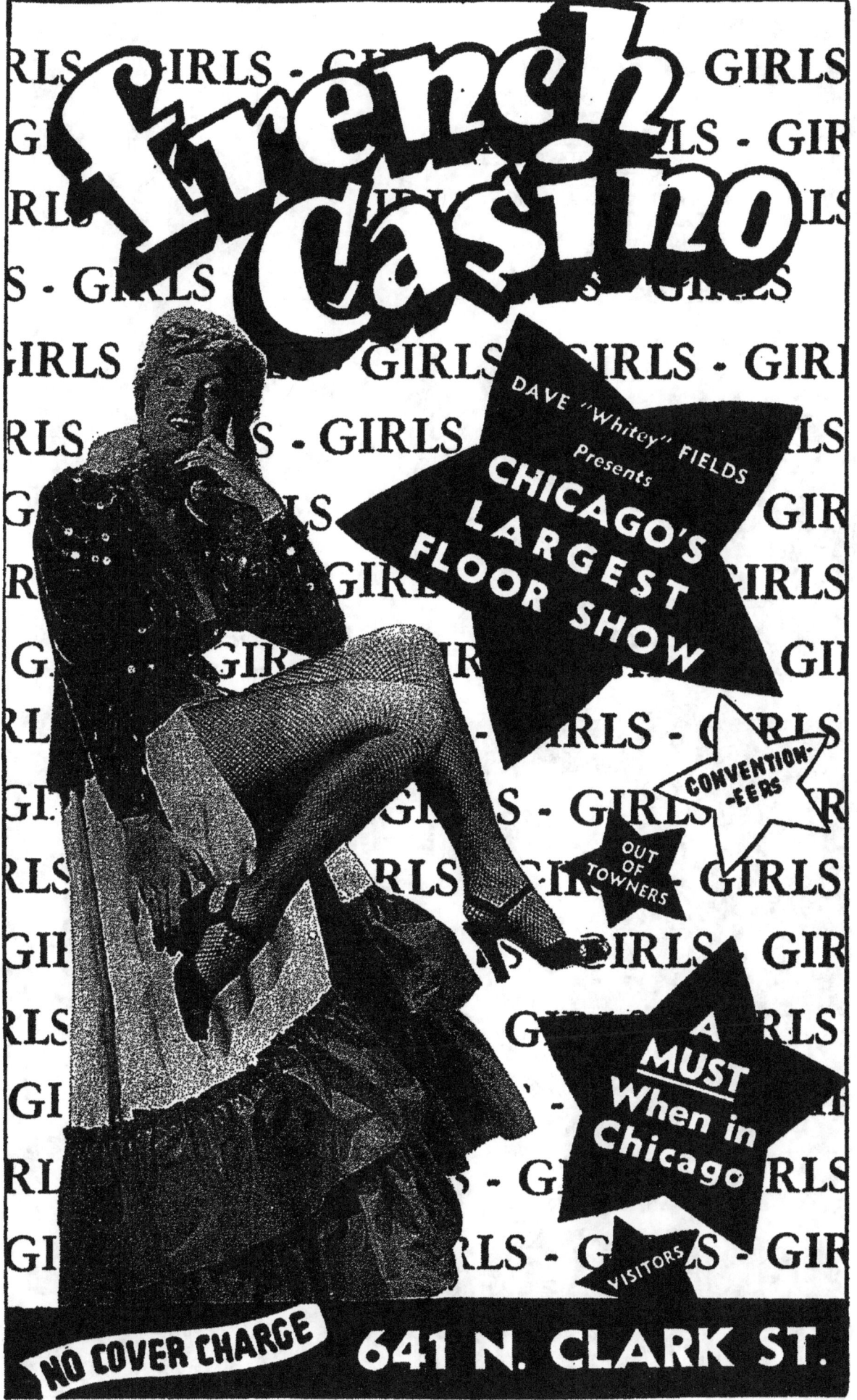

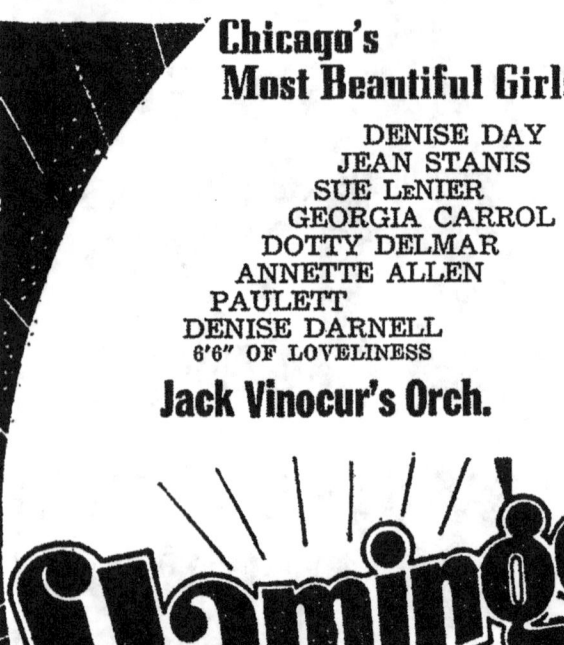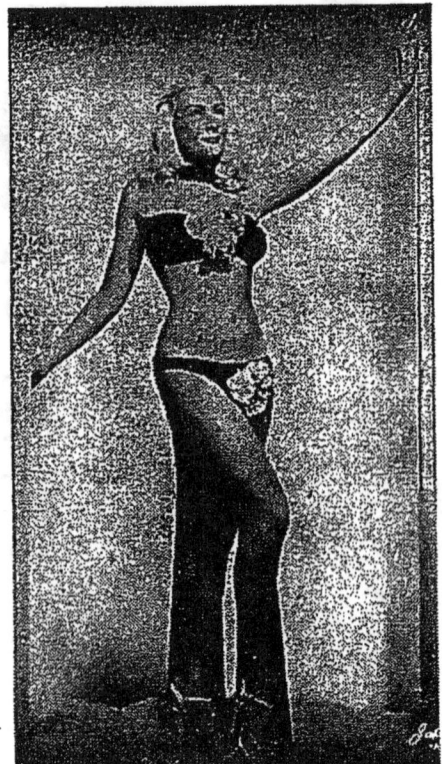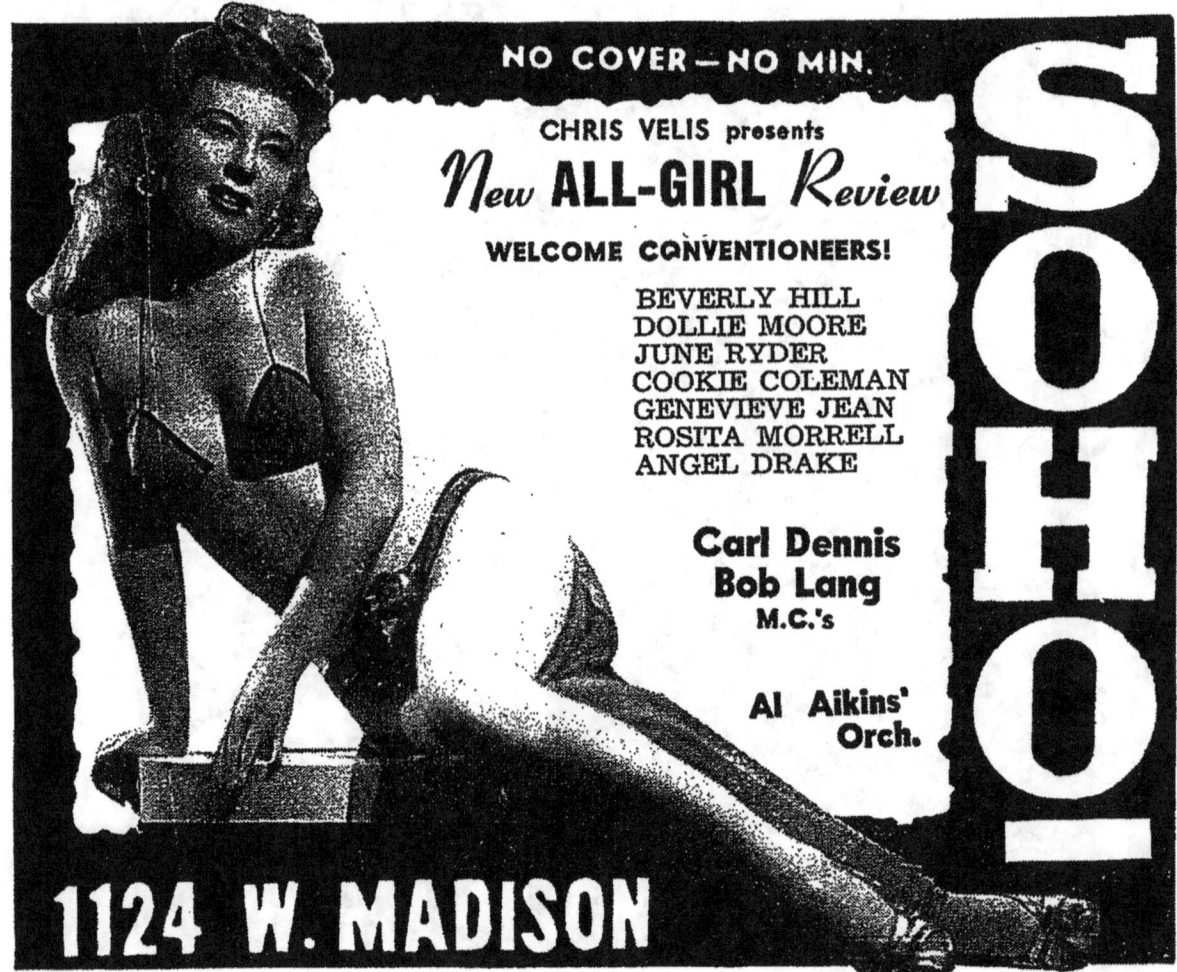

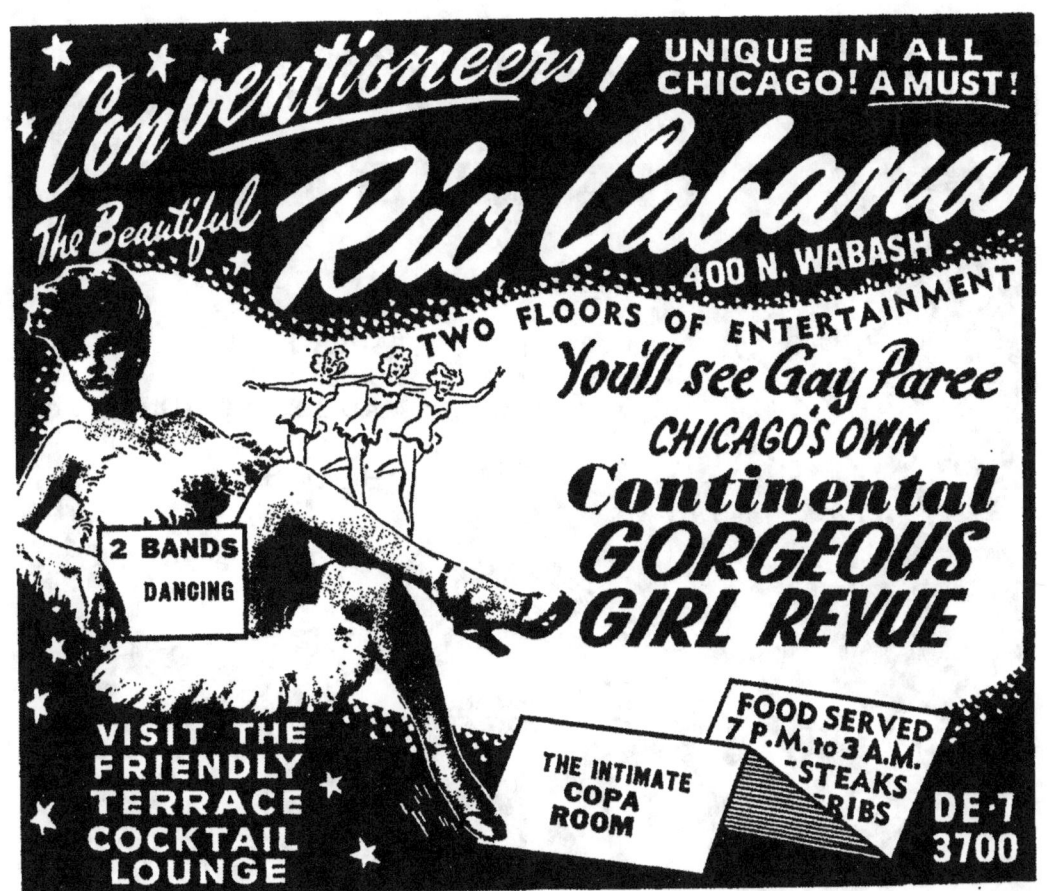
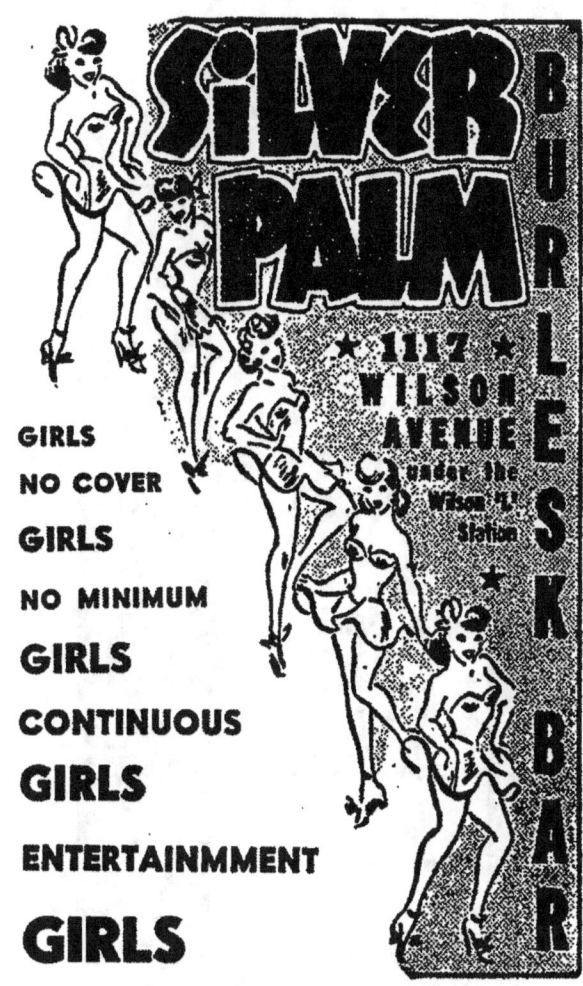
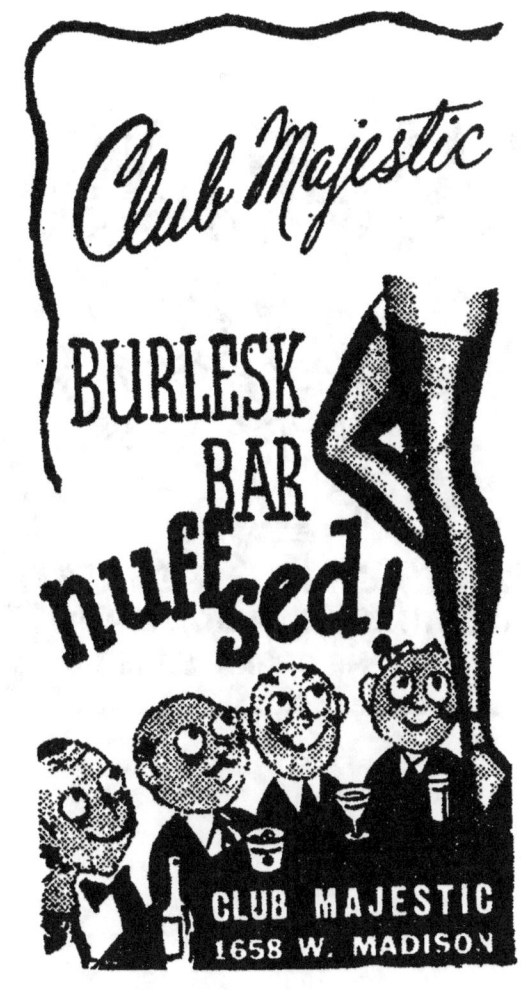

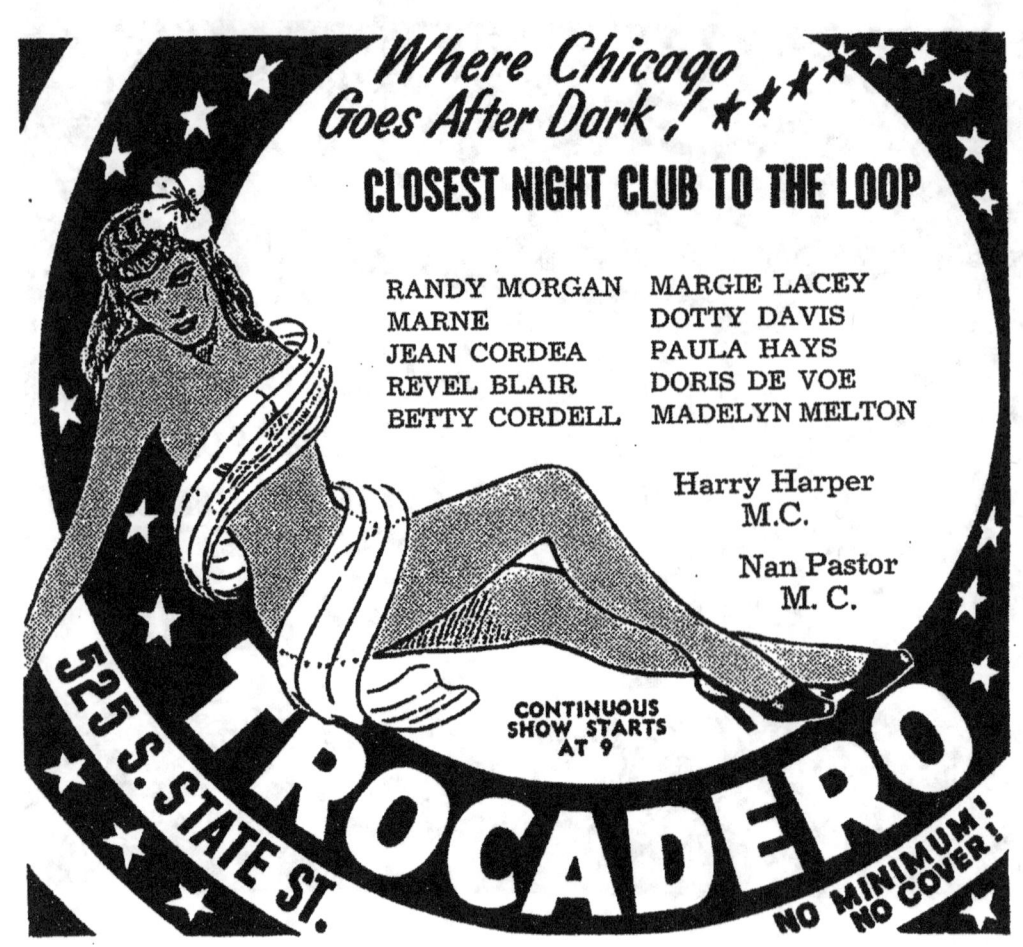

Where Chicago Goes After Dark!

CLOSEST NIGHT CLUB TO THE LOOP

RANDY MORGAN	MARGIE LACEY
MARNE	DOTTY DAVIS
JEAN CORDEA	PAULA HAYS
REVEL BLAIR	DORIS DE VOE
BETTY CORDELL	MADELYN MELTON

Harry Harper M.C.

Nan Pastor M.C.

CONTINUOUS SHOW STARTS AT 9

TROCADERO

525 S. STATE ST.

NO MINIMUM! NO COVER!

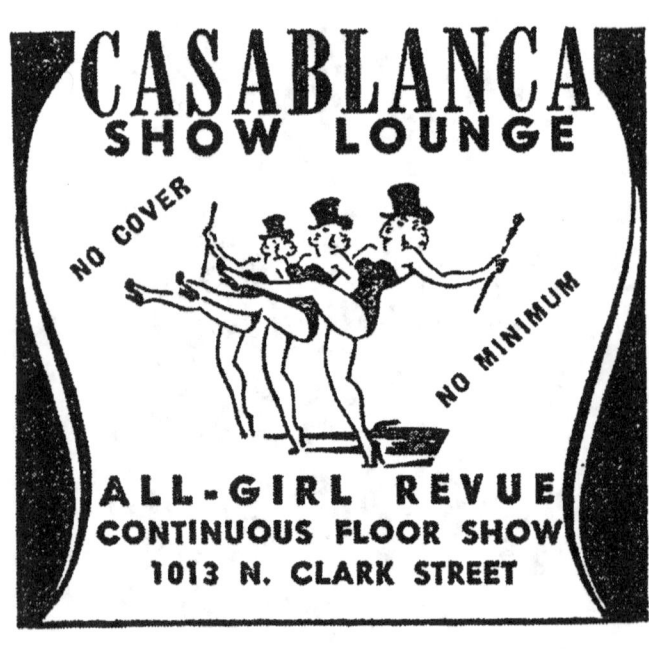

CASABLANCA SHOW LOUNGE

NO COVER — NO MINIMUM

ALL-GIRL REVUE
CONTINUOUS FLOOR SHOW
1013 N. CLARK STREET

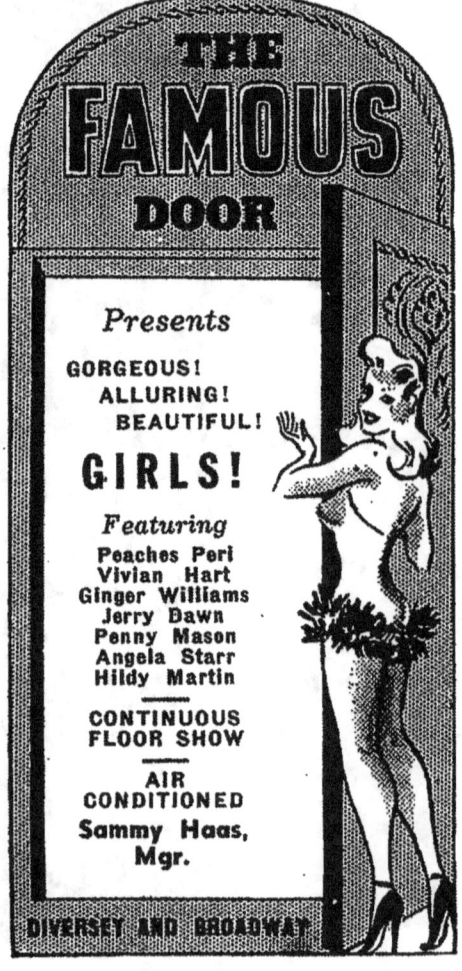

THE FAMOUS DOOR

Presents

GORGEOUS!
ALLURING!
BEAUTIFUL!

GIRLS!

Featuring
Peaches Peri
Vivian Hart
Ginger Williams
Jerry Dawn
Penny Mason
Angela Starr
Hildy Martin

CONTINUOUS FLOOR SHOW

AIR CONDITIONED

Sammy Haas, Mgr.

DIVERSEY AND BROADWAY

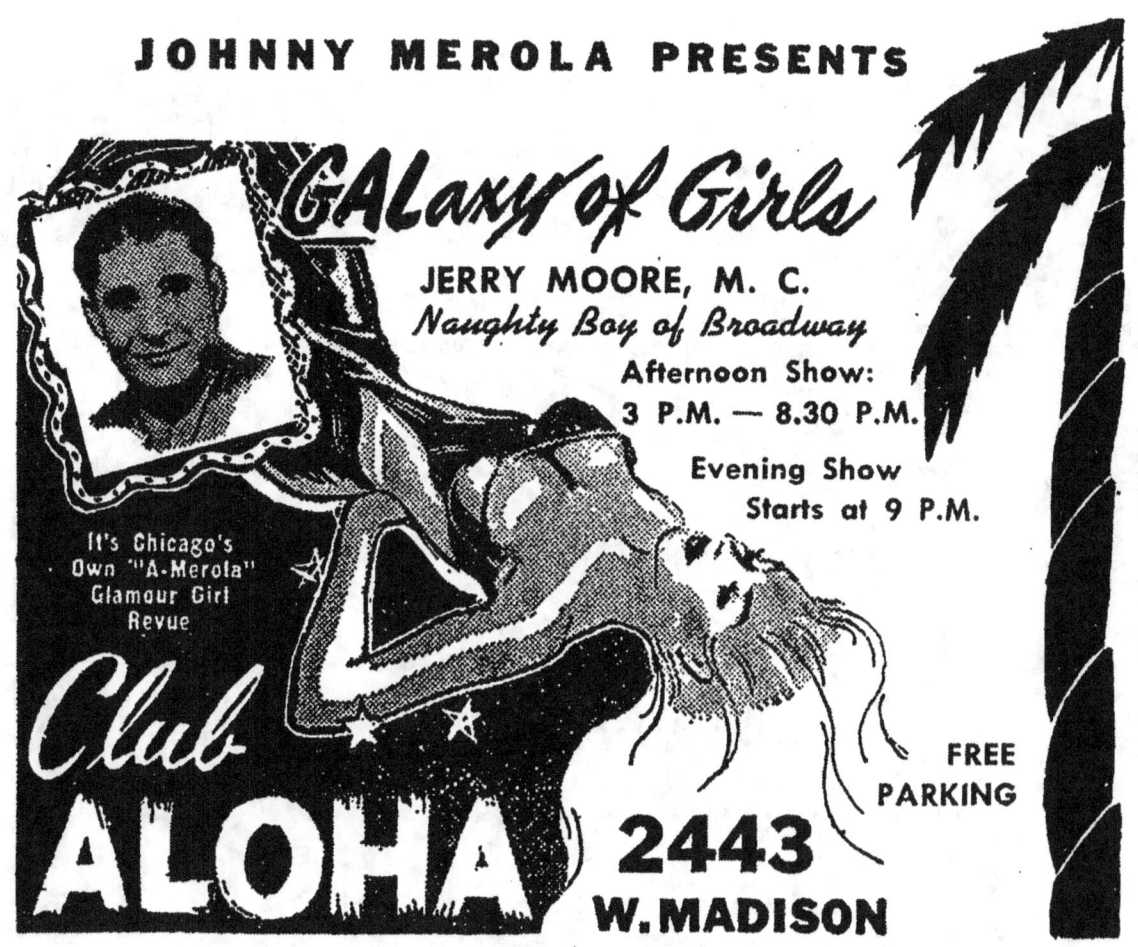

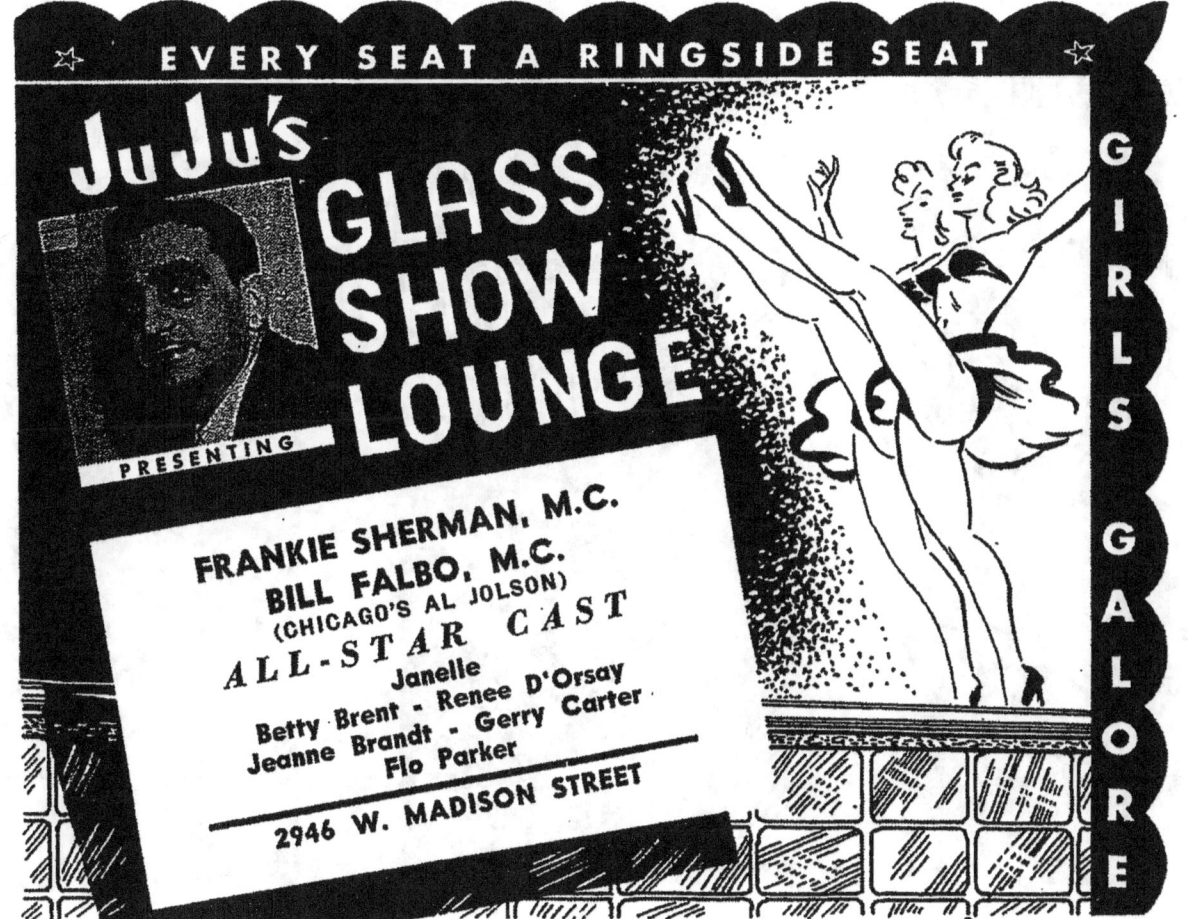

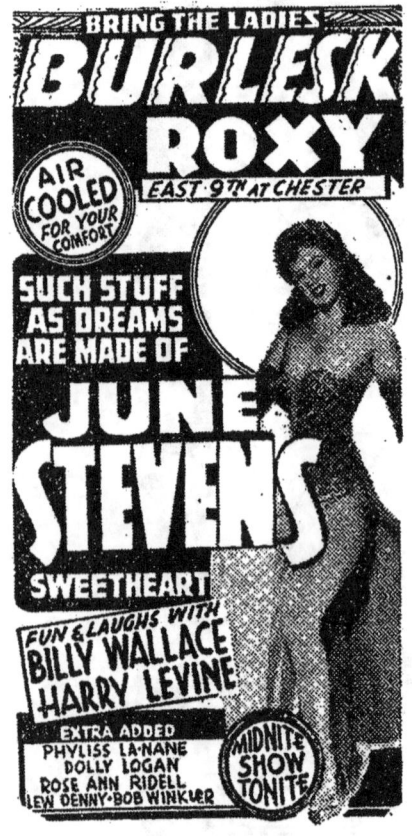
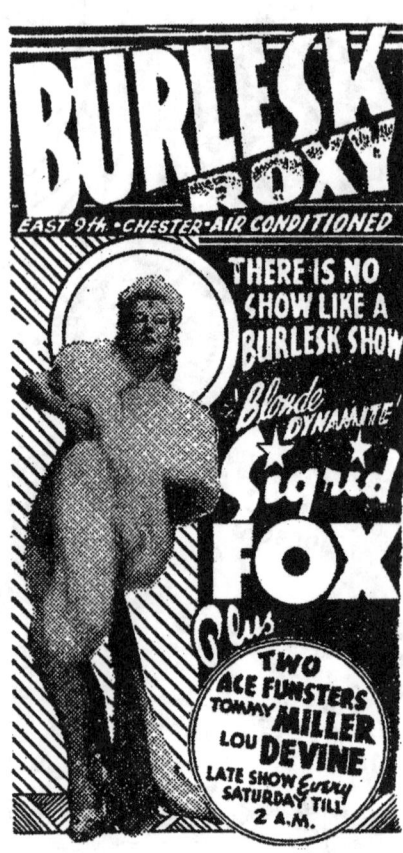
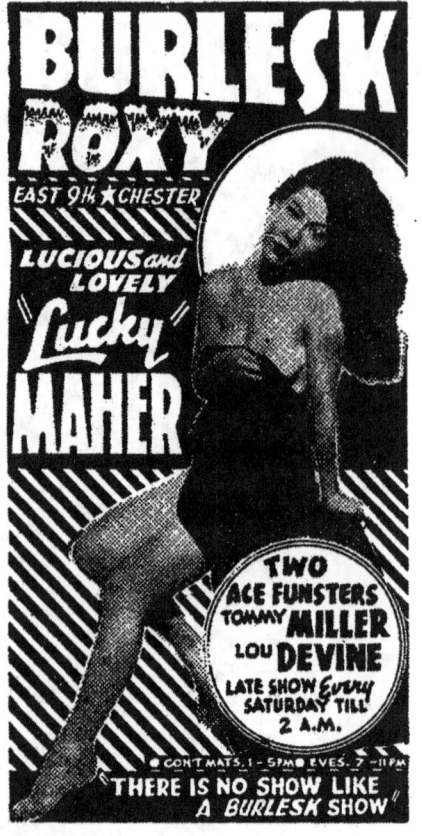

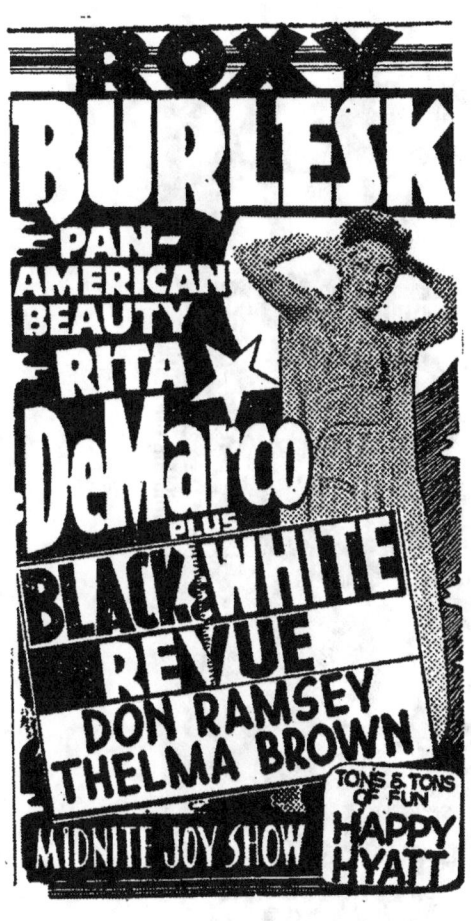
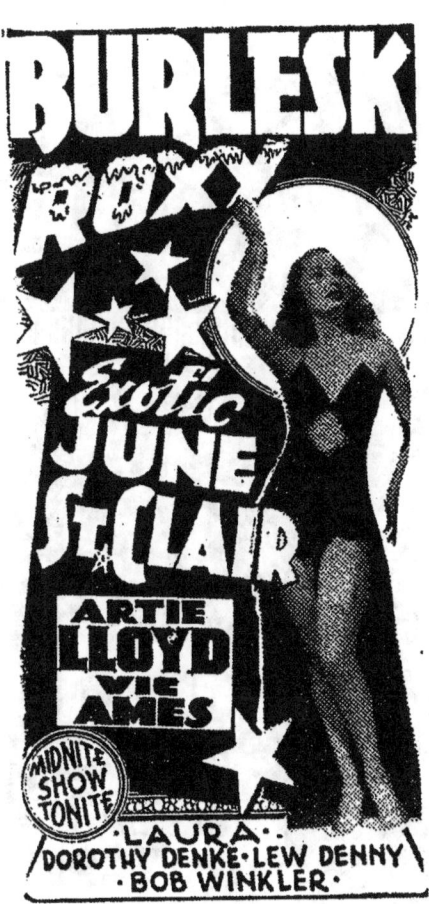
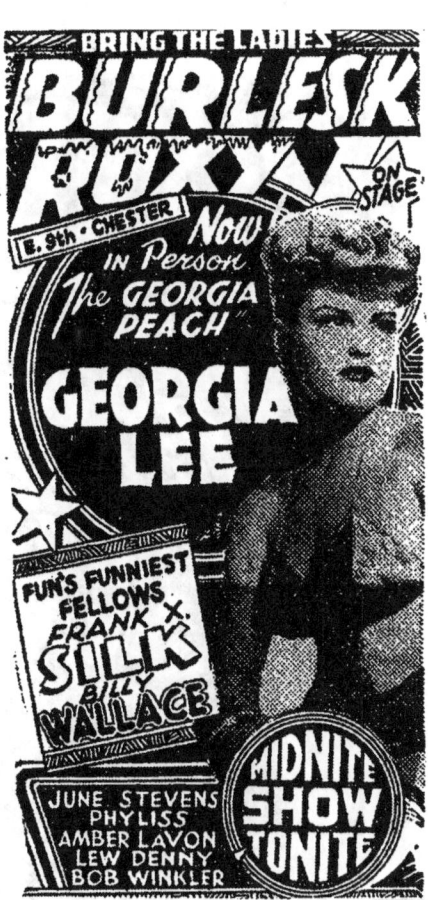
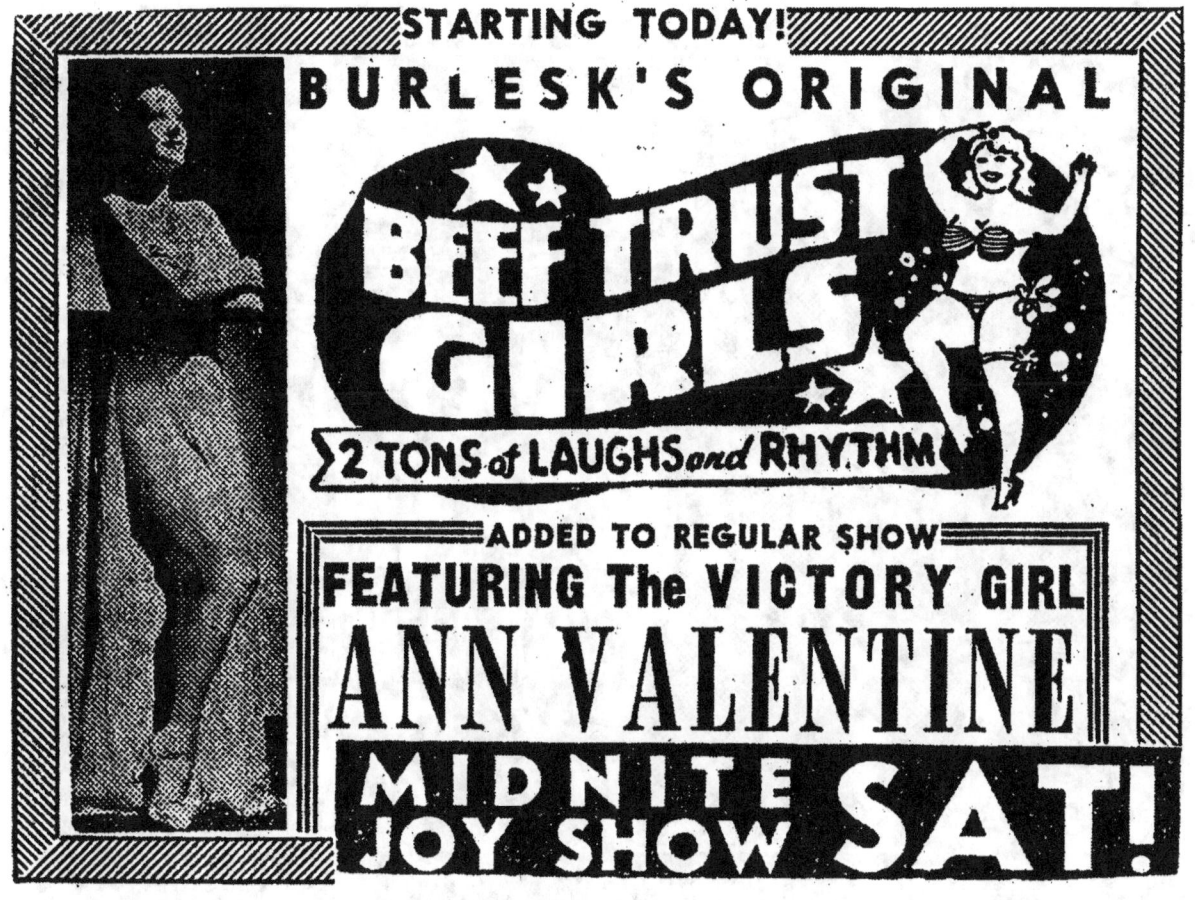

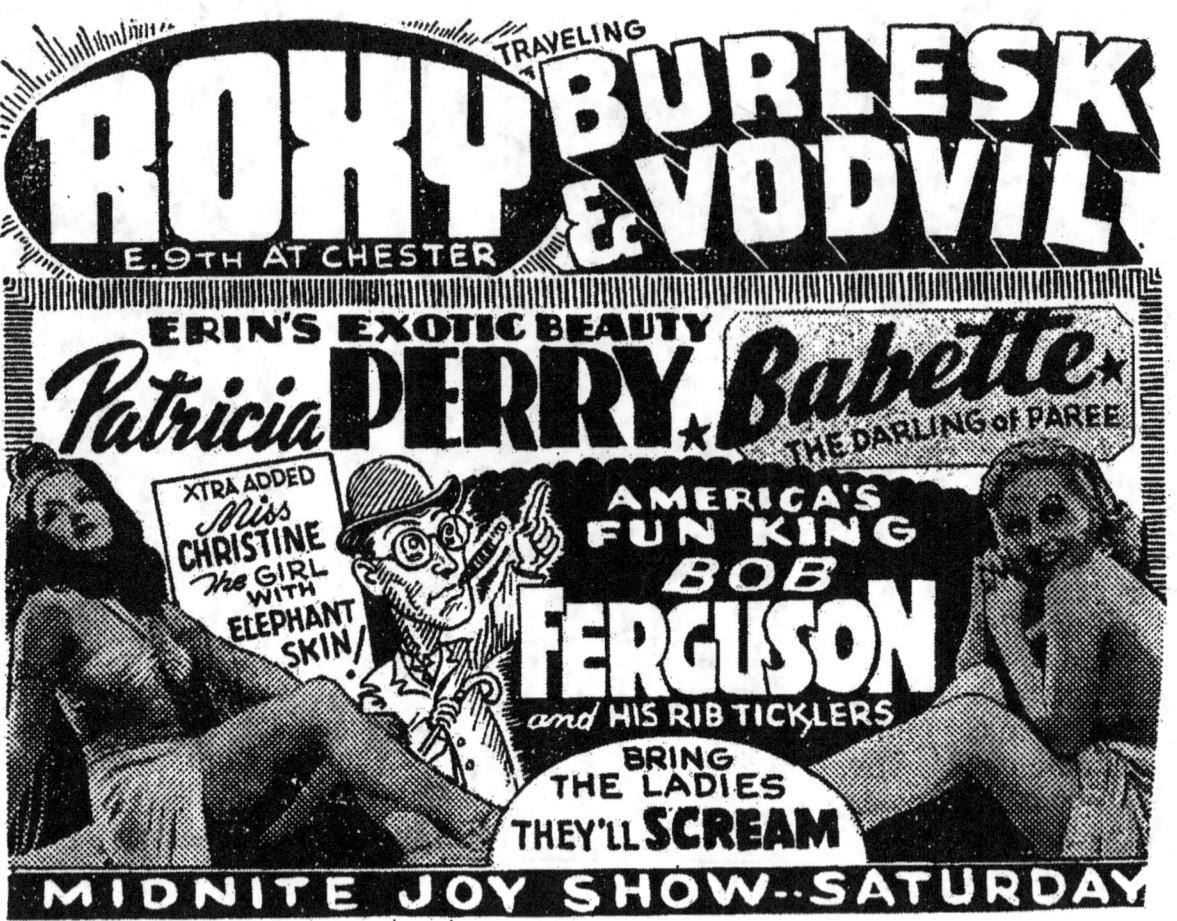

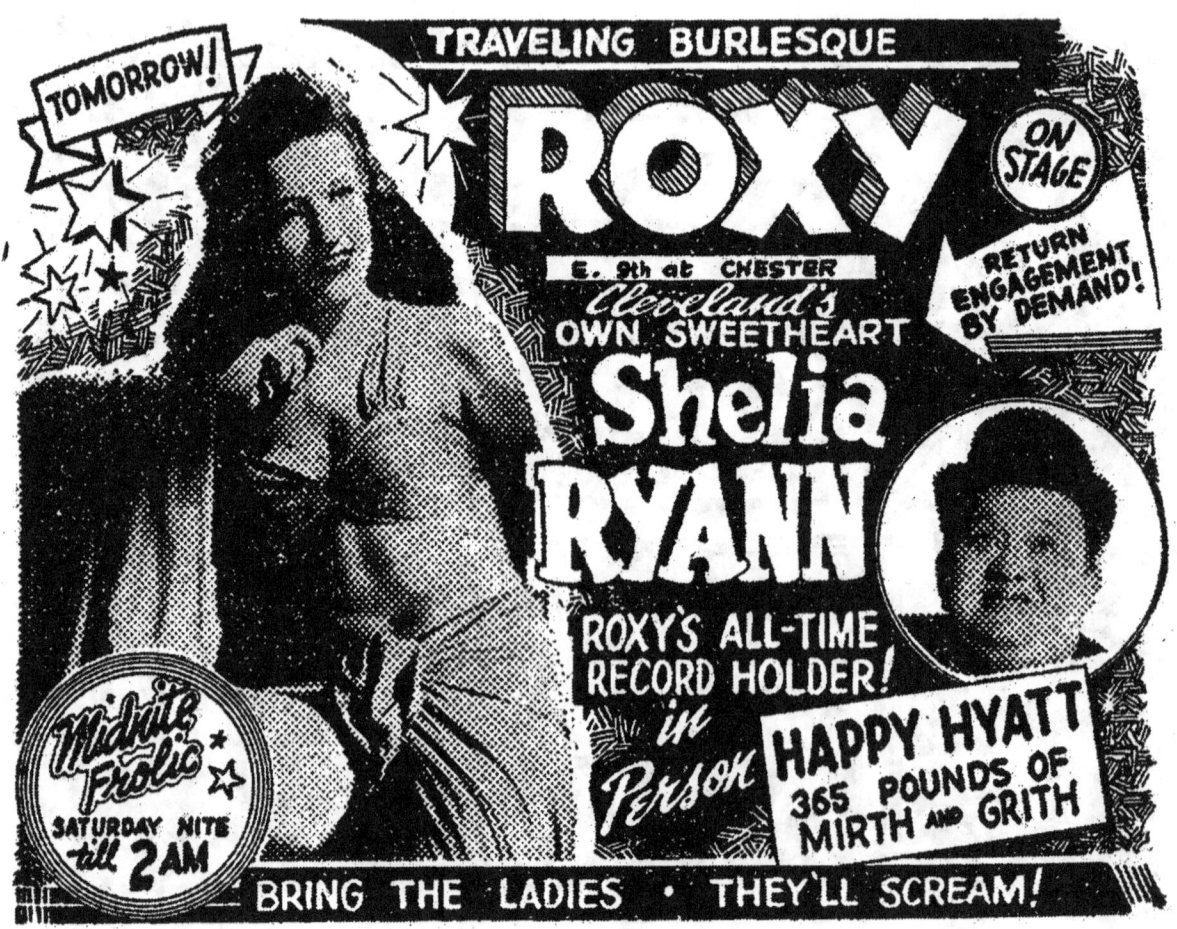

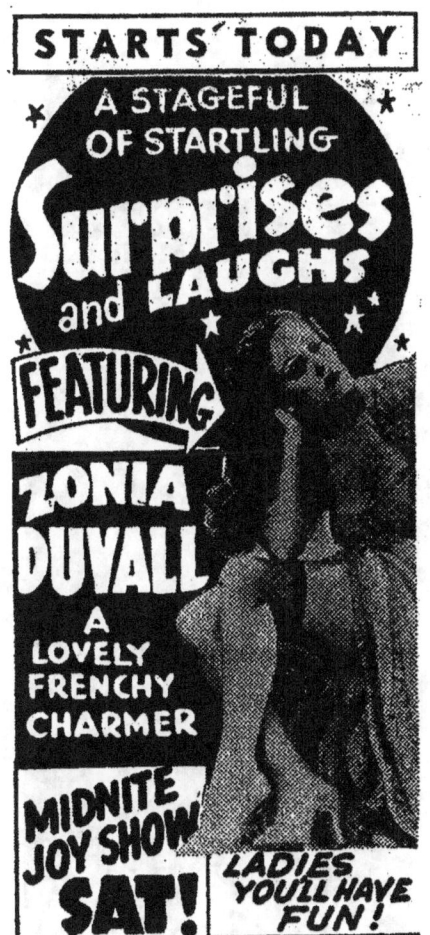
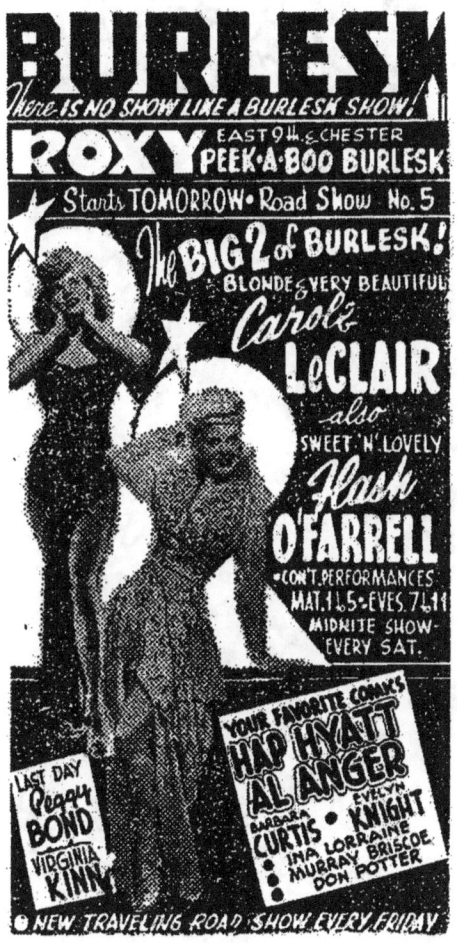

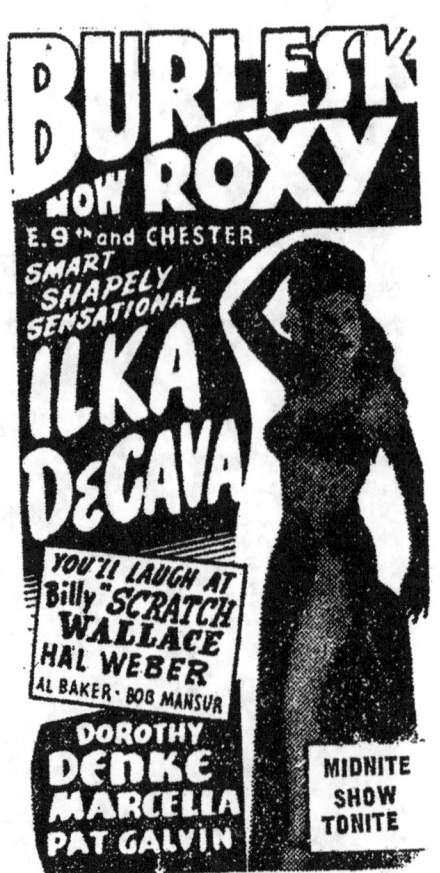
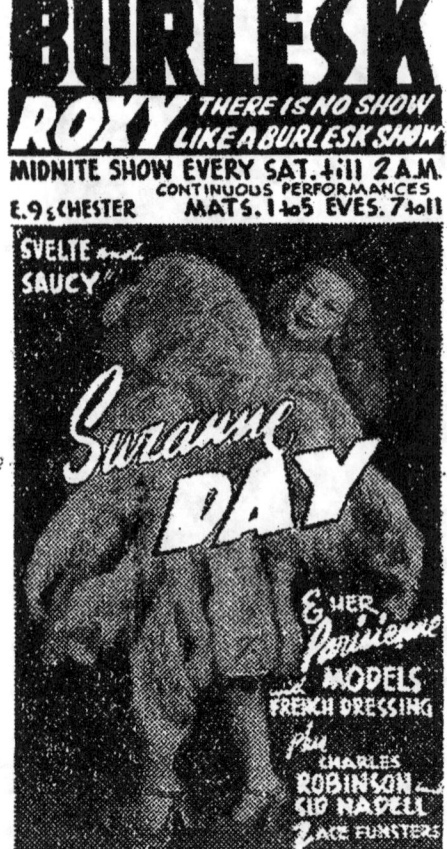

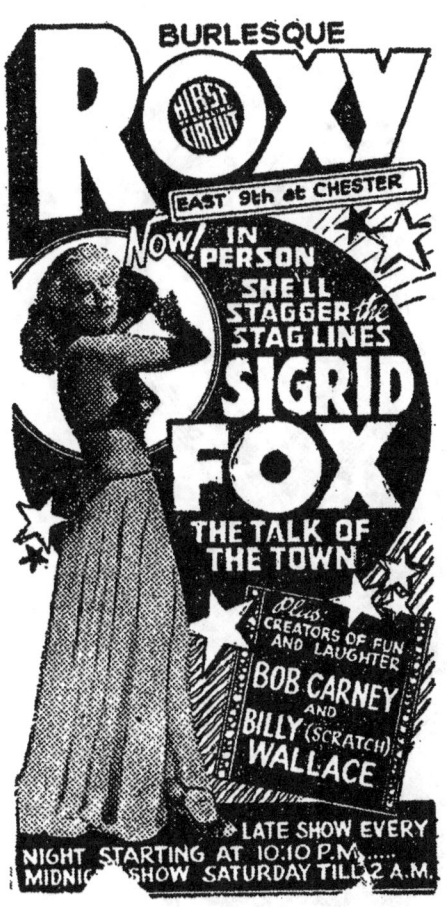
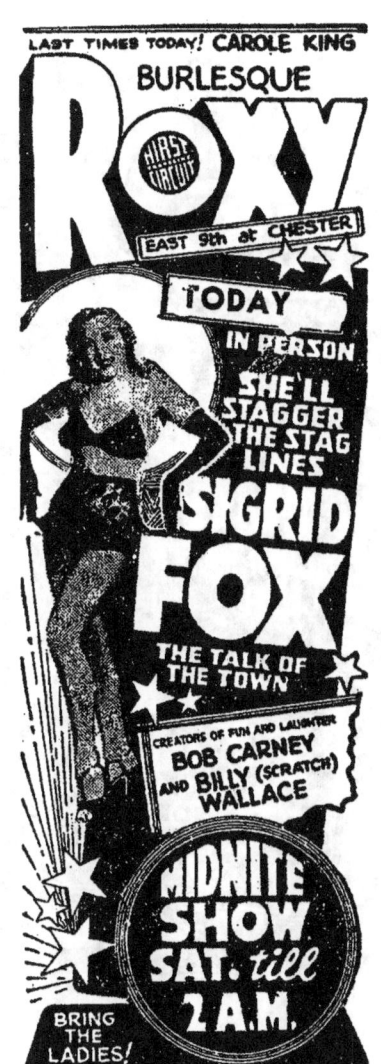
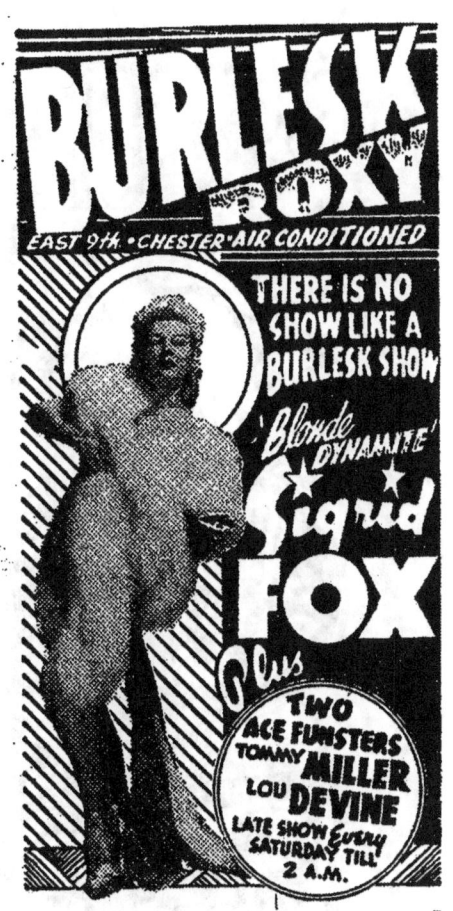
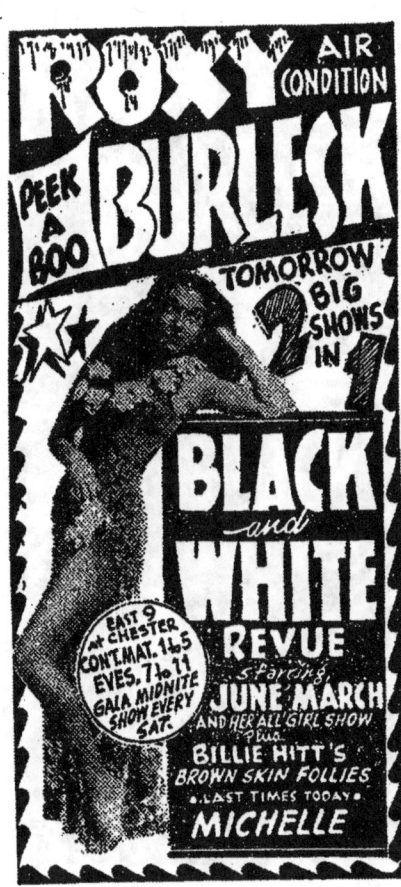
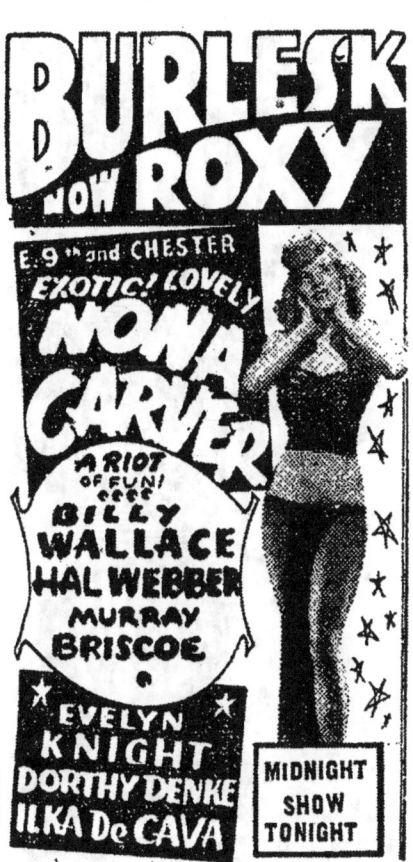

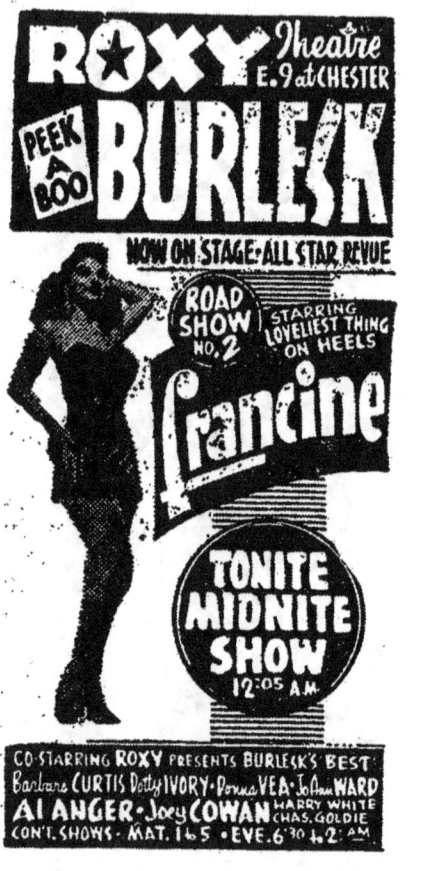
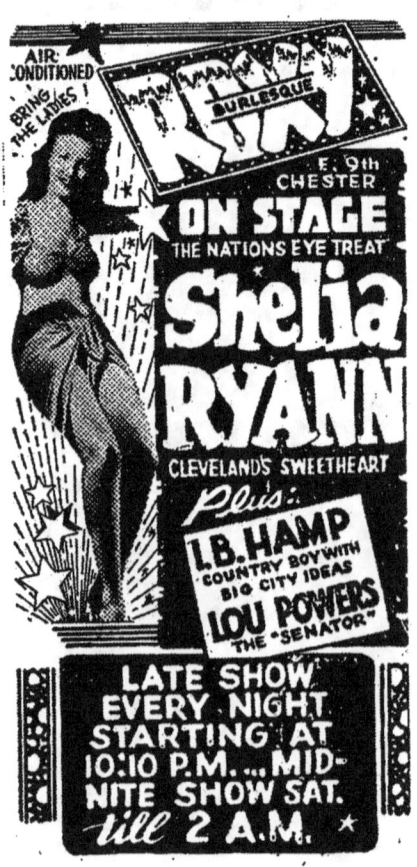
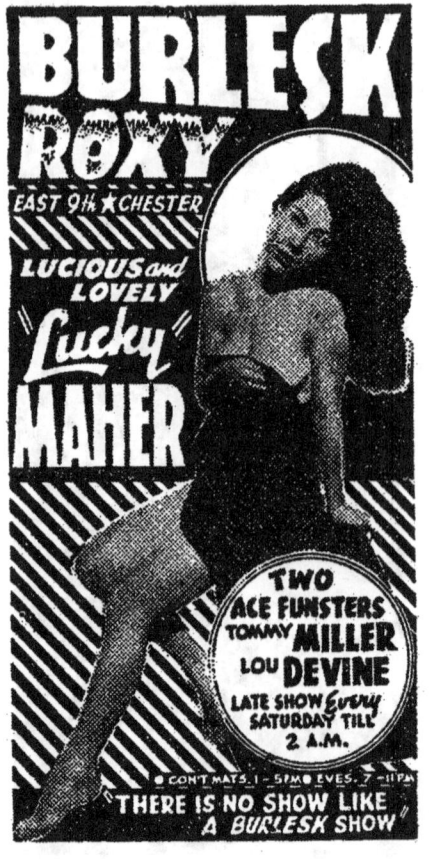

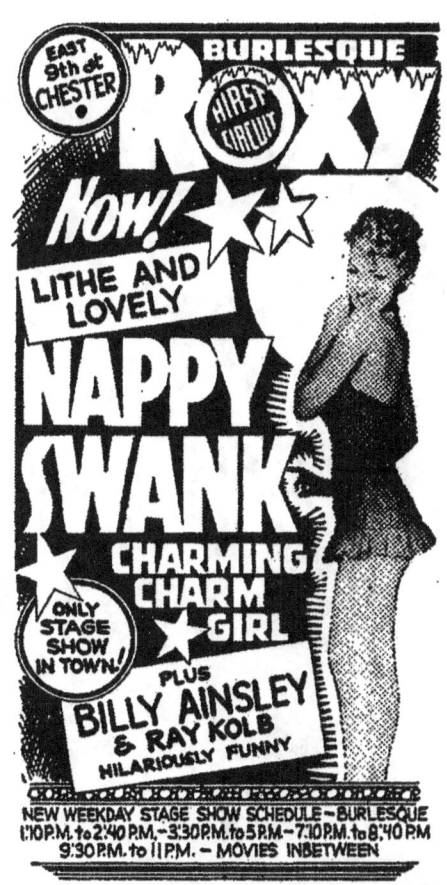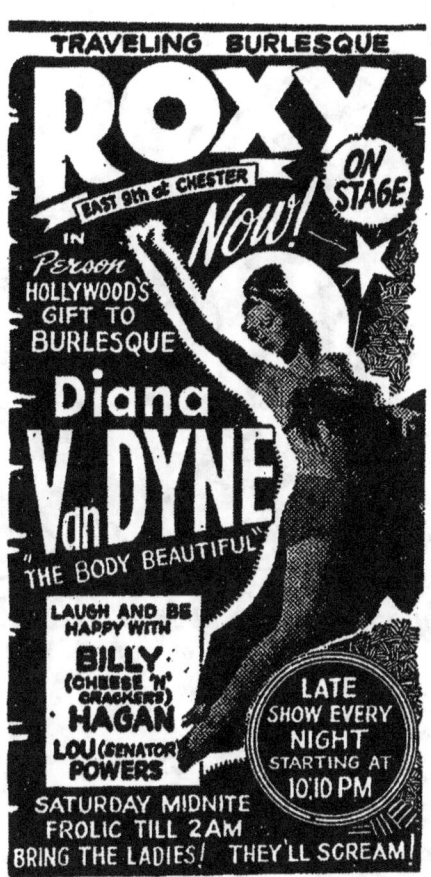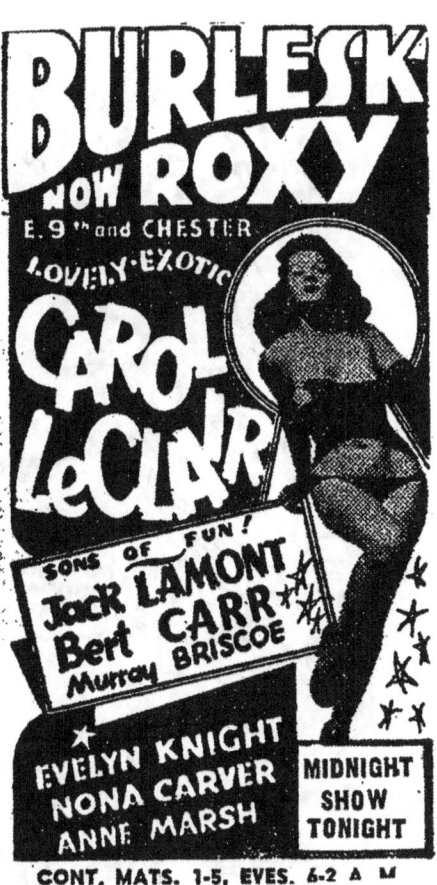

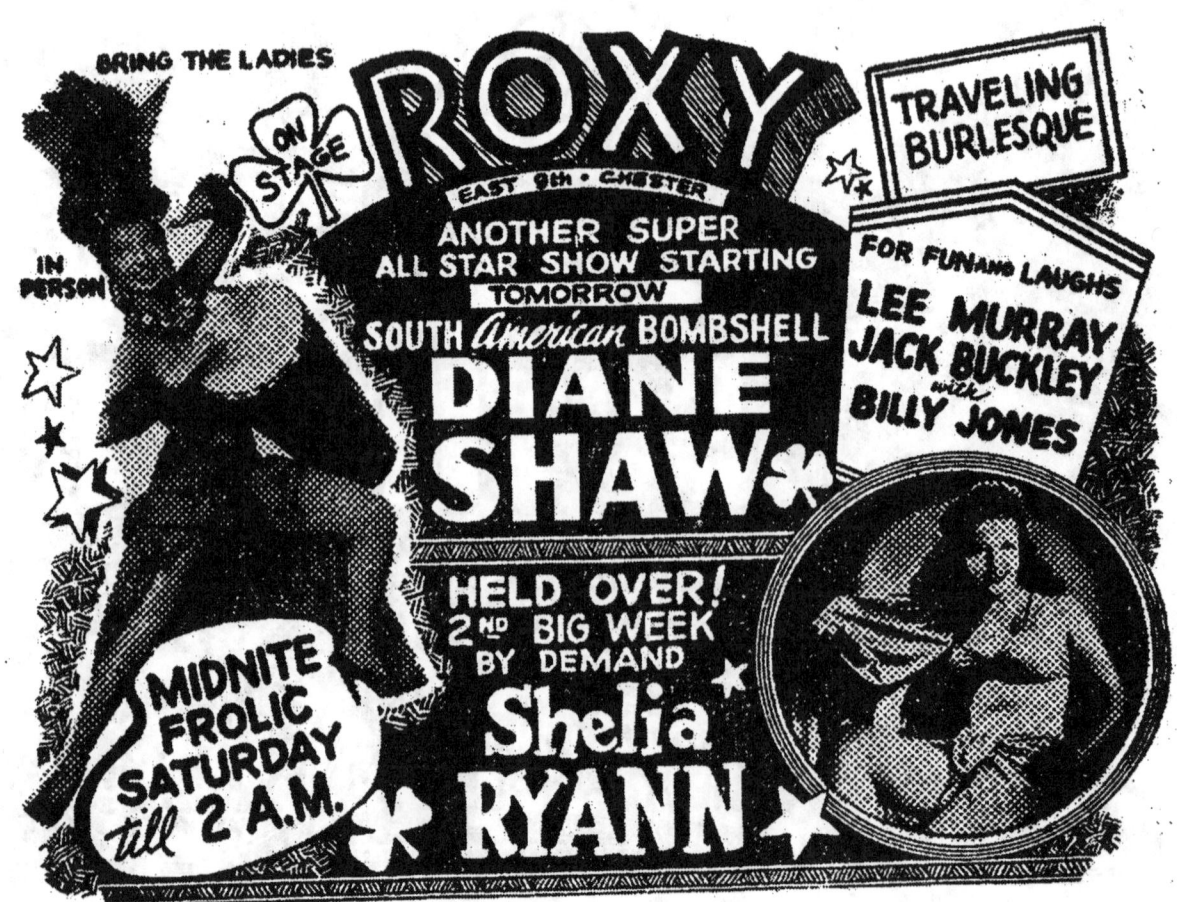

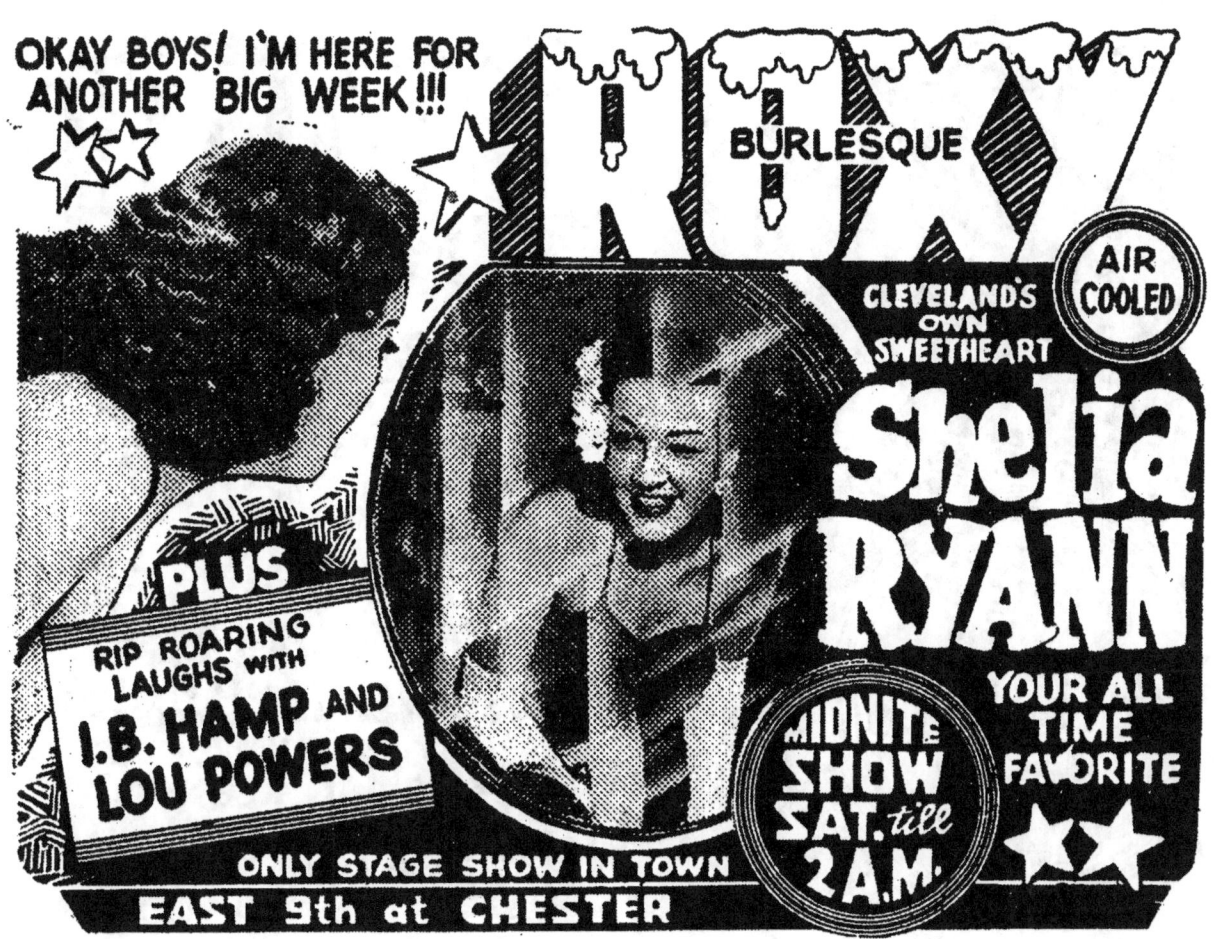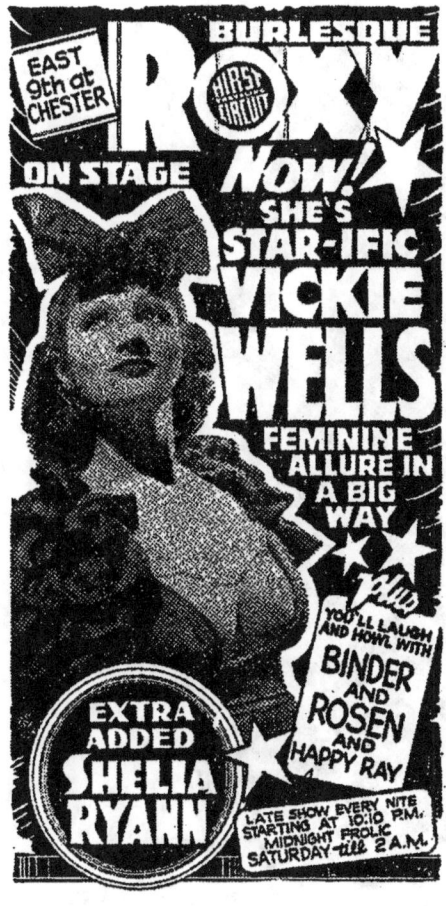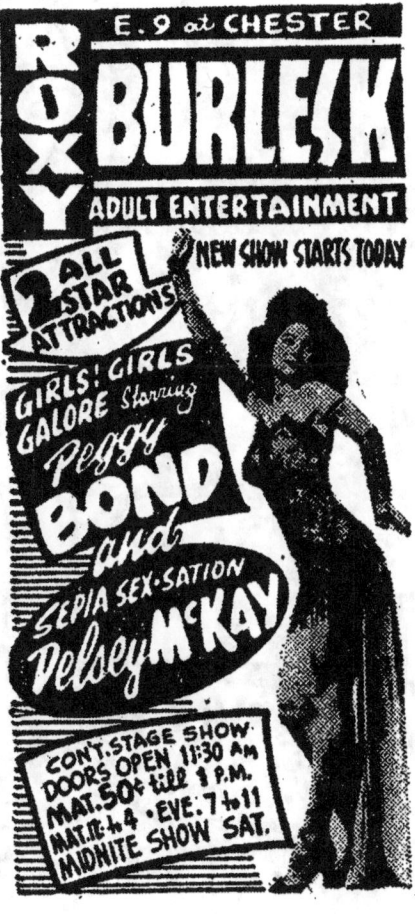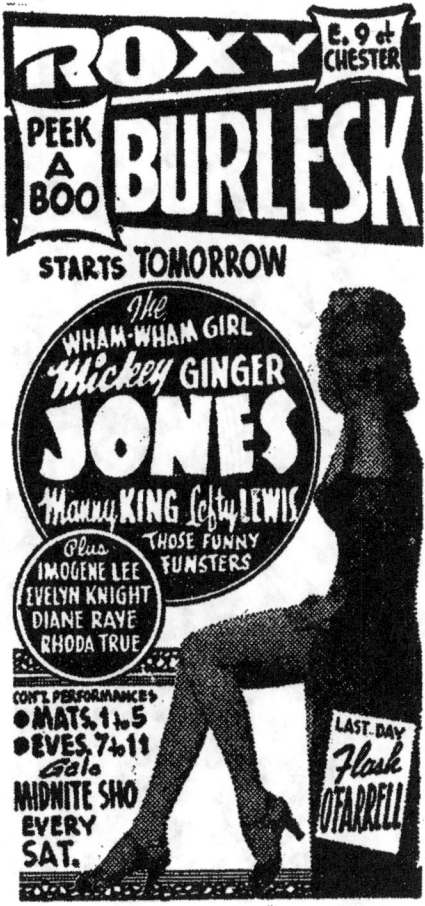

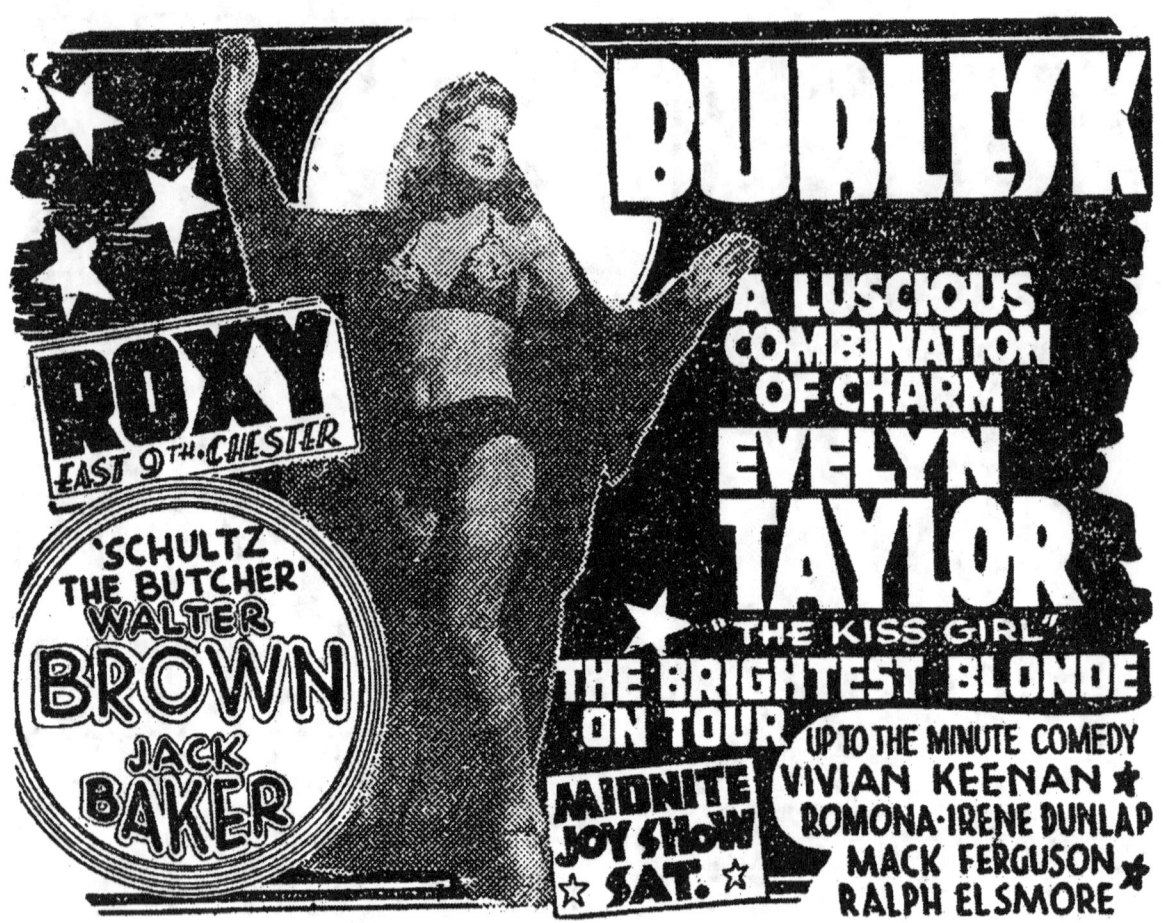

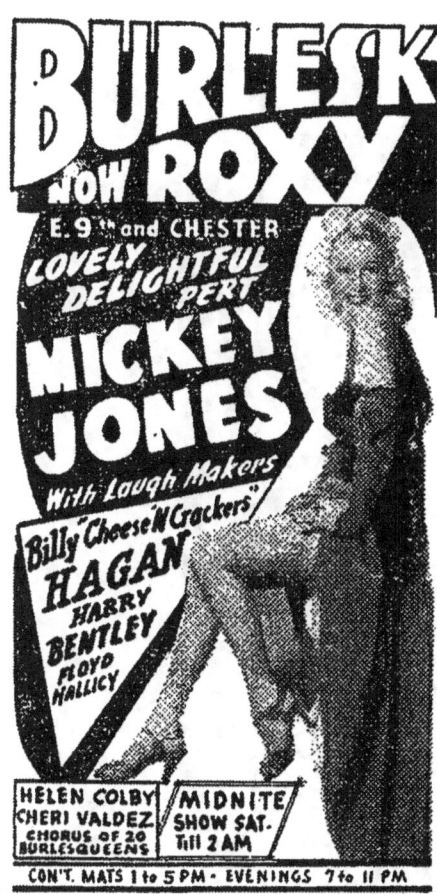
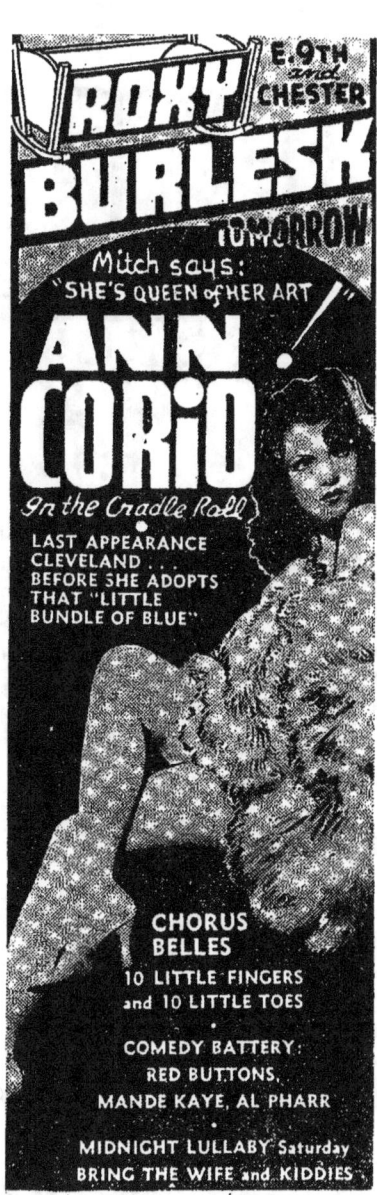
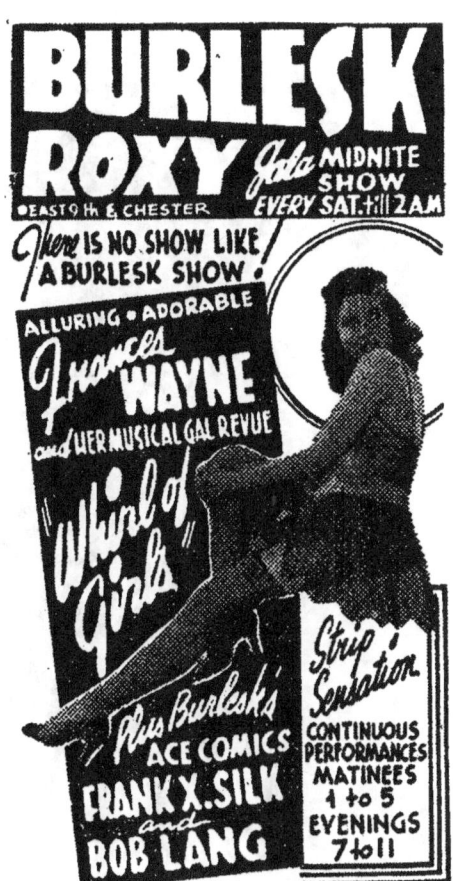
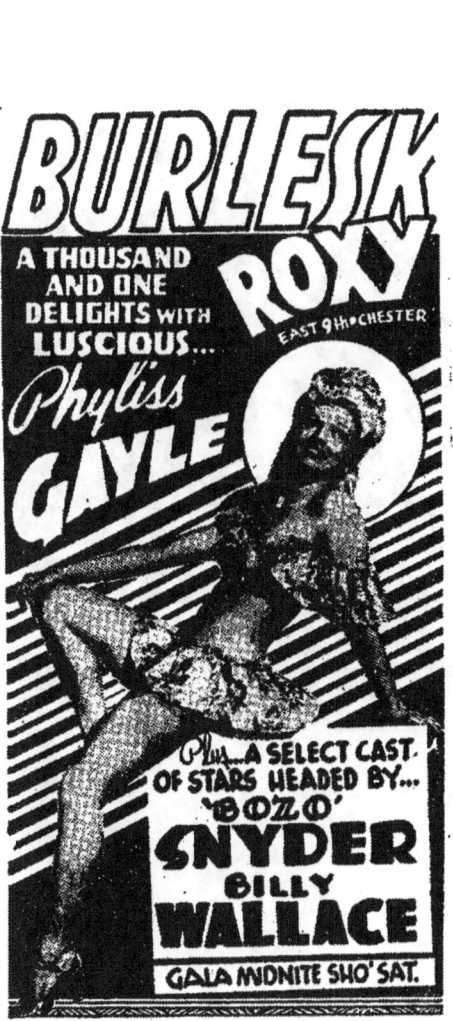
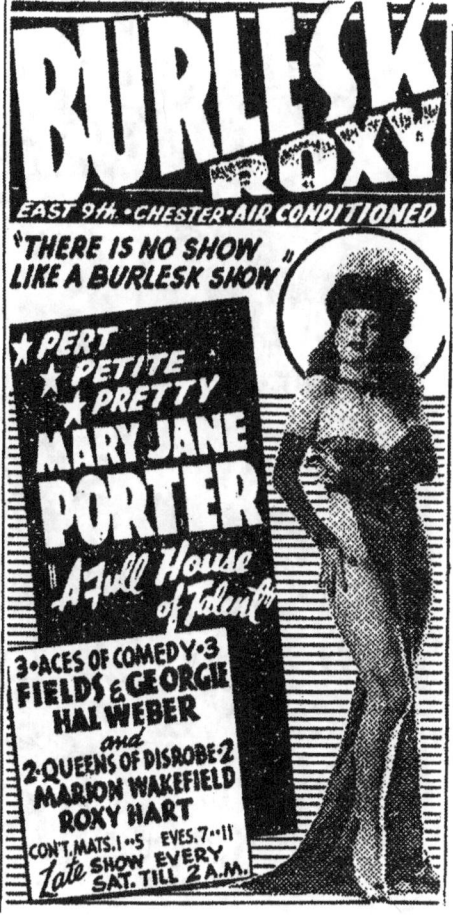

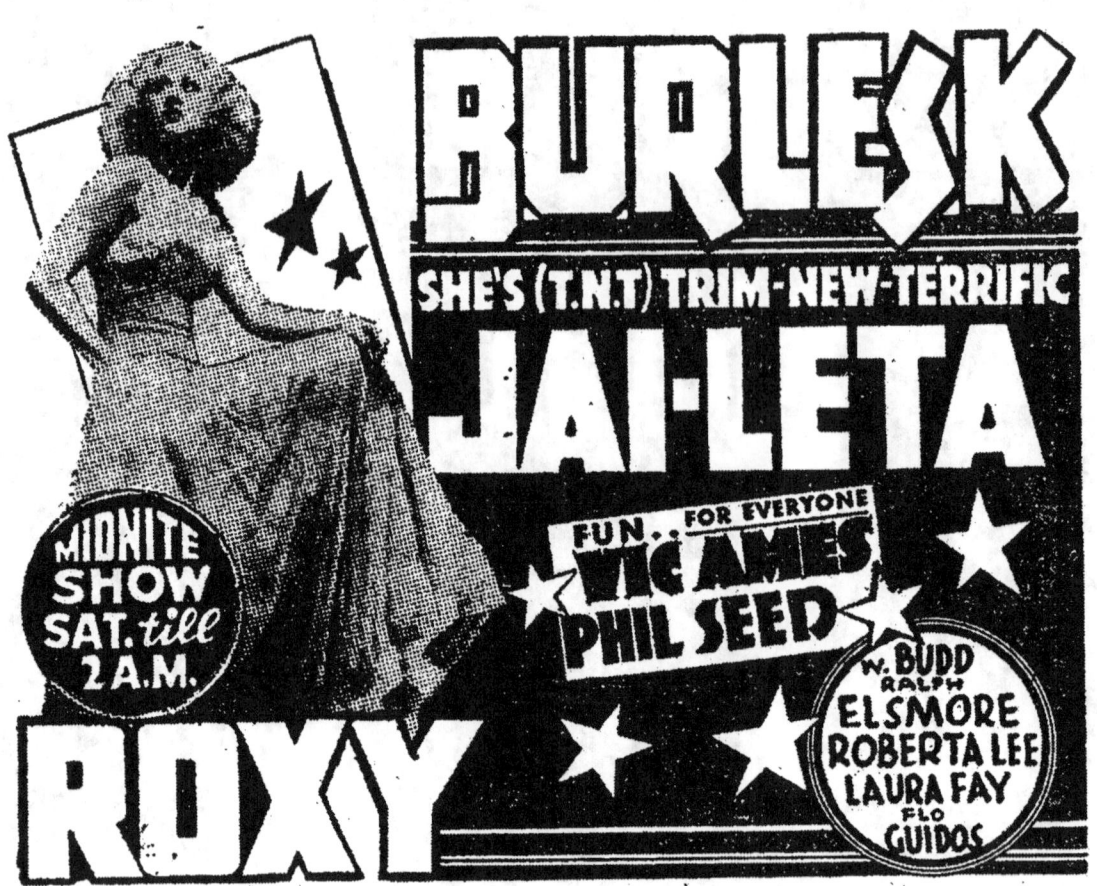
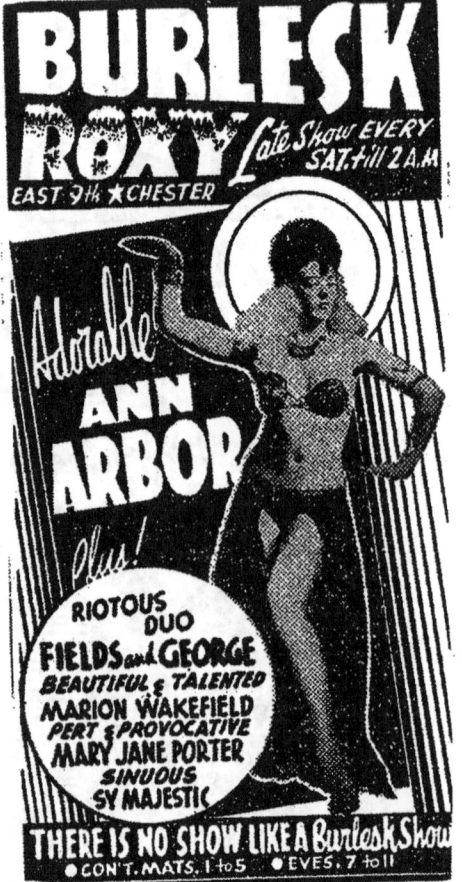
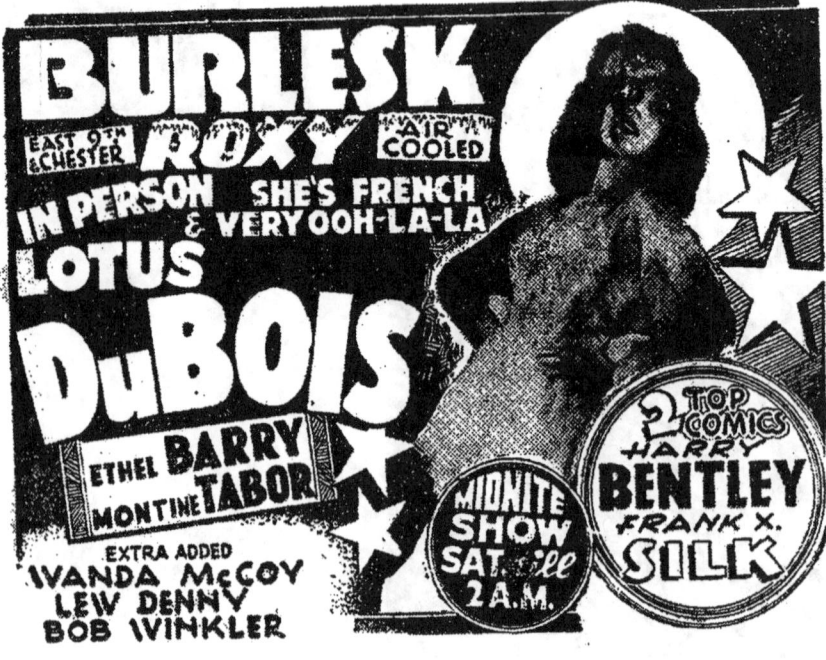

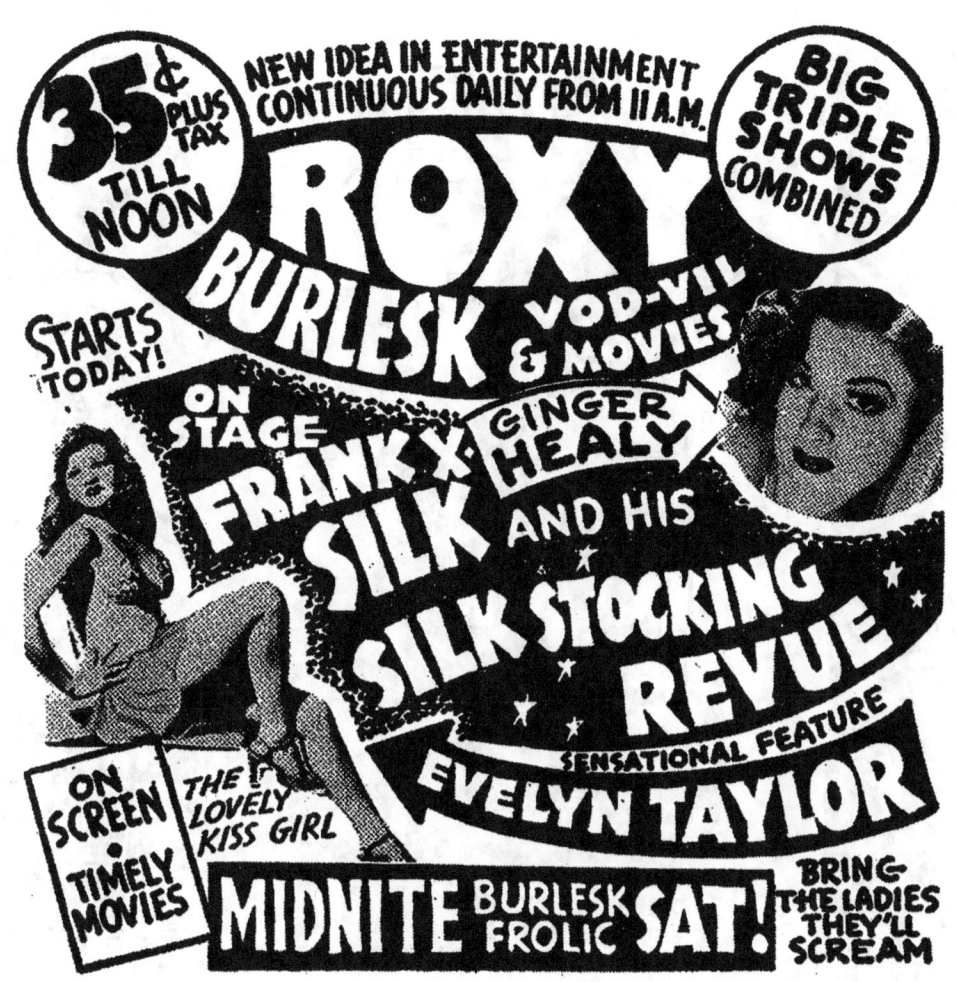
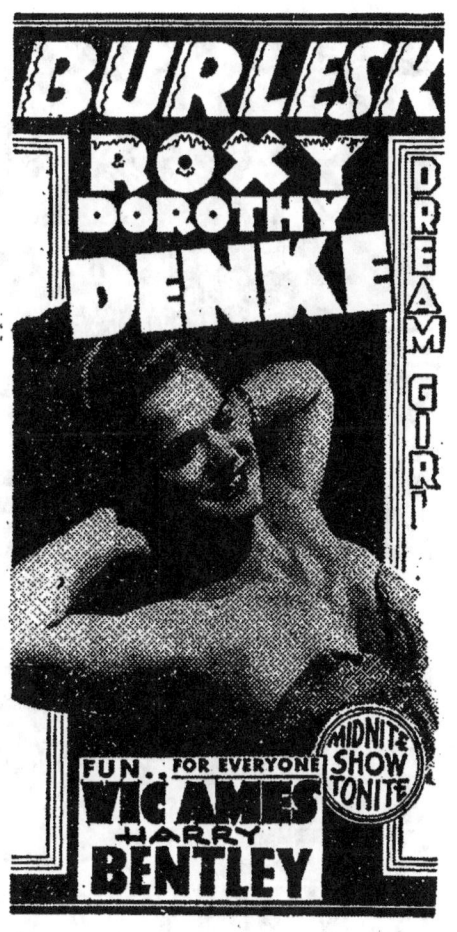
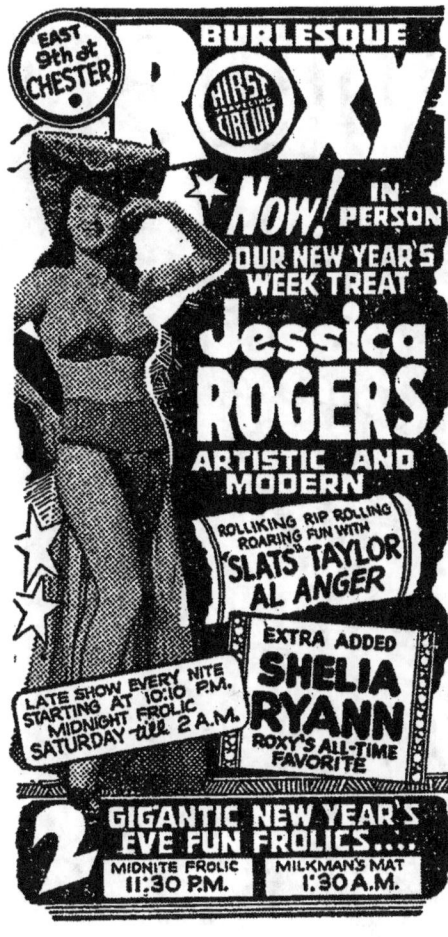
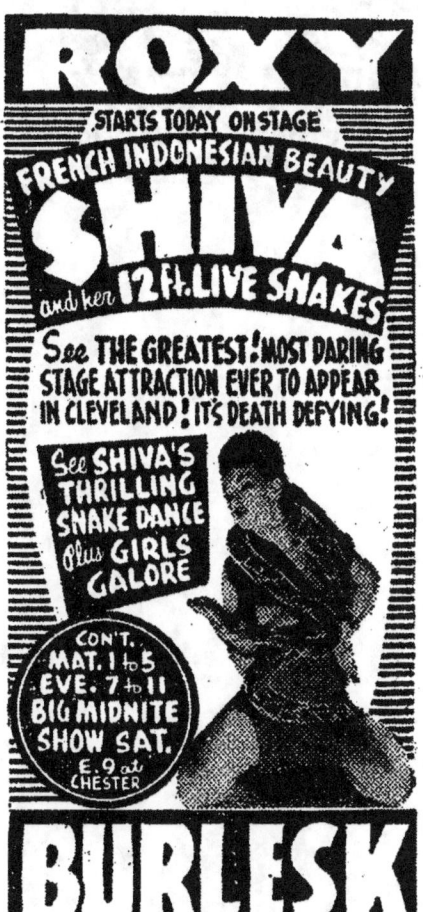

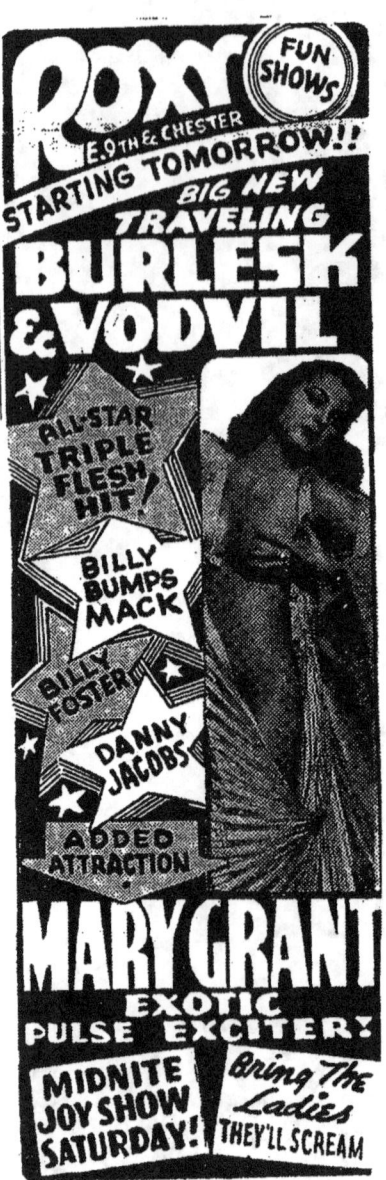

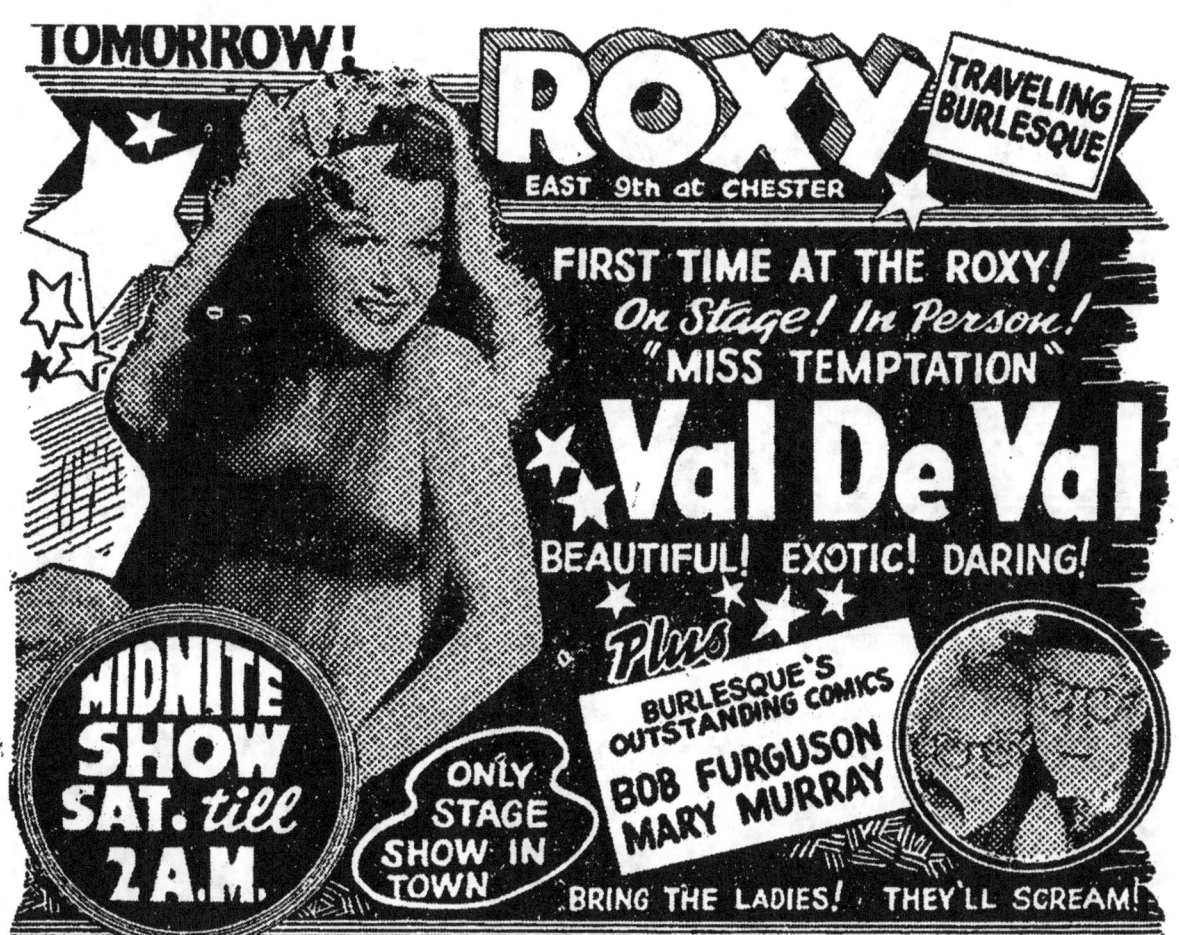

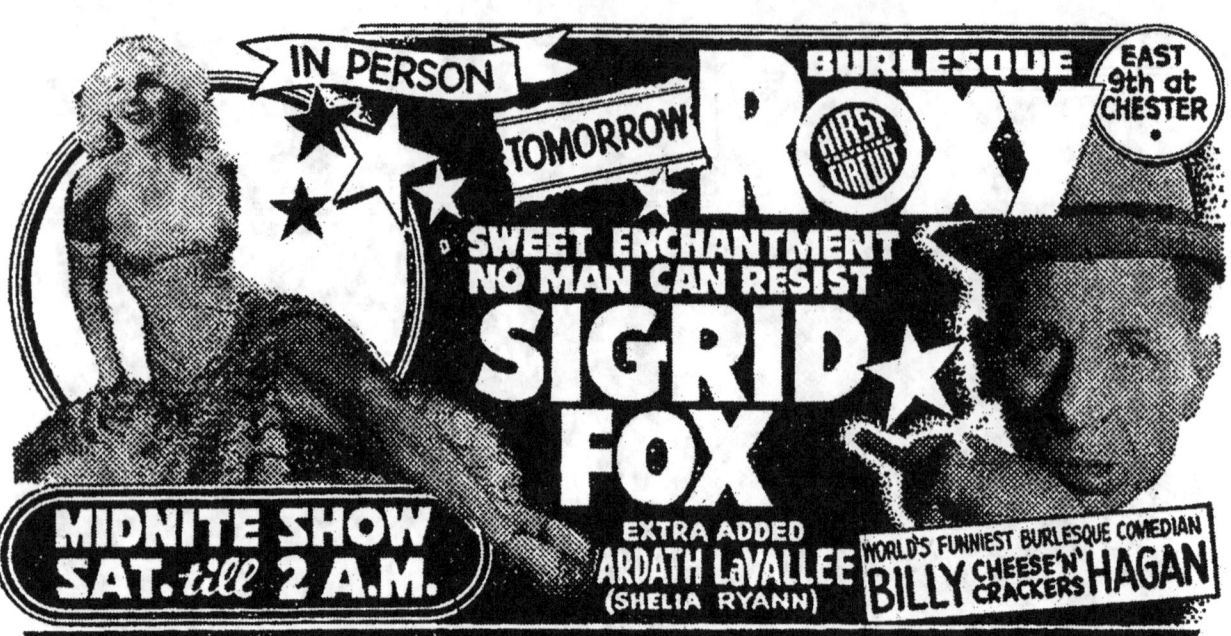
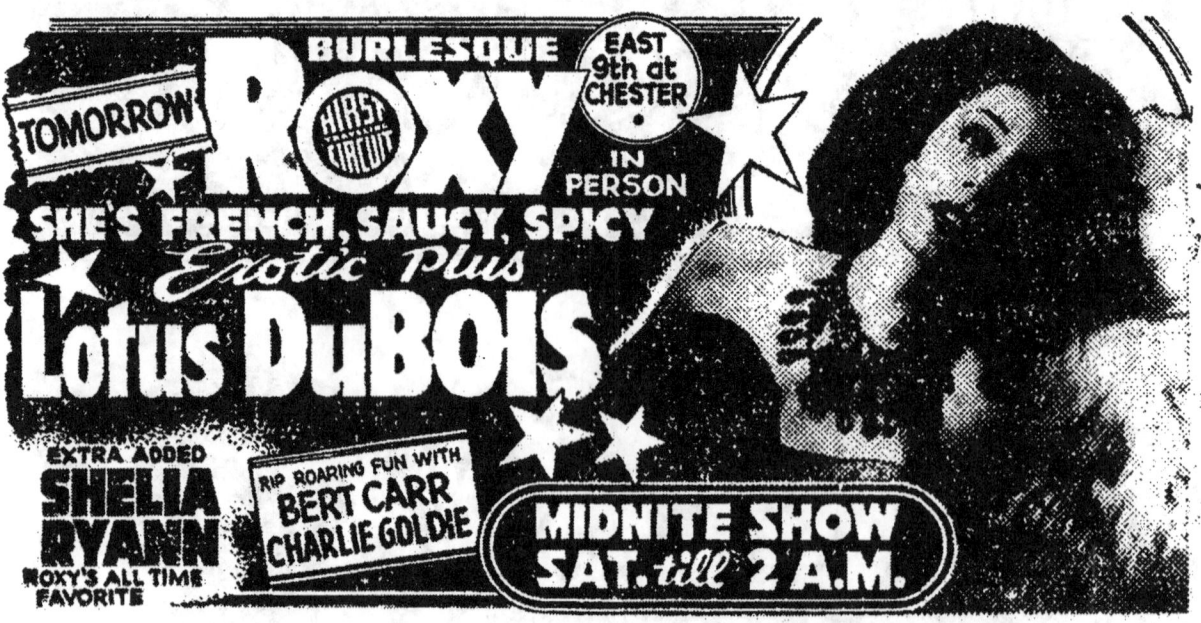
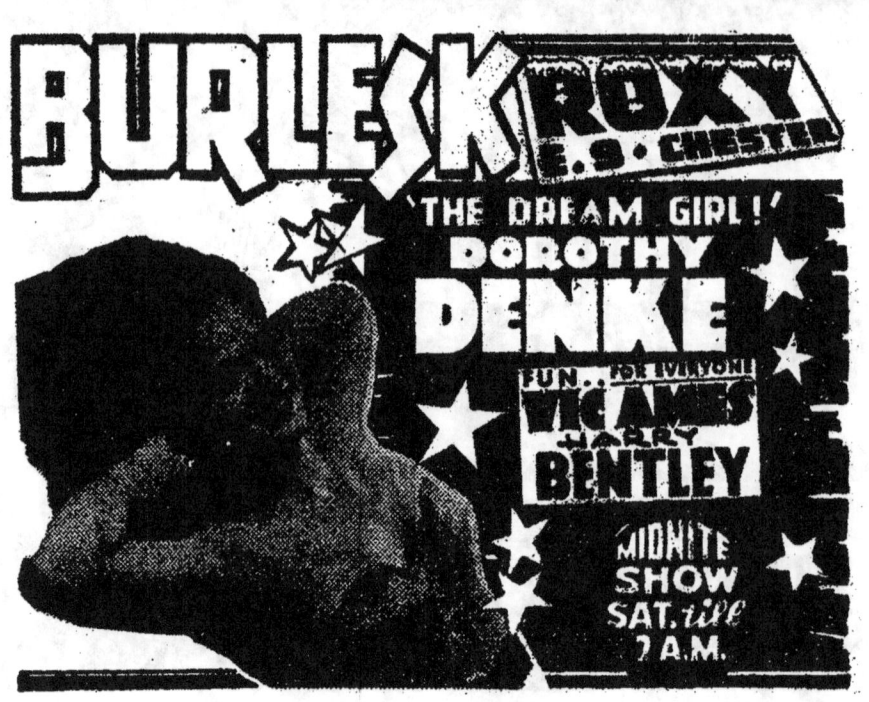

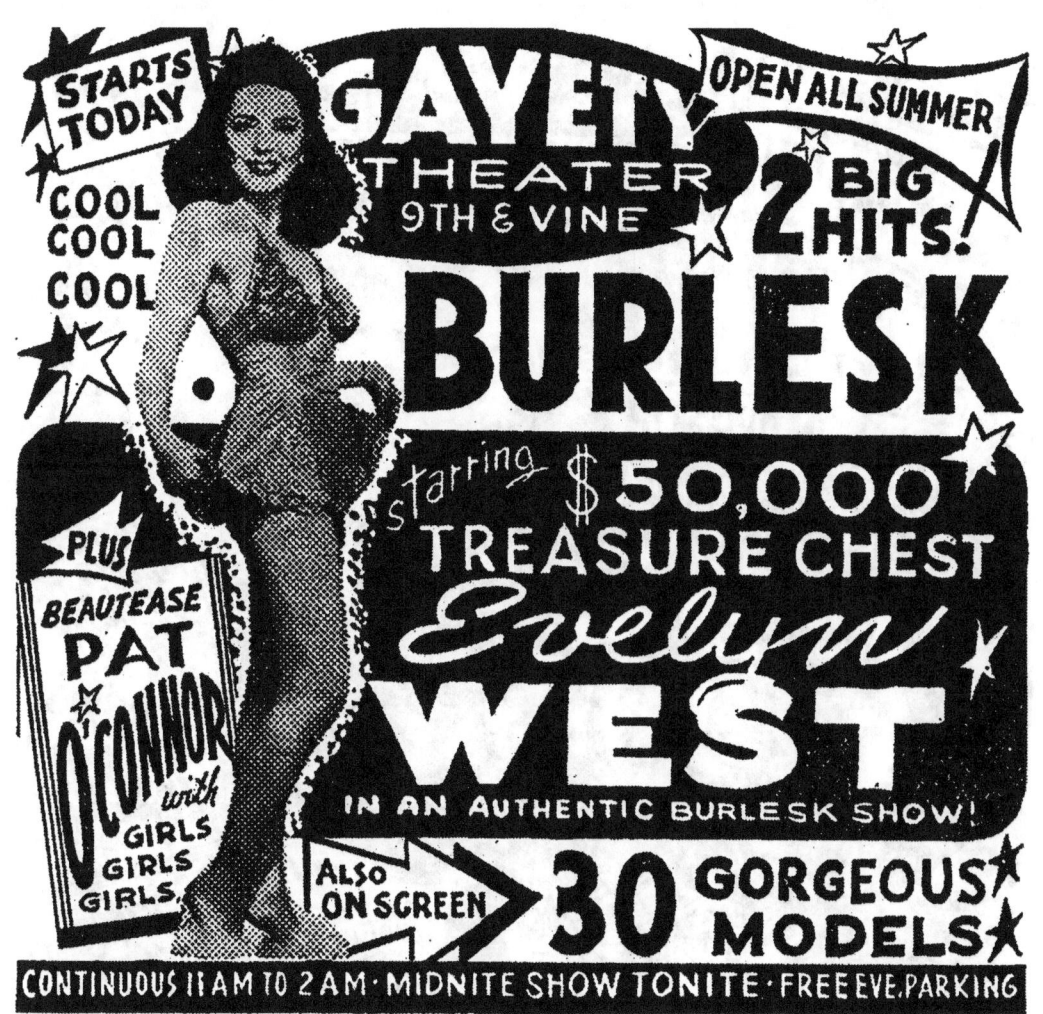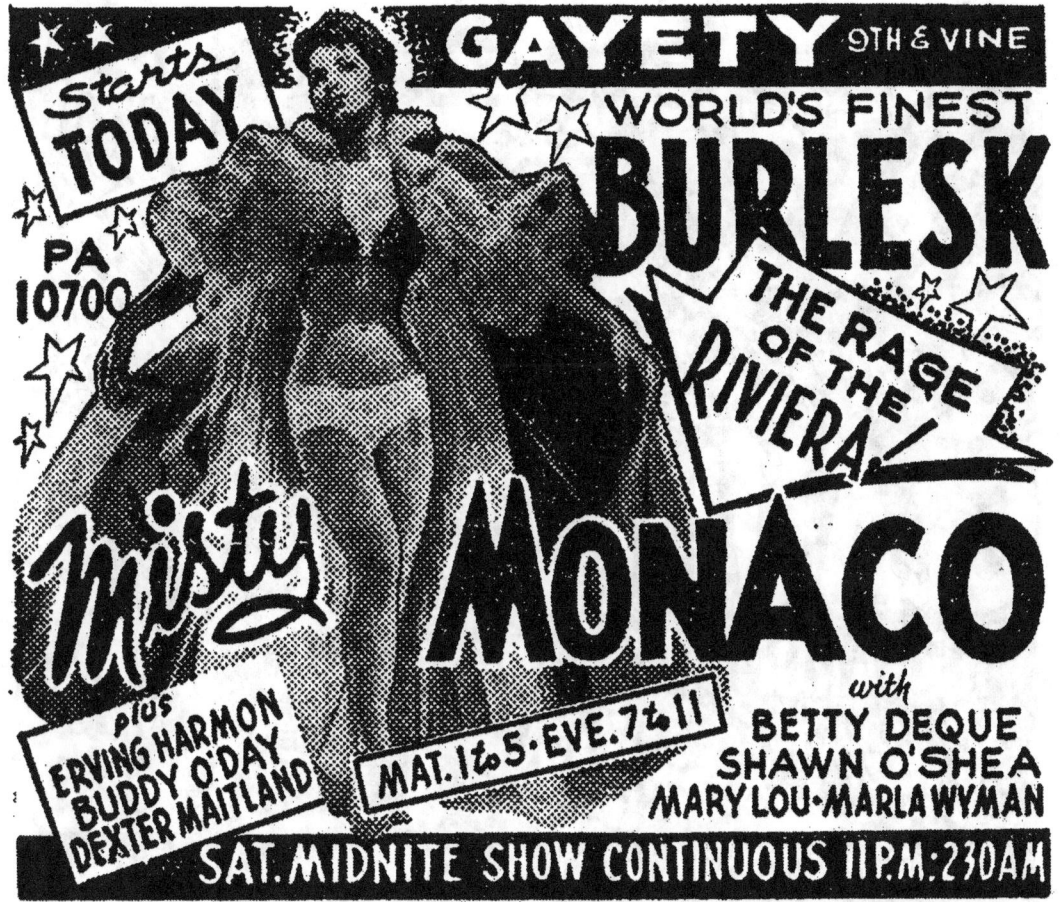

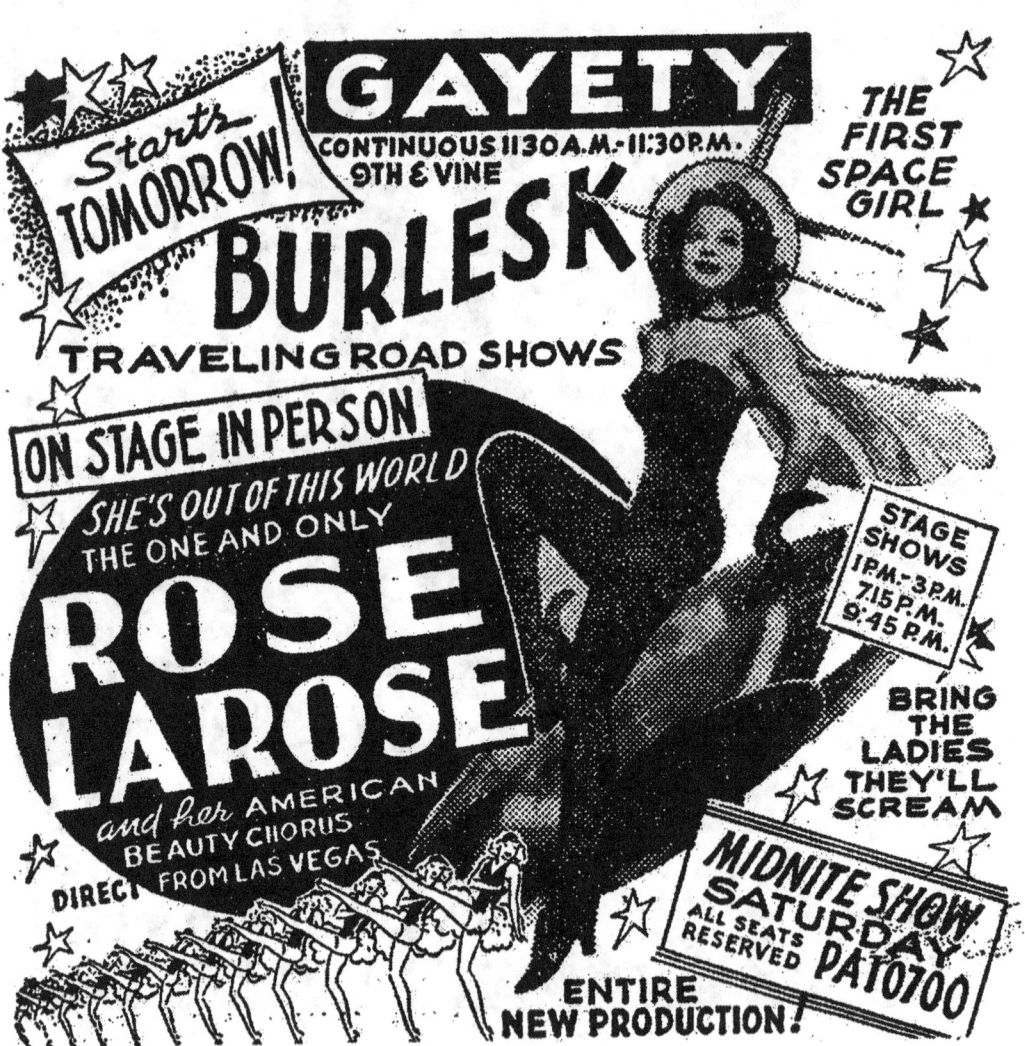
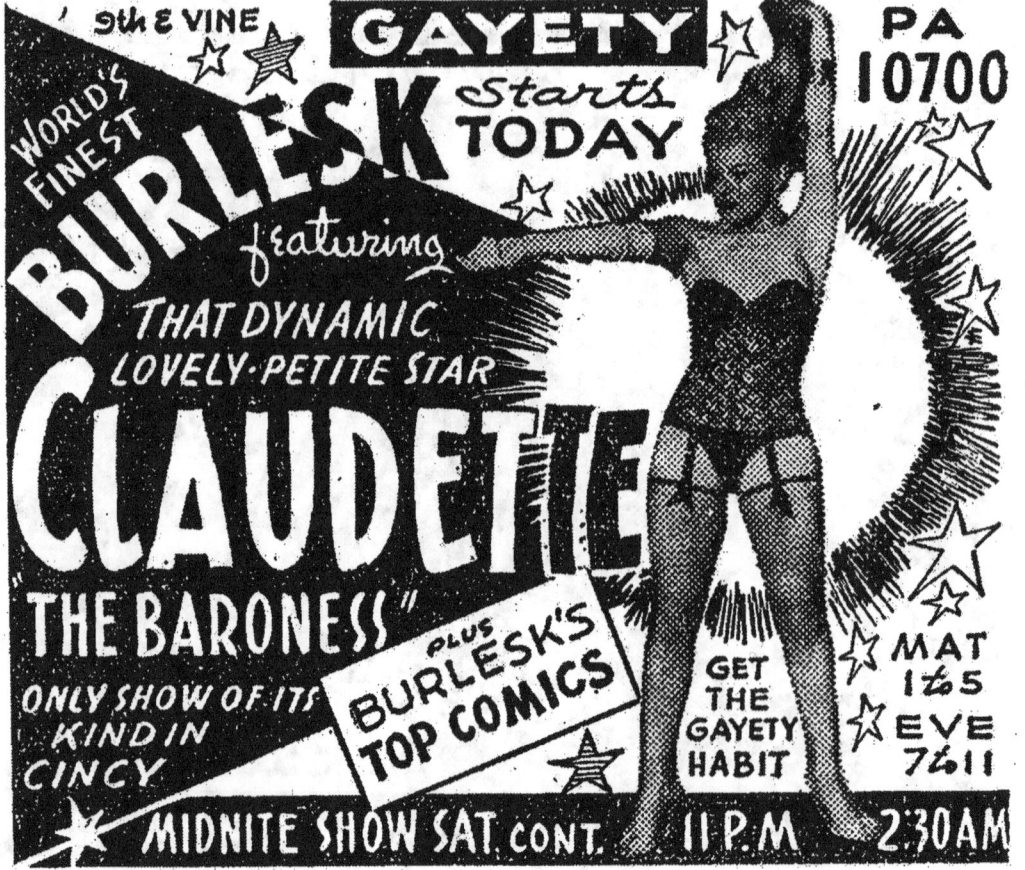

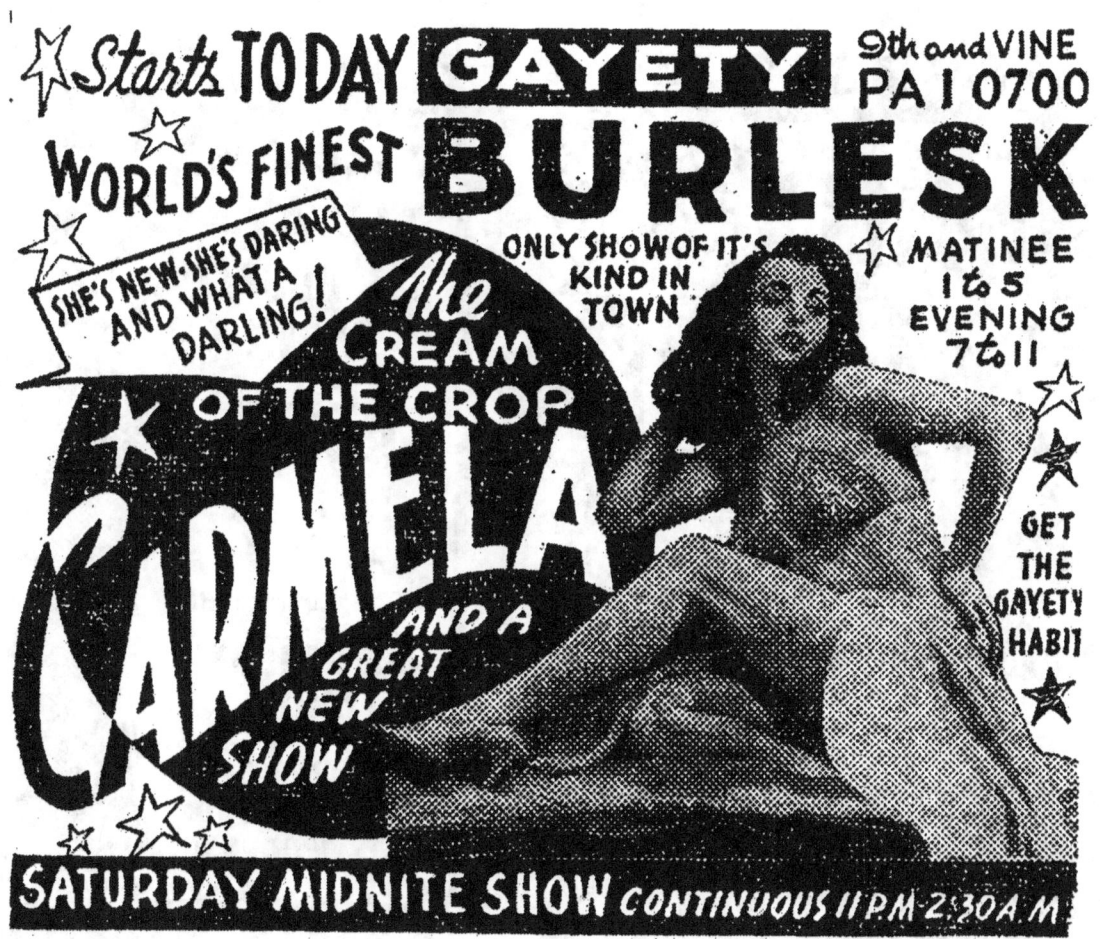

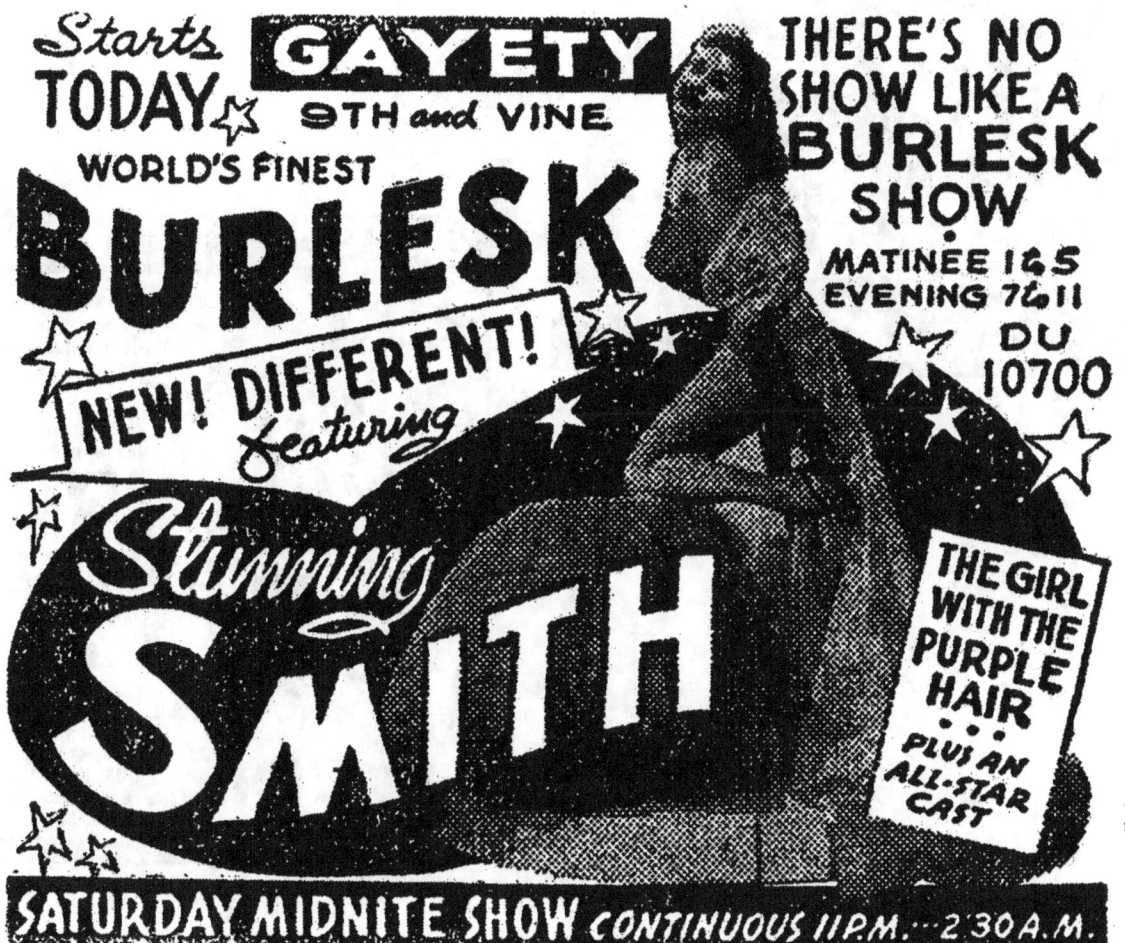

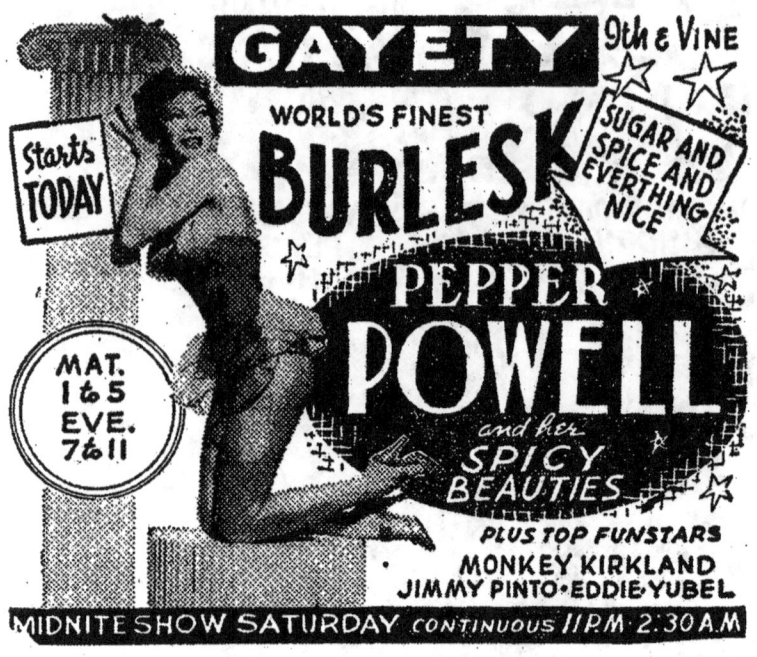
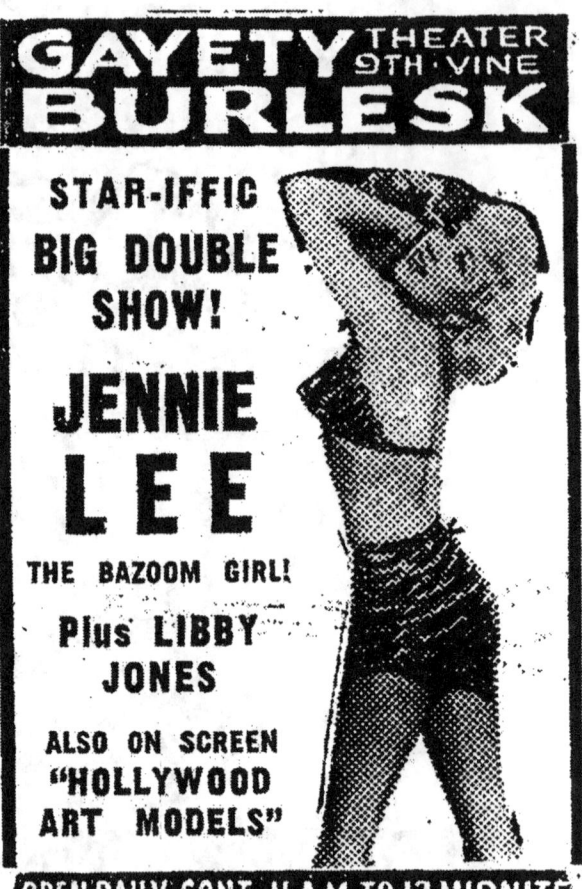
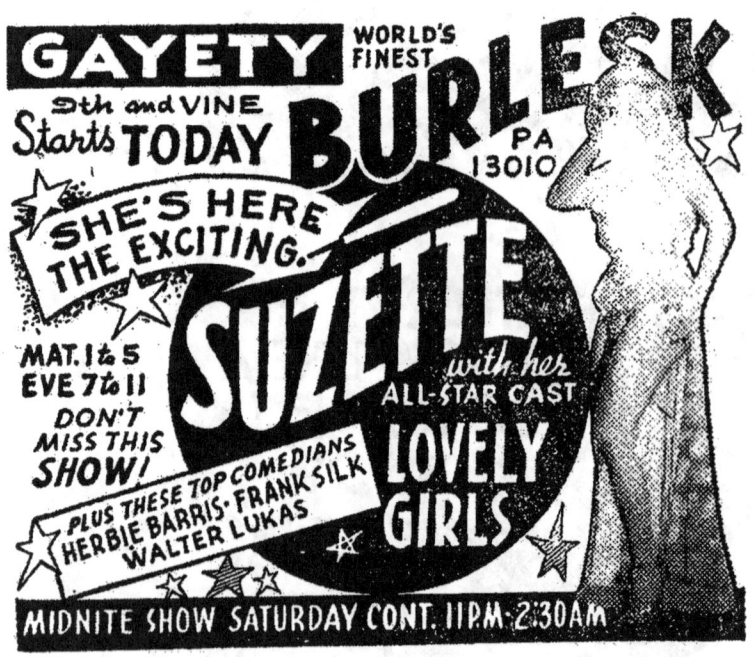
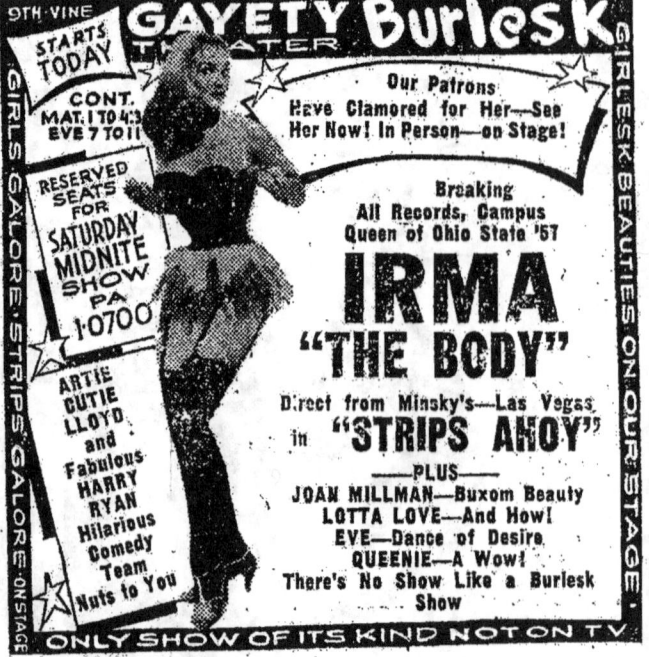

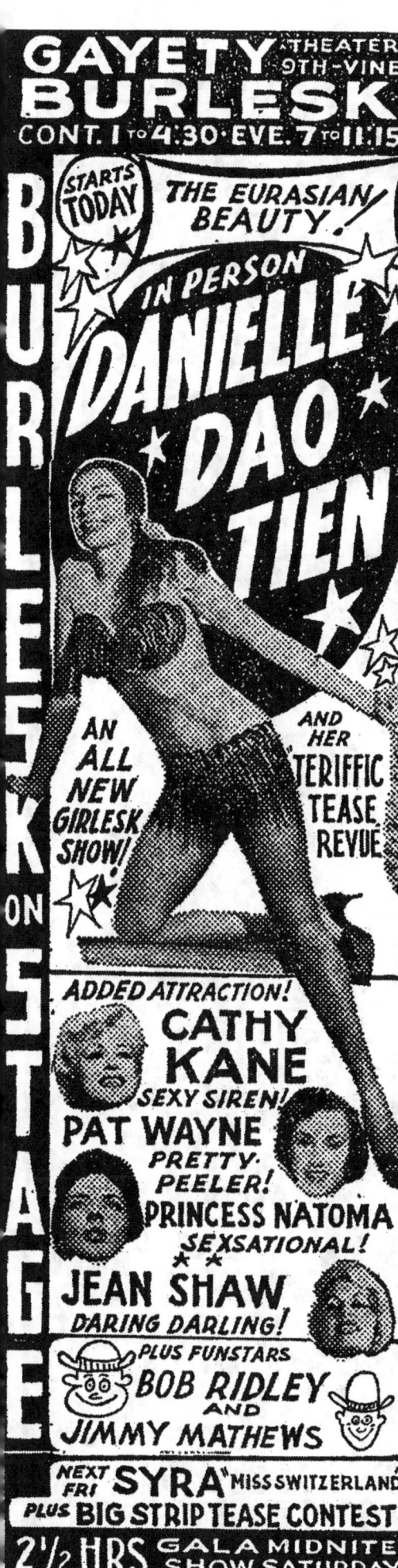
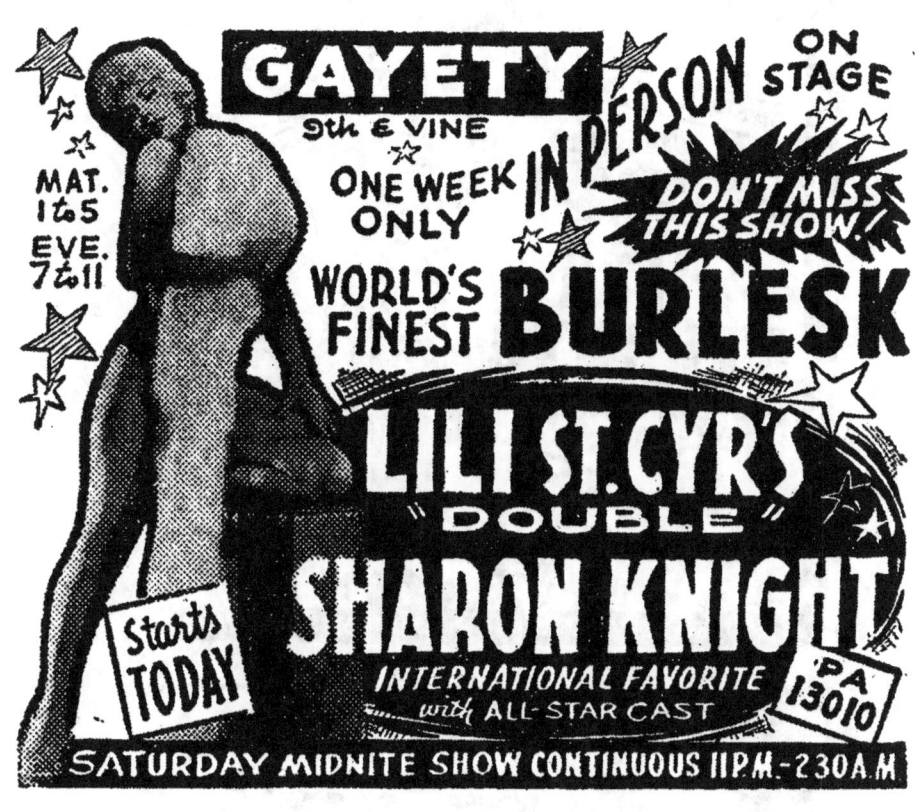
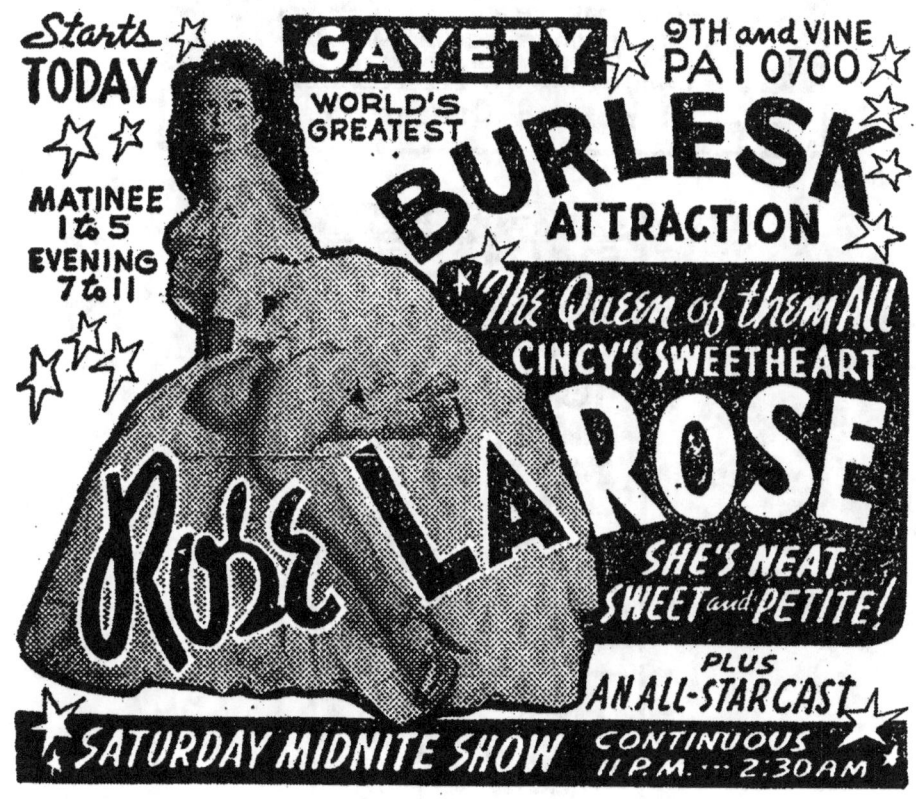

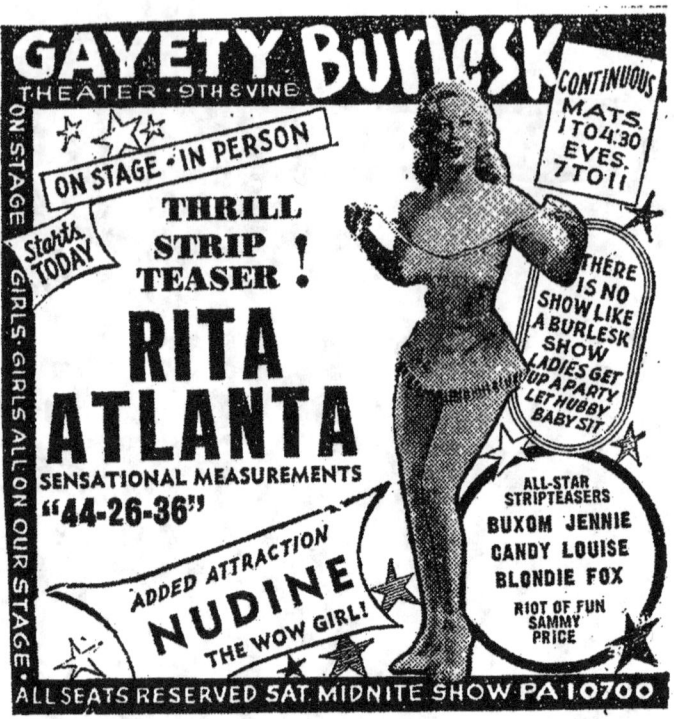
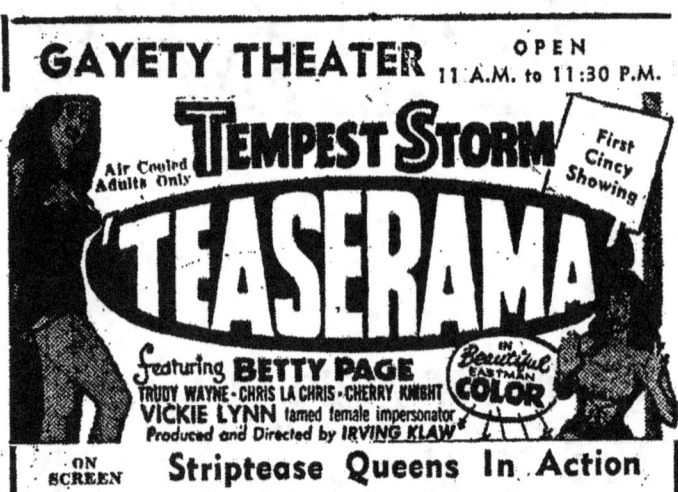
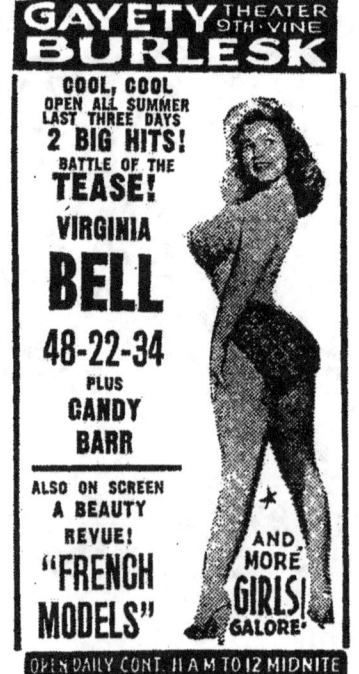
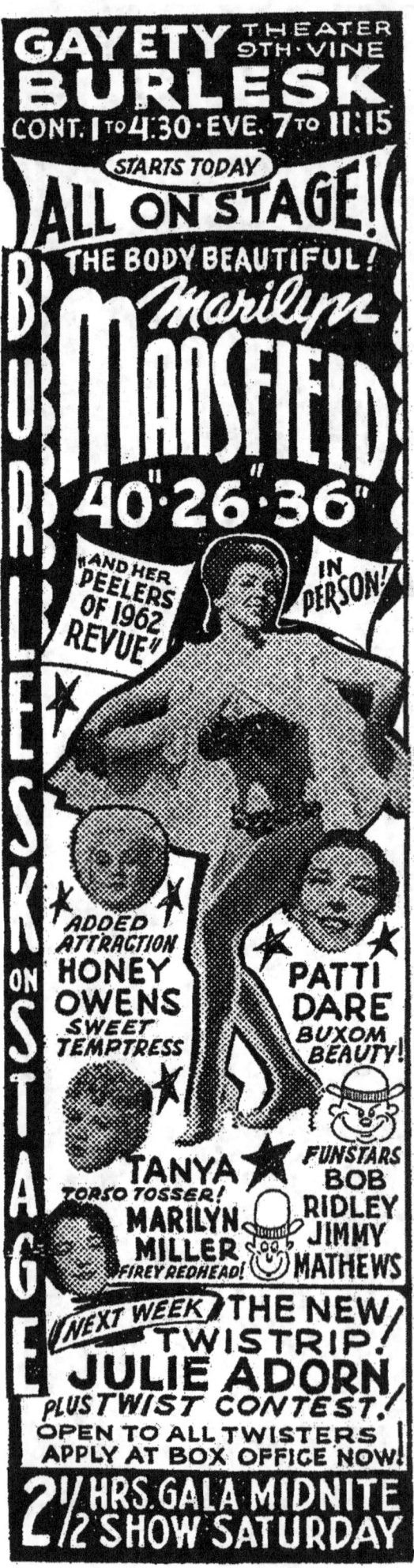

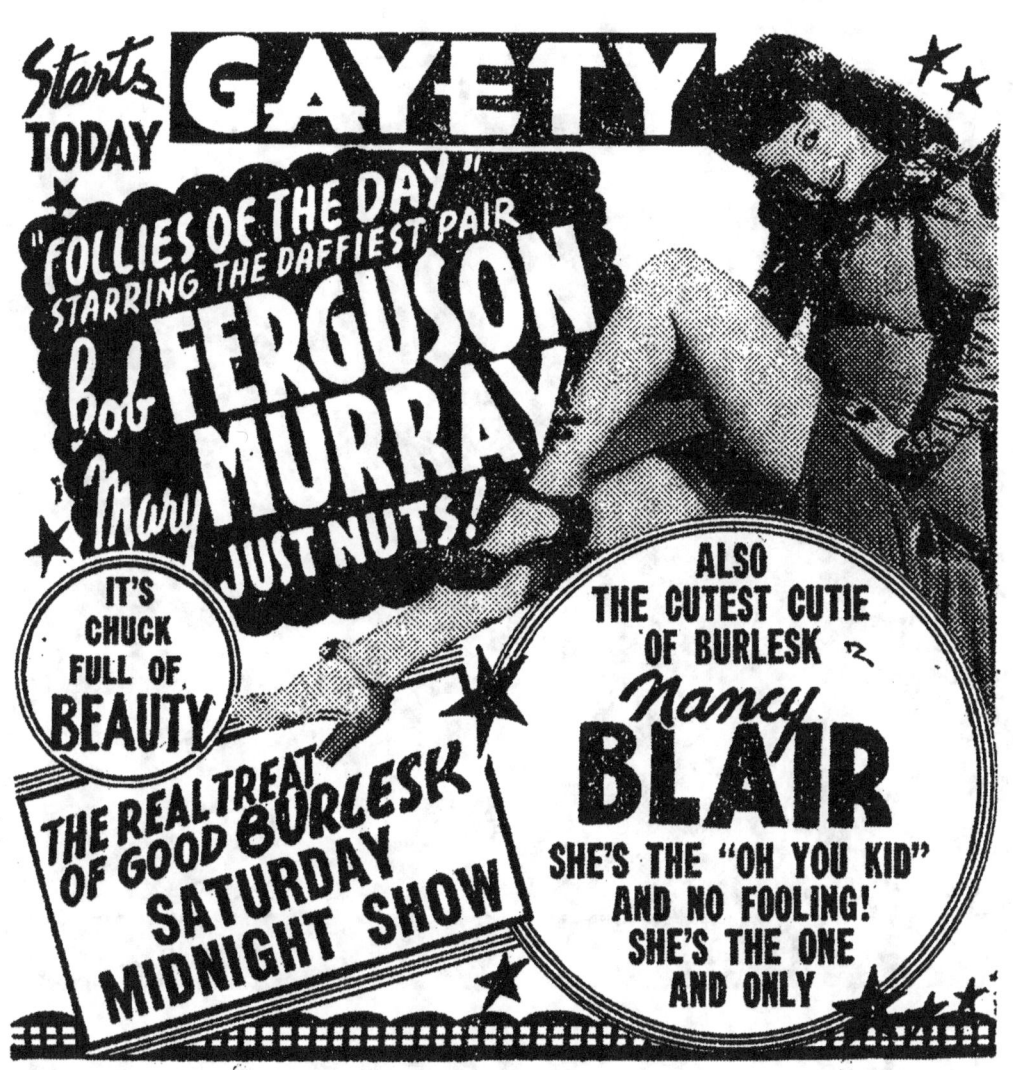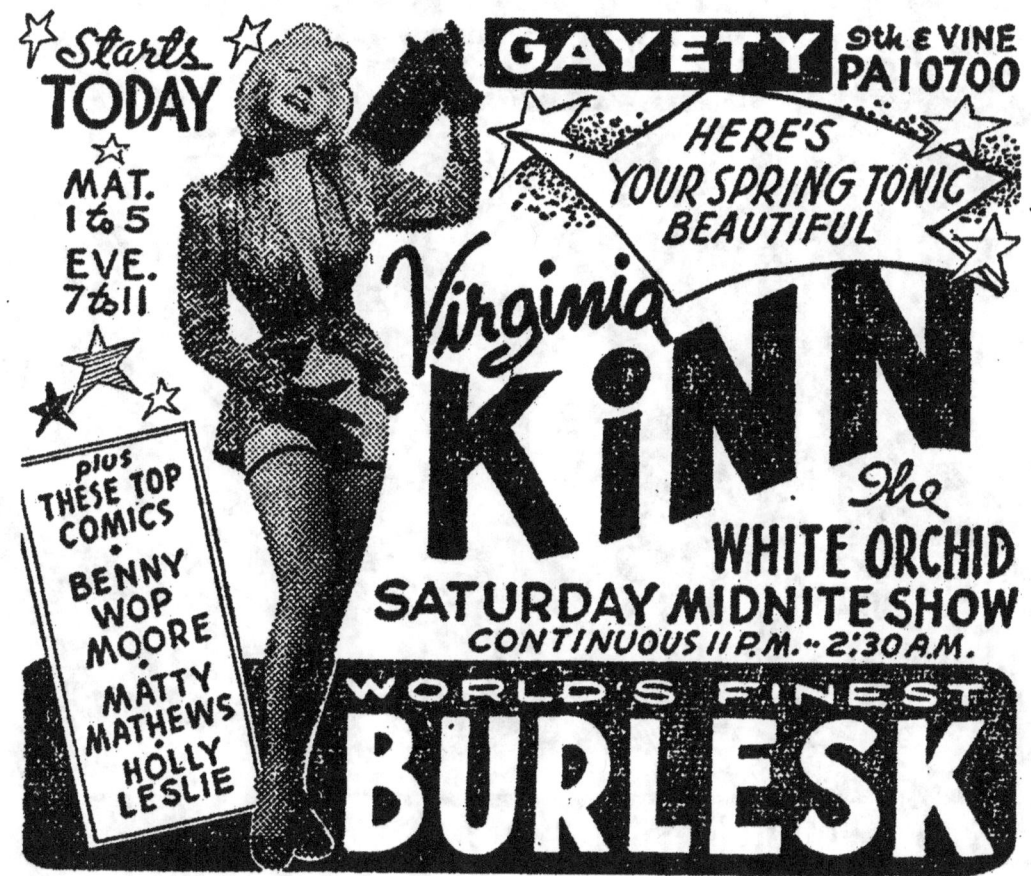

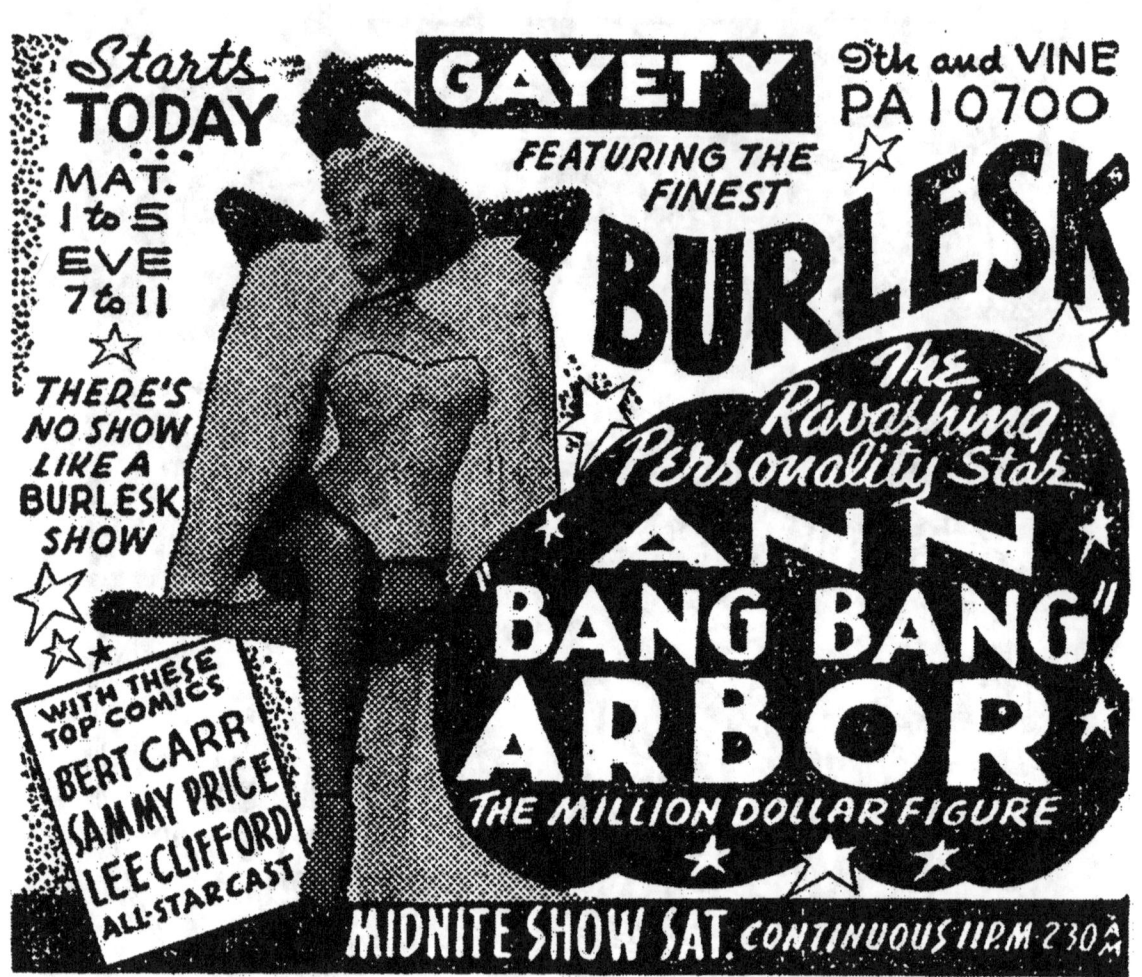
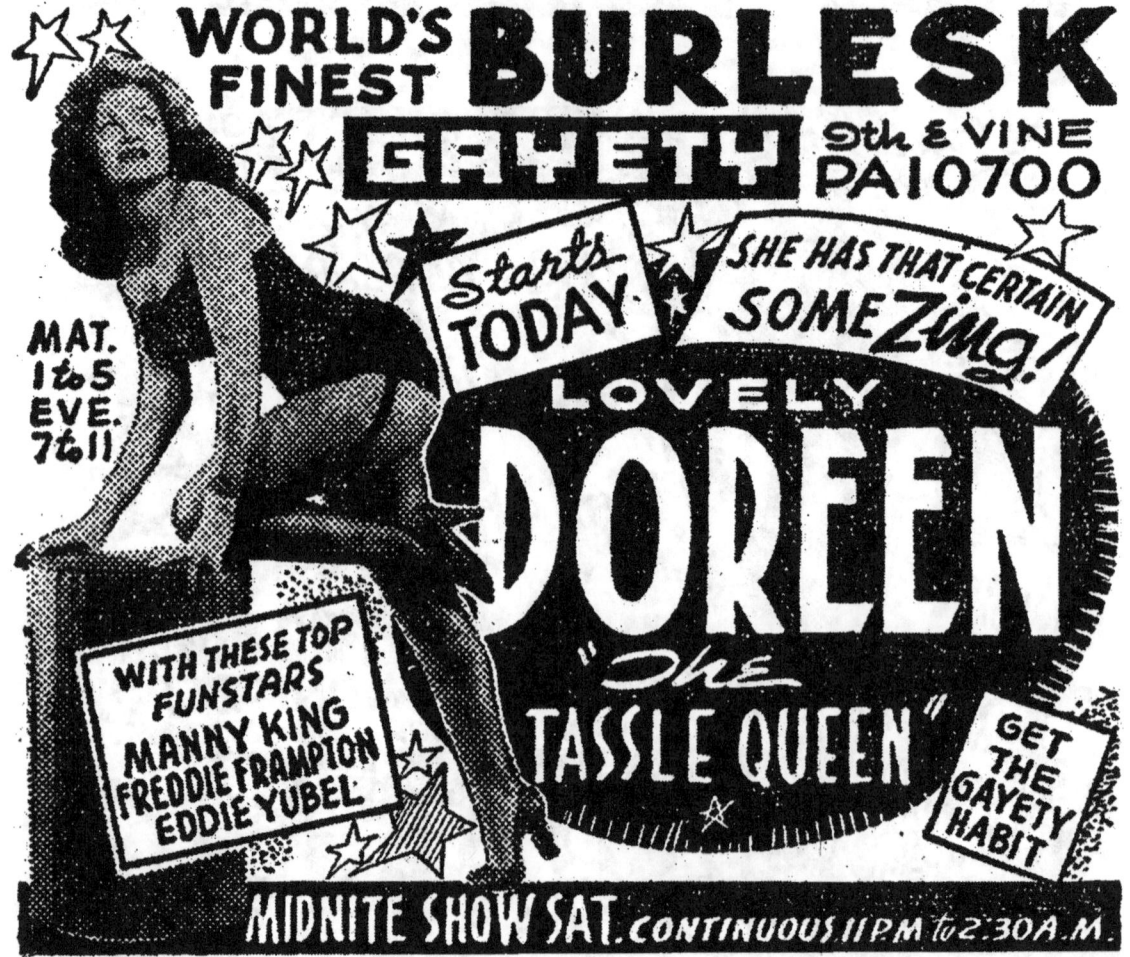

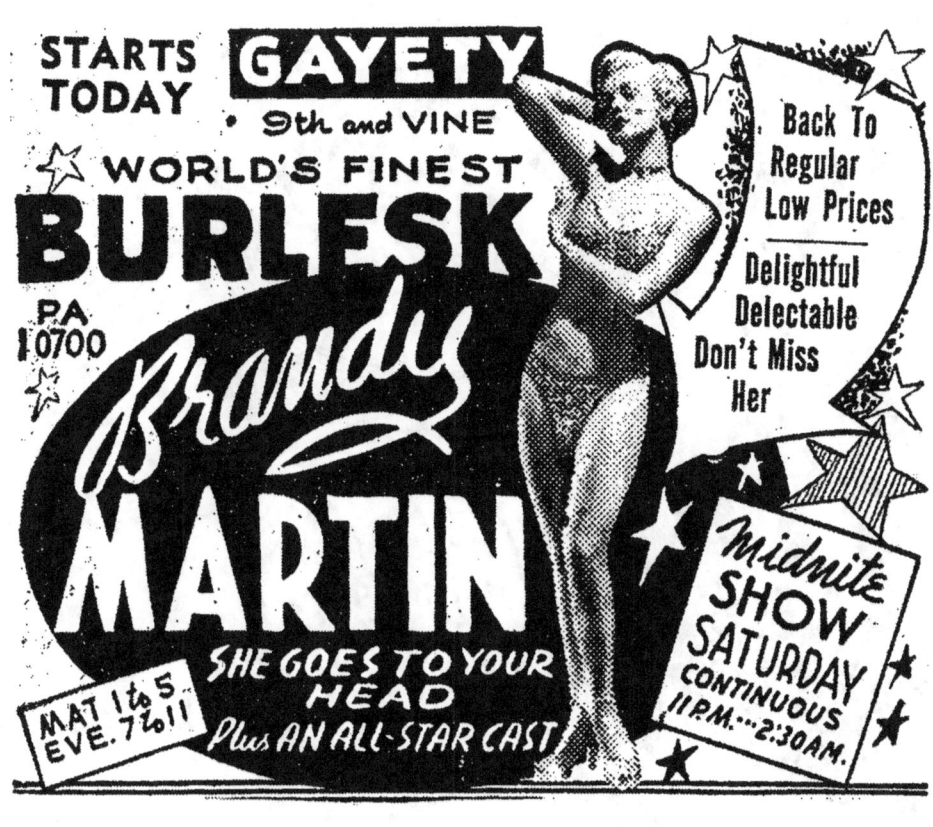
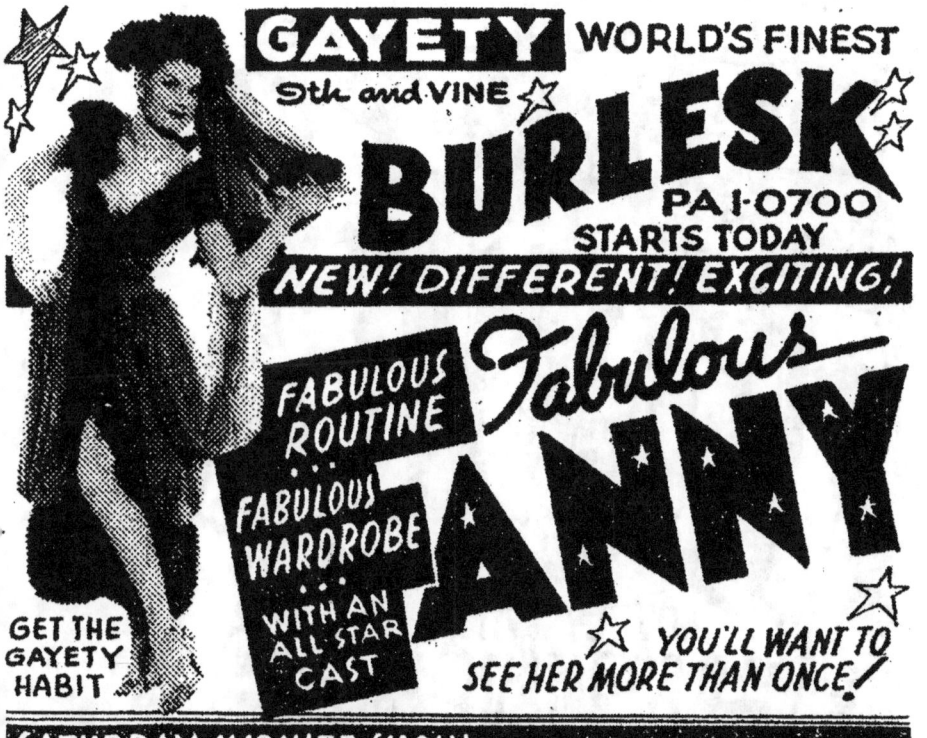
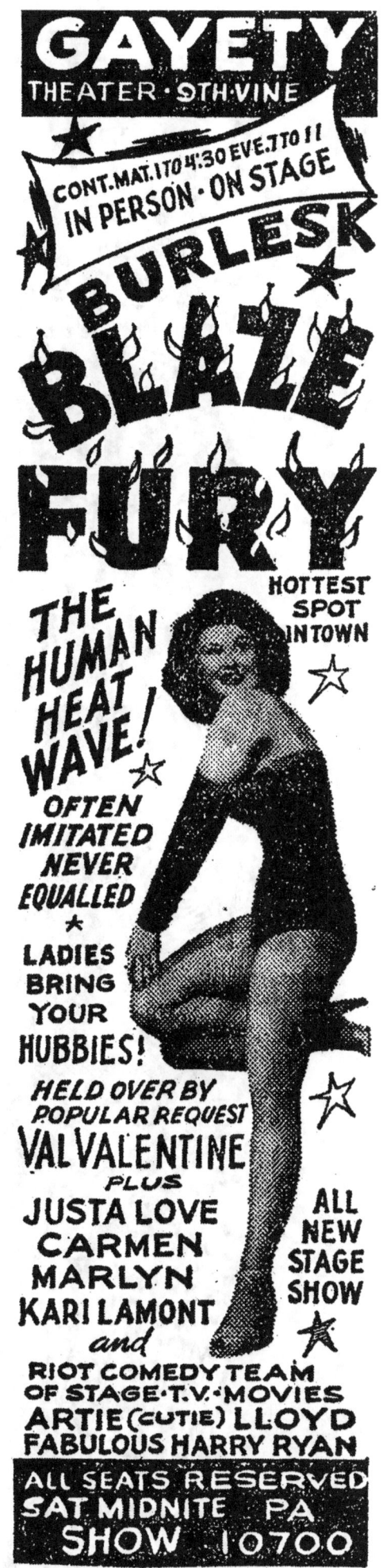

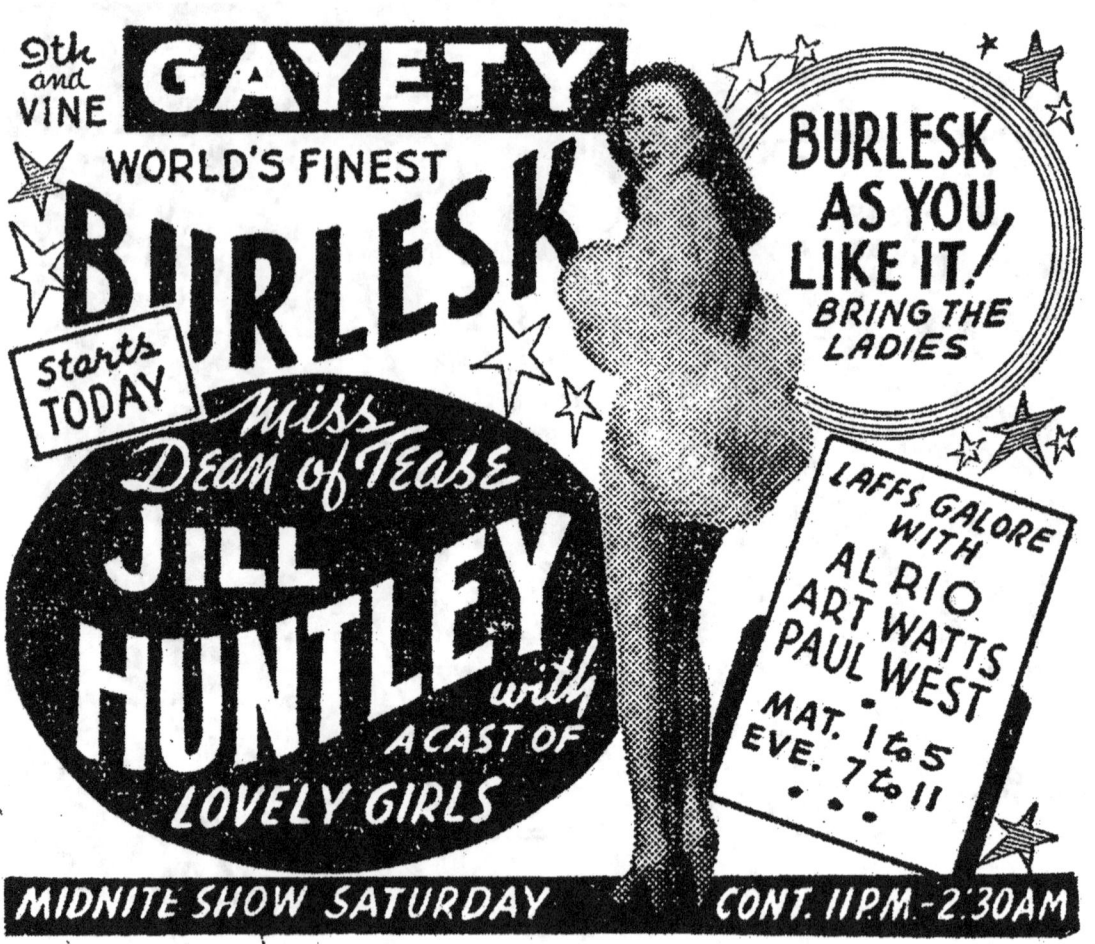

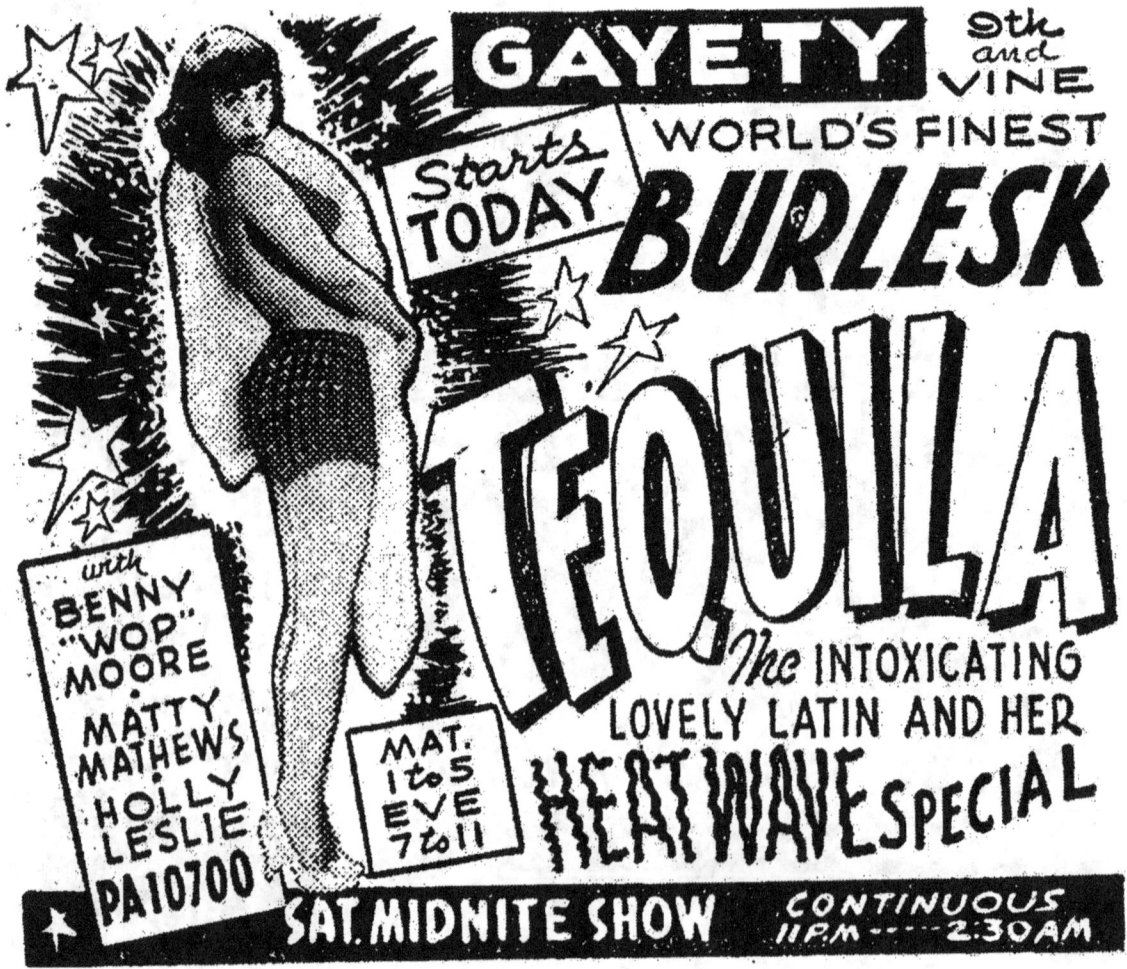

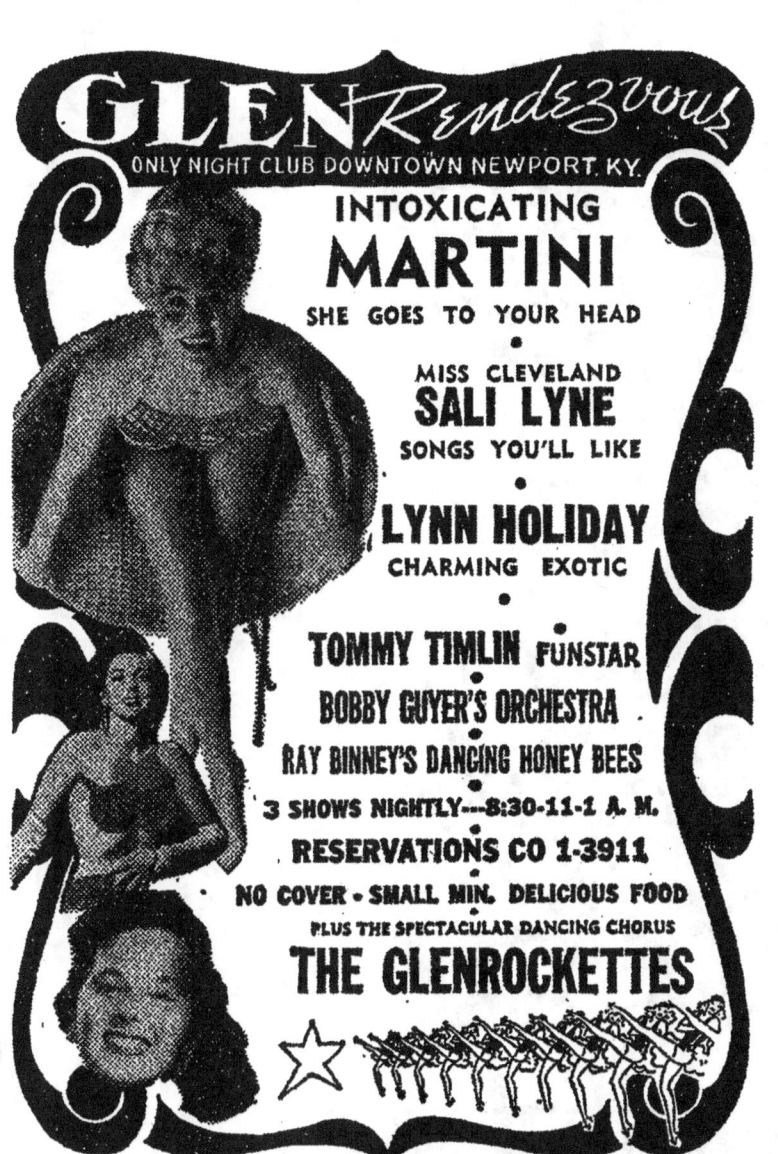
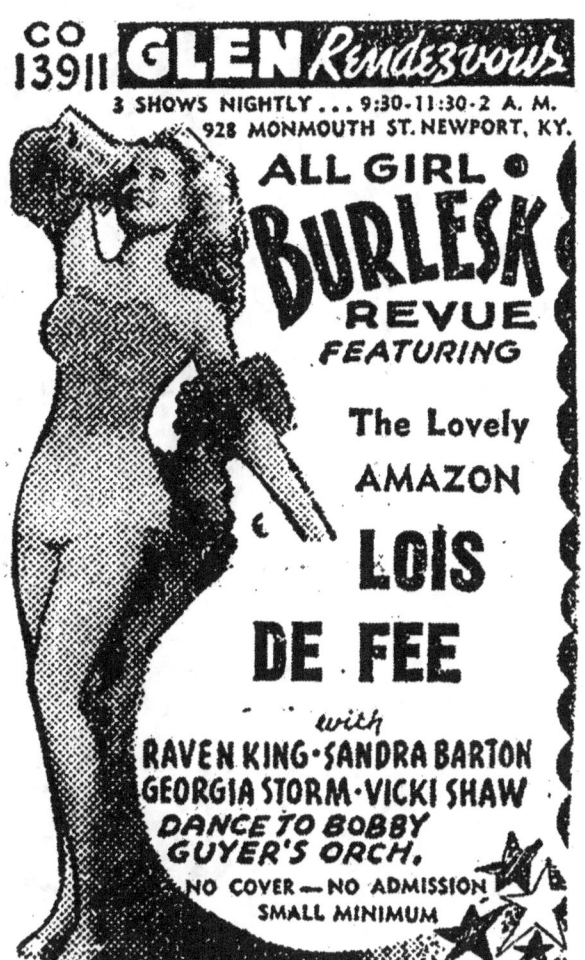
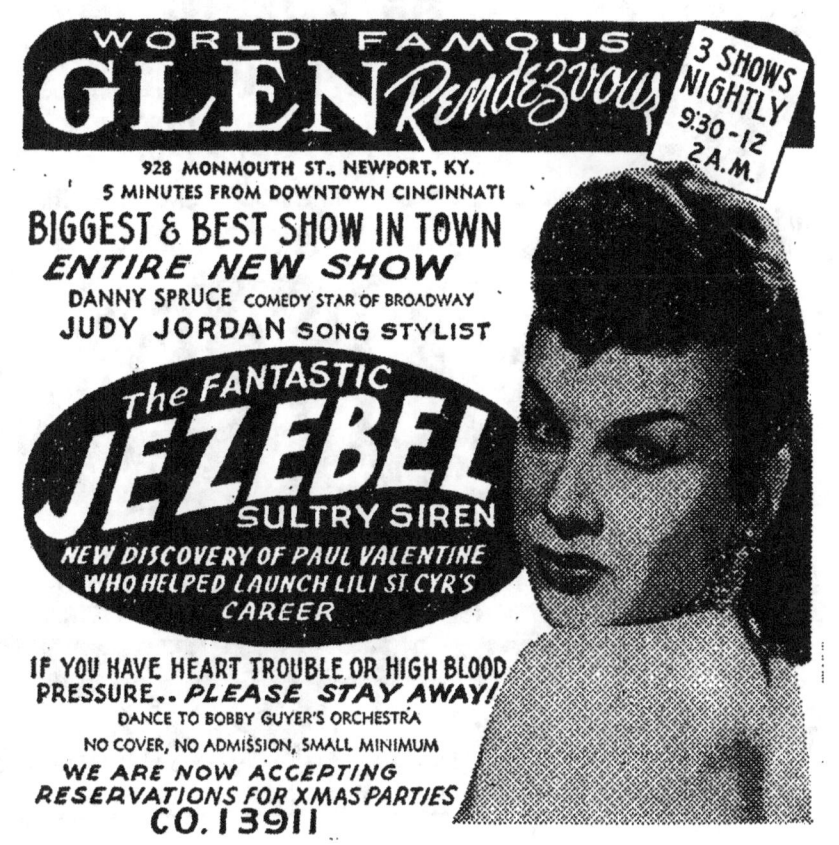

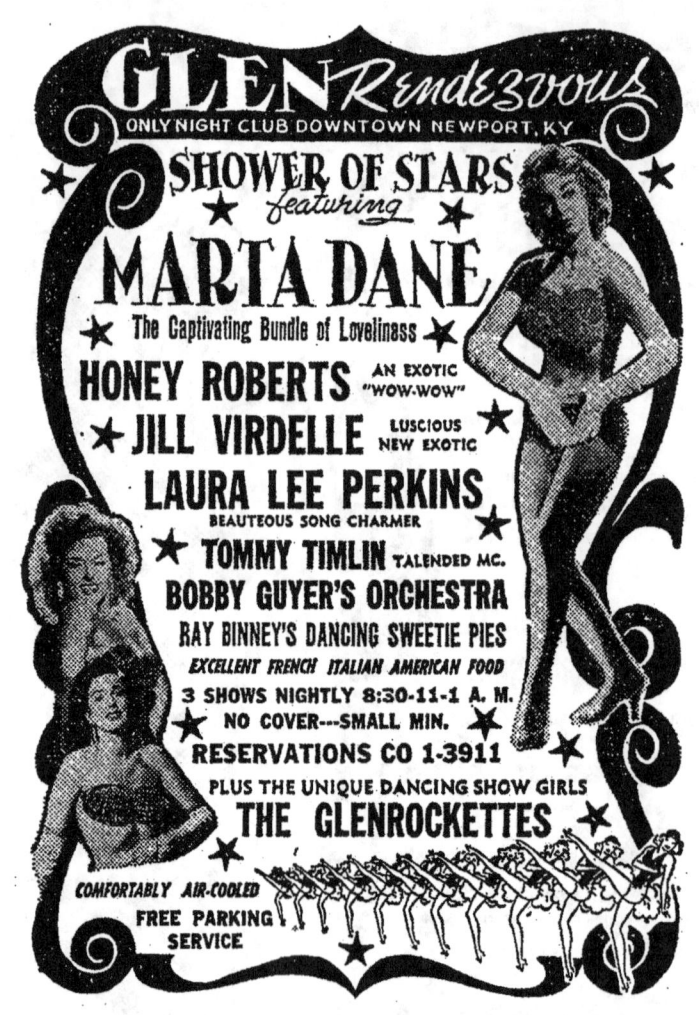

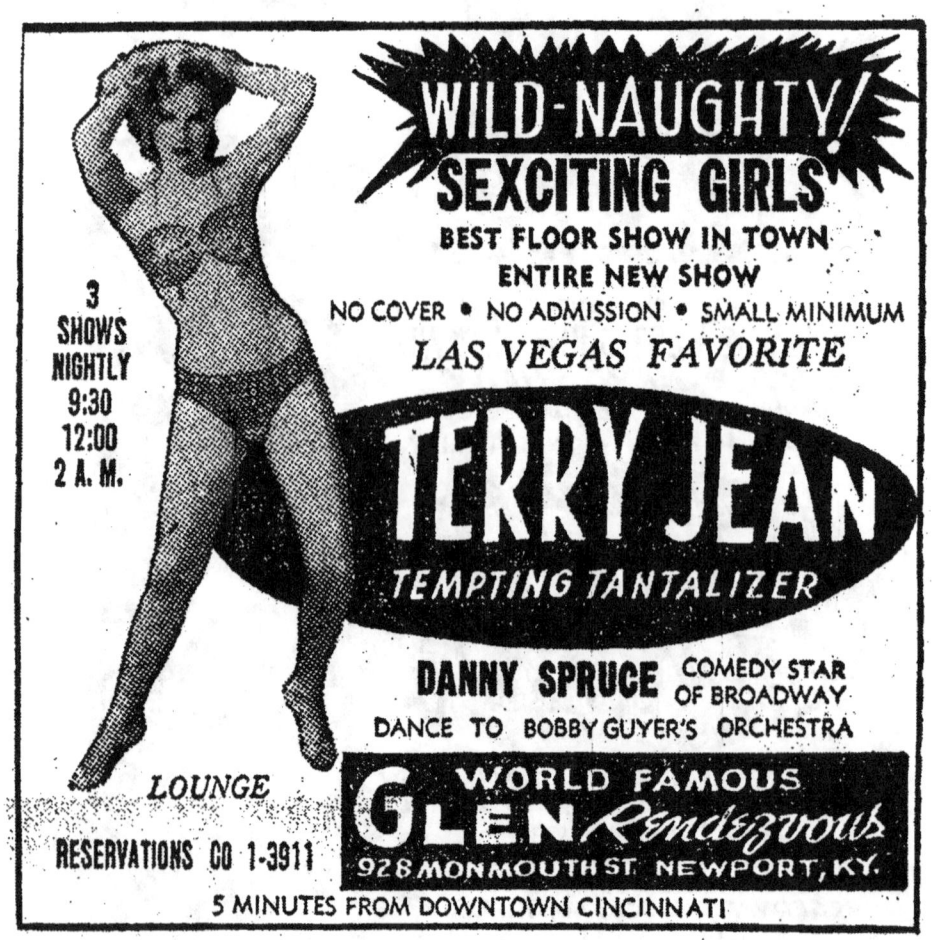

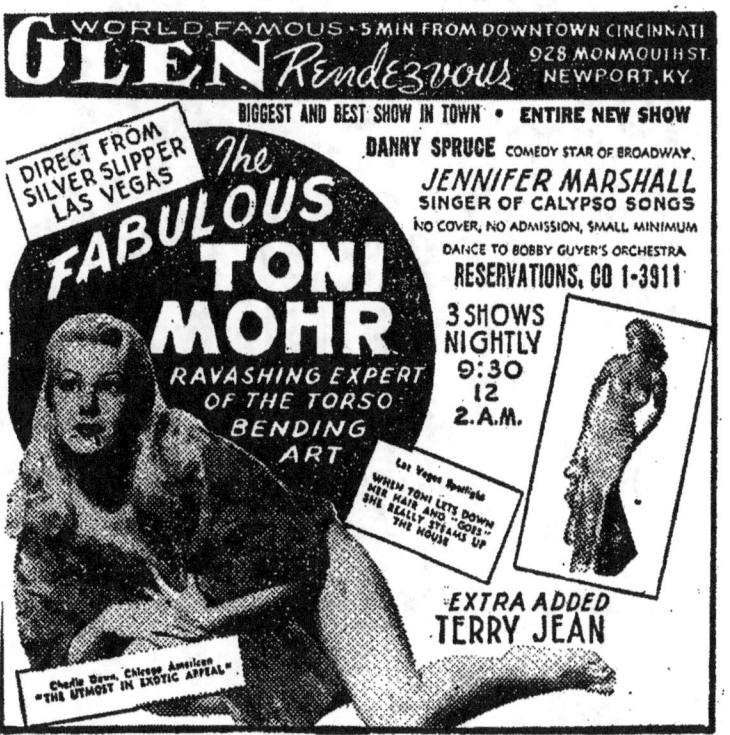
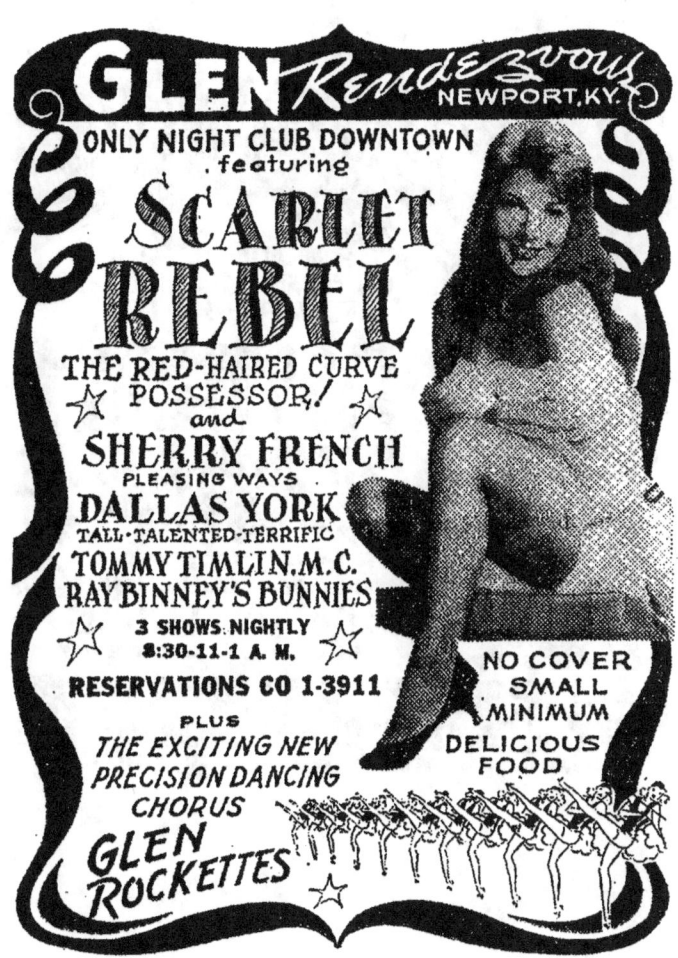
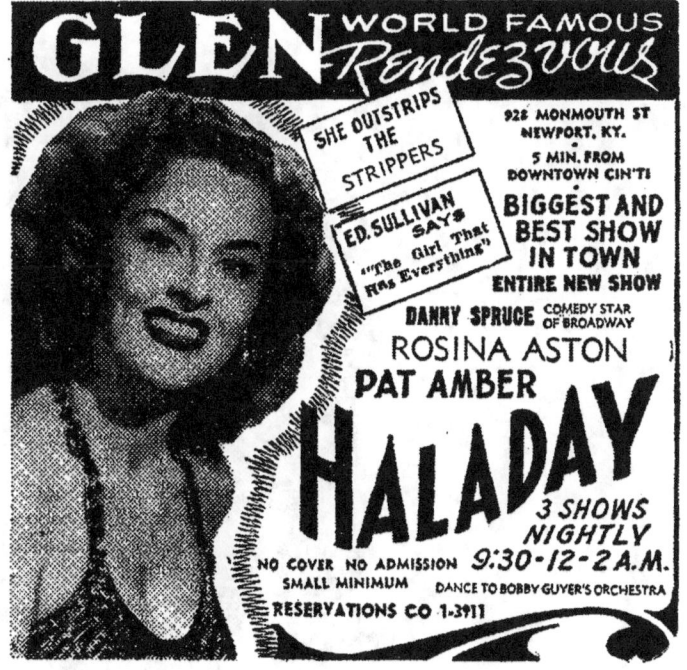

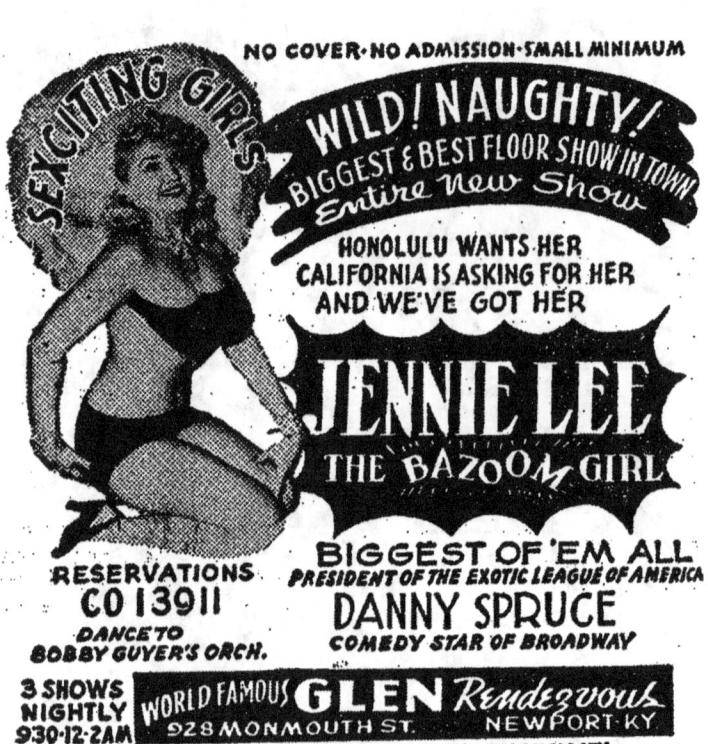
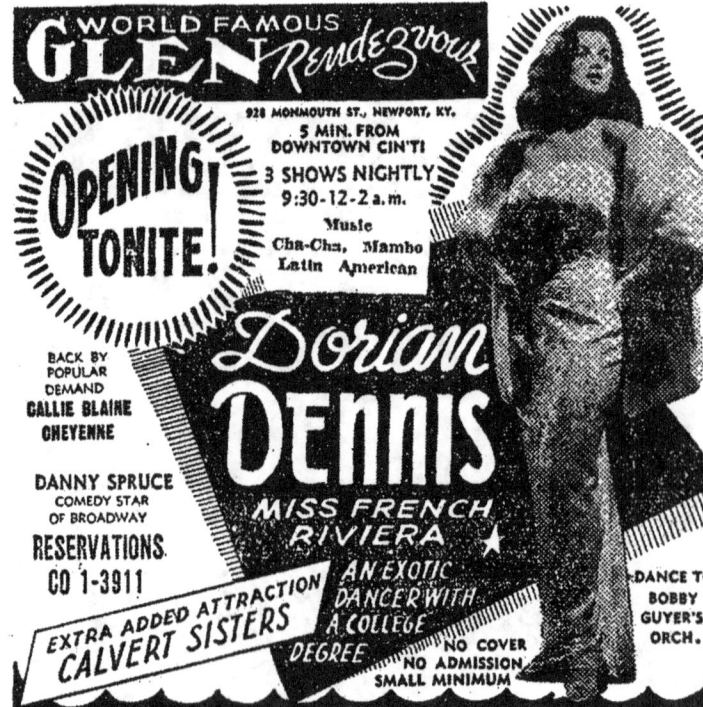
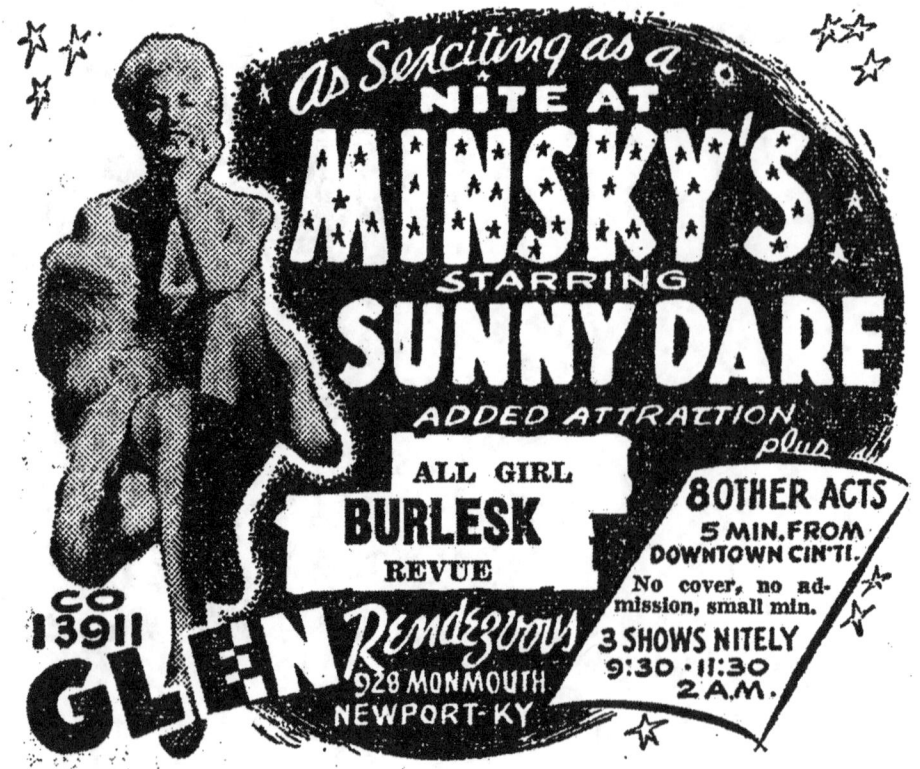

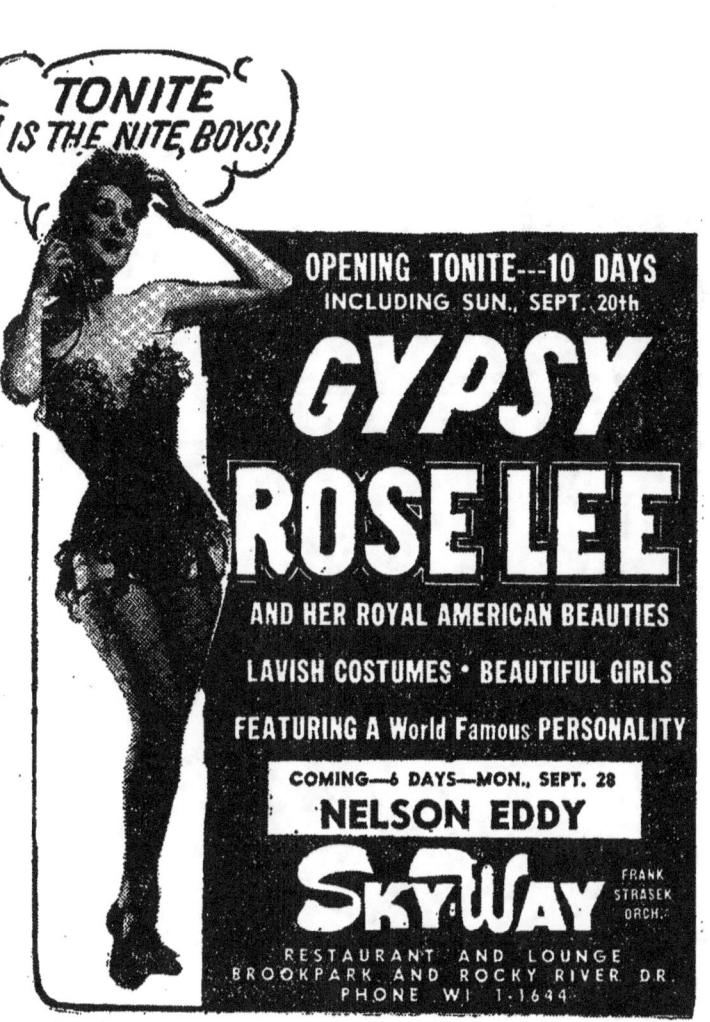
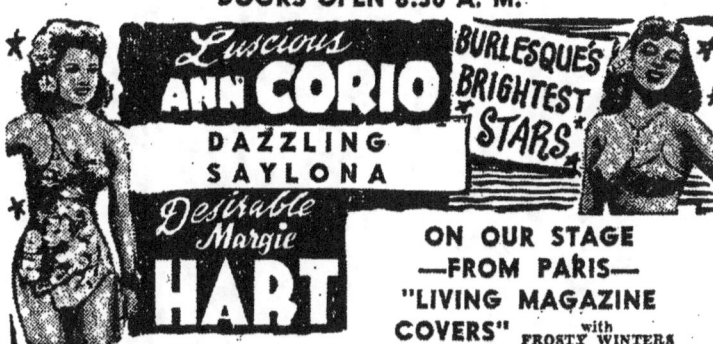
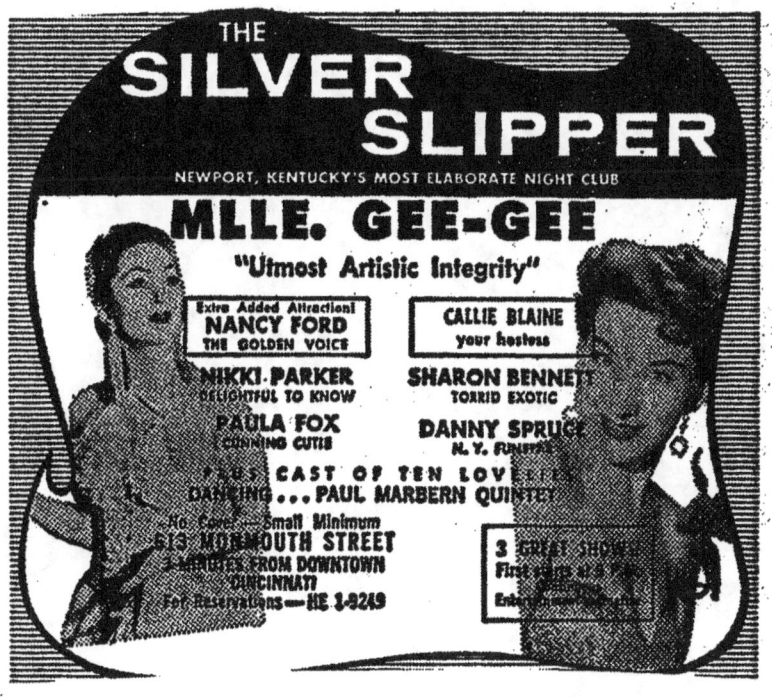

GALLERY THREE

CONSISTING OF:

1950's Burlesque theater programs from Newark, NJ, New York City and Philadelphia, PA

PROGRAM — WEEK OF FEBRUARY 15th, 1952

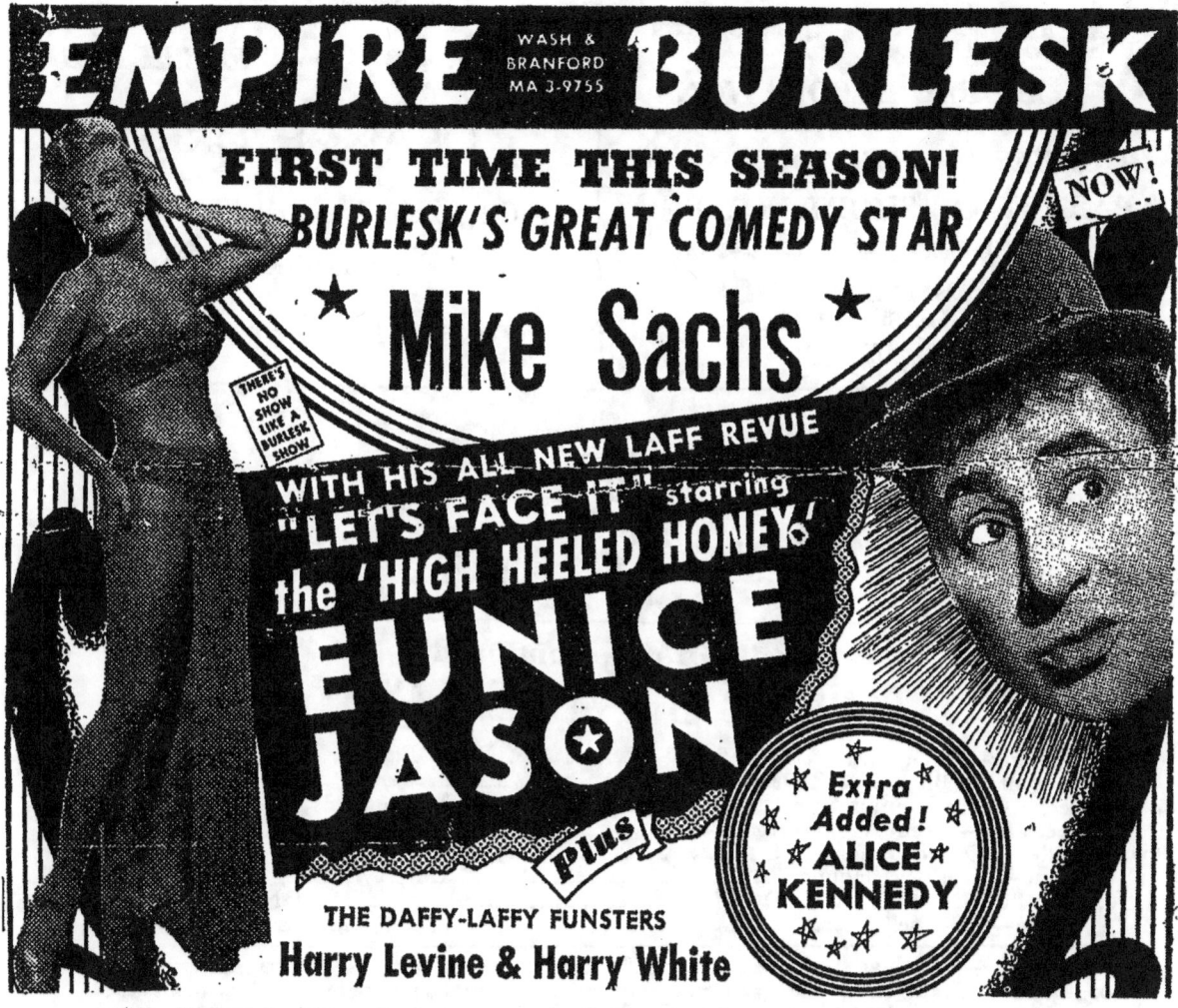

EMPIRE BURLESK
WASH & BRANFORD — MA 3-9755

FIRST TIME THIS SEASON!
BURLESK'S GREAT COMEDY STAR
★ Mike Sachs ★

NOW!

THERE'S NO SHOW LIKE A BURLESK SHOW

WITH HIS ALL NEW LAFF REVUE
"LET'S FACE IT" starring
the 'HIGH HEELED HONEY'
EUNICE JASON

★ Extra Added! ★ ALICE KENNEDY ★

Plus
THE DAFFY-LAFFY FUNSTERS
Harry Levine & Harry White

And :— MAUREEN MARSH — ROBIN LESLIE — JERRY PAULOS
"STRUT" FLASH — PERRY & DELL

★ LATE SHOW EVERY SAT. NITE 11:30 - 2 Cont. Mats. 12 to 5, Eves. 8:30 Res. ★

During Intermission and After the Show
- Visit -
THE EMPIRE BAR
Right Across the Street
CHOICE WINES and LIQUORS
at Popular Prices
Rendezvous for the Theatrical Profession

Tel. MA 2-4516
The Home of the Show Folks
The Rutledge Hotel
in the Heart of the City
High and W. Market Sts.
Newark, N. J.
Sidney Young, Mgr.

Grant Lunch Co.
199 MARKET STREET
76 MARKET STREET
"Around the Corner"
Serves the Best Liquor and Beer

★★★★

Awarded a Cross of Merit and a Gold Metal at the Exposition of Florence, Italy

CAPUTO'S FLORIST

FLORAL DECORATIONS FOR ALL OCCASIONS

BOUQUETS For WEDDINGS and PARTIES ON SHORT NOTICE

Telephones: HUmboldt 2-4356 — 3-9796

167-69-71 EIGHTH AVENUE
Right Hand Cor. Sheffield St.
NEWARK, N. J.

"SUN-DEW"

SUN RIPENED — FRESH FRUIT

ORANGE DRINK!

Sold Exclusively in This Theatre At All Refreshment Counters

Delicious! Pure! Healthful!

MItchell 2-4507

Bran-hall CLOTHES

NAT GOLDBERG
SID ATKINS

ASK ABOUT OUR CLUB PLAN

30 BRANFORD PLACE
NEWARK 2, N. J.

PROGRAM—Continued
"LET'S FACE IT"

ACT TWO

1. Opening—"Blue Birds & Moonlight" Jerry Paulos, Bert Perry & Girls
2. Specialty—"Blonde & Terrific" .. Miss Jean Rich
3. Scene—"The Vampire" .. Sachs, Kennedy, White & Paulos
4. Specialty—"Peek A Boo Again" .. Maureen Marsh
5. Ballet—"Dance Rhapsody" Perry and Dell and The Weldon Girls
6. Scene—"Sherlock Holmes" .. Levine, White, Leslie
7. FEATURE—"DELUXE DOLL" .. EUNICE JASON
8. Finale—"Reprise" The Weldon Girls & Eunice Jason

*Warning: — All stage material, dialogue, sketches, scenes, etc., the registered property of I. Hirst Enterprises, Inc., and may not be used, published or enacted without the express consent of the General Manager, I. Hirst Enterprises, Inc. Unless such permission is received, in writing, violators will be subject legal suit. This prohibits the taking of photographs during the performance.

NOTE: PROGRAM SUBJECT TO CHANGE WITHOUT NOTICE.

MA. 3-1152 MI. 2-8900

Tickets For All Theatres and Sport Events

EMPIRE TICKET SERVICE

266 WASHINGTON STREET **NEWARK, N. J.**

OPPOSITE EMPIRE THEATRE

AL (Sternie) STERNBERG *MANAGER*

EMMA'S LUNCHEONETTE

ACROSS THE STREET
on BRANFORD PLACE

.. ICE CREAM SODAS ..

Deluxe Fountain Service

"WE PICK UP AND DELIVER"

CURRAN CLEANERS

DRY CLEANING — LAUNDRY

Pressing & Repairing

Exclusive But Not Expensive

**35 NORTH 15TH STREET
EAST ORANGE, N. J.**

Phone:-ORange 5-0773

"RIGHT ACROSS THE STREET" **MILLER'S TAVERN** A Complete Line of **WINES & LIQUORS** HOT and COLD SANDWICHES 270 Washington St.　　Newark, N. J.	**ROYAL** RESTAURANT VEGETARIAN-DAIRY ISIDORE KRIEGEL, Proprietor 55 BRANFORD PLACE NEWARK, N. J. Tel. MI. 2-9320

-- PROGRAM --

MIKE SACHS
Presents
HIS ALL NEW REVUE — STAGED BY BUNNY WELDON

ACT ONE **"LET'S FACE IT"** **ACT ONE**

Starring
EUNICE JASON

and featuring
HARRY LEVINE — ALICE KENNEDY — HARRY WHITE

Perry & Dell — Maureen Marsh — Robin Leslie — Jerry Paulos — "Strut" Flash

Costumes By	Musical Direction by	Scenery by
COLLINS CREATIVE COSTUMES	JOSEPH LAFFERTY	CHARLES TIECHNOR, Inc.

1. Opening—"Web Of Melody" Jerry Paulos and The Weldon Girls
2. Scene—"Hee Haw" Levine, White, Marsh, Leslie, Paulos
3. Specialty—"Sittin' Pretty" Miss Robin Leslie
4. Scene—"St. James Infirmary" Mike Sachs, Alice Kennedy & Harry White
5. Ballet—"8th Avenue Today" Perry & Dell, Paulos & Weldon Girls
6. Specialty—"Spicy Tamale" Miss "Blackie" Elvira
7. Scene—"Madame Lipschitz" Levine, White, Paulos, Leslie & Marsh
8. Vaude Act—"Educated Feet" "Strut" Flash
9. Ballet—"Autumn Serenade" Paulos, Alberta, Miss Dell and Girls
10. Specialty—"Snug'n Cuddly" Miss Maureen Marsh
11. Scene—"At The Threshhold" Sachs, Kennedy, White, Paulos, Leslie
12. FEATURE—"HIGH HEELED HONEY" MISS EUNICE JASON
13. Finale—"Fast Getaway" Paulos, The Weldonettes and Eunice

— INTERMISSION —

THE PIANOS USED IN THIS THEATRE, BOTH ON STAGE AND IN ORCHESTRA
SUPPLIED BY
LAUTER PIANO CO.
561 BROAD STREET MArket 2-8080 NEWARK, N. J.

DON'T THROW YOU OLD COAT AWAY We Match Pants to Your Coat **RELIABLE PANTS STORES** DRESS - SPORTS AND WORK PANTS For Men - Young Men and Students 35 SPRINGFIELD AVE. NEWARK, N. J. (Just Below High Street)	Phone MItchell 2-3613 "Before and After the Show" Visit **BRADLEY'S** B A R R E S T A U R A N T Try Our DELICIOUS SANDWICHES 124 MARKET STREET NEWARK, N. J. Party Accommodations Private Dining Room

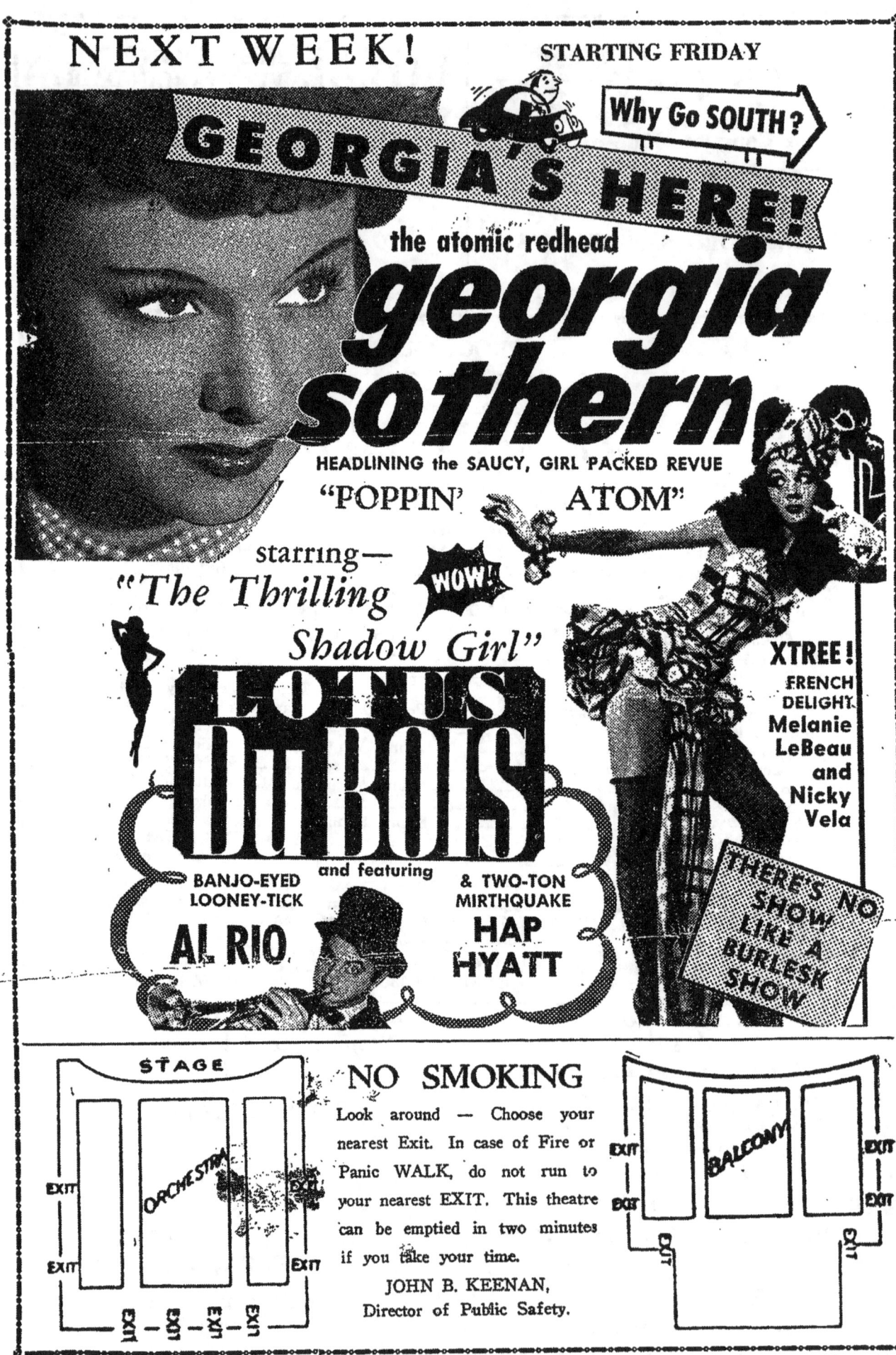

PROGRAM — WEEK OF OCTOBER 15th, 1954

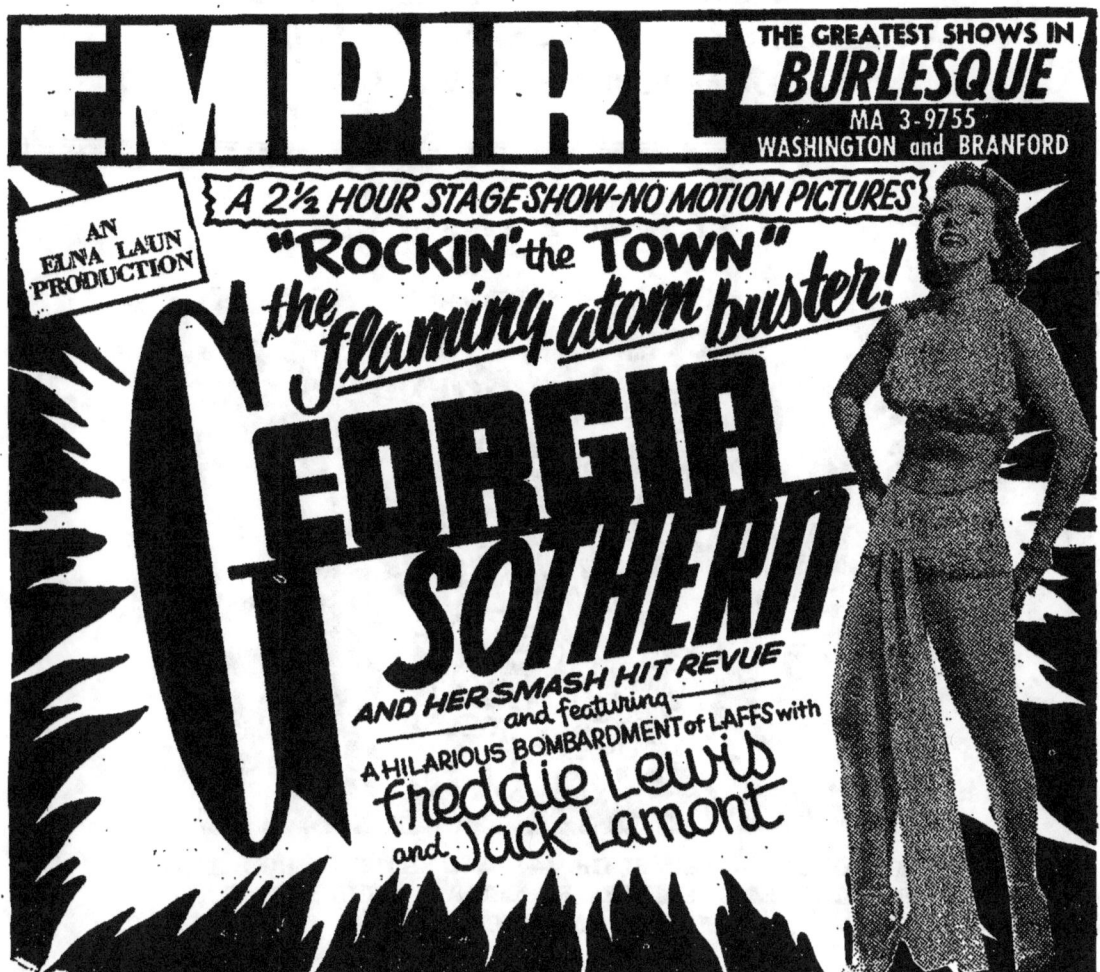

EMPIRE
THE GREATEST SHOWS IN BURLESQUE
MA 3-9755
WASHINGTON and BRANFORD

AN ELNA LAUN PRODUCTION

A 2½ HOUR STAGE SHOW—NO MOTION PICTURES

"ROCKIN' the TOWN"

the flaming atom buster!

GEORGIA SOTHERN

AND HER SMASH HIT REVUE

and featuring

A HILARIOUS BOMBARDMENT of LAFFS with

Freddie Lewis and Jack Lamont

"MAR-SHAN" — TED BLAIR — ARLENE MOODY — BOB HART
SHIRLEY RUSCELLA — DELILAH LEE — TRUDY LANE
THE ELNA LAUN DANCERS & THE ESQUIRES

LATE SHOW EVERY SAT. NITE 11:30-2 Cont. Mats. 12 to 5, Eves. 8:30 Res.

During Intermission and After the Show
- Visit -

THE EMPIRE BAR

Right Across the Street
CHOICE WINES and LIQUORS
at Popular Prices
Rendezvous for the Theatrical Profession

Under New Management

The Rutledge Hotel

The Home of the Show Folks
in the Heart of the City
High and W. Market Sts.
Newark, N. J.
Tel. MA 2-4516

Grant Lunch Co.

199 MARKET STREET
76 MARKET STREET

"Around the Corner"

Serves the Best Liquor and Beer

"RIGHT ACROSS THE STREET"
MILLER'S TAVERN
A Complete Line of WINES & LIQUORS
HOT and COLD SANDWICHES

270 Washington St. Newark, N. J.

---PROGRAM---

ACT ONE **ACT ONE**

AN ELNA LAUN PRODUCTION
"ROCKIN' the TOWN"
the flaming atom buster!
GEORGIA SOTHERN
AND HER SMASH HIT REVUE
and featuring
A HILARIOUS BOMBARDMENT of LAFFS with
Freddie Lewis and Jack Lamont

ARLENE MOODY — TED BLAIR — "MAR-SHAN" — BOB HART
DELILAH LEE — SHIRLEY RUSCELLA — TRUDY LANE
ELNA LAUN DANCERS

Costumes By	Musical Direction	Scenery By
COLLINS CREATIVE COSTUMES	JOSEPH LAFFERTY	FRANK STEVENS, Inc.

1. Opening "Cookin' Up Some Jive" Bob Hart, The Empire Girls & Boys
2. Scene—"International Street" LaMont, Blair, Moody, Mar-Shan, Trudy, Betty
3. Specialty—"Peek A Beaut" .. "Mar-Shan"
4. Scene—"Sale Of The Year" Lewis, Blair & Moody
5. Ballet—"Alice Blue Gown" Bob Hart, The Empire Girls & Boys
6. Specialty—"The Empire Darling" Miss Shirley Ruscella
7. Scene—"Pot O' Gold" LaMont, Blair, Mar-Shan, Hart
8. Specialty—"Luscious Curves" .. Arlene Moody
9. Ballet—"Flame Of Life" Bob Hart, The Empire Ensemble
10. Scene—"Honeymoon Hotel" Lewis, Blair, Hart, Moody, Mar-Shan, Betty
11. FEATURE—"THE ATOMIC REDHEAD" MISS GEORGIA SOTHERN
12. Finale—"Beauty In Review" Bob Hart, The Beauty Stars & Ensemble

— INTERMISSION —

Phone MItchell 2-3613
"Before and After the Show" Visit —

BAR **BRADLEY'S** RESTAURANT

Try Our DELICIOUS SANDWICHES

124 MARKET STREET NEWARK, N. J.
Party Accommodations — Private Dining Room

EMMA'S LUNCHEONETTE

ACROSS THE STREET
on BRANDFORD PLACE
- Serving -
Delicious Sandwiches and Hot Blue Plates
Deluxe Fountain Service

NAT GOLDBERG
SID ATKINS

Bran-hall CLOTHES

ASK ABOUT
OUR
CLUB
PLAN

30 BRANFORD PLACE
NEWARK 2, N. J.

PROGRAM—Continued

ACT TWO "ROCKIN' the TOWN" **ACT TWO**

1. Opening—"Luck Be A Lady" Bob Hart, The Empire Girls & Boys
2. Specialty—"Petite & Dynamic" Miss Delilah Lee
3. Scene—"Elk's Convention" Lewis, LaMont, Blair, Moody, Mar-Shan
4. Specialty—"Another Peek" Mar-Shan
5. Scene—"Running For Mayor" LaMont, Blair, Moody, Mar-Shan, Betty
6. Ballet—"Tenement Symphony" Bob Hart, The Empire Girls & Boys
7. FEATURE—"BOMBSHELL" GEORGIA SOTHERN
8. Finale—"Reprise" The Empire Girls & Georgia Sothern

★★

*Warning: — All stage material, dialogue, sketches, scenes, etc., the registered property of I. Hirst Enterprises, Inc., and may not be used, published or enacted without the express consent of the General Manager, I. Hirst Enterprises, Inc. Unless such permission is received, in writing, violators will be subject legal suit. This prohibits the taking of photographs during the performance.

NOTE: PROGRAM SUBJECT TO CHANGE WITHOUT NOTICE.

"SUN-DEW"

SUN RIPENED — FRESH FRUIT
ORANGE DRINK!
Sold Exclusively in This Theatre
At All Refreshment Counters

Delicious! Pure! Healthful!

ORange 3-0349

H. YASNER

CLEANING - PRESSING
EXPERT ALTERATION

- Prompt Service -

6 WASHINGTON STREET
EAST ORANGE

MA. 3-1152 MA. 3-6779

Tickets For All Theatres and Sport Events

EMPIRE TICKET SERVICE

266 WASHINGTON STREET NEWARK, N. J.

OPPOSITE EMPIRE THEATRE
MURRAY or STERNIE

NEXT WEEK! STARTING FRIDAY...

BURLESK'S GREATEST STAR!
THE ONE AND ONLY!

Rose La Rose

and her own show **'VANI-TEASE'**

with The "Clown Prince of Comedy"

MANNY KING
and MATTY MATHEWS

THERE'S NO SHOW LIKE A BURLESK SHOW

NO SMOKING

Look around — Choose your nearest Exit. In case of Fire or Panic WALK, do not run to your nearest EXIT. This theatre can be emptied in two minutes if you take your time.

JOHN B. KEENAN,
Director of Public Safety.

PROGRAM — WEEK OF OCTOBER 22nd, 1954

EMPIRE

THE GREATEST SHOWS IN BURLESQUE
MA 3-9755
WASHINGTON and BRANFORD

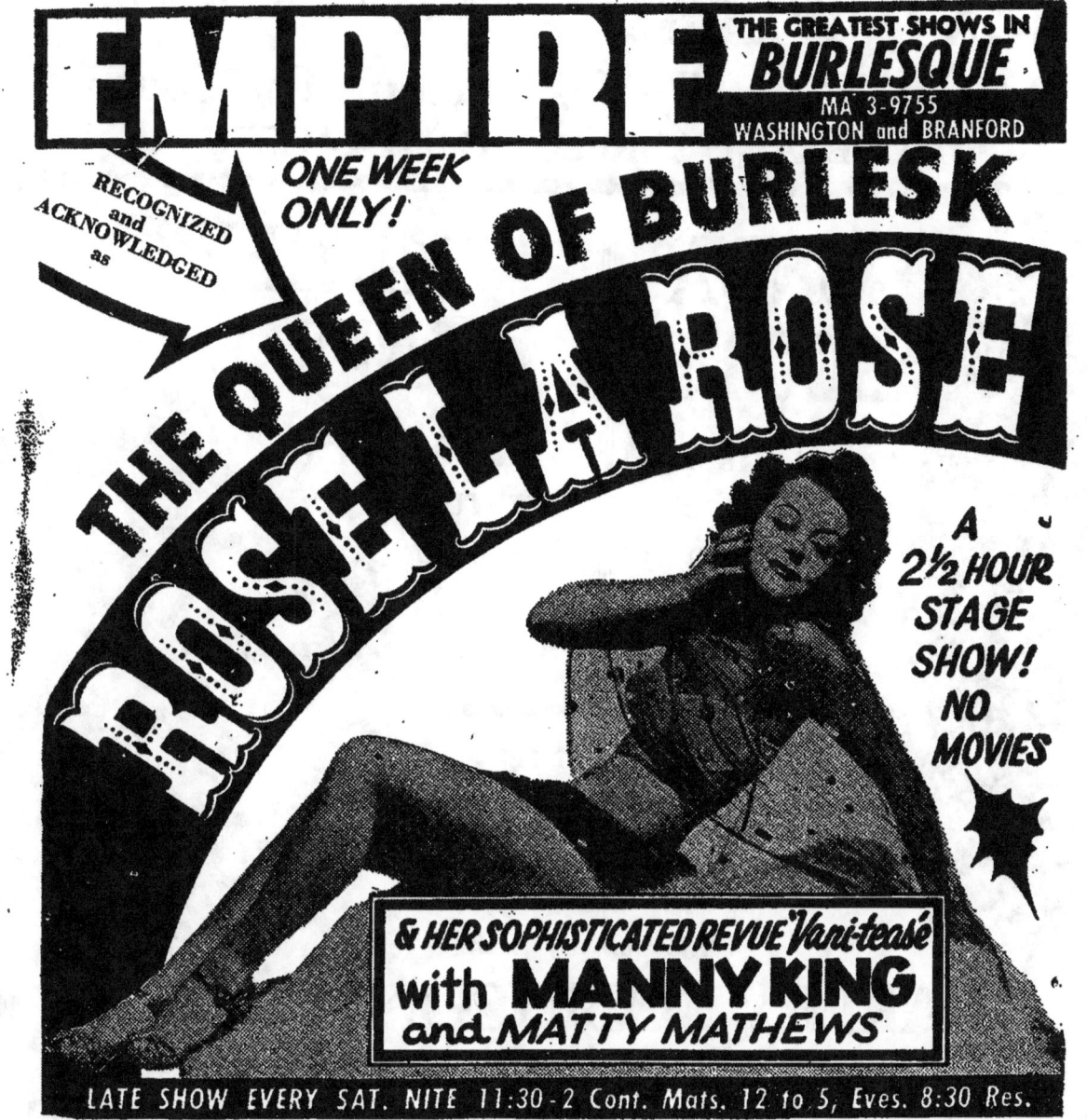

RECOGNIZED and ACKNOWLEDGED as
ONE WEEK ONLY!

THE QUEEN OF BURLESK
ROSE LA ROSE

A 2½ HOUR STAGE SHOW! NO MOVIES

& HER SOPHISTICATED REVUE Vani-tease
with **MANNY KING** and **MATTY MATHEWS**

LATE SHOW EVERY SAT. NITE 11:30-2 Cont. Mats. 12 to 5, Eves. 8:30 Res.

During Intermission and After the Show
- Visit -

THE EMPIRE BAR

Right Across the Street
CHOICE WINES and LIQUORS
at Popular Prices
Rendezvous for the Theatrical Profession

Under New Management

The Rutledge Hotel

The Home of the Show Folks
in the Heart of the City
High and W. Market Sts.
Newark, N. J.
Tel. MA 2-4516

Grant Lunch Co.

199 MARKET STREET
76 MARKET STREET

"Around the Corner"

Serves the Best
Liquor and Beer

NEXT WEEK! STARTING FRIDAY...
Here's What We Like About The South!
DIXIELAND'S RED HOT DE-ICERS...

LINDA SCOTT
"THAT FABULOUS GAL FROM BALTIMORE!"

"MICKEY" JONES
GO! GO! GO!

HIGH STEPPING KENTUCKY BEAUTY!

★ ★ ★ ★

Co-Starring
In The Frisky Frolic
"PEEK-A-VUE"
With Comedy Stars
CHARLEY ROBINSON
and
EARL VAN

LATE SHOW EVERY SAT. NITE 11:30 - 2 Cont. Mats. 12 to 5, Eves. 8:30 Res.

NO SMOKING

Look around — Choose your nearest Exit. In case of Fire or Panic WALK, do not run to your nearest EXIT. This theatre can be emptied in two minutes if you take your time.

JOHN B. KEENAN,
Director of Public Safety.

PROGRAM — WEEK OF NOVEMBER 19th, 1954

EMPIRE

NEWARK'S ONLY 'LIVE' 2½-HOUR GIRLY SHOW

THE GREATEST SHOWS IN **BURLESQUE**
MA 3-9755
WASHINGTON and BRANFORD

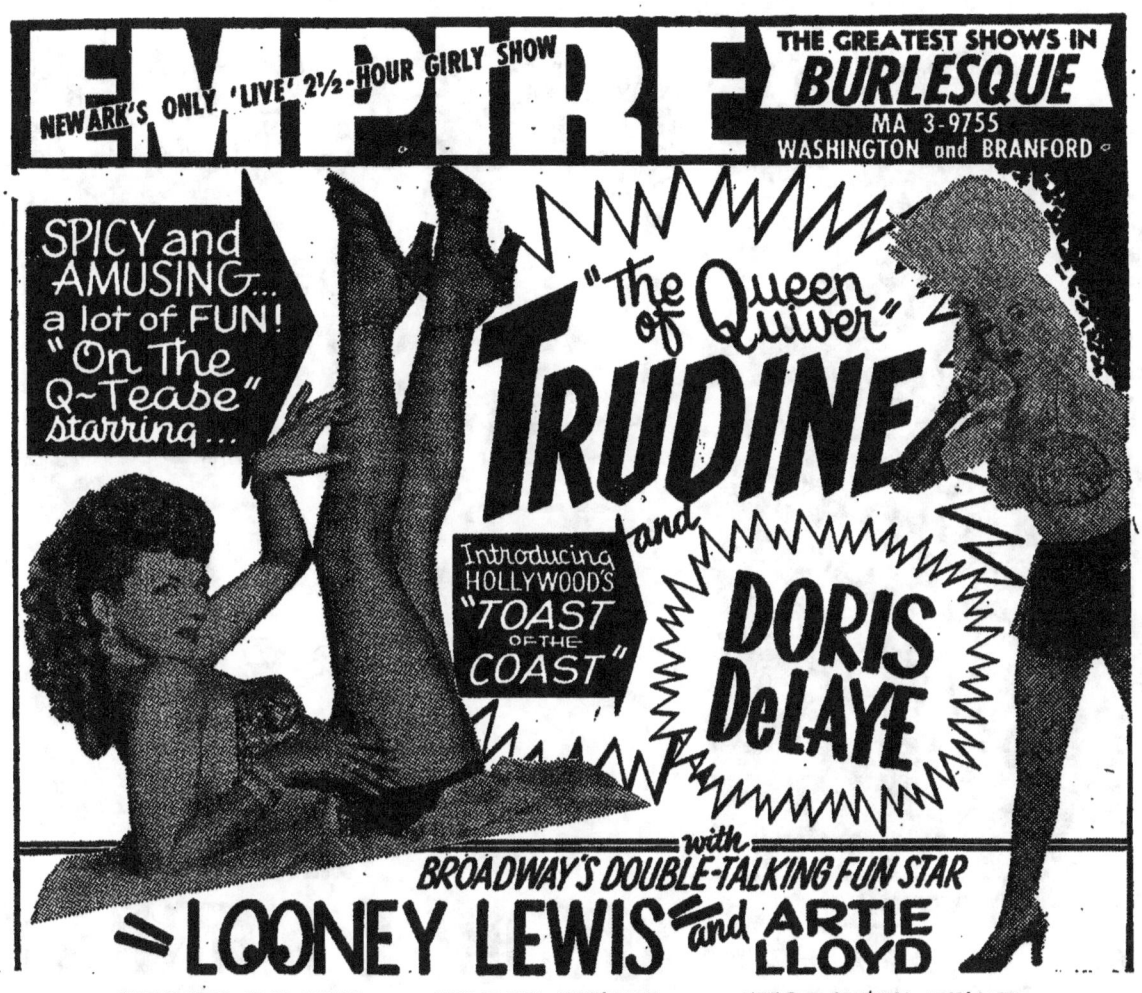

SPICY and AMUSING... a lot of FUN! "On The Q-Tease" starring...

"The Queen of Quiver" **TRUDINE**

Introducing HOLLYWOOD'S "TOAST OF THE COAST"

and **DORIS DeLAYE**

with BROADWAY'S DOUBLE-TALKING FUN STAR

LOONEY LEWIS and **ARTIE LLOYD**

HELEN DRAKE — EDDIE YUBEL — "TORCHY" BLAIR
JACK BRUNO — ELISSA SHIELDS
THE ESQUIRES & THE HALE - ARLEN GIRLS

★ LATE SHOW EVERY SAT. NITE 11:30 ★ 2 Cont. Mats. 12-5. Eves. 8:30. Res. ★

During Intermission and After the Show
- Visit -
THE EMPIRE BAR
Right Across the Street
CHOICE WINES and LIQUORS
at Popular Prices
Rendezvous for the Theatrical Profession

Under New Management
The Rutledge Hotel
The Home of the Show Folks
in the Heart of the City
High and W. Market Sts.
Newark, N. J.
Tel. MA 2-4516

Grant Lunch Co.

199 MARKET STREET

76 MARKET STREET

"Around the Corner"

Serves the Best Liquor and Beer

NEXT WEEK! STARTING FRIDAY...

Packed with Pretties! **Bubbling with Laughs!**

THERE'S NO SHOW LIKE A BURLESK SHOW

featuring "THE GIRL THAT HAS EVERYTHING"
Betty HOWARD
WITH THE

GAY HOLIDAY REVUE!
"SAUCY SWEETS"

featuring

A REAL "FUN FOR ALL"

with

GEORGE MURRAY
and
HARRY J. CONLEY

EXTRA
"A FEAST FOR YOUR EYES"
RUTH SWANK

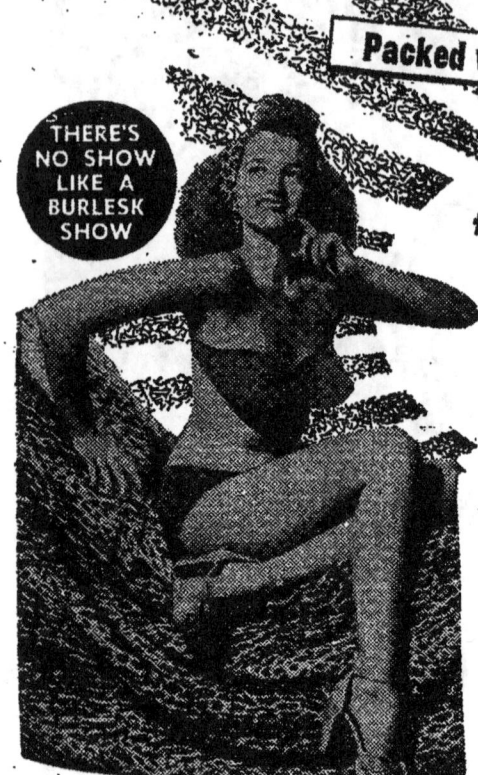

LATE SHOW EVERY SAT. NITE 11:30 - 2 Cont. Mats. 12 to 5, Eves. 8:30 Res.

NO SMOKING

Look around — Choose your nearest Exit. In case of Fire or Panic WALK, do not run to your nearest EXIT. This theatre can be emptied in two minutes if you take your time.

JOHN B. KEENAN,
Director of Public Safety.

PROGRAM — WEEK OF NOVEMBER 26th, 1954

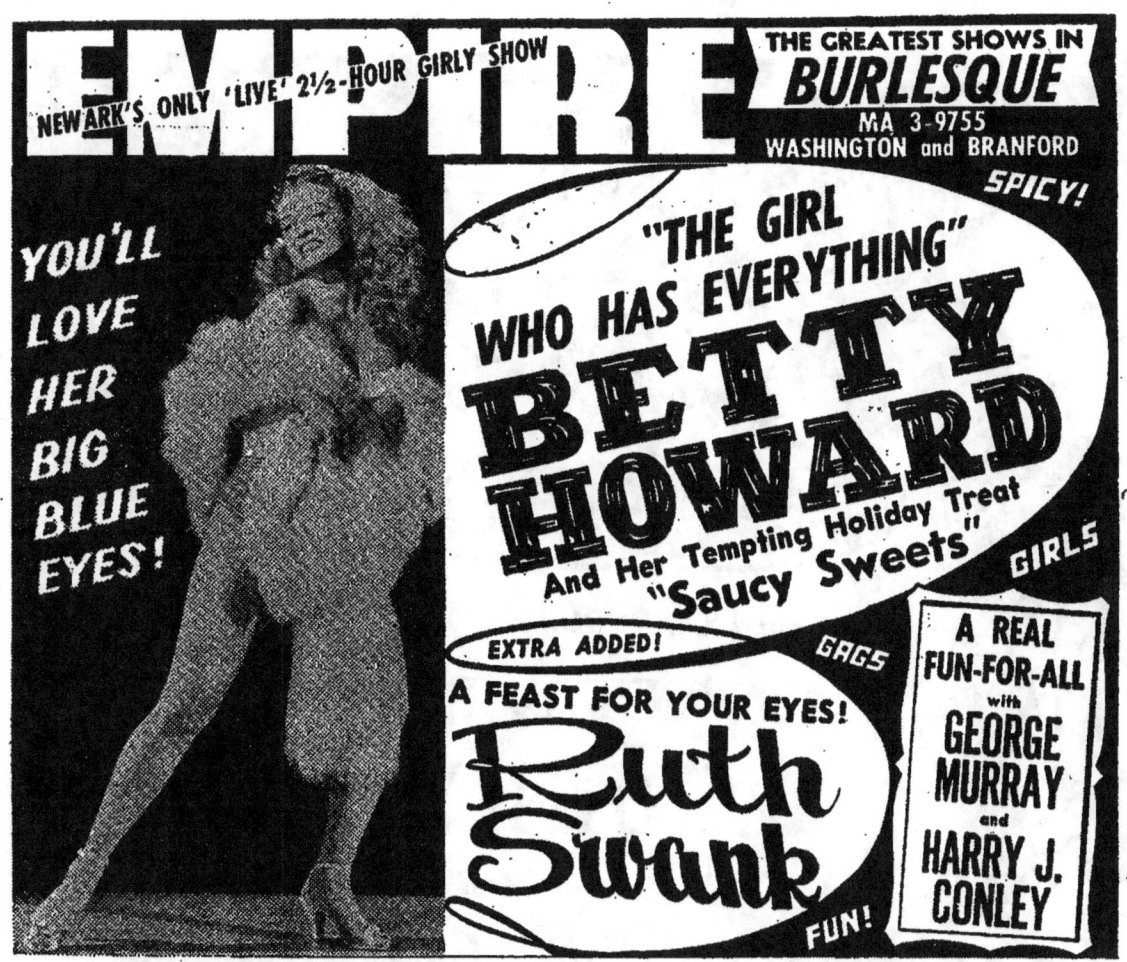

EMPIRE
NEWARK'S ONLY 'LIVE' 2½-HOUR GIRLY SHOW

THE GREATEST SHOWS IN BURLESQUE
MA 3-9755
WASHINGTON and BRANFORD

YOU'LL LOVE HER BIG BLUE EYES!

SPICY!

"THE GIRL WHO HAS EVERYTHING"
BETTY HOWARD
And Her Tempting Holiday Treat
"Saucy Sweets"

GIRLS

EXTRA ADDED!
A FEAST FOR YOUR EYES!
Ruth Swank

GAGS

A REAL FUN-FOR-ALL with
GEORGE MURRAY and **HARRY J. CONLEY**

FUN!

EILEEN HUBERT — BILLY KING — LINDA LESLIE
JACK BRUNO — SHIRLEY RUSCELLA — DELILAH LEE
THE ESQUIRES — THE HALE-ARLEN GIRLS — VICKI REYNOLDS

★ LATE SHOW EVERY SAT. NITE 11:30 ★ 2 Cont. Mats. 12-5. Eves. 8:30. Res. ★

During Intermission and After the Show
- Visit -
THE EMPIRE BAR
Right Across the Street
CHOICE WINES and LIQUORS
at Popular Prices
Rendezvous for the Theatrical Profession

Under New Management
The Rutledge Hotel
The Home of the Show Folks
in the Heart of the City
High and W. Market Sts.
Newark, N. J.
Tel. MA 2-4516

Grant Lunch Co.
199 MARKET STREET
76 MARKET STREET
"Around the Corner"

Serves the Best
Liquor and Beer

★ ★ ★ ★

NEXT WEEK! STARTING FRIDAY...

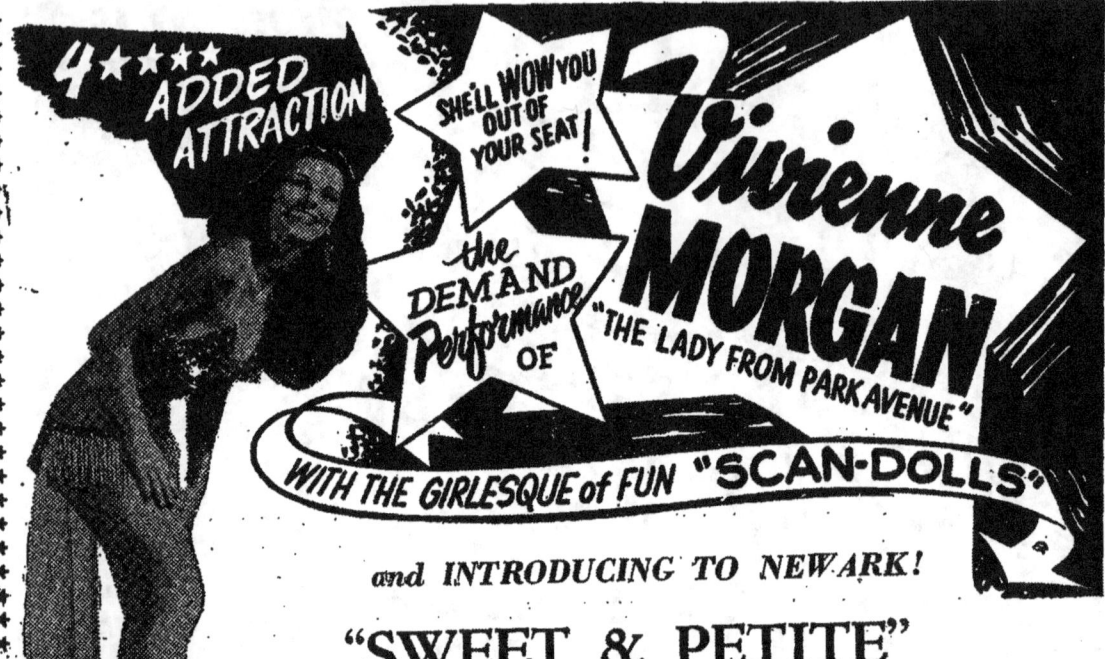

4 ★★★★ ADDED ATTRACTION

She'll wow you out of your seat!

The DEMAND Performance OF Vivienne MORGAN "THE LADY FROM PARK AVENUE"

WITH THE GIRLESQUE of FUN "SCAN-DOLLS"

and INTRODUCING TO NEWARK!

"SWEET & PETITE" SUNNY DARE

And Featuring

The Comedy Stars Of Mike Todd's "Peep Show"

JACK MANN & "RED" MARSHALL

LATE SHOW EVERY SAT. NITE 11:30-2 Cont. Mats. 12 to 5, Eves. 8:30 Res.

NO SMOKING

Look around — Choose your nearest Exit. In case of Fire or Panic WALK, do not run to your nearest EXIT. This theatre can be emptied in two minutes if you take your time.

JOHN B. KEENAN,
Director of Public Safety.

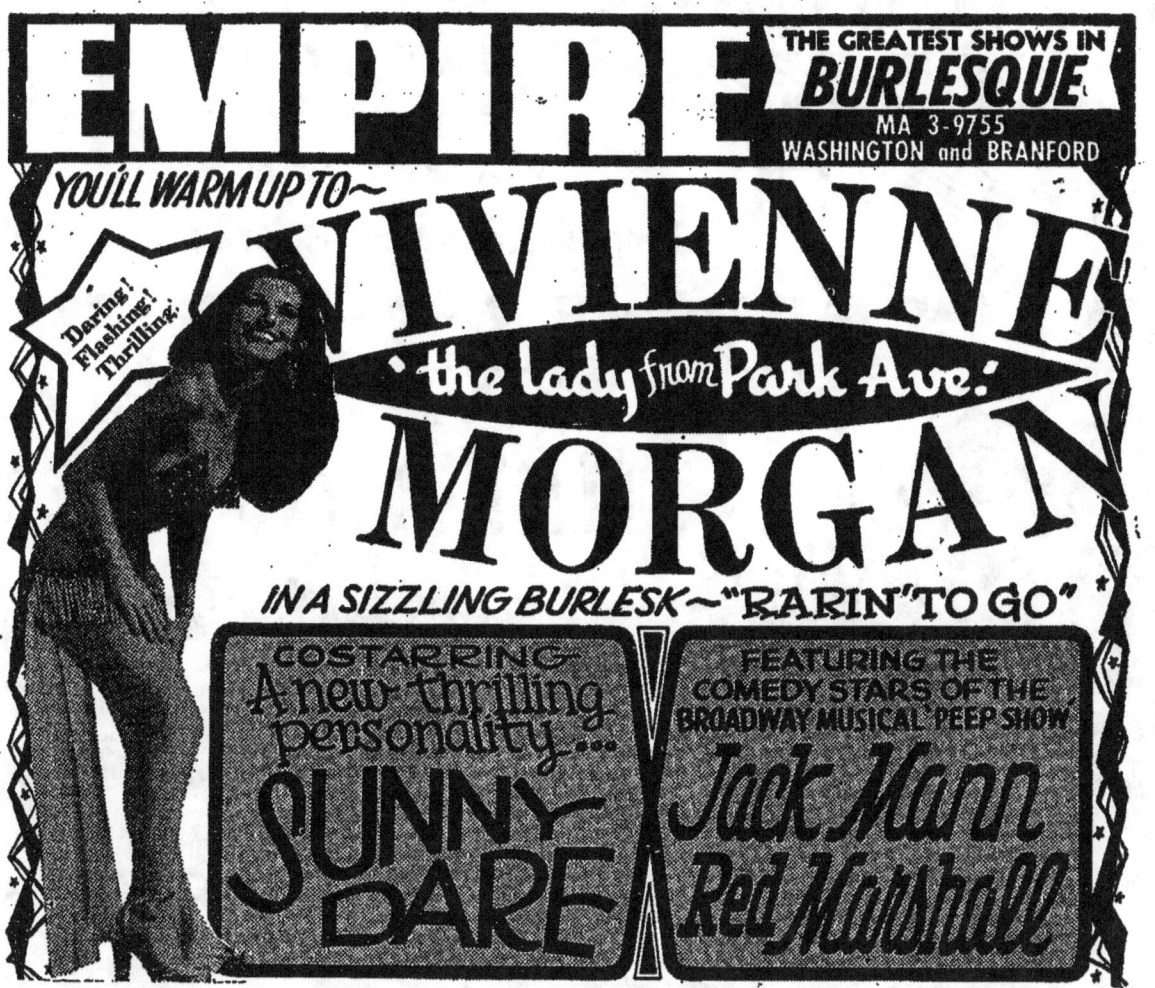

THE BATTLE OF CURVES!
EAST MEETS WEST!

THERE'S NO SHOW LIKE A BURLESK SHOW

NEXT WEEK!
STARTING FRIDAY...

Walter Winchell says...
"The Most Exotic Dancer Of Them All!"

"SEN LEE FU"

Plus "The Miss Dean Of Tease"

JILL HUNTLEY

IN

"WHIRL OF GIRLS"

AN ALL NEW HALE - ARLEN SHOW

Starring
BURLESK'S GREAT FUN EXPERTS

AL ANGER & MAC DENNISON

LATE SHOW EVERY SAT. NITE 11:30 - 2 Cont. Mats. 12 to 5, Eves. 8:30 Res.

NO SMOKING

Look around — Choose your nearest Exit. In case of Fire or Panic WALK, do not run to your nearest EXIT. This theatre can be emptied in two minutes if you take your time.

JOHN B. KEENAN,
Director of Public Safety.

PROGRAM — WEEK OF DECEMBER 10th, 1954

EMPIRE

THE GREATEST SHOWS IN BURLESQUE
MA 3-9755
WASHINGTON and BRANFORD

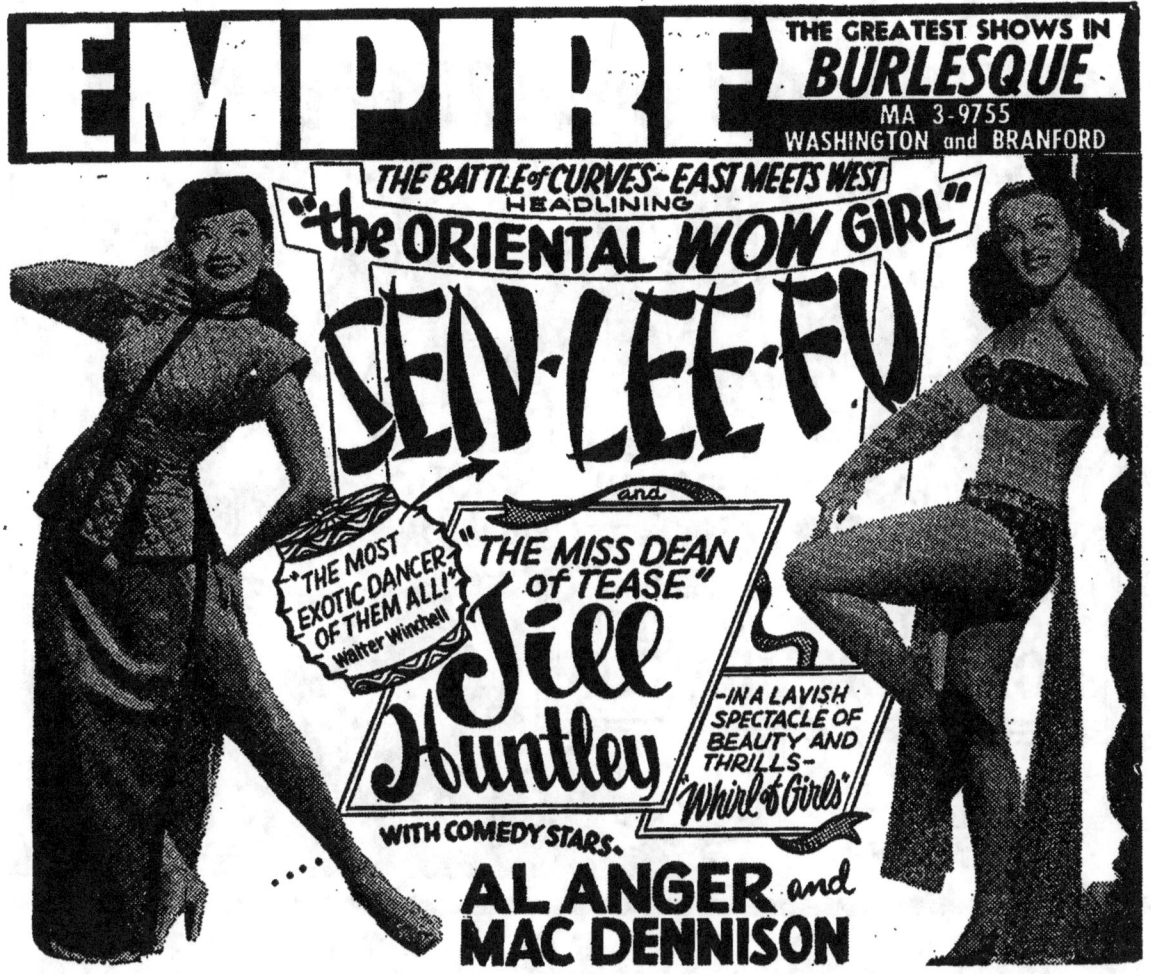

THE BATTLE of CURVES – EAST MEETS WEST
HEADLINING
"the ORIENTAL WOW GIRL"
SEN-LEE-FU
and
"THE MOST EXOTIC DANCER OF THEM ALL!" – Walter Winchell

"THE MISS DEAN of TEASE"
Jill Huntley
– IN A LAVISH SPECTACLE OF BEAUTY AND THRILLS –
"Whirl of Girls"

WITH COMEDY STARS

AL ANGER and MAC DENNISON

BARBARA CURTIS — AL MURRAY — JACK BRUNO
DELILAH LEE — DEE PARKS
THE HALE-ARLEN SHOW GIRLS & DANCERS — THE ESQUIRES

★ LATE SHOW EVERY SAT. NITE 11:30 ★ 2 Cont. Mats. 12-5. Eves. 8:30. Res. ★

During Intermission and After the Show
- Visit -

THE EMPIRE BAR

Right Across the Street
CHOICE WINES and LIQUORS
at Popular Prices
Rendezvous for the Theatrical Profession

Under New Management

The Rutledge Hotel

The Home of the Show Folks
in the Heart of the City
High and W. Market Sts.
Newark, N. J.
Tel. MA 2-4516

Grant Lunch Co.

199 MARKET STREET
76 MARKET STREET

"Around the Corner"

Serves the Best Liquor and Beer

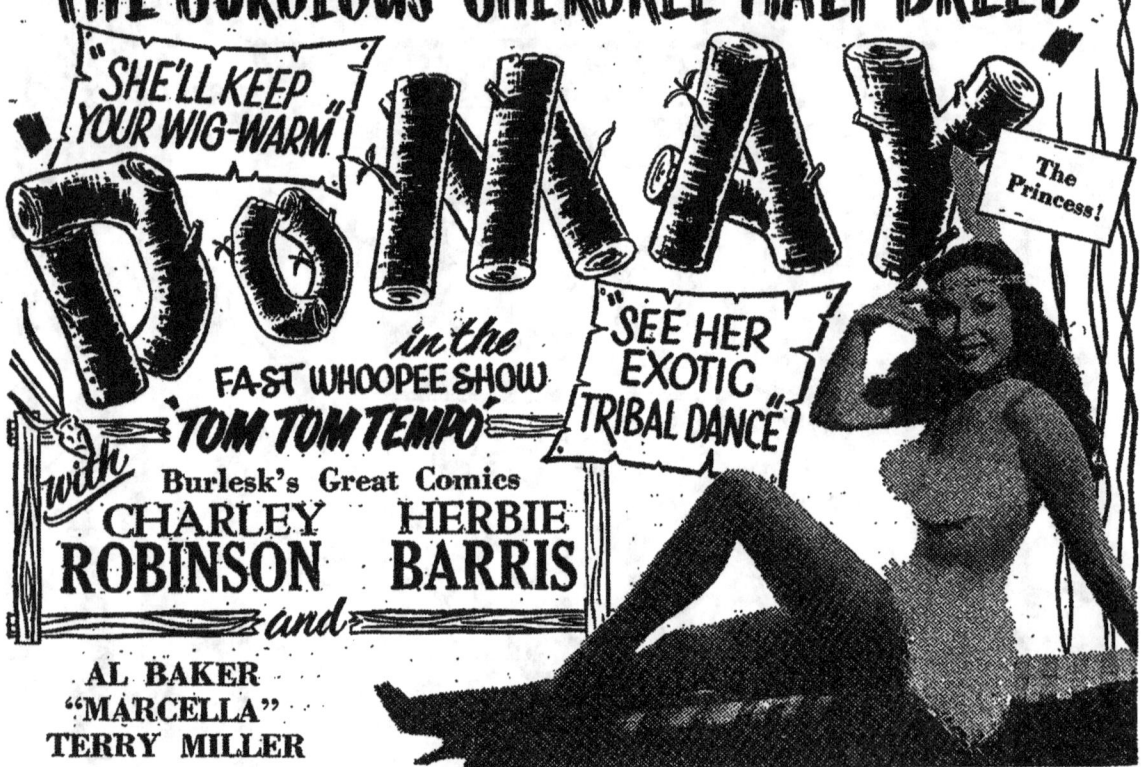

NEXT WEEK! STARTING FRIDAY...

THE GORGEOUS CHEROKEE HALF BREED

DONAY

The Princess!

"SHE'LL KEEP YOUR WIG-WARM"

"SEE HER EXOTIC TRIBAL DANCE"

in the FAST WHOOPEE SHOW 'TOM TOM TEMPO'

with Burlesk's Great Comics

CHARLEY ROBINSON — **HERBIE BARRIS**

and

AL BAKER
"MARCELLA"
TERRY MILLER

A SPECIAL ADDED ATTRACTION
CHORUS GIRLS TALENT CONTEST
COME AND APPLAUDE YOUR FAVORITE GIRL ON HER WAY TO STARDOM

LATE SHOW EVERY SAT. NITE 11:30-2 Cont. Mats. 12 to 5, Eves. 8:30 Res.

NO SMOKING

Look around — Choose your nearest Exit. In case of Fire or Panic WALK, do not run to your nearest EXIT. This theatre can be emptied in two minutes if you take your time.

JOHN B. KEENAN,
Director of Public Safety.

★ ★ ★ ★

PROGRAM — WEEK OF MAY 6th, 1955

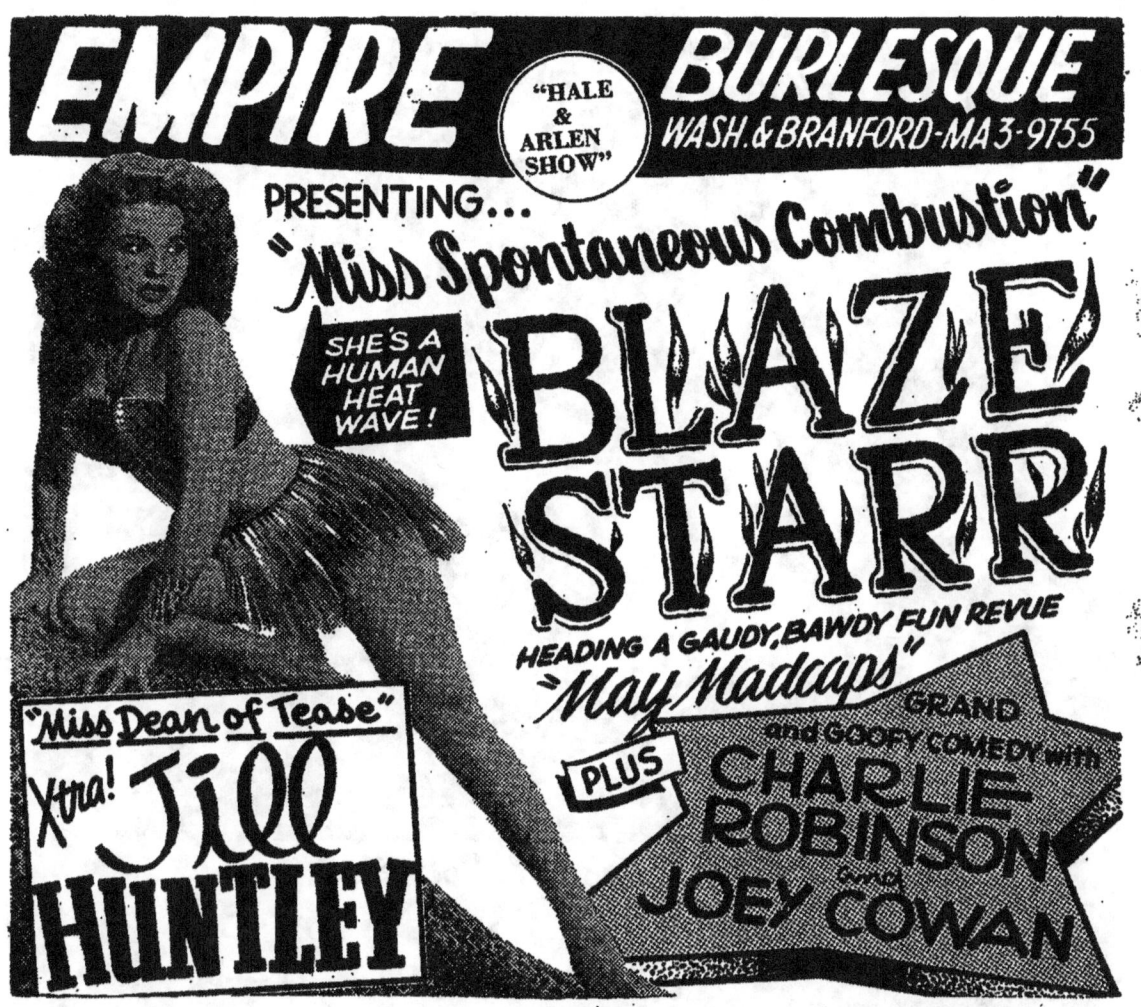

EMPIRE BURLESQUE
"HALE & ARLEN SHOW"
WASH. & BRANFORD — MA 3-9755

PRESENTING...

"Miss Spontaneous Combustion"

BLAZE STARR
SHE'S A HUMAN HEAT WAVE!

HEADING A GAUDY, BAWDY FUN REVUE
"May Madcaps"

"Miss Dean of Tease"
Xtra! Jill Huntley

PLUS GRAND and GOOFY COMEDY with
CHARLIE ROBINSON and **JOEY COWAN**

Also :- COUNTESS BARASSY — DANNY JACOBS — JOAN TAYLOR
JACK BRUNO — THE LEONARDS — THE HALE-ARLEN GIRLS

★ LATE SHOW EVERY SAT. NITE 11:30 ★ 2 Cont. Mats. 12-5. Eves. 8:30. Res. ★

During Intermission and After the Show
- Visit -

THE EMPIRE BAR

Right Across the Street
CHOICE WINES and LIQUORS
at Popular Prices
Rendezvous for the Theatrical Profession

Under New Management

The Rutledge Hotel

The Home of the Show Folks
in the Heart of the City
High and W. Market Sts.
Newark, N. J.
Tel. MA 2-4516

Grant Lunch Co.

199 MARKET STREET
76 MARKET STREET

"Around the Corner"

Serves the Best Liquor and Beer

★ ★ ★ ★

NEXT WEEK! STARTING FRIDAY...

ONE WEEK ONLY!

RECOGNIZED and ACKNOWLEDGED as

THE QUEEN OF BURLESK
ROSE LA ROSE

A 2½ HOUR STAGE SHOW! NO MOVIES

& HER SOPHISTICATED REVUE
"ROSE BUDS of '55"
Full of Fun.. Pretty Girls!

AND FEATURING A GREAT TRIO OF FUN MAKERS!

STEVE MILLS **CONNY RYAN** **HERBIE BARRIS**

LATE SHOW EVERY SAT. NITE 11:30-2 Cont. Mats. 12 to 5, Eves. 8:30 Res.

NO SMOKING

Look around — Choose your nearest Exit. In case of Fire or Panic WALK, do not run to your nearest EXIT. This theatre can be emptied in two minutes if you take your time.

By Order Of:
JAMES T. OWENS,
Director, Fire Department.
Newark, N. J.

PROGRAM — WEEK OF AUGUST 12th, 1955

EMPIRE

MA 3-9755
WASHINGTON and BRANFORD

THE GREATEST SHOWS IN BURLESQUE

AIR CONDITIONED

BREAKING ALL RECORDS!

"THE LADY FROM PARK AVE."
Vivienne Morgan
in a fast and furious frolic "Fun in the Sun"

Co-starring the Gorgeous Siren of Thrills
LYNN SHERWOOD

and Howl-A-Minute Comics —
MANNY KING 'CLOWN PRINCE'
RED MARSHALL

HALE ARLEN SHOW

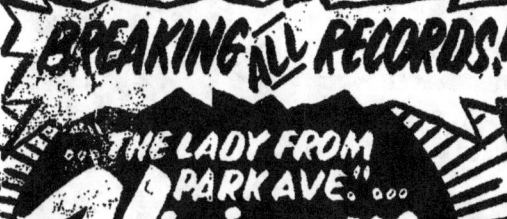

You never had it SO COOL

"NIKI" — BOB ROGERS — "TONI" — JACK BRUNO

LATE SHOW EVERY SAT. NITE 12:00-2 — Cont. Mats. 12 to 5, Eves. 8:45 Res.

During Intermission and After the Show
· Visit ·

THE EMPIRE BAR

Right Across the Street
CHOICE WINES and LIQUORS
at Popular Prices

Rendezvous for the Theatrical Profession

Under New Management

The Rutledge Hotel

The Home of the Show Folks

in the Heart of the City
High and W. Market Sts.
Newark, N. J.
Tel. MA 2-4516

Grant Lunch Co.

199 MARKET STREET
76 MARKET STREET

"Around the Corner"

Serves the Best Liquor and Beer

★ ★ ★ ★

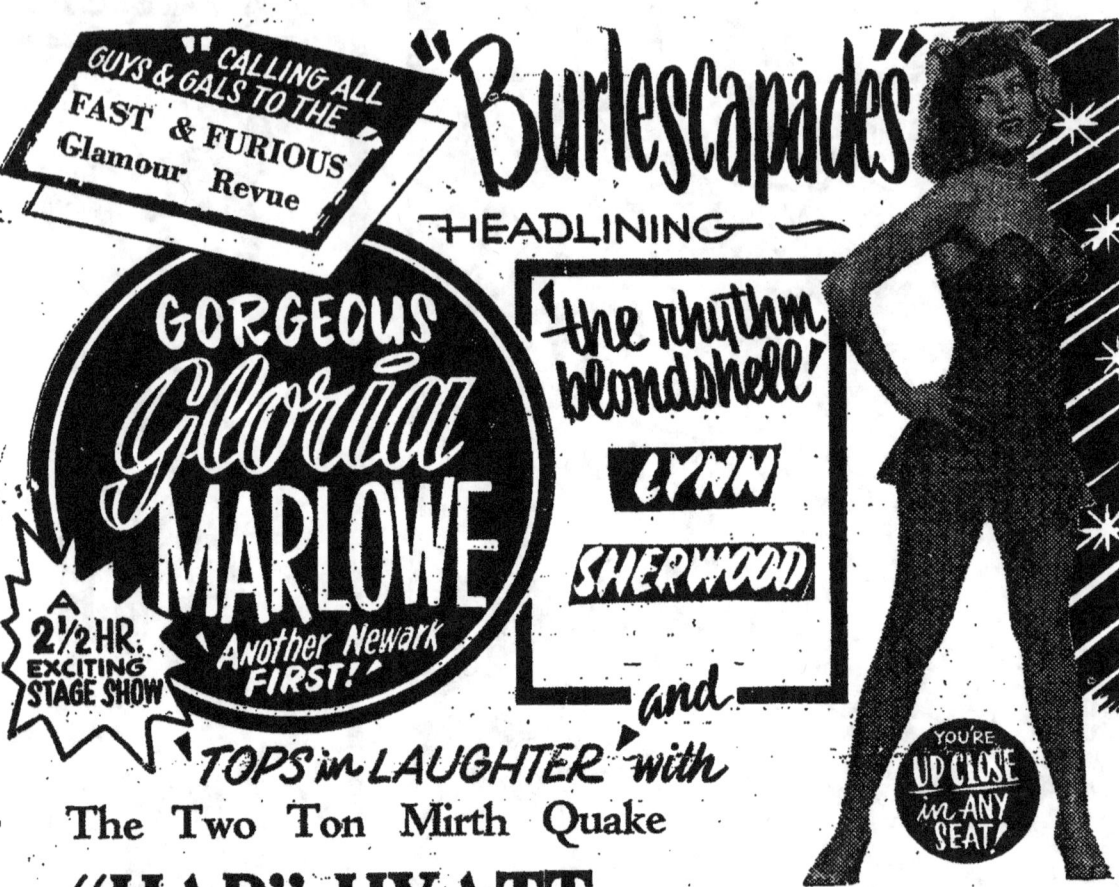

NEXT WEEK! STARTING FRIDAY...

"Calling All Guys & Gals to the" FAST & FURIOUS Glamour Revue

"Burlescapades"

HEADLINING —

GORGEOUS **Gloria MARLOWE** "Another Newark FIRST!"

A 2½ HR. EXCITING STAGE SHOW

"The Rhythm Blondshell" **LYNN SHERWOOD**

YOU'RE UP CLOSE in ANY SEAT!

and TOPS in LAUGHTER with

The Two Ton Mirth Quake

"HAP" HYATT

And The "Clown Prince" **MANNY KING**

EXTRA! EXTRA!
"NIKI" — "TONI"

LATE SHOW EVERY SAT. NITE 12:00-2 — Cont. Mats. 12 to 5, Eves. 8:45 Res.

NO SMOKING

Look around. — Choose your nearest Exit. In case of Fire or Panic WALK; do not run to your nearest EXIT. This theatre can be emptied in two minutes if you take your time.

By Order Of:
JAMES T. OWENS,
Director, Fire Department.
Newark, N. J.

★★★★

PROGRAM — WEEK OF AUGUST 24th, 1956

NOW! COMPLETELY AIR CONDITIONED
A BOB HALE SHOW — EMPIRE Burlesk
LATE SHOW EVERY SAT. NITE 11:30 2-Cont. Mats. 12 to 5. Eves. 8:30 Res.
MA 3-9755
WASHINGTON and BRANFORD

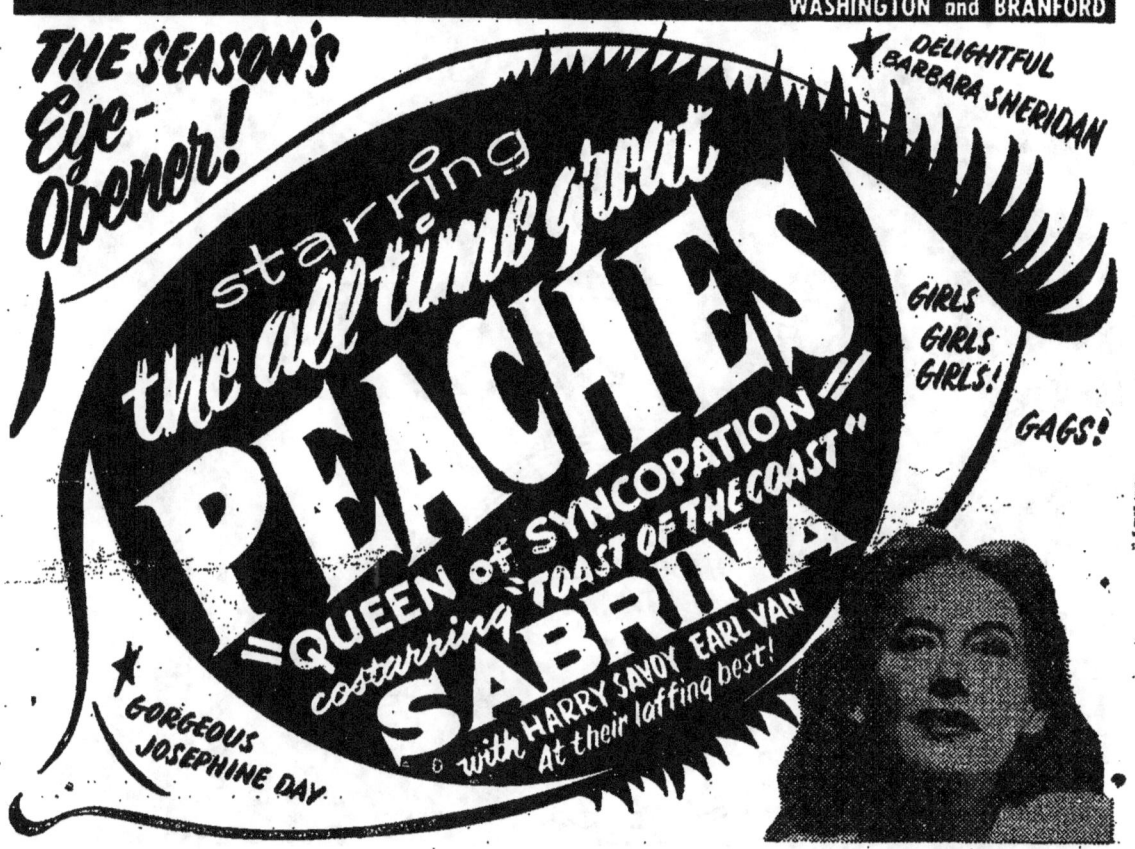

THE SEASON'S Eye-Opener!

★ DELIGHTFUL BARBARA SHERIDAN

starring the all time great **PEACHES** — QUEEN of SYNCOPATION costarring "TOAST OF THE COAST" **SABRINA**
with HARRY SAVOY • EARL VAN at their laffing best!

★ GORGEOUS JOSEPHINE DAY

GIRLS GIRLS GIRLS!
GAGS!

HARRY WHITE - ELLIS & WINTERS - JACK BRUNO - DIANE REYNOLDS

★ LATE SHOW EVERY SAT. NITE 11:30 ★ 2 Cont. Mats. 12-5. Eves. 8:30. Res. ★

During Intermission and After the Show
- Visit -
THE EMPIRE BAR
Right Across the Street
CHOICE WINES and LIQUORS
at Popular Prices
Rendezvous for the Theatrical Profession

Under New Management
The Rutledge Hotel
The Home of the Show Folks
in the Heart of the City
High and W. Market Sts.
Newark, N. J.
Tel. MA. 2-4516

Grant Lunch Co.
199 MARKET STREET
76 MARKET STREET
"Around the Corner"

Serves the Best
Liquor and Beer

★★★★

NEXT WEEK! STARTING FRIDAY.....

A Beauty Pageant...A Full Of Fun Frolic!

"PIN-UP-PARADE"

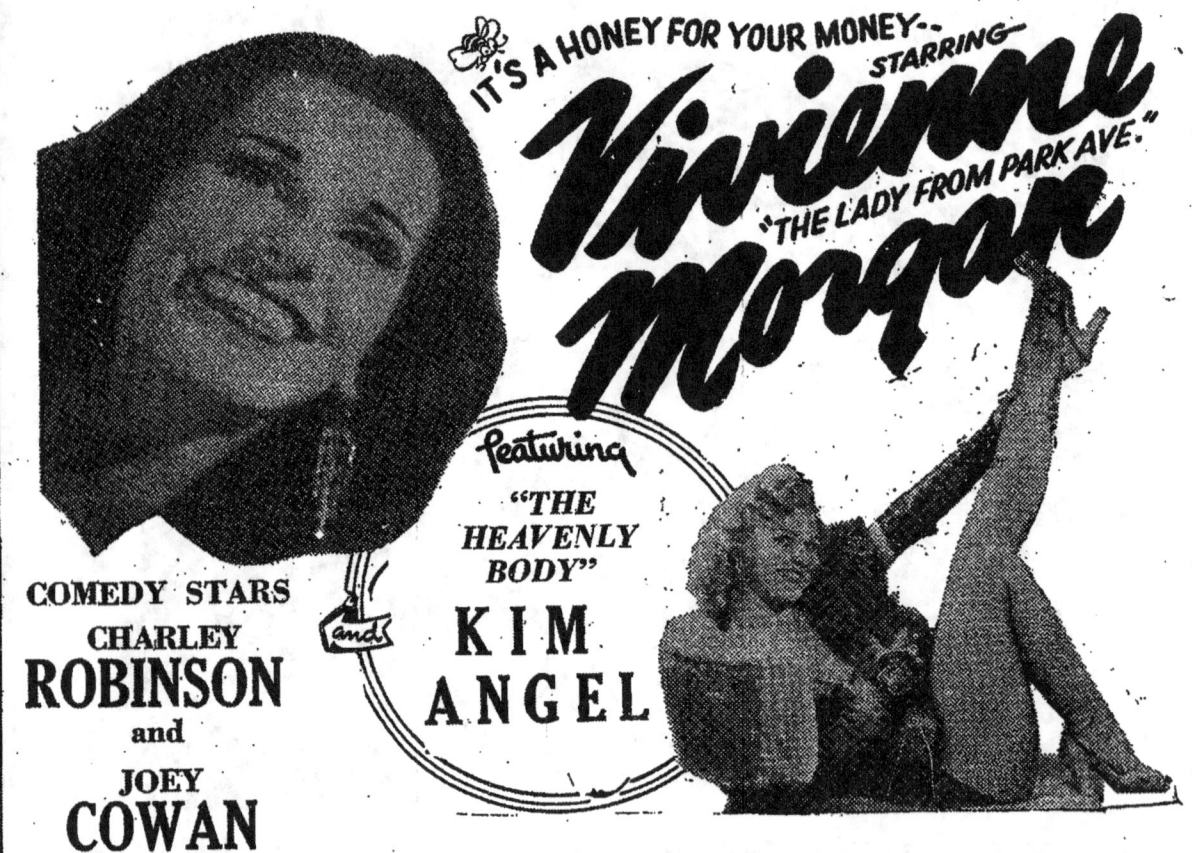

IT'S A HONEY FOR YOUR MONEY—
STARRING
Vivienne Morgan
"THE LADY FROM PARK AVE."

Featuring "THE HEAVENLY BODY"
KIM ANGEL

COMEDY STARS
CHARLEY ROBINSON
and
JOEY COWAN

PAUL WEST — MAE JOYCE — JUNE KIELY

LATE SHOW EVERY SAT. NITE 11:30-2 Cont. Mats. 12 to 5, Eves. 8:30 Res.

NO SMOKING

Look around — Choose your nearest Exit. In case of Fire or Panic WALK, do not run to your nearest EXIT. This theatre can be emptied in two minutes if you take your time.

By Order Of:
JAMES T. OWENS,
Director, Fire Department.
Newark, N. J.

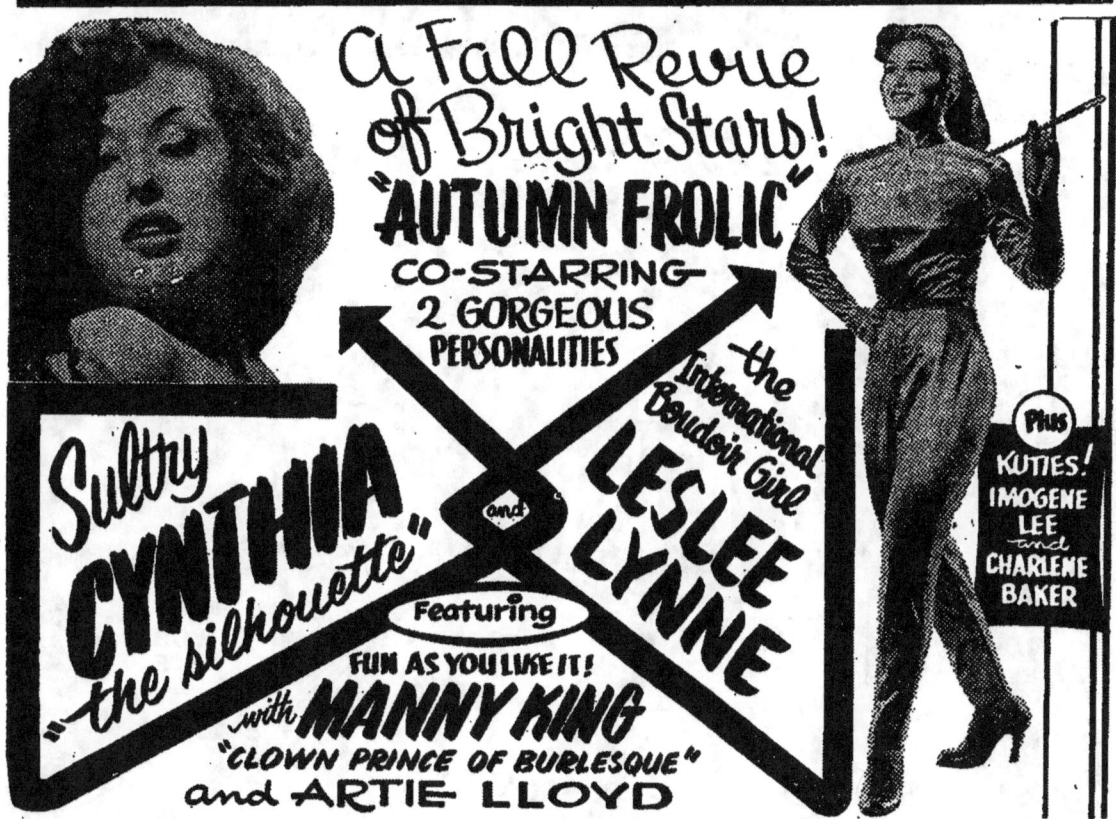

NEXT WEEK! STARTING FRIDAY.....

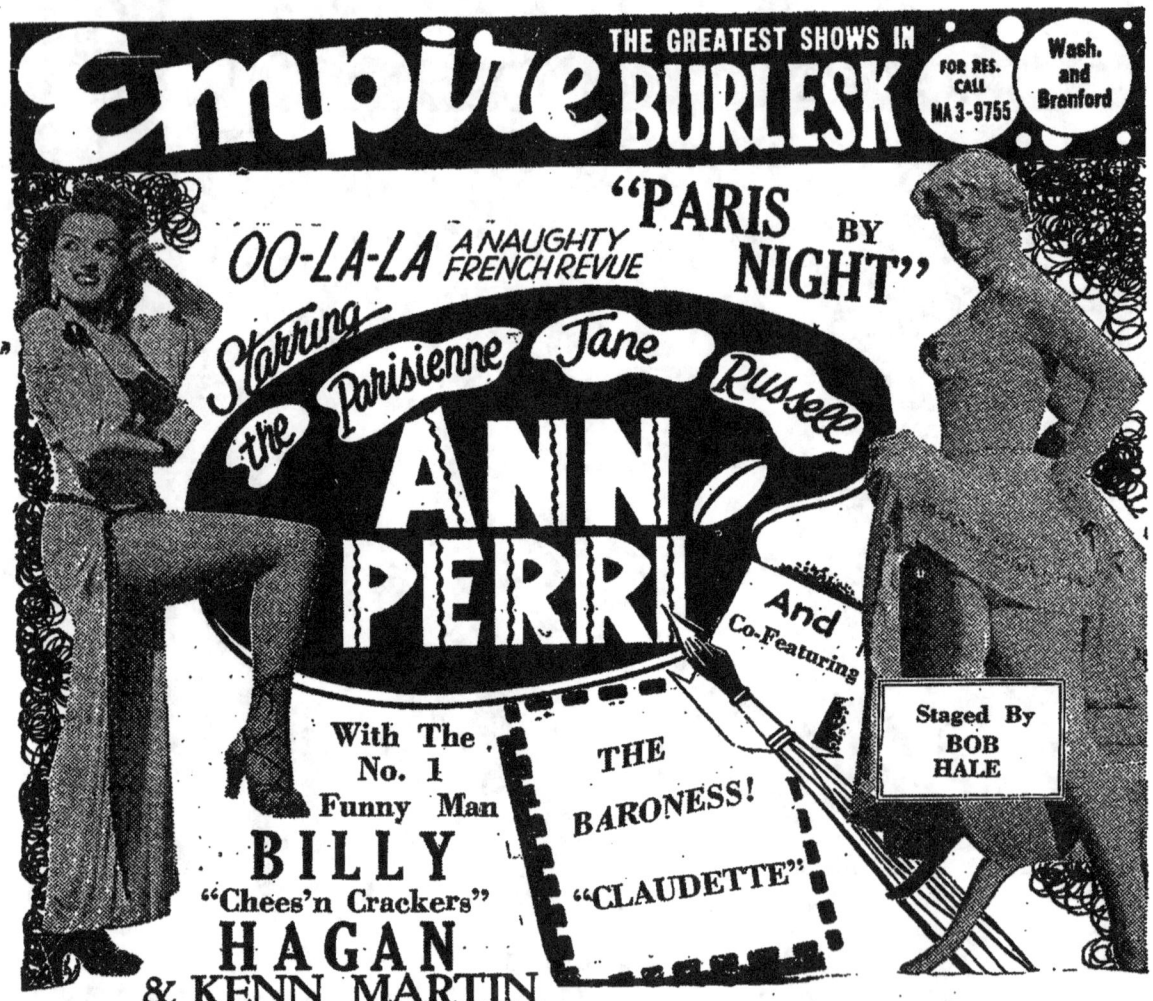

Empire BURLESK
THE GREATEST SHOWS IN

FOR RES. CALL MA 3-9755

Wash. and Branford

OO-LA-LA A NAUGHTY FRENCH REVUE "PARIS BY NIGHT"

Starring the Parisienne — Jane Russell

ANN PERRI

And Co-Featuring

THE BARONESS! "CLAUDETTE"

Staged By BOB HALE

With The No. 1 Funny Man
BILLY "Chees'n Crackers" **HAGAN**
& KENN MARTIN

Plus... KARI LaMONT — FLOYD HALLICY — LINDA LESLIE
JACK BRUNO — "FRENCHIE" FAURE — DIANE REYNOLDS

LATE SHOW EVERY SAT. NITE 11:30-2 Cont. Mats. 12 to 5, Eves. 8:30 Res.

NO SMOKING

Look around — Choose your nearest Exit. In case of Fire or Panic WALK, do not run to your nearest EXIT. This theatre can be emptied in two minutes if you take your time.

By Order Of:
JAMES T. OWENS,
Director, Fire Department.
Newark, N. J.

PROGRAM — WEEK OF OCTOBER 26th, 1956

EMPIRE Burlesk
A BOB HALE SHOW

MA 3-9755
WASHINGTON and BRANFORD

LATE SHOW EVERY SAT. NITE 11:30 — 2 Cont. Mats. 12 to 5, Eves. 8:30 Res.

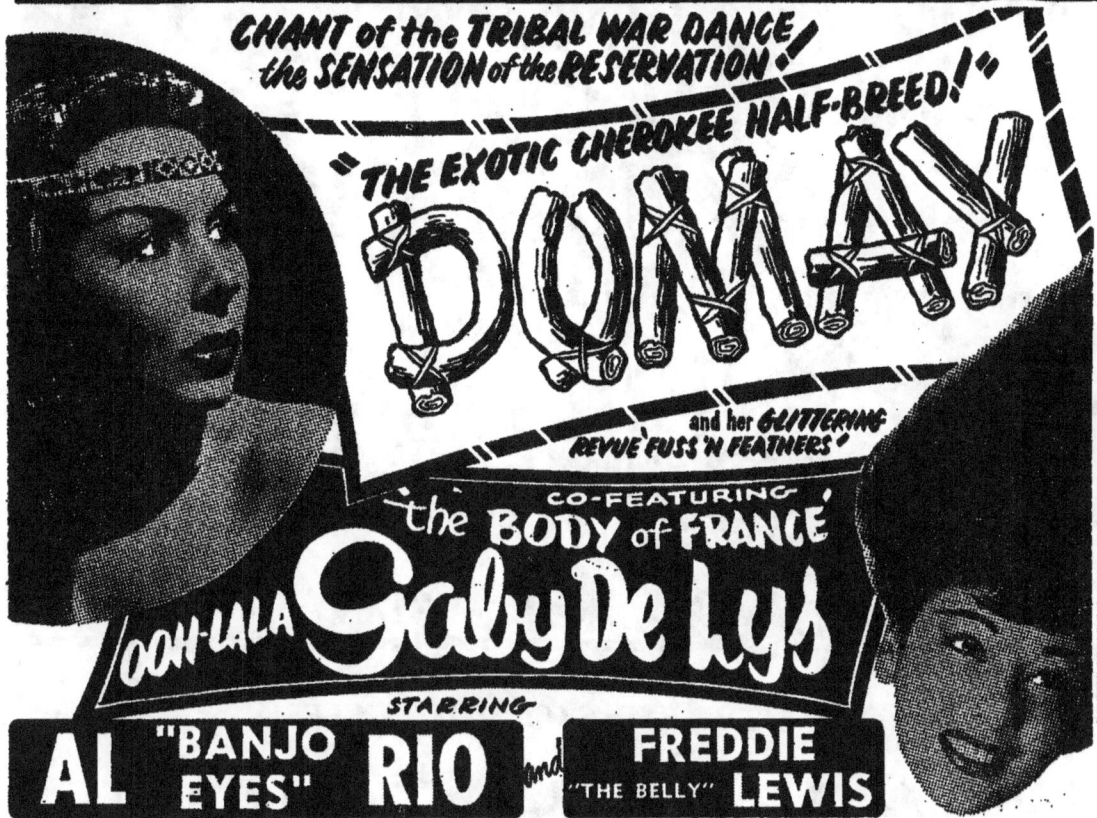

CHANT of the TRIBAL WAR DANCE, the SENSATION of the RESERVATION!

"THE EXOTIC CHEROKEE HALF-BREED!"

DOMAY

and her GLITTERING REVUE 'FUSS 'N FEATHERS'

CO-FEATURING
the BODY of FRANCE
OOH-LA-LA Gaby De Lys

STARRING

AL "BANJO EYES" RIO and **FREDDIE "THE BELLY" LEWIS**

HELEN DRAKE — EDDIE YUBEL — MARLA WYMAN
JACK BRUNO — LAURA HALE — THE BOB HALE DANCERS & SHOW GIRLS

★ LATE SHOW EVERY SAT. NITE 11:30 ★ 2 Cont. Mats. 12-5. Eves. 8:30. Res. ★

During Intermission and After the Show
- Visit -

THE EMPIRE BAR

Right Across the Street
CHOICE WINES and LIQUORS
at Popular Prices
Rendezvous for the Theatrical Profession

Under New Management

The Rutledge Hotel

The Home of the Show Folks
in the Heart of the City
High and W. Market Sts.
Newark, N. J.
Tel. MA. 2-4516

Grant Lunch Co.

199 MARKET STREET
76 MARKET STREET

"Around the Corner"

Serves the Best Liquor and Beer

NEXT WEEK! STARTING FRIDAY.....
A REAL "SHAKE and ROLL REVUE"
STARRING

A BEVY OF GALS & GAGS IN A GREAT BURLESK!

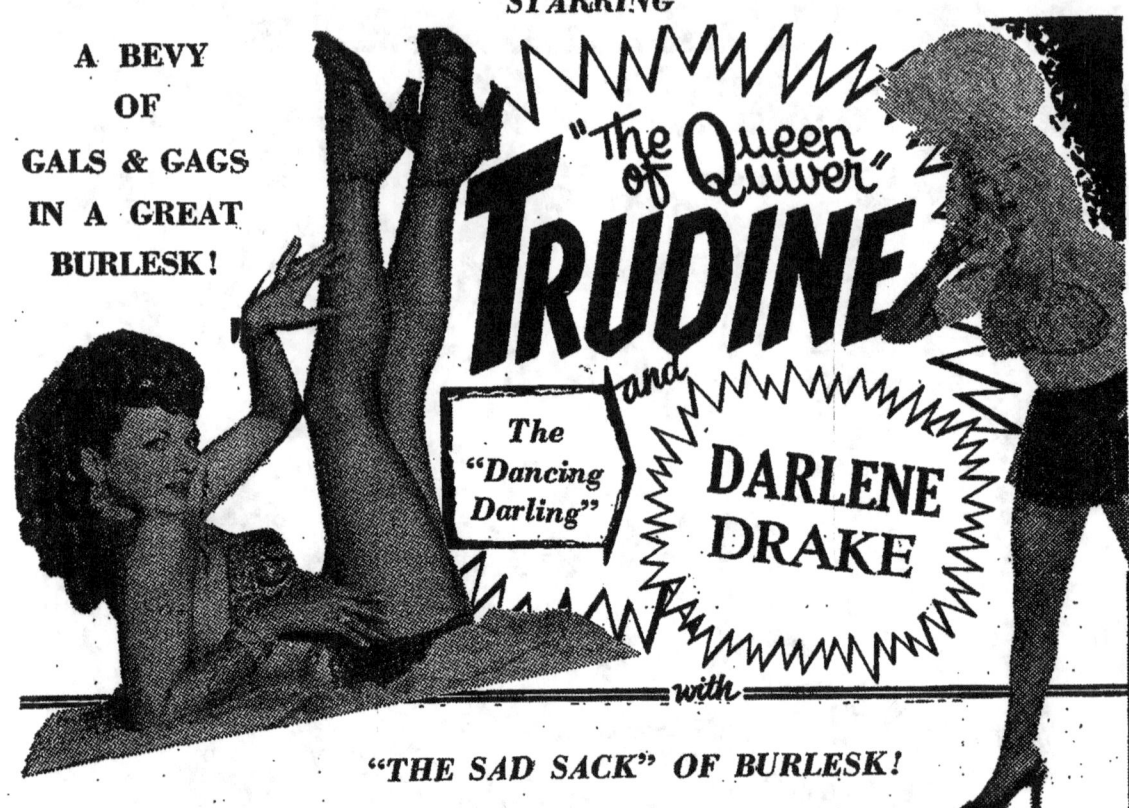

"The Queen of Quiver" **TRUDINE**

and

The "Dancing Darling" **DARLENE DRAKE**

with

"THE SAD SACK" OF BURLESK!

AL ANGER

SAMMY PRICE — LEE CLIFFORD
Barbara Curtis — June Darlene

LATE SHOW EVERY SAT. NITE 11:30-2 Cont. Mats. 12 to 5, Eves. 8:30 Res.

NO SMOKING

Look around — Choose your nearest Exit. In case of Fire or Panic WALK, do not run to your nearest EXIT. This theatre can be emptied in two minutes if you take your time.

By Order Of:
JAMES T. OWENS,
Director, Fire Department.
Newark, N. J.

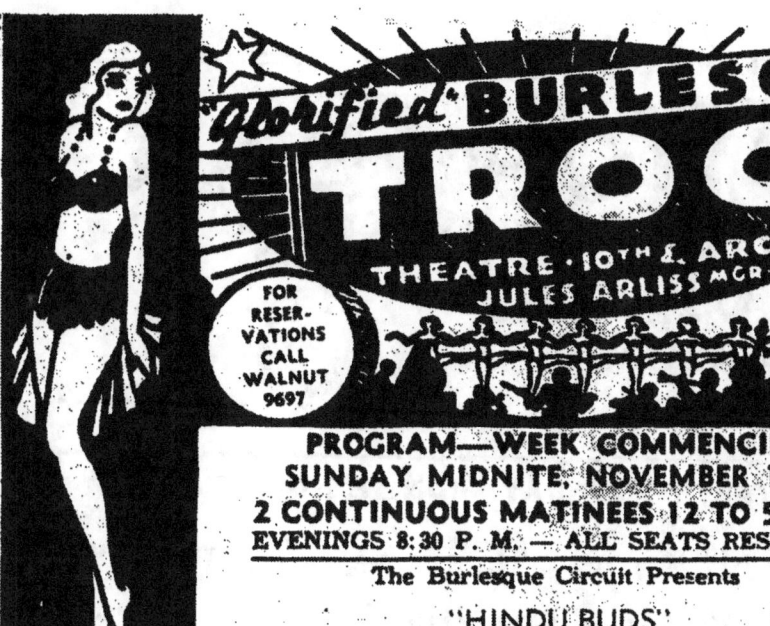

Glorified BURLESQUE
TROC THEATRE · 10TH & ARCH
JULES ARLISS, MGR.

FOR RESERVATIONS CALL WALNUT 9697

**PROGRAM—WEEK COMMENCING
SUNDAY MIDNITE, NOVEMBER 17th!
2 CONTINUOUS MATINEES 12 TO 5 P. M.
EVENINGS 8:30 P. M. — ALL SEATS RESERVED**

The Burlesque Circuit Presents

"HINDU BUDS"
Featuring
THE BLONDE BOMBSHELL!

"Hinda WASSAU"

The Baby Doll Beauty!
"HELEN COLBY"

Prince of Comedy! A Fascination! The Always Funny!
Max Furman—"ALOHA"—Dick Richards

And Favorite Burlesquers Featuring
"ALMA MAIBEN" "MURRY BRISCOE"

"JIMMY CAVANAUGH" — "LEE CURDY" — "CHARLIE JOHNSON"
A MAXIE FURMAN PRODUCTION!
(Program Continued Inside)

AN ENTIRE NEW TRAVELING SHOW EVERY WEEK!

BEFORE & AFTER THE SHOW VISIT
JACK TOLAND'S CAFE
Where Theatrical People Meet

AT THE NORTHEAST COR. 10th & ARCH STS. 100 BRANDS OF FINE LIQUORS

For Good Eats & Beer 5¢

Served To You in Your Seat

SUPPLEE
ICE CREAM

During the Intermission!

SEE THE NEW
Musical Bar

BEFORE & AFTER THE SHOW VISIT
The Rendezvous
HOTEL SENATOR
915 WALNUT ST. — KINGSLEY 0859

A Smart, Intimate, Revue
Continuous Entertainment

Irvin Wolf, Prop. No Cover Charge At Anytime Mixed Drinks & Liqueurs

=== PATRONIZE OUR ADVERTISERS ===

BEFORE AND AFTER THE SHOW VISIT

THE SHOW BAR

WHERE THE THEATRICAL PROFESSION GATHER!

BEER ON TAP 5¢
Sandwiches

BOOTH SERVICE **NEXT DOOR TO THE TROC**

NEXT WEEK!!! STARTING SUNDAY MIDNITE, NOVEMBER 24th!

ONE WEEK ONLY — GET SEATS NOW!

Stageland's Most Beautiful Girl!

"ANN CORIO"

and

"HER OWN BIG NEW SHOW"

When in New York City
STOP AT THE
HOTEL Claridge
BROADWAY & 44th ST.
SPECIAL RATES
To the Profession
in the Heart of Times Square

AFTER THE SHOW
VISIT THE
MERRY GO ROUND CAFE
Music & Dancing Every Nite
N. E. Cor. 10th & Race Sts.
in the Heart of Chinatown

PARKING
Worries Over
LEAVE YOUR CAR
ALMOST NEXT DOOR
THE THEATRE
PARK AT
1013-15 Arch St.
SAFE SYSTEM
Courteous Attendants

IN NEWARK STOP AT THE
BILTMORE HOTEL
IN THE HEART OF THE CITY
CATERING TO THE PROFESSION

HIGH ST. AT WEST MARKET, NEWARK, N. J. Monroe M. Vartan, Mgr.

SAM MILLER
139 No. 9th St. Market 0807
TAILOR and CLEANER
Pressing While You Wait
ALL FANCY ALTERATIONS

JUST LIKE MAGIC!
KWIT (Quit) 25c
Cold Capsules Will Make
That Disgusting Cold Disappear
MADE & SOLD AT
HARRY A. BRADBURD'S DRUG STORE
716 RACE ST. WALNUT 2340

TROC LUNCH ROOM

102 North 10th St. Just Around the Corner

HOT DOGS **5¢** SOFT DRINKS
SANDWICHES CIGARS — CANDIES

We Beat Them All! Accurate, Quick Service!

=== PATRONIZE OUR ADVERTISERS ===

―PATRONIZE OUR ADVERTISERS―

FOR A GOOD TIME VISIT
THE BUCKET
LARGE GLASS OF BEER 5c
Sandwiches 5c Up

Music and Dancing Every Night

Opposite the Troc 1002 ARCH ST.

Watch **FAUST'S**
Opening Specials At Our New Building
223 NORTH 8th ST.
Next Door To Auditorium — Most Reliable Place On 8th St.
Full Line of Goldtex & Silvertex — Toys, Novelties, Etc.

FIRE NOTICE: The exits indicated by red lights and signs nearest to the seat you occupy are the quickest exits to the street. In the event of fire or emergencies, please do not run — WALK TO THE NEAREST EXIT!

BEFORE & AFTER THE SHOW VISIT
BROWN'S
CAFETERIAS & BARS — LARGE GLASS OF BEER 5¢
All Kinds of Liquors & Wines
N. E. COR. BROAD & RACE STS. 804 ARCH ST.

Hold Your Theatre Parties Here!
Attractive BENEFIT Plan!
CONSULT THE MANAGER OR CALL WAL 9697.

HOTEL ARCH
931-33 ARCH ST. Walnut 9063
Rooms 75c & $1.00 Daily
Single $3.00 To $4.00
Weekly Double $5.00 To $7.00

The Costumes: Of All Shows Playing This Theatre
Are Supplied By the
COLLINS CREATIVE COSTUME CO.
447 Broadway, New York Canal 6-9782
Costumes Rented For All Occasions or Made To Order
All Inquiries Invited EVA COLLINS

BAUM'S
INCORPORATED
PEN. 1742-43
114 So. 11th ST.
Theatrical and Display Fabrics
Costumer's Supplies Theatrical Footwear

THE THEATRICAL FLORIST 6 No. 52nd ST.
Mayfair 8917 Say it with flowers Allegheny 6318

Rapps Flowers

Corsages, Wedding Bouquets, Funeral Design.

Before & After the Show
FOR YOUR RECREATION
STOP OVER TO
Bill's Pool Parlor
WHERE FRIENDS MEET FRIENDS
933 ARCH ST.
NEXT TO TOLAND'S CAFE
Known in This Vicinity Since 1913

Reserve Your Seats Now!
For Next Week's
— NEW BIG SHOW —
AVOID STANDING IN LINE!

Program Continued—Subject To Change Without Notice.
Warning—Taking of Photographs & Candid Camera Shots Is Prohibited.
All Material, Scenes, Dialogue, Etc., Are Protected by T. B. C. Through the Copyright Laws.

"HINDU BUDS"

ACT ONE

Scene 1. Opening—"Stars of the Future"......Jimmy Cavanaugh and Girls
Scene 2. Whiz and Wham......Dick Richards, Briscoe, Cavanaugh, & Co.
Scene 3. "Rhumboogie"......The Furmanettes
Scene 4. Auto Flirtation......Maxie Furman, Briscoe, Maiben, "Aloha"
Scene 5. "Polynesian Beauty"......The Furmanettes
Scene 6. Slumming in Park Avenue......Alma Maiben, Lee Curdy, Cavanaugh & Girls
Scene 7. Specialty......Charlie Johnson
Scene 8. Gaston the Lover......Dick Richards, Briscoe, Cavanaugh, Maiben & Co.
Scene 9. "Our Baby Bud"......"Helen Colby"
Scene 10. "Farmerettes"......The Furman Buds
Scene 11. It Happened One Night......Maxie Furman, Briscoe, Maiben & Cast
Scene 12. Ballet—"Love Parade"......Aloha, Cavanaugh, & Ensemble
Scene 13. Familiar Gags......Furman, Richards & Players
Scene 14. "The Bombshell Bud"......"Hinda Wassau"
Scene 15. Finale—"Hits of the Day"......The Entire Company

—Intermission—
ACT TWO

Scene 16. Opening—"Under the Wysteria"......Jimmy Cavanaugh & Ensemble
Scene 17. "Our Bud of Sweetness"......"Helen Colby"
Scene 18. New Stenographer......Dick Richards, Briscoe, Maiben & Cast
Scene 19. "A Fascinating Bud"......"Aloha"
Scene 20. "Jazzamania"......The Furmanettes
Scene 21. An Illusion......Maxie Furman, Briscoe, Maiben & Co.
Scene 22. "She'll Fool You"......"Dear Richards"
Scene 23. Ballet—"The Breeze and I"......Lee Curdy, Cavanaugh & Ensemble
Scene 24. Black-Outs......Furman, Richards & Players
Scene 25. "The Blonde Bud"......"Hinda Wassau"
Scene 26. Finale—"The Bud Hits"......The "Hindu Buds" Co.
MUSIC BY MERRICK VALINOTE AND HIS SWINGSTERS!

NEXT WEEK!!! Starting Sunday Midnite, Nov. 24th! NEXT WEEK!!!

THE MANAGEMENT IS PLEASED TO BRING YOU!
Stageland's Most Beautiful Girl!

"ANN CORIO"
and
"HER OWN BIG NEW SHOW"

ONE WEEK ONLY — GET SEATS NOW!

A NEW SHOW
STARTS EVERY
SUNDAY MIDNITE
AT 12:01 A. M.
GET TICKETS NOW!

Before & After the Show Visit
ROMAN'S
CAFETERIA and BAR
EAT — DRINK AND BE MERRY
Sandwiches, Hot & Cold Platters
1104 ARCH ST.

NANA — The History of A French Courtesan
By Emile Zola — Now On Sale At 49c
Also **THE TORCH OF LIFE**—A Key To Sex Harmony
By Dr. Rossiter — Originally Sold At $2.50 — Reduced To 98c
Also A Large Variety of Books Sold At 39c

JEAN'S BOOK SHOP
Next Door To S. W. Cor. 10th & Arch Sts.
58 N. 10th ST. — WAL. 2493 — Mail Orders Filled

Milton Wants To See You!
FULL MEAL 10¢ & up
"Original Busy Bee" 256 No. 9th St.

ALAN HOTEL
820-22 WALNUT ST.
Catering To the Profession
Newly Furnished & Renovated
PEN. 7110

ORIGINAL **HARRY'S**
227 NORTH 8th ST.
RUBBER GOODS & TRICK GOODS
We Undersell Everyone in Town

BROWN'S CAPSULES
AND **935 Injection** $1.00 EACH
CURES MEN IN A FEW DAYS
DR. BROWN'S DRUG STORE 113 N. 10th ST.

JUST AROUND THE CORNER
LARRY'S LUNCH ROOM
HOT DOGS 5¢ SOFT DRINKS
SANDWICHES CIGARS — CANDIES
102 No. 10th ST. ACCURATE, QUICK SERVICE

ATTEND OUR BIG
— **MIDNITE SHOW** —
Every Sunday At 12:01 A. M.

BEFORE AND AFTER THE SHOW VISIT
"808"
RACE STREET
For A Square Deal — Dancing — Wines & Liquors
BEER Direct From the KOOLER KEG

Air Conditioned Throughout For Your Comfort!
PATSY'S VENICE GRILL
S. W. Cor. 12th & Filbert Sts.
Renowned For Its **SEA FOOD**
SPECIAL LUNCHEON PLATTERS — 35c
DINNERS — 75c & UP
FLOOR SHOW — MUSIC — DANCING
Nightly From 6 P. M. Until ?

―PATRONIZE OUR ADVERTISERS―

NEXT ATTRACTION
SUNDAY MATINEE JUNE 27th, 1954

WILLIAM KOUD PRESENTS

THE ONE AND ONLY
The Cream Of The Crop

"PEACHES"
"QUEEN of QUIVER"
AND HER
"SCAN TEASE of '54"

Held Over By Popular Demand

GEORGE MURRAY
HERBIE BARRIS
AL BAKER — BOB RIDLEY
Ronnie Russell
Vickie Revnolds

BEFORE AND AFTER THE SHOW
— CALL —
CITY SERVICE CAB
DIAL 5-3244
PROMPT AND COURTEOUS SERVICCE

HEADQUARTERS FOR ATLANTIC CITY SOUVENIRS

TILDEN'S NOVELTY SHOP
733 BOARDWALK
(Next to Globe Theatre)
LARGEST SELECTION OF SOUVENIRS ON THE BOARDWALK

JACK'S GULF SUPER SERVICE STATION
States and Pacific Avenues
Dealer J. O. Hartman
Telephone 4-9992

PROGRAM — STARTING JUNE 18th, 1954
ATLANTIC CITY'S HOME OF GLORIFIED BURLESK

Globe theater
Jack Beck, Mgr.
DELAWARE & BOARDWALK
Phone 4-1601

WILLIAM KOUD PRESENTS
CENTENNIAL BURLESKERS OF 1954
STARRING EXOTIC

"FRANCINE"
WITH
THE HILARIOUS MEN OF MIRTH
GEORGE MURRAY
HERBIE BARRIS
AL BAKER — BOB RIDLEY
Eillen Hubert — Dottie Dean
Alverda — Leslie Gaines

2 SHOWS NIGHTLY—9 P. M. and 12 MIDNIGHT
MATINEE SUNDAY AT 3 P. M.
ENTIRE NEW SHOW EVERY SUNDAY

AFTER THE SHOW THE PLACE TO GO —
PICADILLY BAR
CONN. and PACIFIC AVENUES — PHONE 5-0054
DRINKS AT POPULAR PRICES EXCELLENT SANDWICHES
YOUR HOSTS
CHARLEY and JOE

ORIENTAL GARAGE 139 S. MASS. AVE.
COMPLETE AUTO REPAIRS — NEVER CLOSED
- PROMPT ROAD SERVICE -
ATLANTIC CITY
PARKING - PHONE 4-3676 - AAA SERVICE
J. HANNON R. RAVIELLI

GALLERY FOUR

CONSISTING OF:

Covers and sample interior pages of Cartoon Books sold at Burlesque theaters

"Just wait 'til you see her in a BATHING suit!"

"I don't care what ya been used to, venetian blinds don't go that way."

"We've been out of mixer for the last two rounds, but nobody's noticed it."

"Fourth floor—LOVE SEATS."

"Ahem! You can find that under ala carte, Sir!"

What kind of a policy did you have in mind, Mr. Winks.

"You're going to spoil all the good my beauty treatments do if you worry me about what they cost."

"Now that you've created them, Ormsby, I think it's a shame not to let them walk around a while before putting them back in a test tube."

I don't want to sound flattering but you're the first man I've gone out with in years.

"McGloon is a bad risk. Have you seen his wife wrestle on TV?"

I feel positively undressed without my earrings!

"I'll be back in an hour or two. I know some fellows that'd like to kiss the bride."

THE FARMER'S DAUGHTER

LORD PUSHBOTTOM and EMMA

"SHE FITS — HAVE HER REPORT TO MY OFFICE MONDAY MORNING!"

GUS THE GREEK

FLASH JORDAN

"So Tyrone is as handsome as ever—so what are you sore at me for?"

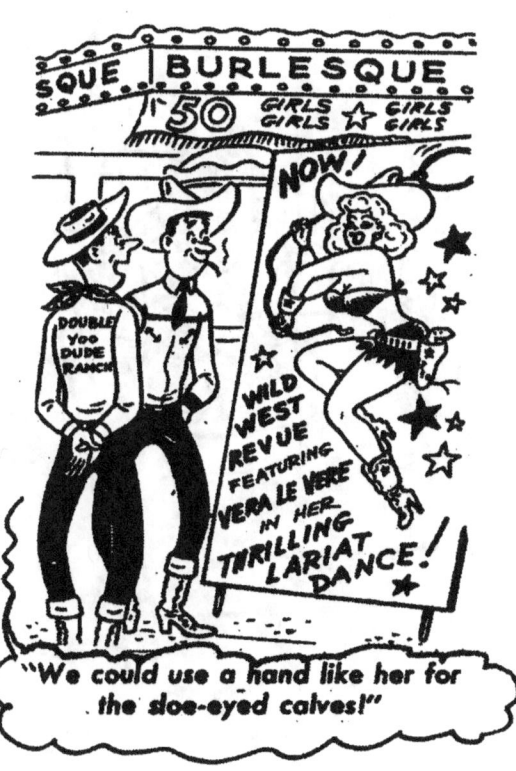

"We could use a hand like her for the doe-eyed calves!"

"Is this the first time you've come across, Miss Benson?"

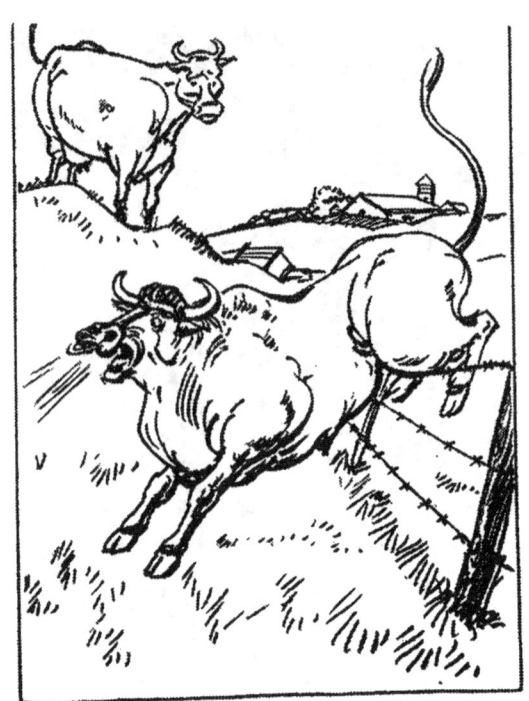

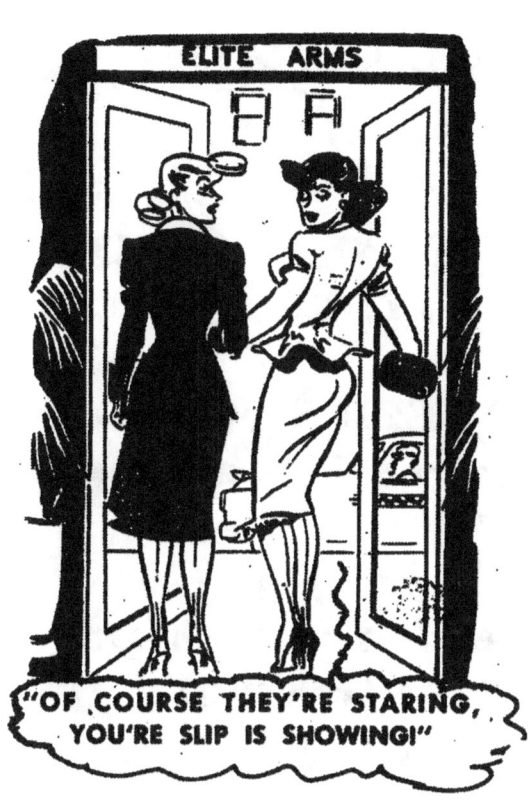

"OF COURSE THEY'RE STARING, YOU'RE SLIP IS SHOWING!"

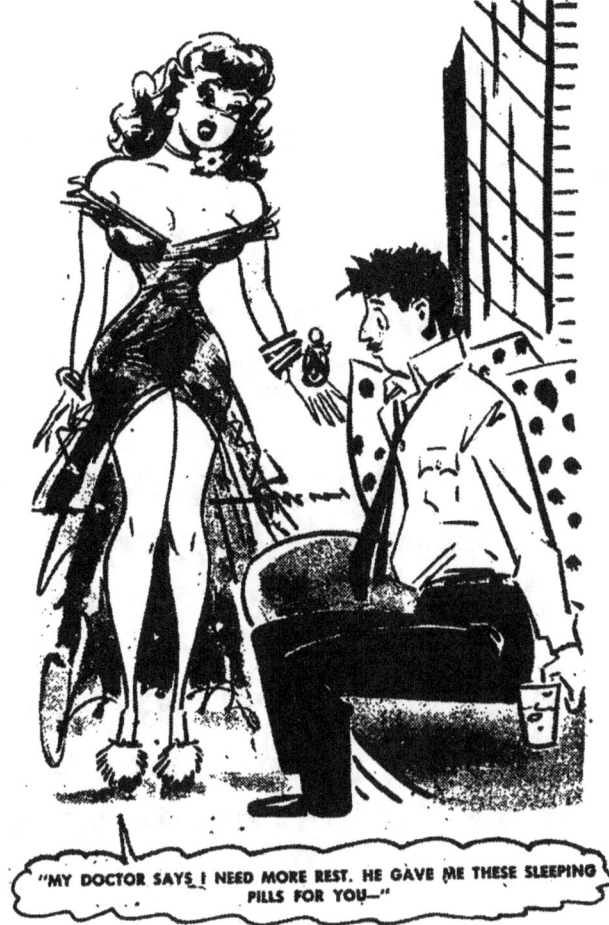

"MY DOCTOR SAYS I NEED MORE REST. HE GAVE ME THESE SLEEPING PILLS FOR YOU—"

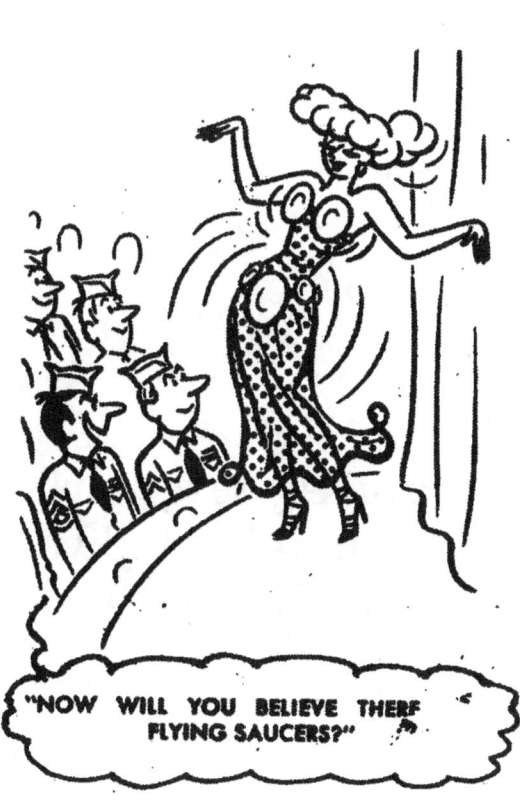

"NOW WILL YOU BELIEVE THERE FLYING SAUCERS?"

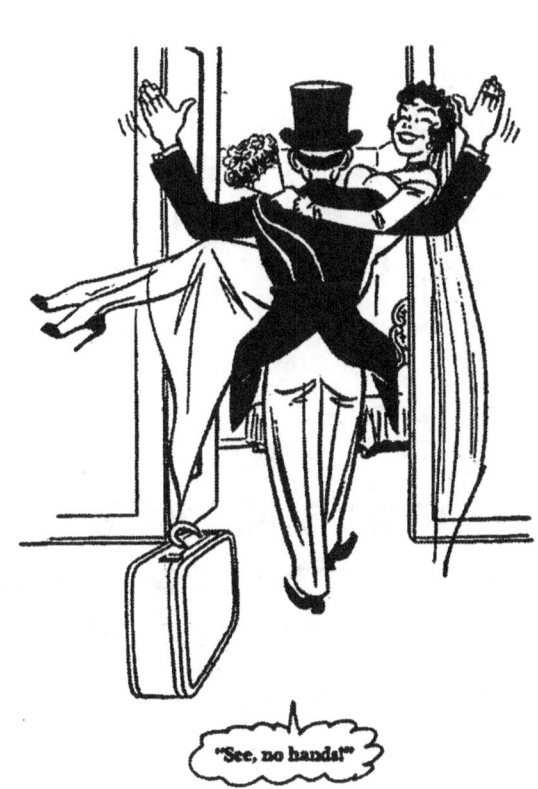

"See, no hands!"

MORE BOOKS BY BRUCE SIMON

FIRE IN THE CULTURE MINE- COLLECTED MINESHAFT MAGAZINE ESSAYS 2004-2010

THE LADY WHO USED TO FEED HIM HAS MOVED AWAY and other incredibly sad dog cartoons

DISRUPTING SILENCE- the transition from silent film to sound as seen through contemporary advertising

Available through Amazon.com or the author

BRUCE SIMON likes a good laugh and a pretty girl and married a pretty girl who likes to laugh. He lives with his brilliant wife Jackie and their Chilli Dog in Berkeley, CA

www.ingramcontent.com/pod-product-compliance
Lightning Source LLC
Chambersburg PA
CBHW081431220526
45466CB00008B/2342